Prized Possessions:

European Paintings

from Private Collections

of Friends of the

Museum of Fine Arts, Boston

Prized Possessions

European Paintings from Private Collections of Friends of the Museum of Fine Arts, Boston

by Peter C. Sutton

with Robert J. Boardingham, John J. Chvostal, Andrew Noone,
Katherine Rothkopf, Perrin Stein, Marjorie E. Wieseman,
and Eric M. Zafran

Museum of Fine Arts, Boston

Copyright © 1992 by Museum of Fine Arts, Boston
Library of Congress catalogue card no. 92-54161
ISBN: 0-87846-357-7

Designed by Janet O'Donoghue
Edited by Robin Jacobson
Typeset by DEKR Corporation
Printed by Meridian Printing

Exhibition Dates
June 17–August 16, 1992
The exhibition was organized by the Museum of Fine Arts, Boston.

Cover
Details from:
Claude Monet (French, 1840–1926)
Poplars at Giverny, 1887
Oil on canvas, 29¼ x 36 in. (74.9 x 91.4 cm)
Signed and dated at lower left: *Claude Monet 87*
Private collection

Contributing Authors

R.J.B.	Robert J. Boardingham
J.J.C.	John J. Chvostal
A.N.	Andrew Noone
K.R.	Katherine Rothkopf
P.S.	Perrin Stein
P.C.S.	Peter C. Sutton
M.E.W.	Marjorie E. Wieseman
E.M.Z.	Eric M. Zafran

Foreword

*F*or over a hundred years, collectors and museum curators have been solemnly announcing that the era of private art collecting is quickly drawing to a close, lamenting that "great" works of art are no longer available in meaningful quantity, and that virtually all of the "masterpieces" of the world have already found permanent homes in public institutions. The prediction of the demise of art collecting has—time and again—proved to be premature. Although the supply of masterworks is clearly diminishing, the art market is certainly still vital, and anyone who regularly does the rounds of the art dealers in New York, Amsterdam, London, or Zurich, or who visits one of the great international art fairs in Paris or Maastricht quickly discovers that wonderful works of art are still very much available, albeit more expensive than ever before. More to the point, there are still adventuresome collectors willing to engage in the exciting search for objects of quality and distinction, spend the necessary dollars, and buy works of art that they can peruse every day in the privacy of their homes, thus enhancing their lives by providing unmatchable opportunities for private contemplation and aesthetic satisfaction.

This exhibition is a testament to the personal and private collecting of European paintings by individuals in the Boston area and by other friends of the Museum of Fine Arts. The exhibition virtually spans the history of easel painting in Europe, and contains works of exceeding beauty and quality. It is gratifying to know that there is in this community a substantial body of collectors for whom the ownership of superb works of art is a high priority and who share the enthusiasm of our Museum for the assembling and enjoyment of wonderful pictures. It is also gratifying that so many collectors have consented to part with their paintings for several months so they can be shared with the public. The pleasure and sense of discovery these paintings will bring to tens of thousands of Museum visitors this summer is immeasurable, as is our gratitude to the generous lenders, who will have to live with bare walls during the run of the present exhibition.

The selection of this superb show was supervised by Peter C. Sutton, the Mrs. Russell W. Baker Curator of European Paintings; with the assistance of Eric M. Zafran, Associate Curator of European Paintings; Robert J. Boardingham, Assistant Curator of European Paintings; Marjorie E. Wieseman, Research Assistant; Katherine Rothkopf, Research Assistant; Perrin Stein, Curatorial Assistant; John C. Chvostal, Museum Intern; and Andrew Noone, Museum Intern. Together, these outstanding scholars of European painting also prepared this excellent catalogue, which was handsomely designed by Janet O'Donoghue. The complex arrangements for borrowing from the sixty-two lenders were ably undertaken by Patricia Loiko, Associate Registrar; and Jill Kennedy-Kernohan, Department Assistant, Shipping.

ALAN SHESTACK
Director

Acknowledgments

*T*he authors would like to thank those individuals who assisted them both in locating paintings for this exhibition and in providing information about them. Within the Museum of Fine Arts, Boston, these are: Clifford S. Ackley, Trevor Fairbrother, John Herrmann, Erica Hirshler, Darcy Kuronen, Annette Manick, Maureen Melton, Roy Perkinson, Sam Quigley, Sue Welsh Reed, Eleanor Sayre, Barbara Stern Shapiro, Theodore E. Stebbins, Stephanie Stepanek, and Carol Troyen; and from outside the Museum: Eva Allen, Colin Bailey, Joseph Baillio, Karen Baji, Alice Binyon, Cynthea Bogel, David E. Boufford, Edgar Peters Bowron, Jean Cadogan, Alan Chong, Keith Christianson, T. J. Clark, Melanie Clore, Frits Duparc, David Ekserdjian, Everett Fahy, Cynthia Fleming, S. J. Freedberg, Ivan Gaskell, Joseph Giuffrey, Johnny van Haeften, Elizabeth A. Honig, Pamela Ivinski, Laurence B. Kanter, Steven Kern, George S. Keyes, Christopher Kingzett, Silvard P. Kool, Ellen Melas Kyriazi, Justin Moss, Otto Naumann, Sylvie Patin, John Rewald, Christopher Riopelle, Pierre Rosenberg, Alan Salz, Polly Sartori, John Shearman, Robert Simon, Seymour Slive, Peter Tillou, Paul Tucker, Robert Vose, Patricia Ward, Jayne Warman, Dennis Weller, James Welu, Alan Wintermute, and Steven Zwirn.

In addition, we would like to thank the following members of the staff of the Museum for their invaluable contributions toward the realization of this project: Janet O'Donoghue, who expertly designed the catalogue; Judith Downes, Susan Wong, and Tom Wong in the Design Department; Barbara Martin and her staff in the Education Department; Désirée Caldwell and her staff in the Exhibition Planning Department, Catherine King and Kristen Potter; Sally Keeler and her staff in the Facilities Department; René Beaudette in the Management Information Systems Department; Rita Albertson, Irene Konefal, Rhona MacBeth, Brigitte Smith, Stefanie Vietas, Jean Woodward, and James Wright in the Paintings Conservation Department; Tom Lang, Nicole Luongo, John Lutsch, Mary Lyons, Karen Otis, Gary Ruuska, Mary Sluskonis, and Janice Sorkow in the Photographic Services Department; Kim Cafasso and Carl Zahn in the Publications Department; and Jennifer Abel, Jill Kennedy-Kernohan, and Patricia Loiko in the Registrar's Office. Katherine Rothkopf provided diligent coordination of the project from beginning to end. In addition, we would like to express our gratitude to Andrew Haines, Marci Rockoff, Regina Rudser, and all of our colleagues in the Paintings Department for their tireless assistance throughout the organization of this project. We would also like to thank outside photographers Greg Heins, Robert Lorenzson, and Clive Russ for their excellent work, and editor Robin Jacobson for her expertise. Finally, we thank Alan Shestack, Director of the Museum, for his enthusiastic support of this exhibition.

Contributors to the Catalogue

The authors would like to thank the following contributors for their generous financial support of the catalogue:

SCOTT M. BLACK

MR. AND MRS. PETER A. BROOKE

DOROTHY BRAUDE EDINBURG

RICHARD L. FEIGEN & CO., LTD.

ROBERT F. FLORSHEIM

JOHNNY VAN HAEFTEN, LTD.

HOOGSTEDER & HOOGSTEDER

DR. CATHERINE AND MR. JOHN LASTAVICA

OTTO NAUMANN, LTD.

MR. AND MRS. C. W. ELIOT PAINE

MR. AND MRS. MARTIN PERETZ

AZITA BINA-SEIBEL AND ELMAR W. SEIBEL

AND OTHER, ANONYMOUS CONTRIBUTORS

Introduction

*E*xhibitions of paintings from private collections were once more common in the leading museums of this country than they are today. Indeed, it has been fully fifty-three years since the Museum of Fine Arts, Boston, last mounted a major exhibition of the paintings of European Old Masters drawn from regional private collections. Monographic and thematic shows now dominate exhibition programs; however, much can be learned from periodically surveying patterns of private collecting, especially in a museum such as this one, where the character of the permanent collections has been influenced so dramatically by the benefactions of past and present collectors. Whereas in the museums of cities such as Cleveland, Toledo, Kansas City, Fort Worth, and Malibu, collections have been shaped to a great extent by the purchases of directors and curators, Boston has been given more paintings than it has bought; indeed, this admirably philanthropic pattern persists, albeit on a reduced scale, even today, when dramatic increases in the value of art, fixed purchase funds, and the tax laws (despite the current and temporary "window of opportunity") have markedly slowed the rate of acquisition through both purchases and gifts. More than 30 of the 139 paintings exhibited in the private collectors show *Hidden Treasures* in Boston in 1939 were subsequently presented to the Museum, and these gifts included many of the greatest masterpieces of the collection, especially those of the Impressionist period.*

One conspicuous and telling difference between that exhibition and the present one is that, although scarcely 25 pictures were lent anonymously to the earlier show, the vast majority (more than 90 percent) here appear with anonymous credit lines. The collectors' new reticence scarcely reflects false modesty, but rather, legitimate concerns about security and privacy. With the rise in the value of art, paintings often constitute a larger portion of a collector's personal wealth than in earlier times. Still another difference between the two shows is that the present exhibition, though drawn primarily from Boston-area and regional collections, also borrows from more distant friends and benefactors of the institution. This acknowledges actual changes in the audience and base of support of the Museum over the last half-century, as travel and communication have become easier. Although we at the Museum

*Boston, Museum of Fine Arts, *Paintings, Drawings, and Prints from Private Collections in New England*, June 9–September 20, 1939; catalogue published in concert with those of six related shows in *Art in New England: The Arts and Crafts of New England and a Survey of the Taste of Its People* (Cambridge, Massachusetts, 1939).

still regard this institution primarily as belonging to Boston and as the flagship of art museums in New England, its visitors and patrons increasingly offer a national, indeed global, profile.

Surely, the most striking feature of this exhibition is the fact that, despite recent talk of the demise of the great era of collecting, private collectors still thrive and have managed to acquire a great many older paintings of exceptionally high quality. More than sixty collectors are here represented. Though no one collector is typical, several clear patterns and tastes emerge, above all a strong local interest in both seventeenth-century Dutch and nineteenth-century French painting. Some omissions are also obvious. Boston probably boasts more collectors of contemporary art than of any other type, but few collect works by those who are now often called "modern Old Masters," or early-twentieth-century artists — a situation that scarcely bodes well for the hopes of the Museum to eventually fill some of the many lacunae in its own holdings of this still relatively plentiful but costly art.

In assembling this exhibition the curators cast their nets very broadly, seeking, to the extent it was possible, to survey European painting from the quattrocento (Giovanni di Paolo and Pesellino in the South, cats. 59 and 110; the van Eyck school and the Master of the Dijon Madonna in the North, cats. 50 and 85) to the early decades of this century (Léger, Mondrian, and Beckmann). There are fine examples from the Italian Renaissance and Baroque periods by Alessandro Allori, Cavaliere d'Arpino, Lavinia Fontana, Gaspare Traversi, Corrado Giaquinto, and Simone Cantarini (cats. 2, 21, 53, 145, 58, and 18). As previously suggested, a special strength of the show lies in the many exceptionally good pictures by Dutch artists, including the famous Rembrandt, Frans Hals, Hendrick ter Brugghen, and Jan Steen, as well as important representatives of the local school of landscapists: Esaias van de Velde, Jan van Goyen, Aert van der Neer, Salomon van Ruysdael, and his incomparably gifted nephew, Jacob van Ruisdael. The Dutch genre scenes include a superb work by Dirck Hals (cat. 71), a mysterious painting by Pieter Codde (cat. 27), and a characteristic guardroom scene by Rembrandt's compatriot Gerbrand van den Eeckhout (cat. 46), as well as excellent examples of the somewhat lesser-known artists — Pieter Quast, Cornelis Bega, Adriaen van de Venne, Jan Miense Molenaer, Hendrick Sorgh, and Abraham Diepraam — who attest to the legendary depth and quality in the ranks of seventeenth-century Dutch

painters (cats. 116, 117, 9, 151, 152, 89, 138, and 40). The still lifes feature Balthasar van der Ast's arrangement of exotic shells (cat. 4), a little masterpiece by Hendrick de Fromantiou depicting *Flowers in a Glass Vase* (cat. 55), Carstiaen Luyckx's sumptuous *Banquet with a Monkey* (cat. 82), and *Peaches in a Silver-gilt Bowl* (cat. 57) by the gifted Italian woman painter Fede Galizia.

Highlights of the eighteenth-century offerings are a fine capriccio by Canaletto (cat. 17), an exotic head by Giovanni Domenico Tiepolo (cat. 143), and a portrait of the Marquis de Marigny by the Swedish artist Alexandre Roslin (cat. 124). A portrait by Henry Raeburn (cat. 118), a fine early landscape by Gainsborough (cat. 56), and *Orpheus and Eurydice* by George Watts (cat. 159) illustrate the English school. And a special treat is the display of not one but two tiny paintings on ivory by the great Spanish painter Goya (cats. 62 and 63).

Nineteenth-century artists of several national schools are represented: Ivan Aivazovsky from Russia; Joaquín Sorolla y Bastida from Spain; Angelo Morbelli from Italy; and Carl Müller from Austria. Fully one-third of the European paintings in the holdings of the Museum are nineteenth-century French, and this exhibition perpetuates that traditional strength with a little-known sketch by Delacroix (cat. 39), a bold Swiss landscape by Doré (cat. 42), and a fine nocturnal one by Corot (cat. 31). Also well represented is Courbet, with an important early work (cat. 32), which he conceived partly in the tradition of his Romantic predecessors, and a fascinatingly macabre little late sketch (cat. 34), in which he encapsulated many of his favorite themes. A charming nineteenth-century painter who unfortunately is not represented in the permanent collections of the Museum is Marc-Gabriel-Charles Gleyre (cat. 60), the teacher of many of the Impressionists, including Renoir, Monet, Sisley, and Bazille. With its bold and confident brushwork, Edouard Manet's *Portrait of Mme Brunet* (cat. 83) is an example of the type of art that inaugurated the Impressionist era. As might be expected in Boston, Claude Monet is especially well represented, with no less than eight paintings exemplifying aspects of his career — such as the fruits of the painter's early trip, in 1872, to Zaandam (cat. 92) and one of his most dazzling explorations of the theme of poplars from the 1880s (cover illustration and cat. 95) — which are not otherwise represented in the extensive holdings of the Museum. Cézanne is also well represented. A painterly portrait of *Uncle Dominique* (cat. 23) and a fascinating interpretative copy

(cat. 22) of Delacroix's *Dante and Virgil in the Barque* (now in the Louvre) are examples from Cézanne's early career, and *Study for Femme à la Cafetière* (cat. 24), which was preparatory to his famous three-quarter-length image *Woman and a Coffeepot* (in the Musée d'Orsay), attest to his mature style of portraiture. Pastoral views from Pissarro's early and late career are exhibited, revealing strikingly different palettes. Degas also has three paintings here. Especially interesting is the late image *Pagans et le Père De Gas* (cat. 38), which the artist executed from memory long after his father's death and which recalls the much earlier *Degas's Father Listening to Lorenzo Pagans Playing the Guitar* in the permanent collection. There are two fine portraits by Fantin-Latour (cats. 51 and 52), as well as one by the teenage Toulouse-Lautrec of an *Old Man with a Beard* (cat. 144). Another relatively early work, this one by van Gogh (cat. 61), attests to that artist's command of the loaded brush and increasingly colorful palette in a Rubensian moment during his brief residence in Antwerp. Other Post-Impressionist paintings include two Vuillards, notably a portrait of Lucy Hessel, the wife of the painter's dealer, in her salon, which was densely hung with paintings, in the fashion of the period (cat. 157); and a large, especially ambitious, and powerfully conceived Bonnard (cat. 10). The Pointillist movement is documented by the wonderfully blustery *La Régate* by Théodore van Rysselberghe (cat. 131), the Fauves by an important early Dufy (cat. 43) and Kees van Dongen's *Torse (Portrait de Guus)* (cat. 41), and Surrealism by Max Ernst (cat. 48). The pride of the twentieth-century offerings are a Léger (cat. 80), an important late Mondrian (cat. 91), and no less than four Beckmanns (cats. 5–8), evidence, with the excellent Otto Mueller (cat. 103), of the ongoing love in Boston of German Expressionism. Scarcely another early-twentieth-century painter anticipated contemporary painting more clearly than Max Beckmann.

In gathering this splendid group of pictures and visiting individual collectors' homes, the curators discovered that some periods of painting, for example, eighteenth-century French and English, are little represented in local collections today, although this was not the case in 1939. Early-nineteenth-century Bostonian collectors often shunned English painting, still half holding a grudge against Britain for its tyranny over the American colonies. However, English painting was eventually embraced by Bostonians (as attest, for example, the gifts from Governor Alvan T. Fuller [1878–1958] to the Museum), only to

once again fall out of favor. These trends cannot be explained by economics or supply; good English portraits still abound and are today often virtually as inexpensive as they were in the 1920s. With the exception of Corot, Barbizon painting was already falling out of favor by 1939, and it has yet to experience a significant revival among collectors, despite depressed prices and renewed critical attention from scholars and museums. On the other hand French nineteenth-century Salon painting, which was banned for the most part from the cabinets that surveyed the "rebellious" Impressionists so exclusively fifty years ago, are now once more admissible. Moreover, the volume and quality of Northern European paintings, above all Dutch and Flemish, has improved dramatically in the last fifty years, if the earlier show was truly representative of local collecting of the period.

Given the anonymity of many lenders to the Museum, the curators can write only about general patterns of collecting, and that with a modicum of circumspection; it can be noted, however, that modern collectors tend to specialize more than their earlier counterparts. Of course, some early Bostonian collectors did specialize, such as William Morris Hunt (1824–1879), Martin Brimmer (1829–1896), Thomas Gold Appleton (1812–1884), and Quincy Adams Shaw (1825–1908), who promoted Jean-François Millet and the Barbizon school almost exclusively, or Lilla Cabot Perry (1848–1933) and Desmond Fitzgerald (1846–1926), who a few decades later had been evangelical in their support of Claude Monet and the Impressionists. However, these people were virtually apostles of artists who were for them contemporaries; Bostonian collectors of older European art — beginning with John and Richard Codman, whose collection was formed in the late eighteenth century and is still partially preserved in Codman House in Lincoln — were usually more catholic in their tastes. The Codmans owned not only good Dutch and Flemish paintings but also French and Italian works, as well as portraits of themselves by John Singleton Copley. Robert Dawson Evans (1843–1909), for whom the Evans Wing of the Museum is named, owned the obligatory Millets, Corots, Alma-Tademas, and Puvis du Chavanneses, but also excellent works by Vigée-Lebrun, Jordaens, and Reynolds, all now in the permanent holdings of the Museum. Some early Bostonian collectors made mistakes when they diversified; for example, William Sturgis Bigelow (1850–1926), a great and prescient benefactor of the Asiatic collections at

the Museum, had one or two respectable Flemish paintings (by Frans Pourbus and Peter Neefs; now in the Museum) and several Dughet-styled landscapes, but had a greater number of copies (after Zurbarán, Teniers, and so forth) and lesser school pieces among his European paintings. On the other hand, the legendarily labile and eclectic Denman Waldo Ross (1853–1935), who famously presented objects to every curatorial department in the Museum, ranged freely and successfully from Claude Monet to Richard Wilson, Thomas Lawrence, Giovanni Battista Tiepolo, and even Bernhard Strigel (all now in the permanent collection). In Boston about the turn of the century, surely the most energetic collector of paintings by Old Masters was Isabella Stewart Gardner (1840–1929), whose splendid group of Italian Renaissance paintings is well known, but who also acquired excellent northern and Spanish Baroque as well as nineteenth-century French and American art.

The tendency to specialize had already begun by the early decades of this century. John T. Spaulding (1870–1948) assembled and presented to the Museum a fabulous collection of Impressionist paintings, expressing a personal preference, even within this ever more popular style, for depictions of still life and landscape. Likewise, the Edwards family collection, given in memory of Juliana Cheney Edwards (fifty-seven paintings and watercolors presented to the Museum in 1939, but assembled mostly in the 1910s and 1920s), was devoted primarily to Monet, Renoir, Sisley, and the other Impressionists, though the Edwardses also owned a fine Gainsborough and good American portraits. Robert Treat Paine, 2nd (1861–1943), also favored Impressionist paintings, especially figure paintings, presenting to the Museum Degas's *Edmondo and Thérèse Morbilli*, Manet's *Victorine Meurend*, and van Gogh's *Postman Joseph Roulin*, among other masterpieces. Like the Edwards family and, before them, Quincy Adams Shaw (who owned not only scores of Millets and Corots, but also works by Tintoretto, Palma Giovanne, and other Old Masters which are now in the Museum), Paine also owned a handful of paintings by Old Masters, including one by Rembrandt and another now only attributed to Fragonard. The growing tendency to specialize in a single school or style also guided Forsyth Wickes (1876–1965), whose extensive collections, which he devoted almost exclusively to eighteenth-century French paintings, drawings, and decorative arts, came to the Museum in 1965. These works attest to a revived interest in the Rococo which had not been witnessed on a grand scale since the Barbizon enthusiasts displaced the heirs of Peter Parker (including Edward P. Deacon), who presented a great pair of monumental Bouchers to the Museum in 1871, the very first year of its incorporation.

Today, few collectors of Italian art also own Dutch paintings (and vice versa), and only a handful of collectors own Impressionist or modern paintings as well as works by Old Masters. Some collectors even specialize within their specialties, owning, for example, only nineteenth-century academic French art or Dutch landscapes. William A. Coolidge, to whose collection a gallery is devoted in the Evans Wing, is one of those unusually versatile mid-twentieth-century collectors who can range freely among early Italian and Netherlandish, Flemish Baroque, eighteenth-century Italian and English, Barbizon, Impressionist, Post-Impressionist, and even modern American Realist painting without compromising the quality of his collection. As Mr. Coolidge has modestly explained, he was able to successfully explore so many different fields because he relied on the knowledge of a few dealers to whom he was exceptionally loyal, though, of course, he always made the final selections alone. Few collectors today work with a single dealer. Some are advised by curators, art historians, or other experts, and all question the objects they acquire. Most seek their prey in many different galleries and auction houses, and a few buy only at auction. Perennial bargain hunters, however, invariably surround themselves with mediocrity.

The trend toward greater specialization probably in part reflects the diminishing supply of older art; as the availability of works of the first quality by the most famous artists has decreased, some collectors have compensated by sharpening their connoisseurship and narrowing their area of focus, concentrating on the selective virtues of lesser-known masters and the occasional inspired work by an unknown (see, for example, *Soldiers Gaming* by an unknown Dutch artist, cat. 44; or *Portrait of Edouard Detaille* by an unknown French artist, cat. 54). The intelligent acquisition of older paintings has always required more specialized knowledge than that of contemporary art, where the possibilities of forgery or misrepresentation are not as great; by its very nature contemporary art has for the uninitiated collector the possibility of checking with the source of the painting, namely, the living artist. In the last decade the market for paintings by Old Masters has for the most part escaped the effects of the uninformed

speculation that created dramatic fluctuations in the prices of Impressionist, twentieth-century, and contemporary art. Though skyrocketing costs have no doubt encouraged collectors to narrow their fields, Bostonians have long been more selective than those in many other American cities. Unlike Philadelphia, for example, a city that about the turn of the century spawned the vast collections of P. A. B. Widener (now in Washington, D.C., National Gallery of Art) and John G. Johnson (which included more than a thousand paintings now preserved in the Philadelphia Museum of Art), Boston has traditionally given birth to smaller, more discrete collections, which make no claims to being encyclopedic but which often attain a superb level of quality. Although this show includes many extremely valuable paintings by world-renowned painters (Hals, Canaletto, Courbet, Degas, Cézanne, van Gogh, and so on), it also embraces many other works by painters who are scarcely household names, indeed who may even be unfamiliar to art historians (Pieter Duyfhuysen, Cornelis Schaeck, Jean Voille, Marie Ellenrieder, and Léon Pourtau), but whose paintings are, in the popular parlance, of "museum quality." By the same token, many works in this show were purchased, quite recently, for a fraction of the cost of, for instance, a print by Jasper Johns, proof that a great deal of older European art is not prohibitively expensive; indeed, it may still be a relative bargain.

One of the delights of private collections is, of course, the way in which the selections reflect the owners' personal tastes and idiosyncrasies. Without a "committee on the collections" or other such review board, private collectors are at greater liberty than museum professionals to ignore or override such considerations as historical representativeness, the overall balance and distribution of the collection, or the pristine state of a work of art, especially if that image is truly moving — powerful, seductive, intelligent, or simply witty. Thus, collectors are often more daring than curators, who shop with other people's money and thus remain accountable for their recommendations of purchase.

The motivations for acquiring art are at least as varied as the individuals who acquire it, but a few universal, consistent values seem to exist among genuinely passionate collectors. The most fundamental may be the possessor's identification with the work of art. The great nineteenth-century scholar, connoisseur, and museum director Wilhelm Bode, who in Berlin helped create the

Museum Insel — which so recently has been revitalized by the unification of Germany — and who fostered many of the greatest private collections of his day, wrote: "The ownership of art is regarded as the only proper and tastefully permissible way to make a show of one's wealth . . . the great masters confer upon their owners their dignity and majesty [*Würde*], at first only in appearance, then in reality." The social functions of collecting older art have surely changed since Bode's day, when the possession of paintings by Old Masters was regarded in Europe as the outward fulfillment of social ambition, the imprimatur of haute-bourgeois domesticity; at the time, prescriptions were even made for each room in the house — Dutch and Flemish paintings in the dining room, early German in the master's chamber, and French Rococo in the lady's boudoir. By the same token, in the Gilded Age American collectors of older European art were often criticized for emulating foreign aristocracy and feigning princely airs and tastes — for being captains of industry who merely played at being the Medici. If their interests ran to portraits, they might even be accused of trying to purchase ancestors or a whole family tree. The provenance of works of art has long been confused with social pedigrees and the collector's tug of the forelock; however, its study also offers a fascinating window on the changing history of taste and the uses of art. This show alone includes paintings once owned by noblemen and princes, wealthy burghers, a railroad baron (cats. 72, 73, and 89), Princess Di's late father (cat. 100), not one but two prime ministers of England (cats. 4 and 50), a secretary-general of the United Nations (cat. 82), an artist (cat. 92), and at least two museums (the Hermitage and the Metropolitan Museum of Art, cats. 146 and 78, respectively).

Art still has a social cachet, of course; however, in an age when most collectors feel the need to remain anonymous — even in many cases to their own peers — the private and personal rewards of collecting certainly must outweigh the public ones. That so many of the paintings in this exhibition are small or moderately sized emphasizes the ongoing domestic appeal of collecting. People still buy older European paintings in order to live with them, and find them not only companionable but instructive lodgers. As Bode implied, great art truly uplifts and cultivates the collector, at first only outwardly, but eventually in reality (*erst scheinbar, dann wirklich*).

Writing in the introduction to the exhibition of 1939, M. A. de Wolfe Howe likened both the art histori-

an's investigations of the changing functions of painting in the American home and the curator's role in drawing forth illustrative examples of these changes to the activities of Asmodeus, who lifted the roofs off houses to reveal the contents within. The curator as Asmodeus is perhaps an even more evocative image than Howe would have allowed, since Asmodeus is also the name of the jealous demon who haunts the apocryphal Book of Tobit, disrupting Sarah's household — a story that aptly captures the sometimes intrusive and importunate tactics curators use in convincing owners to part temporarily with their prized possessions. For their forbearance and generosity we are grateful.

PETER C. SUTTON
Mrs. Russell W. Baker Curator of European Paintings

Color Plates

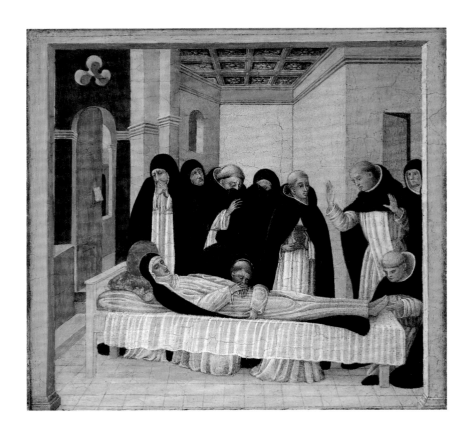

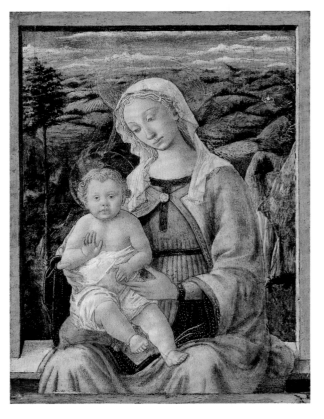

PLATE 1 (cat. 59)
Giovanni di Paolo, *The Death of Saint Catherine of Siena*

PLATE 2 (cat. 110)
Francesco Pesellino, *Madonna and Child*

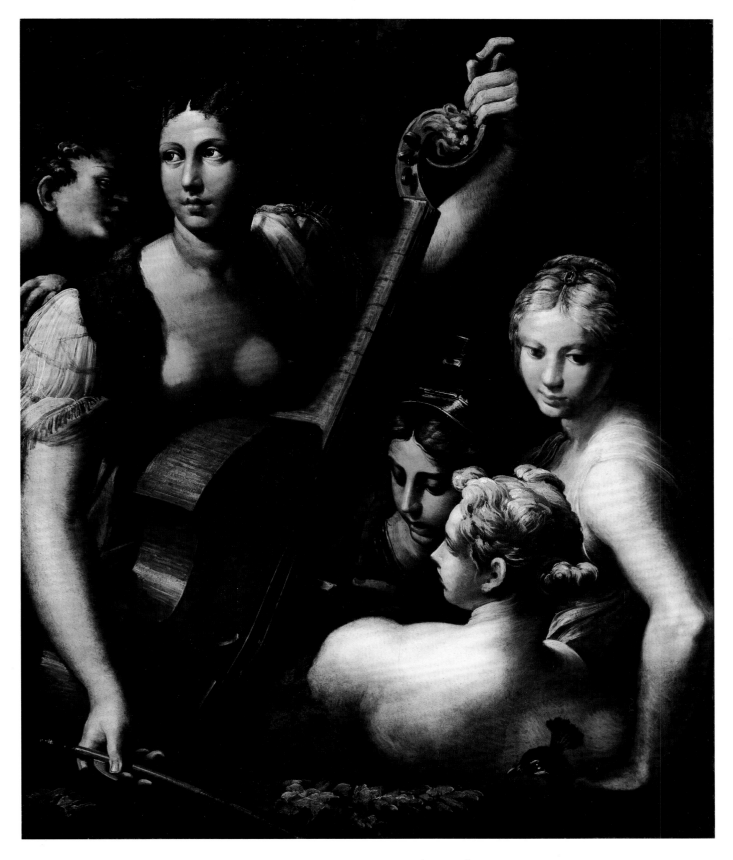

PLATE 3 (cat. 109)
Follower of Parmigianino, *The Concert with Three Goddesses*

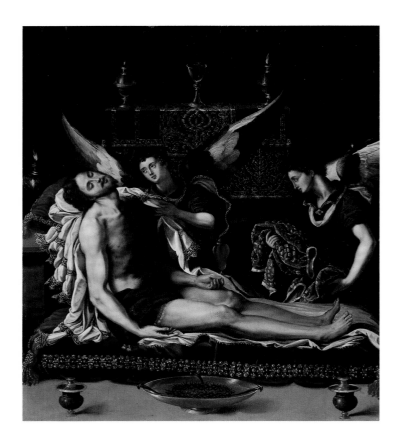

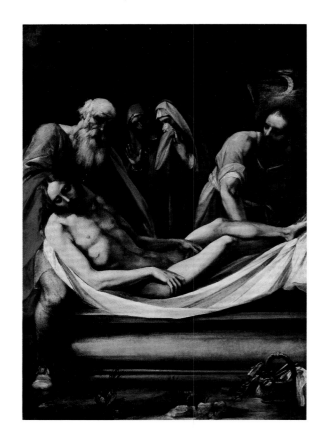

PLATE 4 (cat. 2)
Alessandro Allori, *Dead Christ with Angels*

PLATE 5 (cat. 21)
Giuseppe Cesari (called Il Cavaliere d'Arpino), *Entombment of Christ*

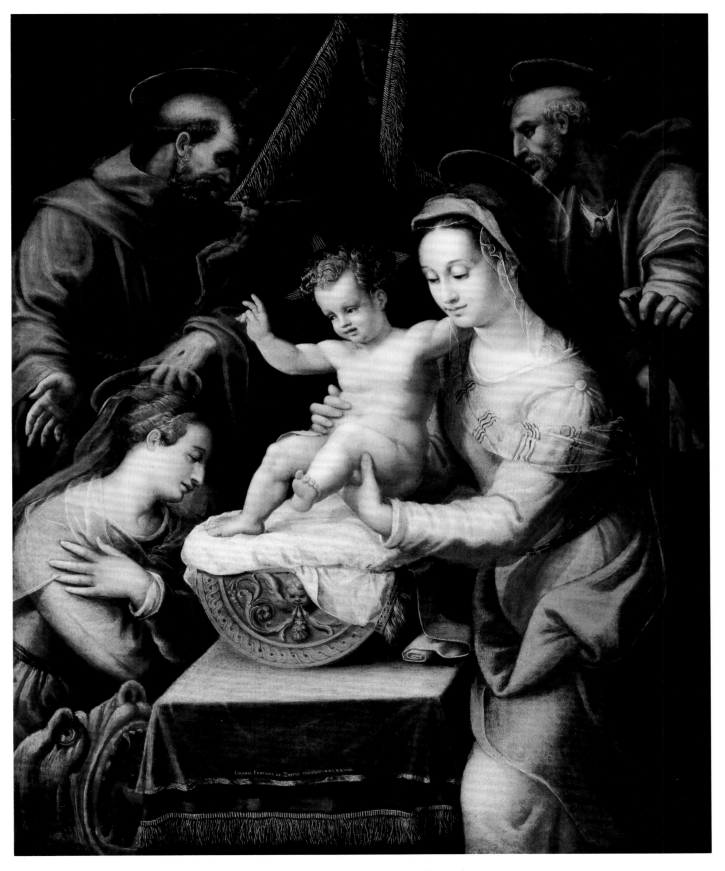

PLATE 6 (cat. 53)
Lavinia Fontana, *The Holy Family with Saints Francis and Margaret*

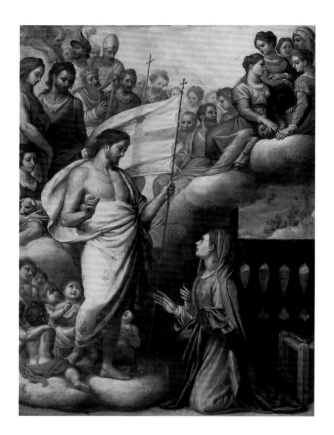

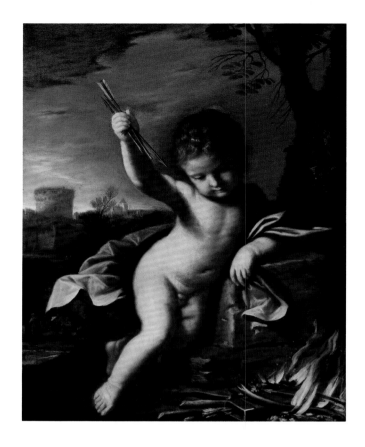

PLATE 7 (cat. 26)
Agostino Ciampelli, *Mary's Vision of Christ's Descent into Limbo*

PLATE 8 (cat. 68)
Gianfrancesco Barbieri (called Il Guercino), *Cupid Burning His Bow and Arrows*

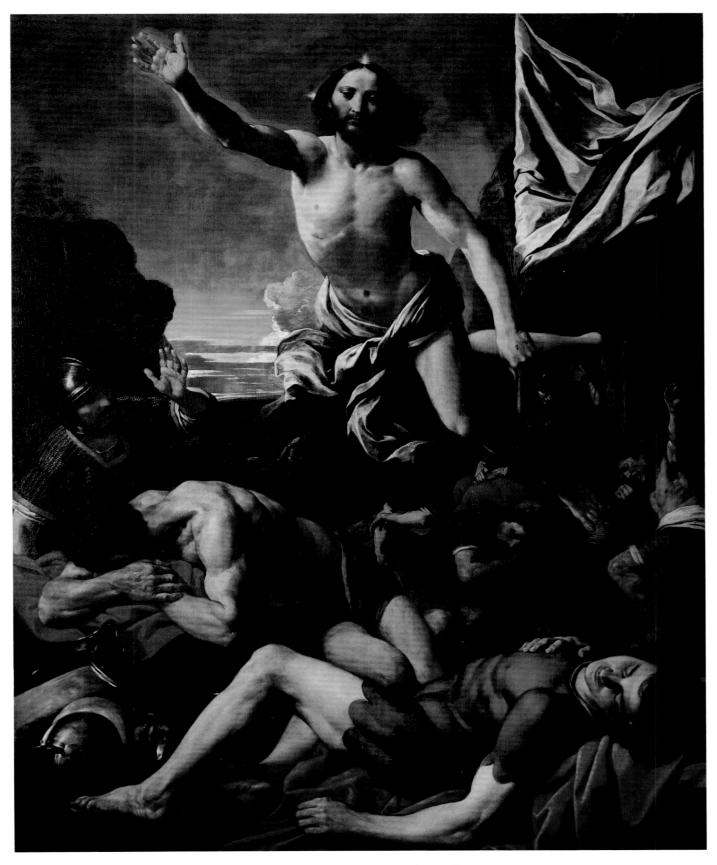

PLATE 9 (cat. 18)
Simone Cantarini (called Il Pesarese), *The Risen Christ*

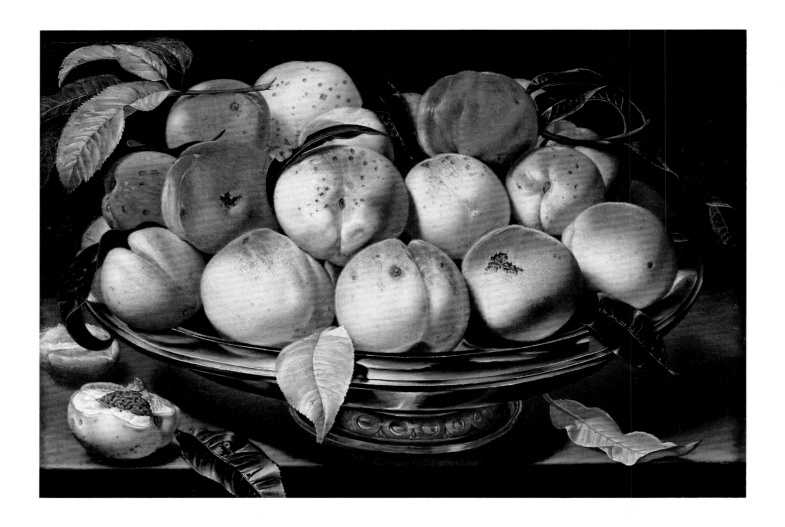

PLATE 10 (cat. 57)
Fede Galizia, *Peaches in a Silver-gilt Bowl*

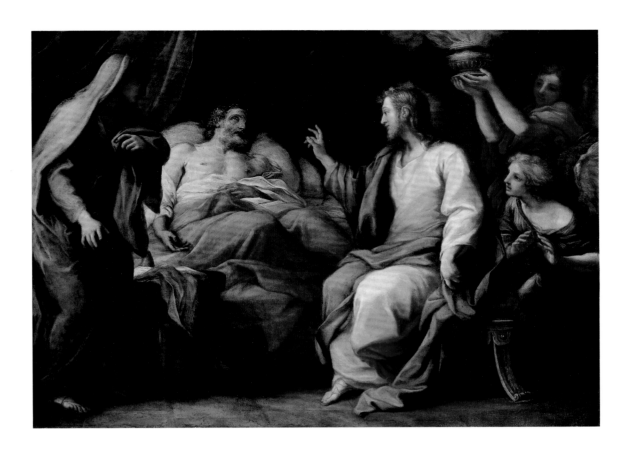

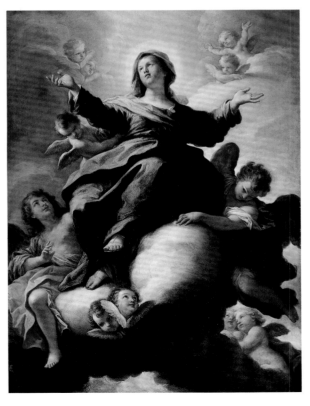

PLATE 11 (cat. 25)
Giuseppe Bartolomeo Chiari, *The Death of Saint Joseph*

PLATE 12 (cat. 87)
Paolo de Matteis, *Assumption of the Virgin*

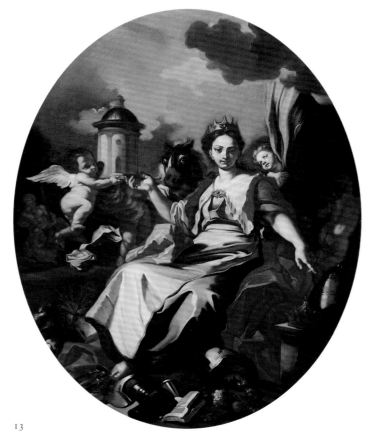

13

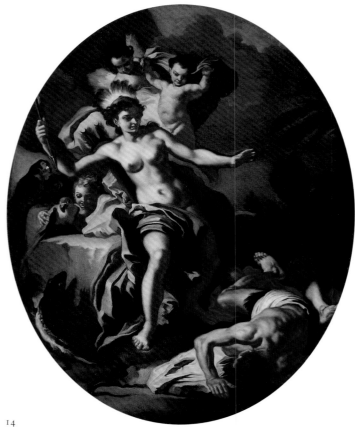

14

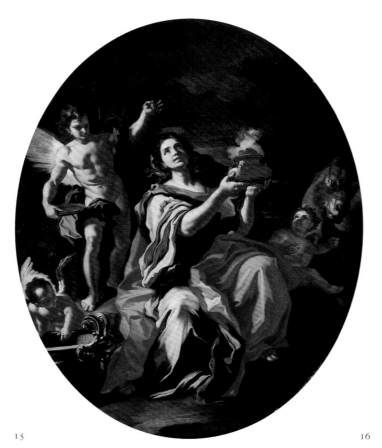

15

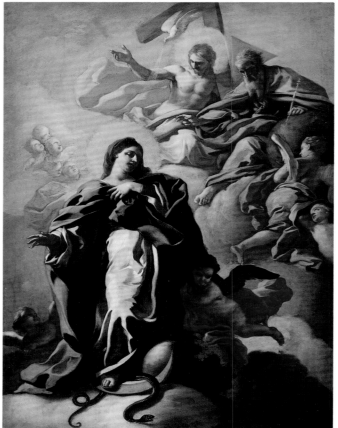

16

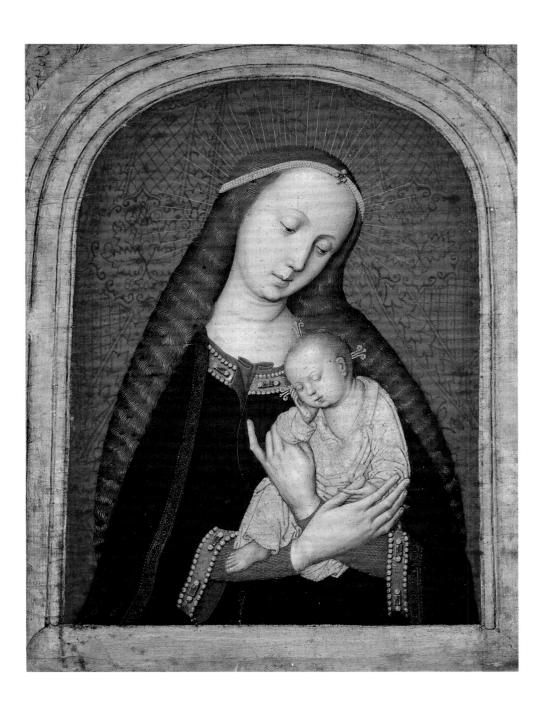

< PLATE 13 (cat. 135)
Francesco Solimena, *Allegory of Europe*

< PLATE 14 (cat. 136)
Francesco Solimena, *Allegory of America*

< PLATE 15 (cat. 137)
Francesco Solimena, *Allegory of Asia*

< PLATE 16 (cat. 134)
Francesco Solimena, *The Immaculate Conception*

PLATE 17 (cat. 85)
Master of the Dijon Madonna, *Madonna and Child*

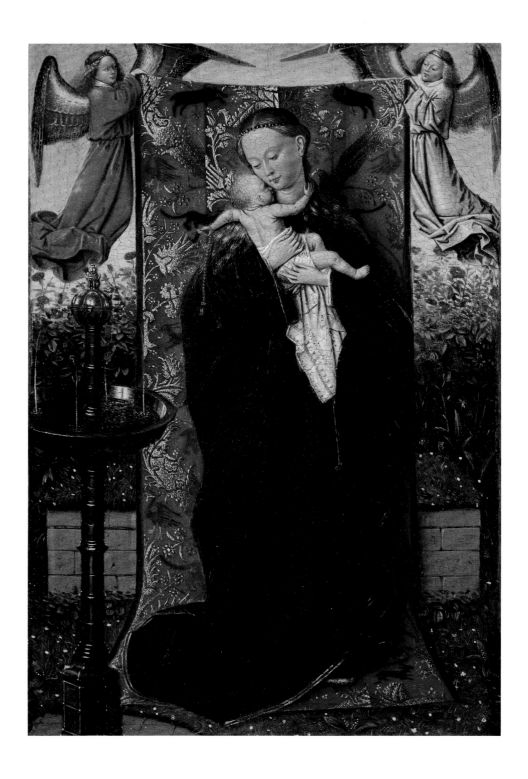

PLATE 18 (cat. 50)
Follower of Jan van Eyck, *Madonna of the Fountain*

> PLATE 19 (cat. 155)
Marten de Vos, *The Virgin and Christ Child Welcoming
the Cross*

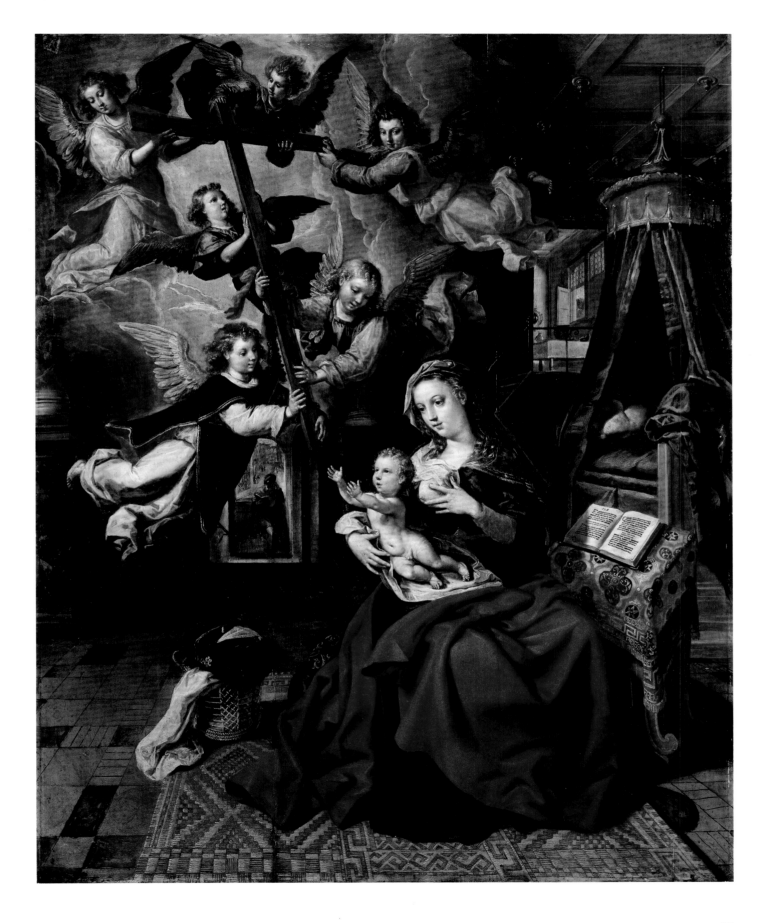

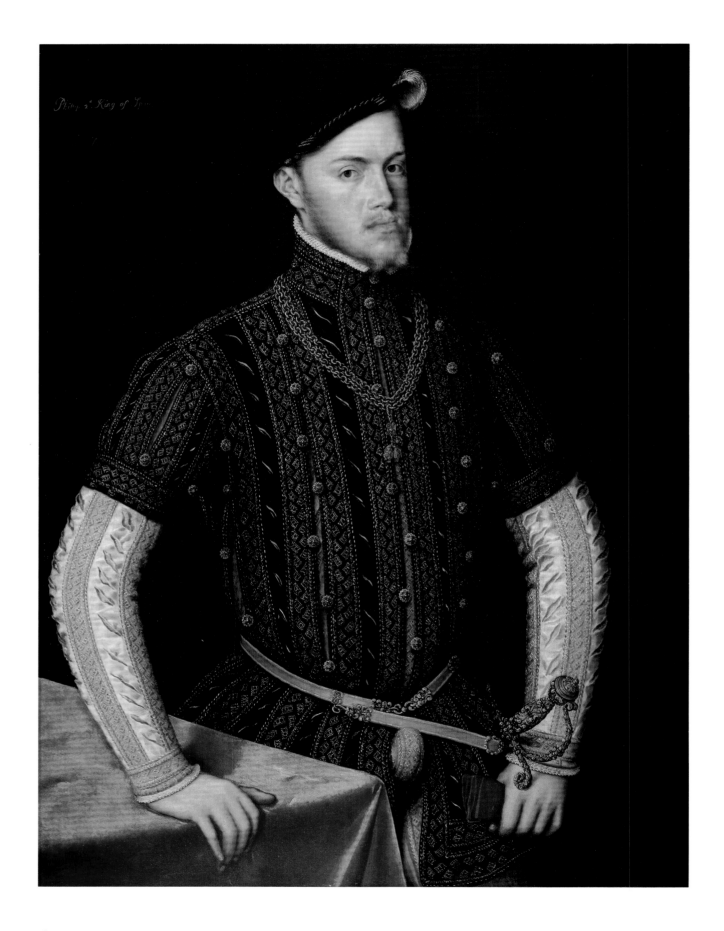

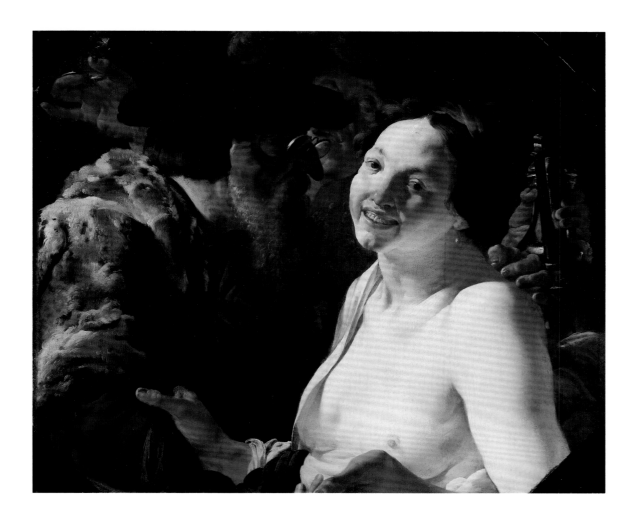

< PLATE 20 (cat. 100)
Antonis Mor, *Portrait of Philip II*

PLATE 21 (cat. 16)
Hendrick ter Brugghen, *Unequal Lovers*

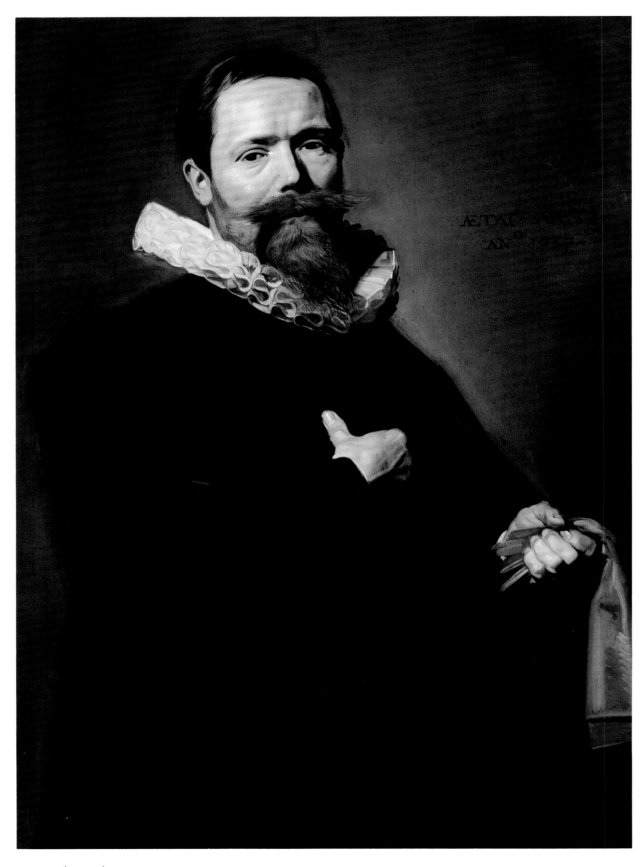

PLATE 22 (cat. 72)
Frans Hals, *Portrait of a Man*

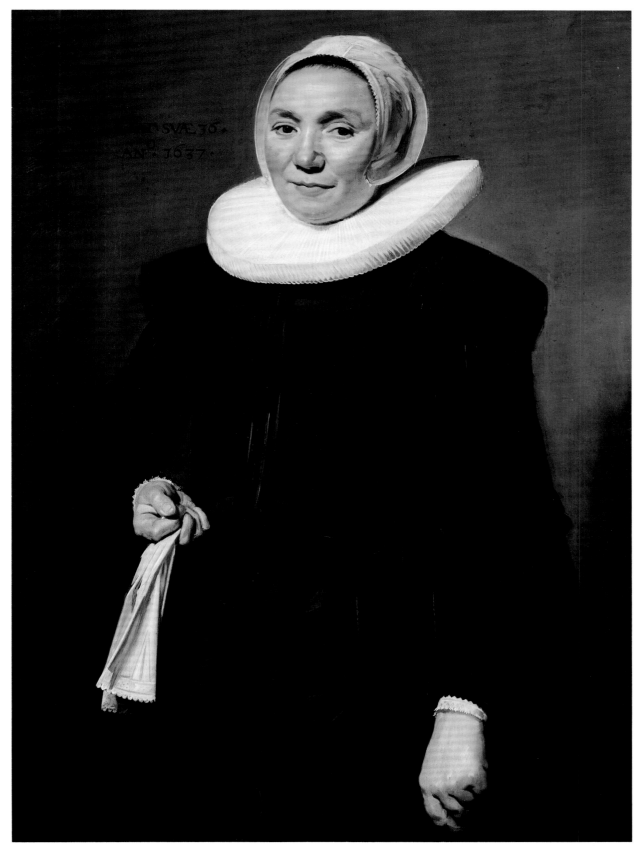

PLATE 23 (cat. 73)
Frans Hals, *Portrait of a Woman*

PLATE 24 (cat. 70)
Cornelis Cornelisz van Haarlem, *Idealized Portrait*

PLATE 25 (cat. 76)
Thomas de Keyser, *Portrait of a Woman Holding a Balance*

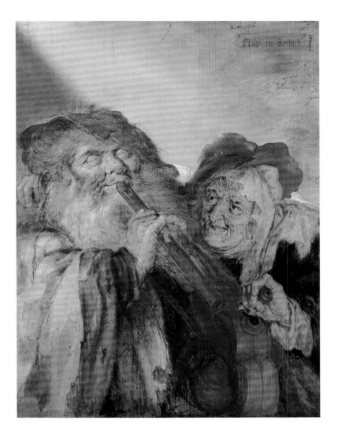

PLATE 26 (cat. 35)
Aelbert Cuyp, *Portrait of a Woman as a Huntress*

PLATE 27 (cat. 151)
Adriaen van de Venne, *"Fray en Leelijck"* (*"Beautiful and Ugly"*)

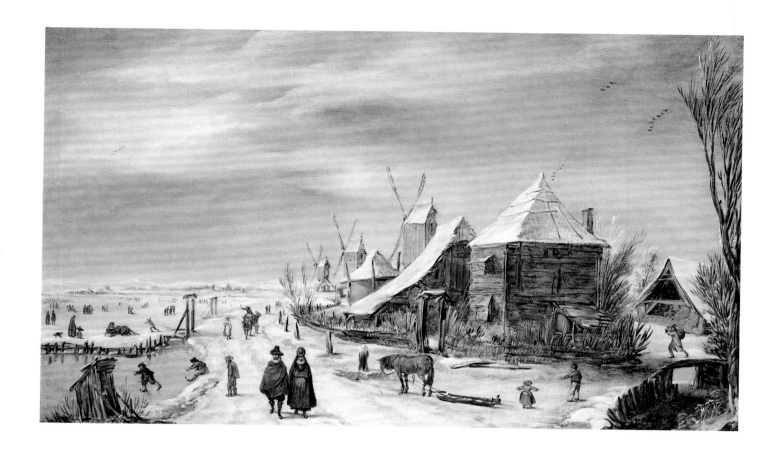

PLATE 28 (cat. 147)
Esaias van de Velde, *Winter Landscape*

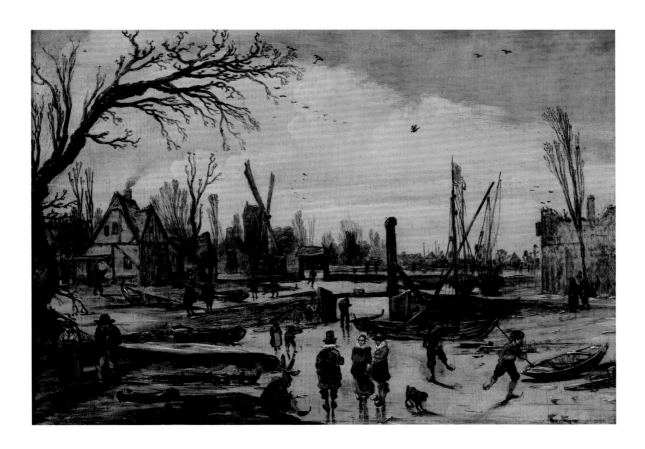

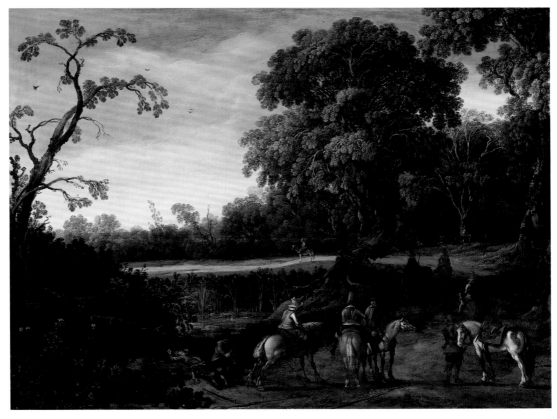

PLATE 29 (cat. 148)
Esaias van de Velde, *Winter Landscape*

PLATE 30 (cat. 149)
Esaias van de Velde, *Riders Resting on a Wooded Road*

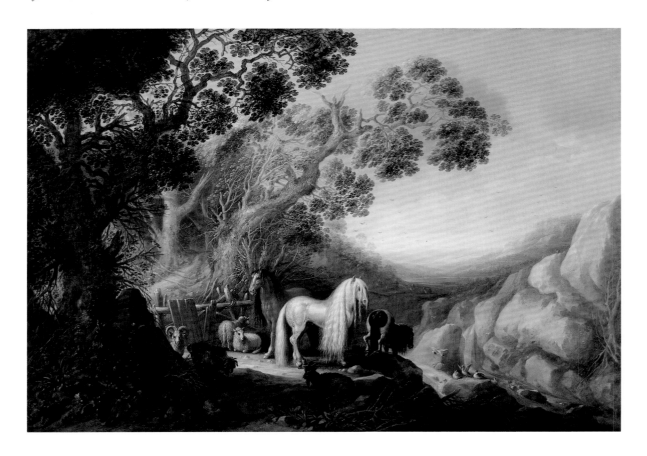

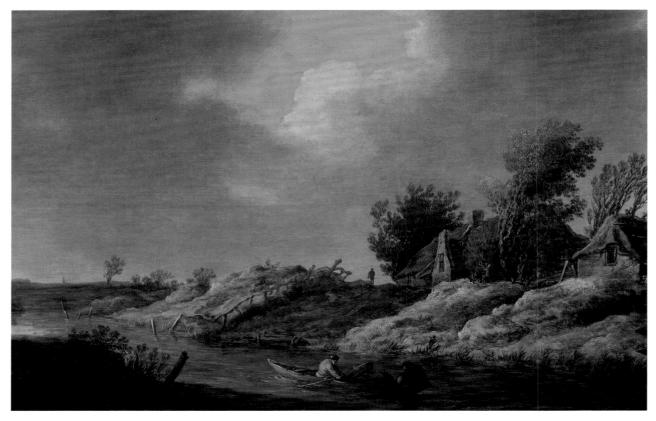

PLATE 31 (cat. 74)
Gijsbert Gillisz d'Hondecoeter, *Landscape with Animals*

PLATE 32 (cat. 90)
Pieter de Molijn, *River Landscape*

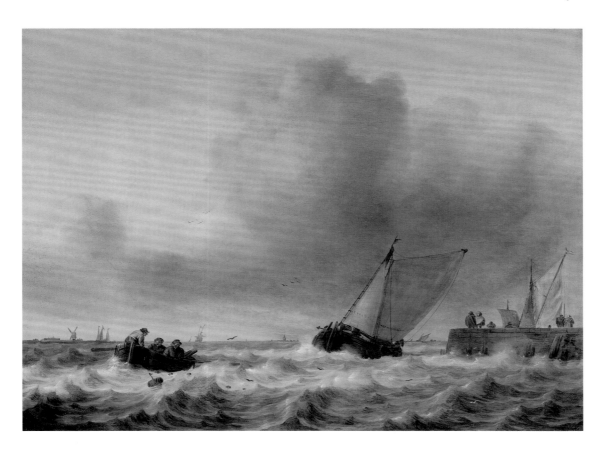

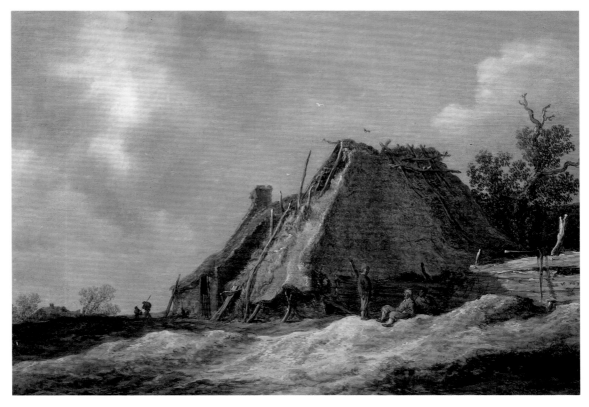

PLATE 33 (cat. 114)
Jan Porcellis, *Boats on a Choppy Sea*

PLATE 34 (cat. 64)
Jan van Goyen, *Farmhouses with Peasants*

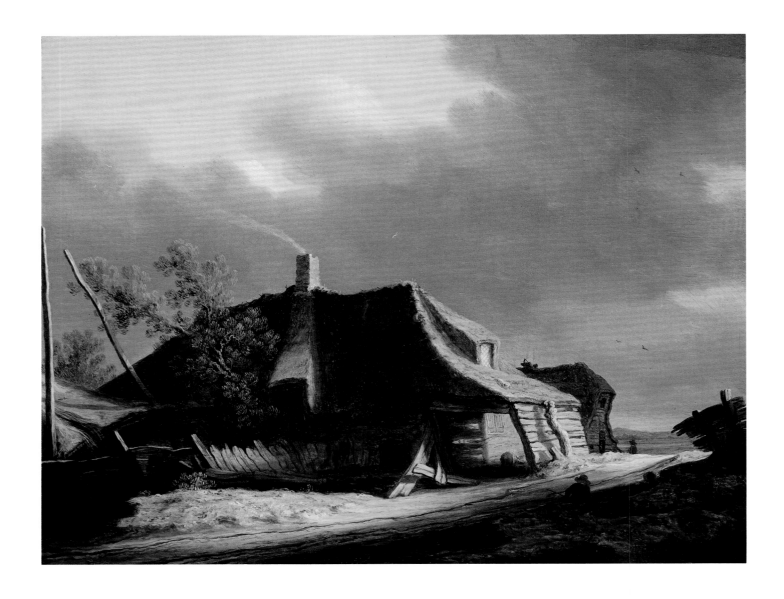

PLATE 35 (cat. 128)
Salomon van Ruysdael, *Landscape with Farmhouse*

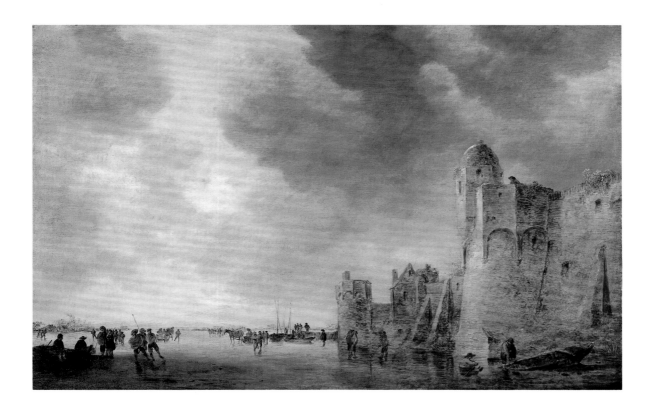

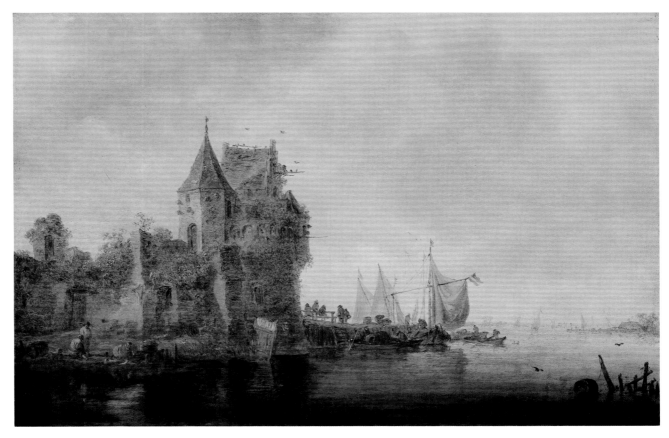

PLATE 36 (cat. 65)
Jan van Goyen, *Winter Landscape with Skaters near a Town Wall*

PLATE 37 (cat. 67)
Jan van Goyen, *Old Buildings with a Tower beside a River*

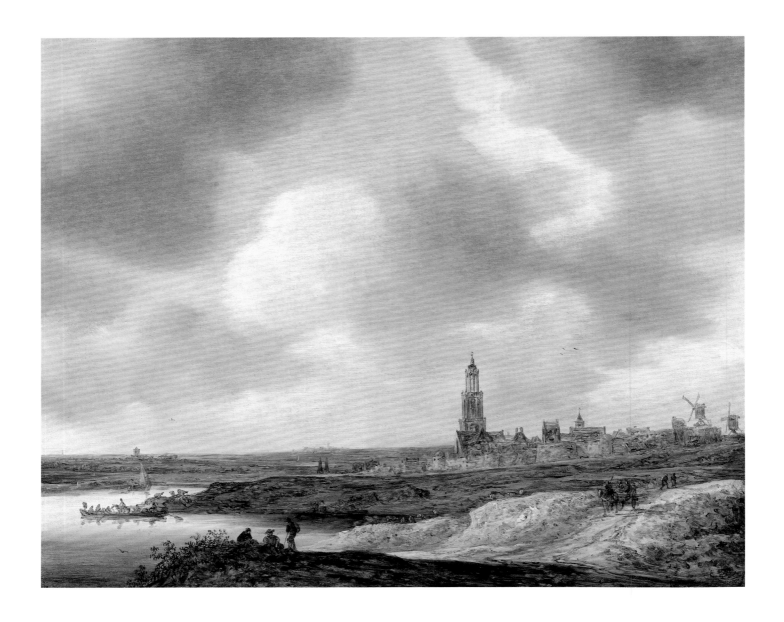

PLATE 38 (cat. 66)
Jan van Goyen, *View of Rhenen*

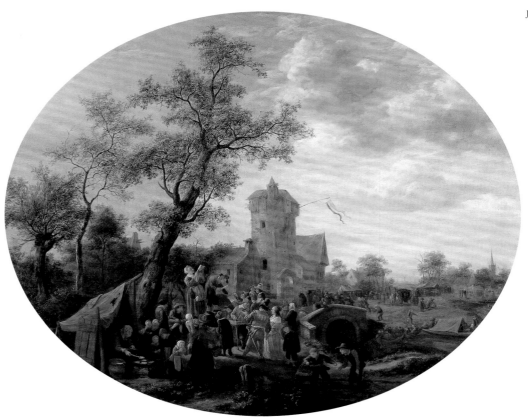

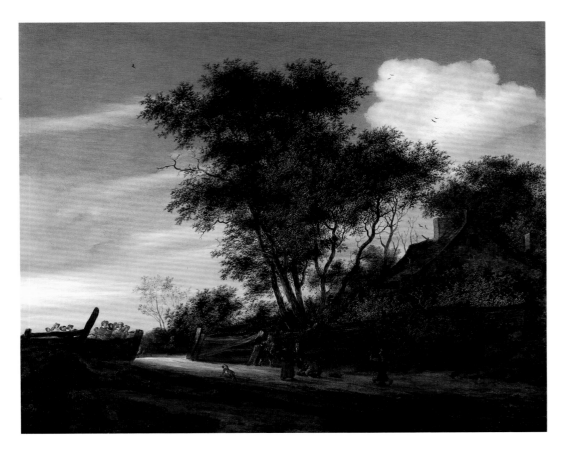

PLATE 39 (cat. 141)
Jan Steen, *Village Fair with a Pamphleteer*

PLATE 40 (cat. 130)
Salomon van Ruysdael, *Wooded Landscape with Children and a Wagon by a Gate*

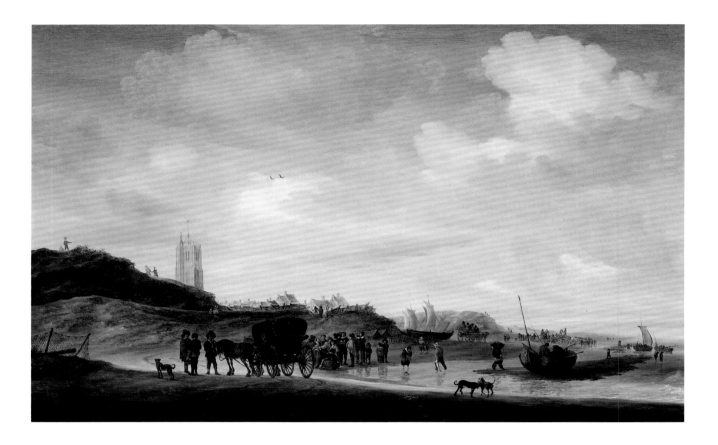

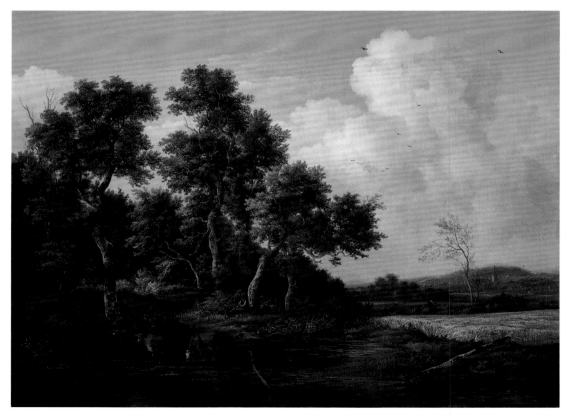

PLATE 41 (cat. 129)
Salomon van Ruysdael, *The Beach at Egmond-aan-Zee*

PLATE 42 (cat. 125)
Jacob van Ruisdael, *A Pool at the Edge of a Wood, with a Village Church in the Distance*

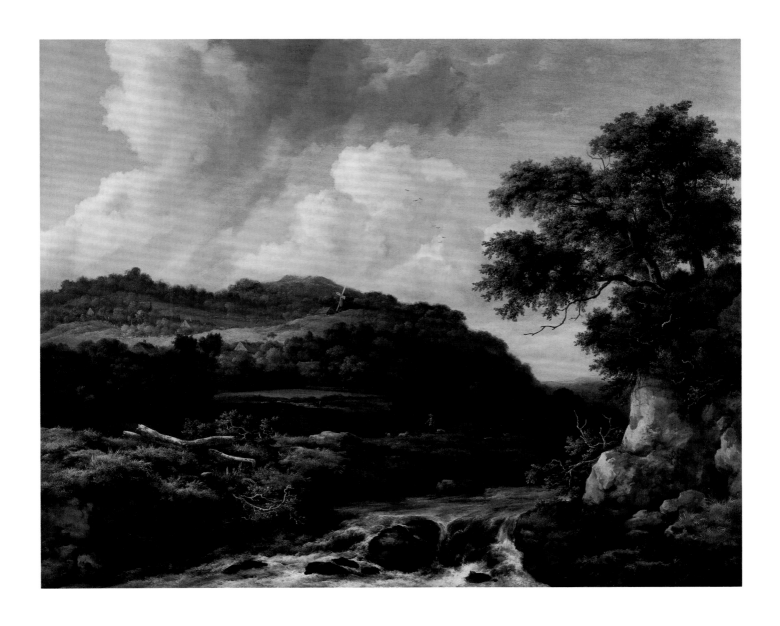

PLATE 43 (cat. 126)
Jacob van Ruisdael, *A Rushing Stream in a Mountain Landscape*

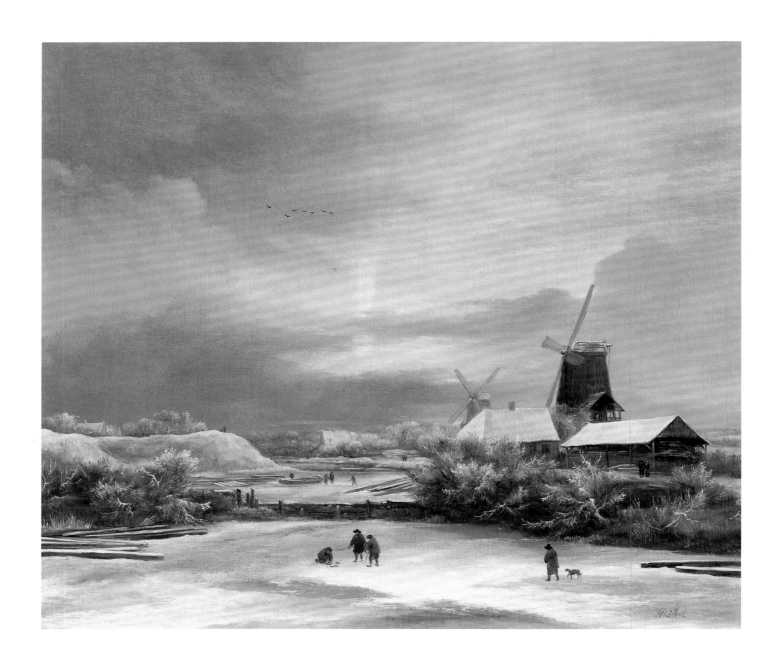

PLATE 44 (cat. 127)
Jacob van Ruisdael, *Winter Landscape with Two Windmills*

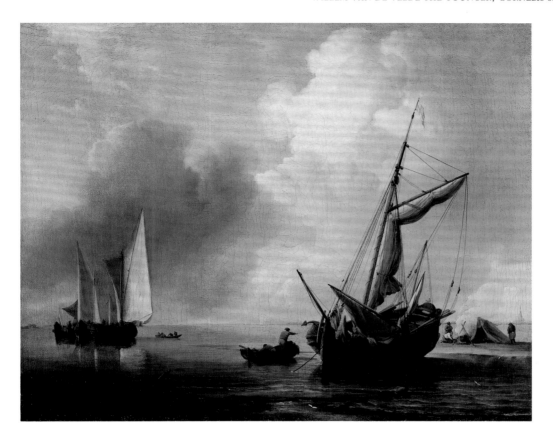

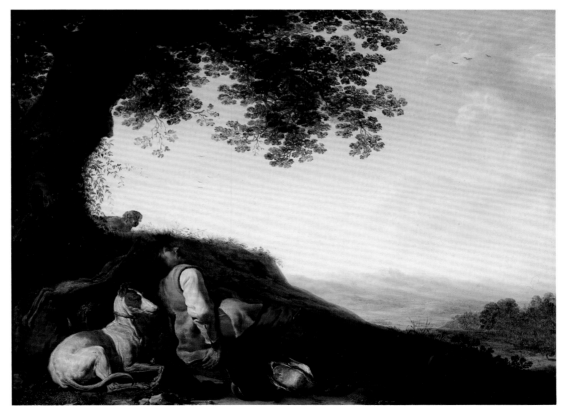

PLATE 45 (cat. 150)
Willem van de Velde the Younger, *Fishing Boats by the Shore in a Calm*

PLATE 46 (cat. 132)
Cornelis Saftleven and Herman Saftleven, *Sleeping Hunter in a Landscape*

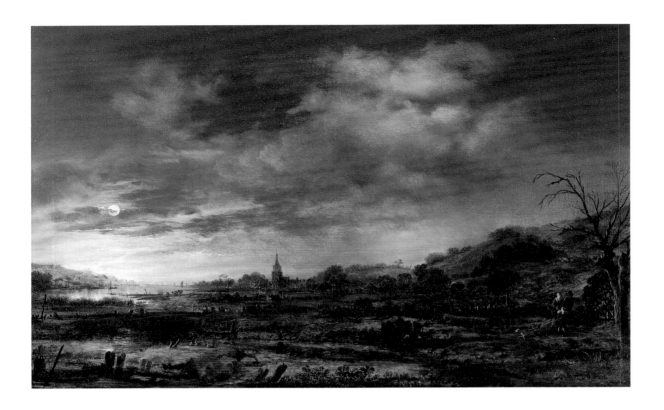

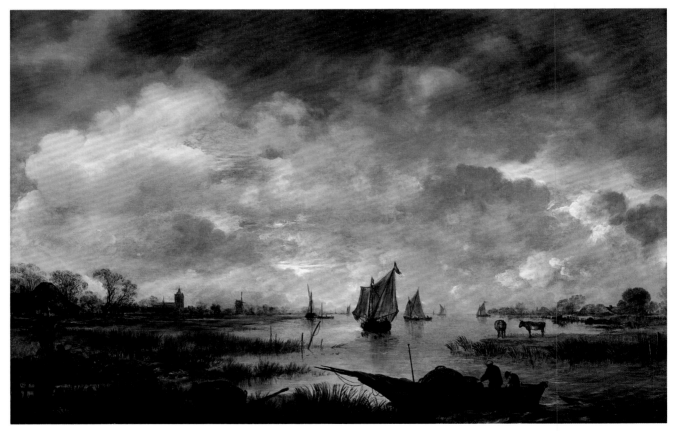

PLATE 47 (cat. 105)
Aert van der Neer, *Moonlit Estuary*

PLATE 48 (cat. 106)
Aert van der Neer, *Estuary Landscape at Evening*

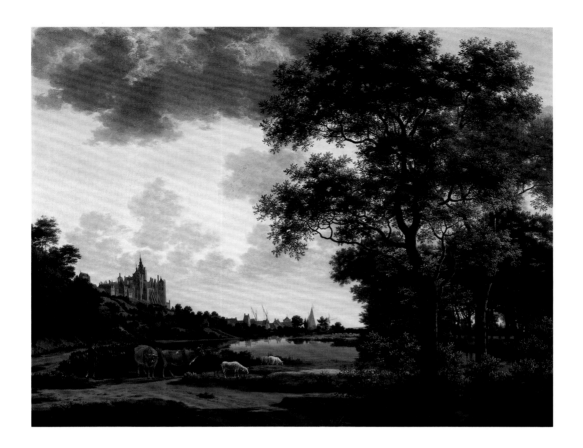

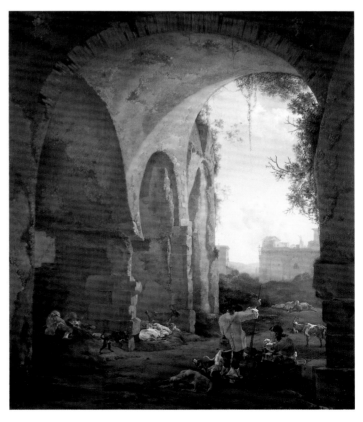

PLATE 49 (cat. 69)
Joris van der Haagen, *View of the Swanenturm, Kleve*

PLATE 50 (cat. 3)
Jan Asselijn, *Figures in the Ruins of the Forum Romanum*

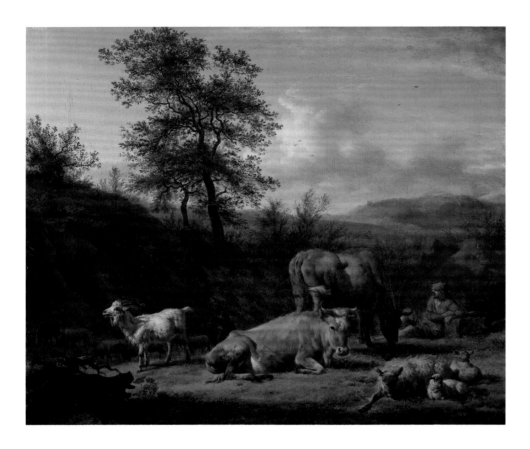

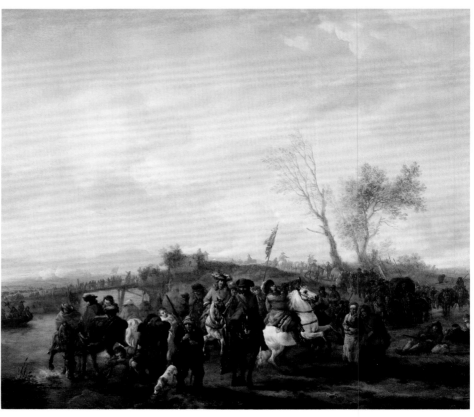

PLATE 51 (cat. 146)
Adriaen van de Velde, *Pastoral Landscape with Herdsmen*

PLATE 52 (cat. 161)
Philips Wouwerman, *Calvary Watering Their Horses*

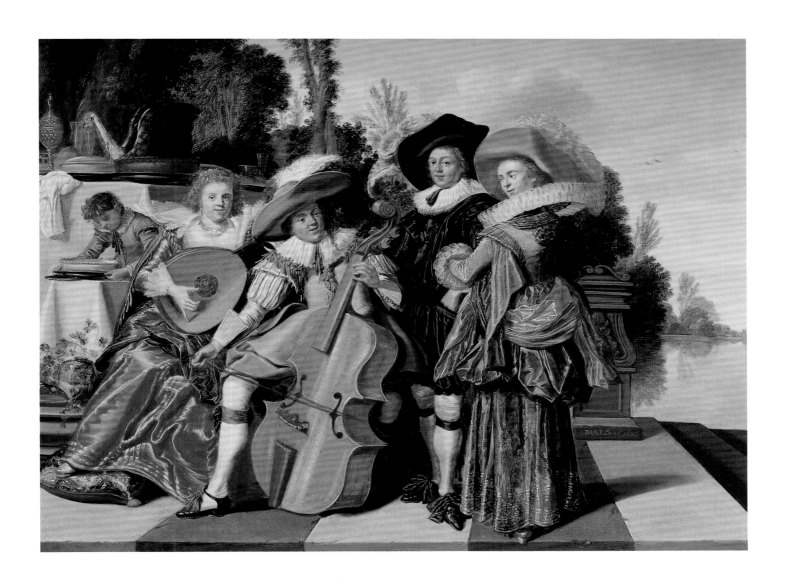

PLATE 53 (cat. 71)
Dirck Hals, *Merry Company*

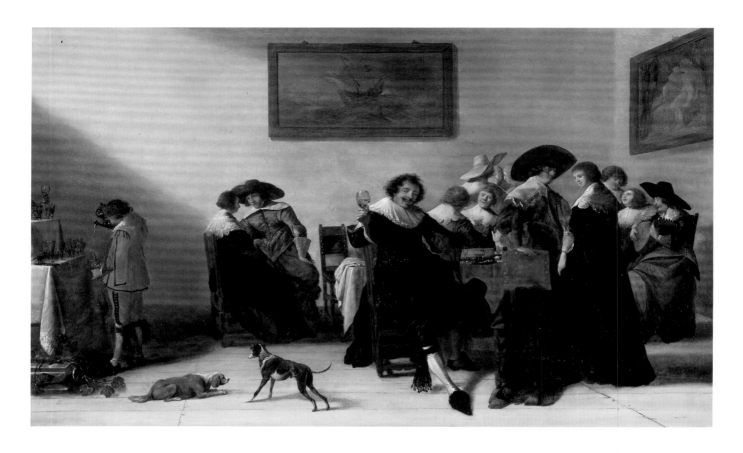

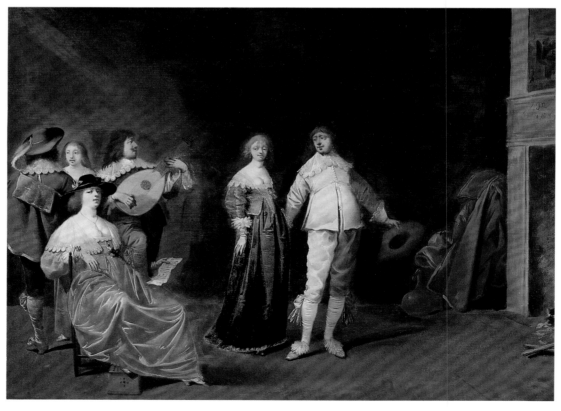

PLATE 54 (cat. 108)
Anthonie Palamedesz, *Merry Company in an Interior Eating and Drinking*

PLATE 55 (cat. 117)
Pieter Jansz Quast, *An Elegant Company*

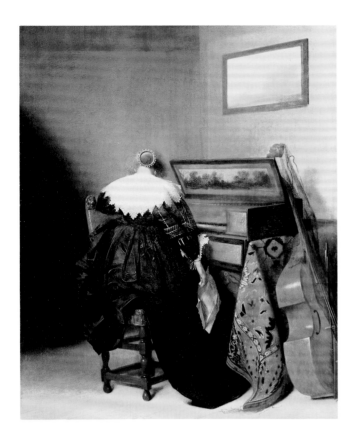

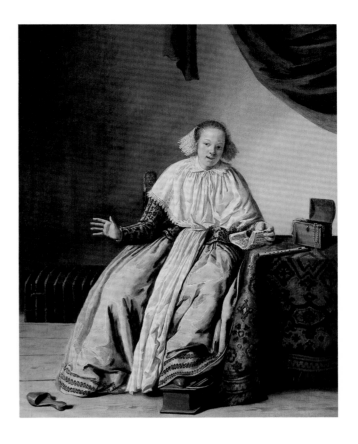

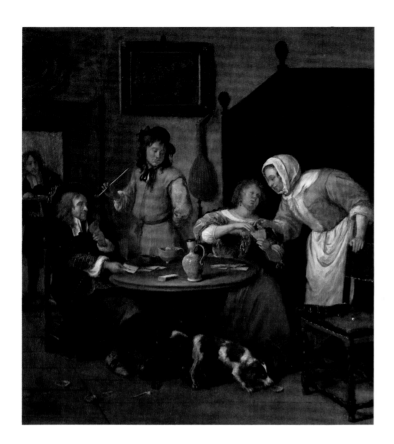

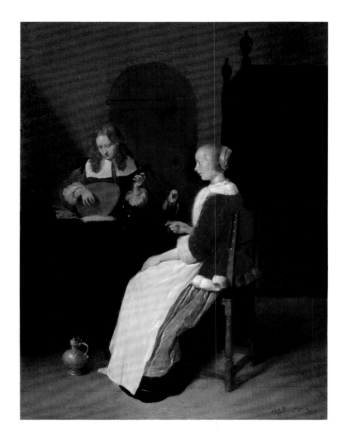

PLATE 58 (cat. 140)
Jan Steen, *Cardplayers*

PLATE 59 (cat. 14)
Quirijn van Brekelenkam, *A Lady with a Lute Player*

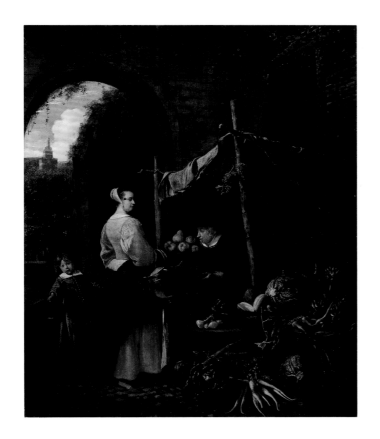

PLATE 60 (cat. 142)
Follower of Jan Steen, *Market Scene with an Old Woman Selling Vegetables*

PLATE 61 (cat. 116)
Pieter Jansz Quast, *Peasants in an Interior*

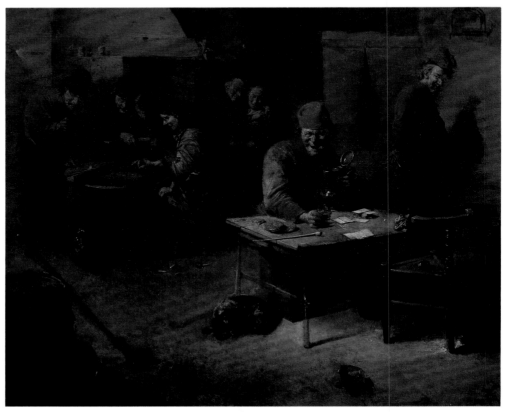

PLATE 62 (cat. 152)
Adriaen van de Venne, *"Alle Baeten Helpen"* (*"Every Profit Helps"*)

PLATE 63 (cat. 40)
Abraham Diepraam, *Tavern Interior*

PLATE 64 (cat. 9)
Cornelis Bega, *Peasants in a Tavern*

PLATE 65 (cat. 44)
Dutch School, 17th century, *Soldiers Gaming*

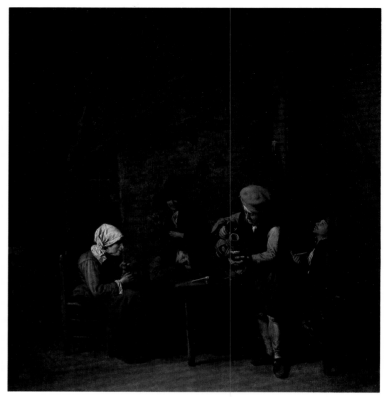

PLATE 66 (cat. 46)
Gerbrand van den Eeckhout, *Two Soldiers in a Guardroom*

PLATE 67 (cat. 133)
Cornelis Schaeck, *Peasants in an Interior*

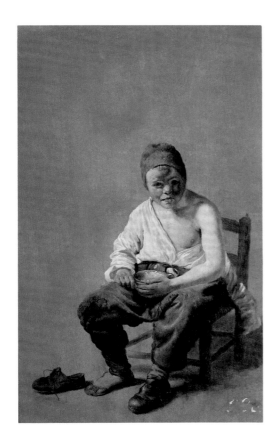

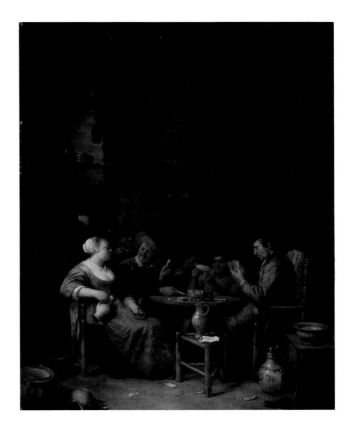

PLATE 68 (cat. 45)
Pieter Duyfhuysen, *Young Boy with Bowl of Porridge*

PLATE 69 (cat. 138)
Hendrick Martensz Sorgh, *Cardplayers in a Tavern*

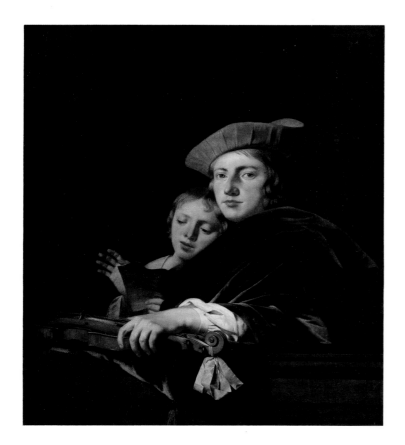

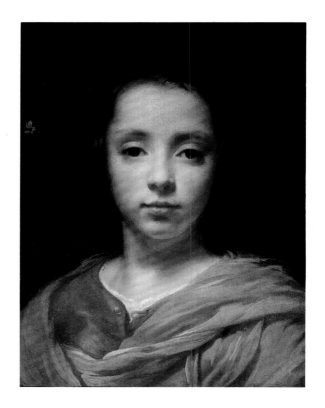

PLATE 70 (cat. 49)
Caesar van Everdingen, *Violinist (Self-portrait?) with a
Woman Singing*

PLATE 71 (cat. 107)
Jacob van Oost the Elder, *Young Woman*

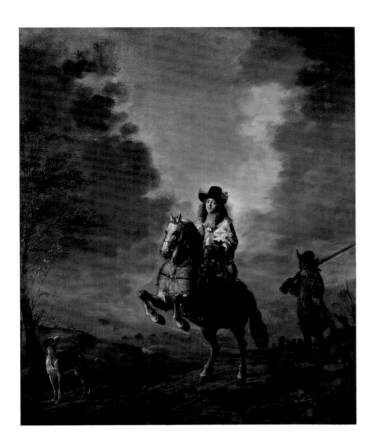

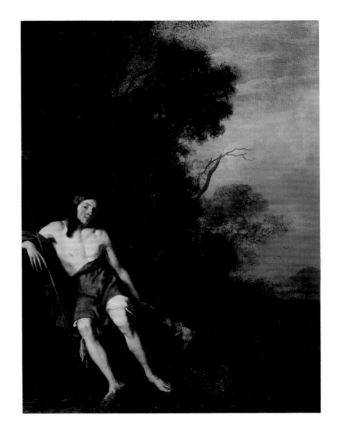

PLATE 72 (cat. 78)
Thomas de Keyser, *Equestrian Portrait of a Man with a Page*

PLATE 73 (cat. 77)
Thomas de Keyser, *Saint John in a Landscape*

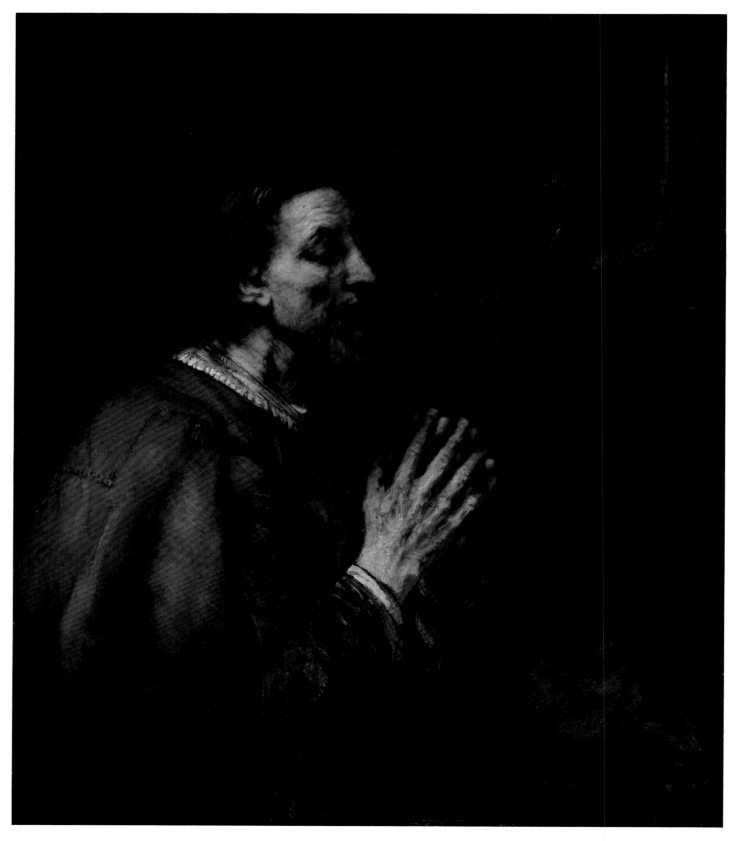

PLATE 74 (cat. 121)
Rembrandt van Rijn, *A Pilgrim in Prayer (Saint James)*

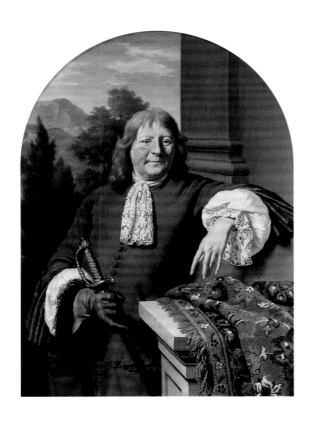

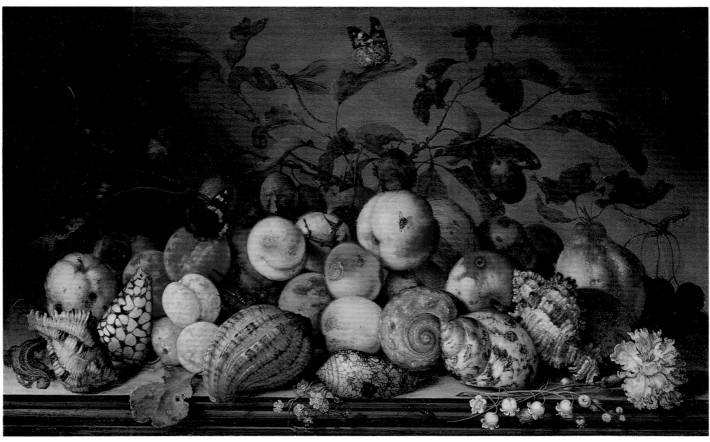

PLATE 75 (cat. 88)
Willem van Mieris, *Portrait of a Man with a Sword*

PLATE 76 (cat. 4)
Balthasar van der Ast, *Still Life with Fruit and Shells*

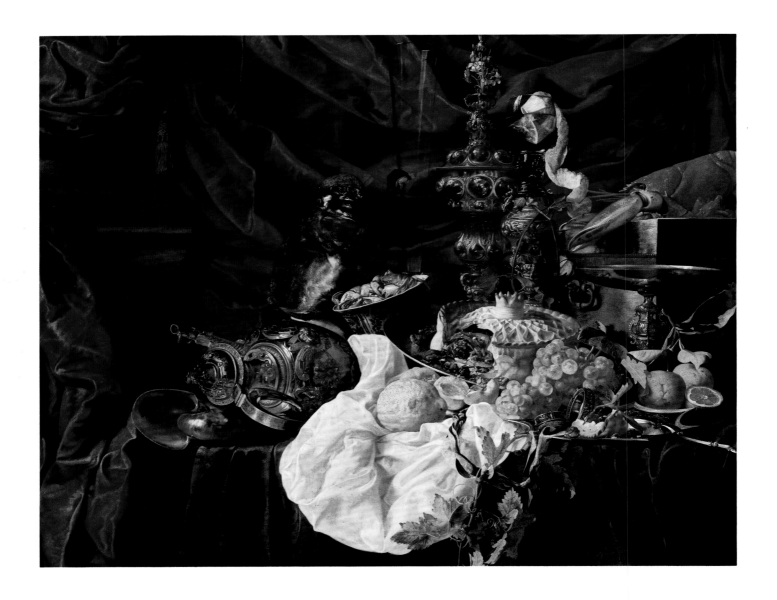

PLATE 77 (cat. 82)
Carstiaen Luyckx, *Banquet with a Monkey*

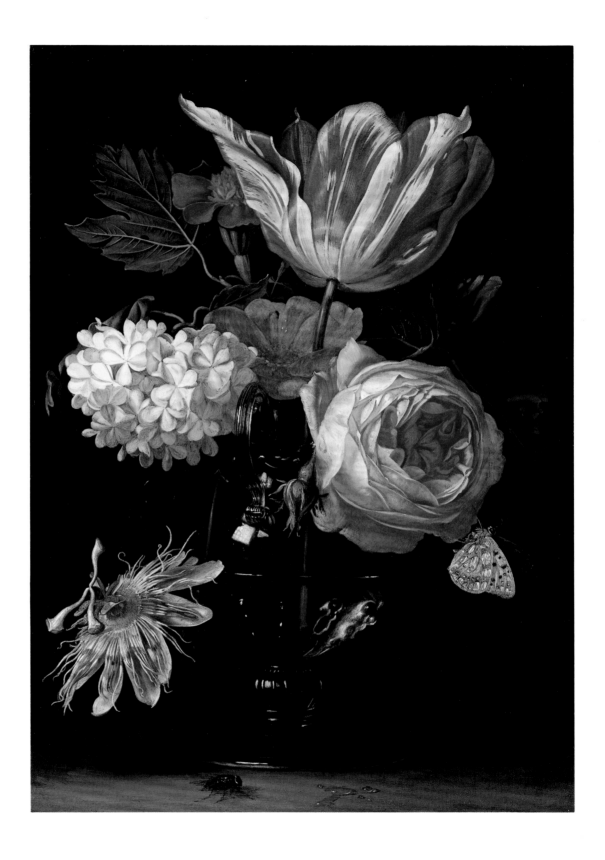

PLATE 78 (cat. 55)
Hendrick de Fromantiou, *Flowers in a Glass Vase*

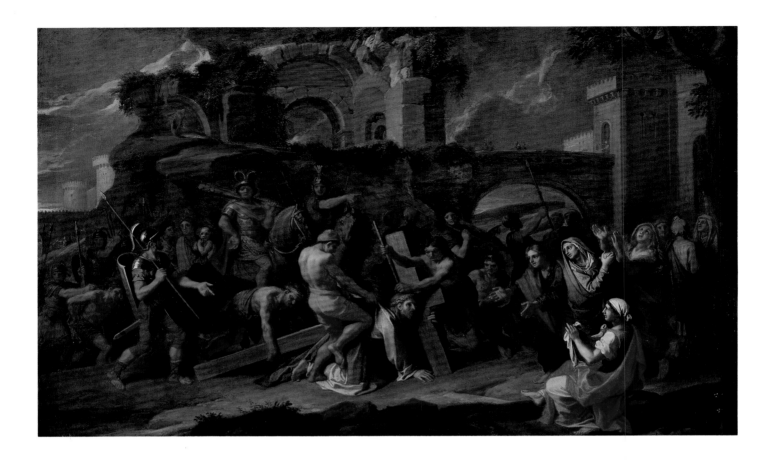

PLATE 79 (cat. 153)
François Verdier, *Christ Carrying the Cross*

PLATE 80 (cat. 75)
Jan van Huysum, *Floral Still Life with Hollyhock and Marigold*

PLATE 81 (cat. 58)
Corrado Giaquinto, *Saint Simon Stock and the Virgin
Interceding for Souls in Purgatory*

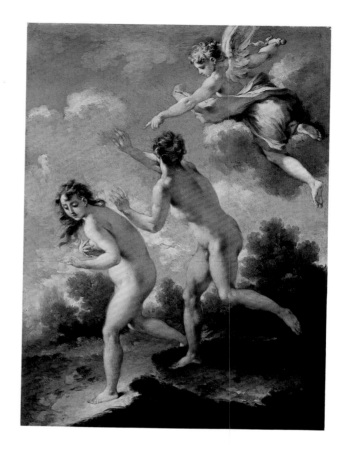

PLATE 82 (cat. 122)
Michele Rocca, *The Temptation of Adam and Eve*

PLATE 83 (cat. 123)
Michele Rocca, *The Expulsion from Paradise*

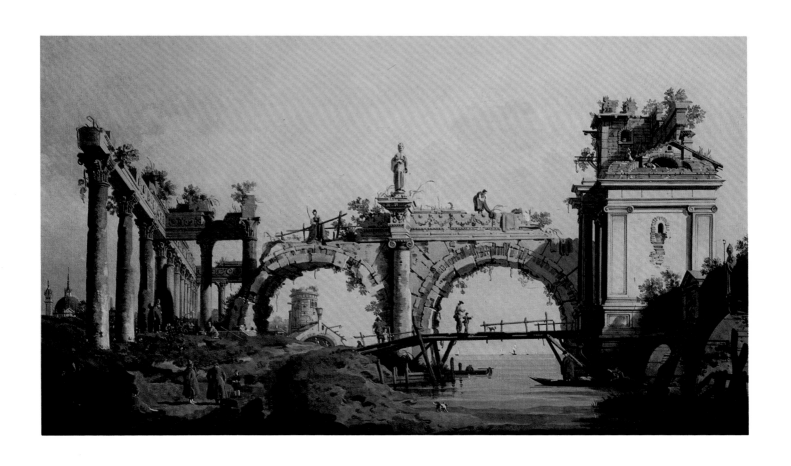

PLATE 84 (cat. 17)
Giovanni Antonio Canal (called Canaletto), *Capriccio of a Pavilion with a Ruined Arcade and a Colonnade on the Lagoon*

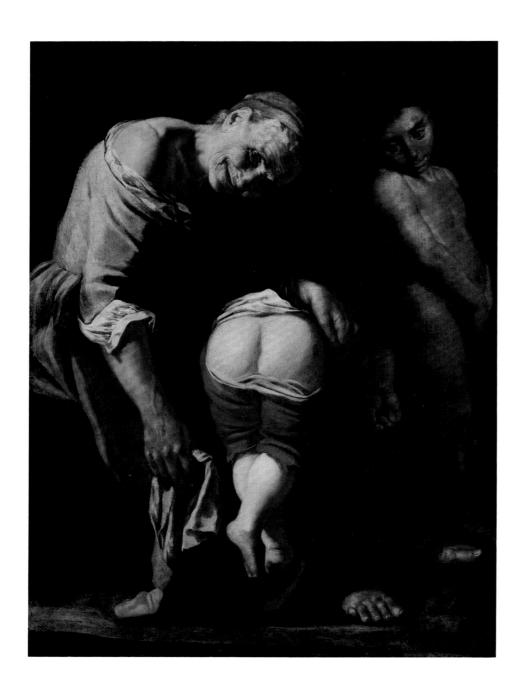

PLATE 85 (cat. 145)
Gaspare Traversi, *Old Woman and Children (An Allegory of the Sense of Smell)*

PLATE 86 (cat. 79)
Maurice-Quentin de La Tour, *Portrait of Claude-Charles Deschamps*

PLATE 87 (cat. 15)
Nicolas-Guy Brenet, *Bacchus and Ariadne*

PLATE 88 (cat. 124)
Alexandre Roslin, *Portrait of Abel-François Poisson, Marquis de Marigny*

PLATE 89 (cat. 56)
Thomas Gainsborough, *Wooded Landscape with Figures, Cows, and Distant Flock of Sheep*

∧ PLATE 90 (cat. 143)
Giovanni Domenico Tiepolo, *Old Man with a Gilt Buckle*

⌐ PLATE 91 (cat. 154)
Jean Louis Voille, *Portrait of John Cayley*

> PLATE 92 (cat. 160)
Jean Baptiste Wicar, *Portrait of an Officer*

PLATE 93 (cat. 62)
Francisco José de Goya y Lucientes, *A Woman, Her Clothes Blowing in the Wind*

PLATE 94 (cat. 63)
Francisco José de Goya y Lucientes, *Boy Staring at an Apparition*

PLATE 95 (cat. 118)
Sir Henry Raeburn, *Portrait of John Home Home, Esq.*

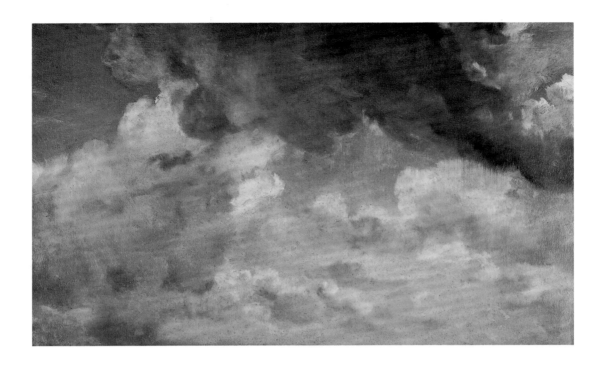

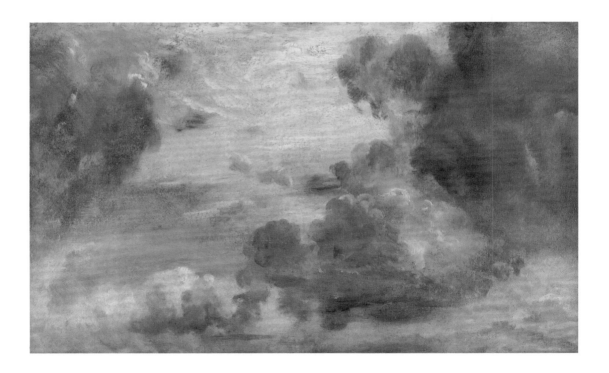

PLATE 96 (cat. 28)
John Constable, *Cloud Study*

PLATE 97 (cat. 29)
John Constable, *Cloud Study*

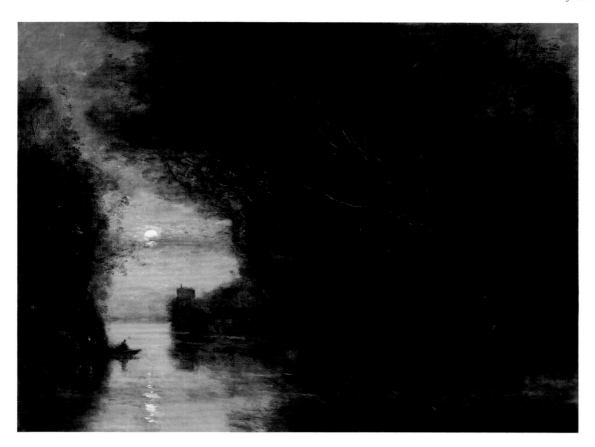

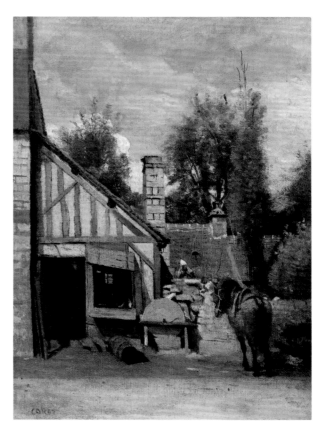

PLATE 98 (cat. 31)
Jean-Baptiste-Camille Corot, *Claire de Lune sur les Eaux*

PLATE 99 (cat. 30)
Jean-Baptiste-Camille Corot, *A Small Farmyard in Normandy*

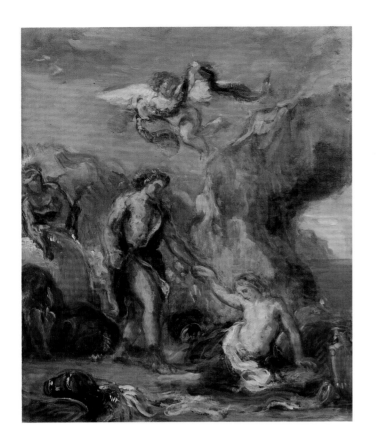

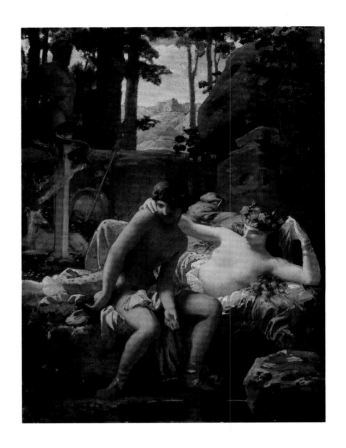

PLATE 100 (cat. 39)
Eugène Delacroix, *Autumn — Bacchus and Ariadne*

PLATE 101 (cat. 60)
Marc-Gabriel-Charles Gleyre, *Cléonis et Cydippe*

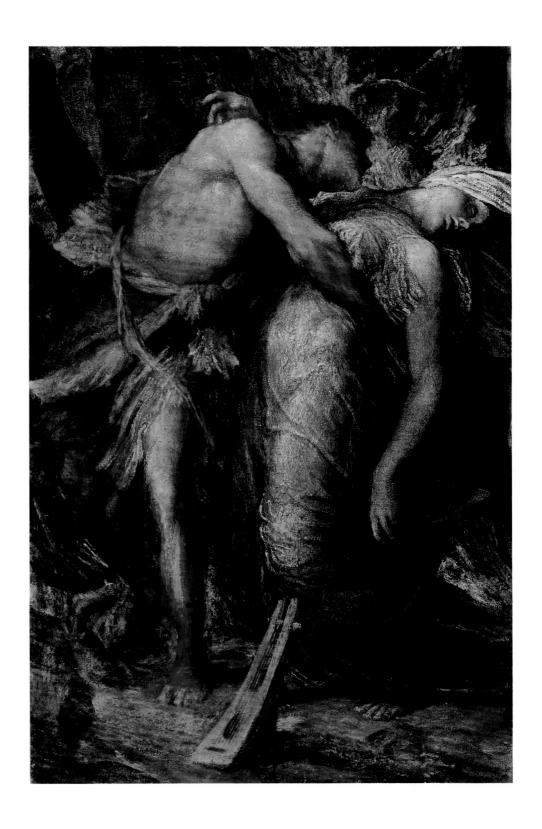

PLATE 102 (cat. 159)
George Frederick Watts, *Orpheus and Eurydice*

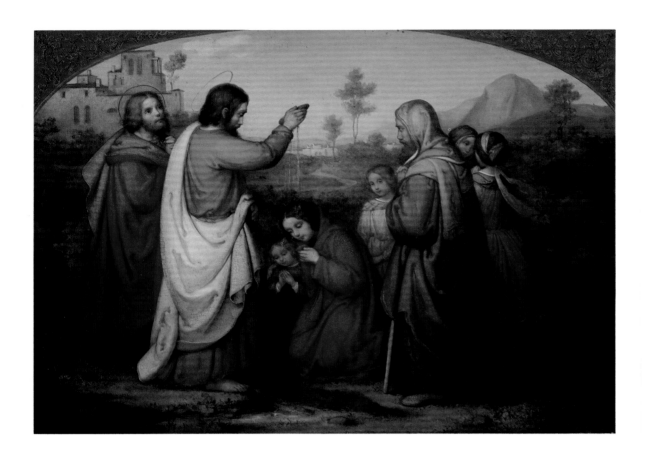

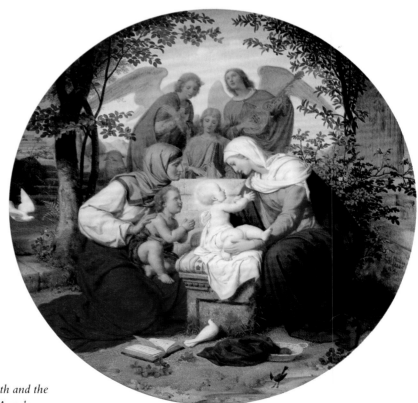

∧ PLATE 103 (cat. 47)
Marie Ellenrieder, *The Baptism of Lydia*

> PLATE 104 (cat. 104)
Carl Müller, *The Virgin and Child with Saint Elizabeth and the
Infant Saint John the Baptist and Three Music-making Angels*

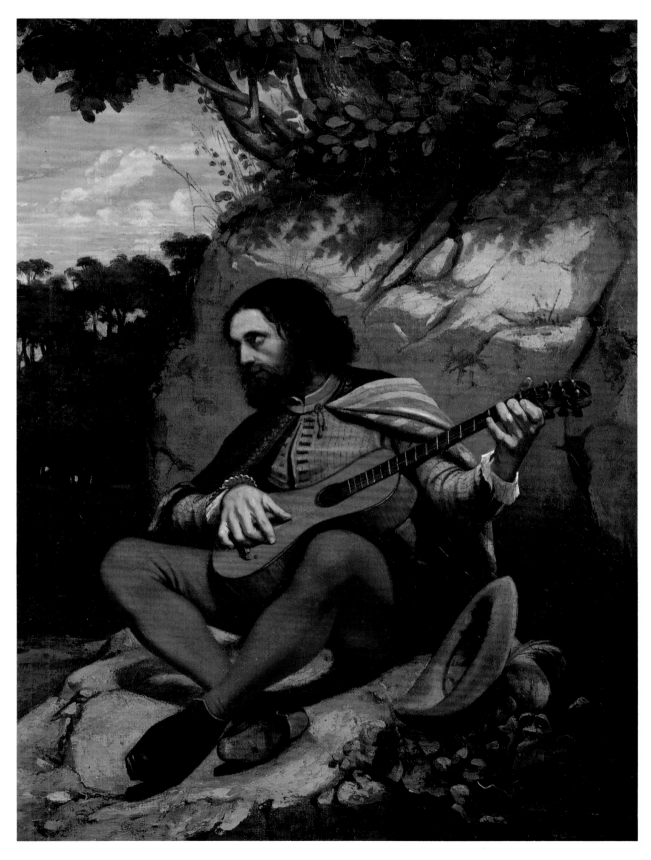

PLATE 105 (cat. 32)
Gustave Courbet, *The Guitar Player*

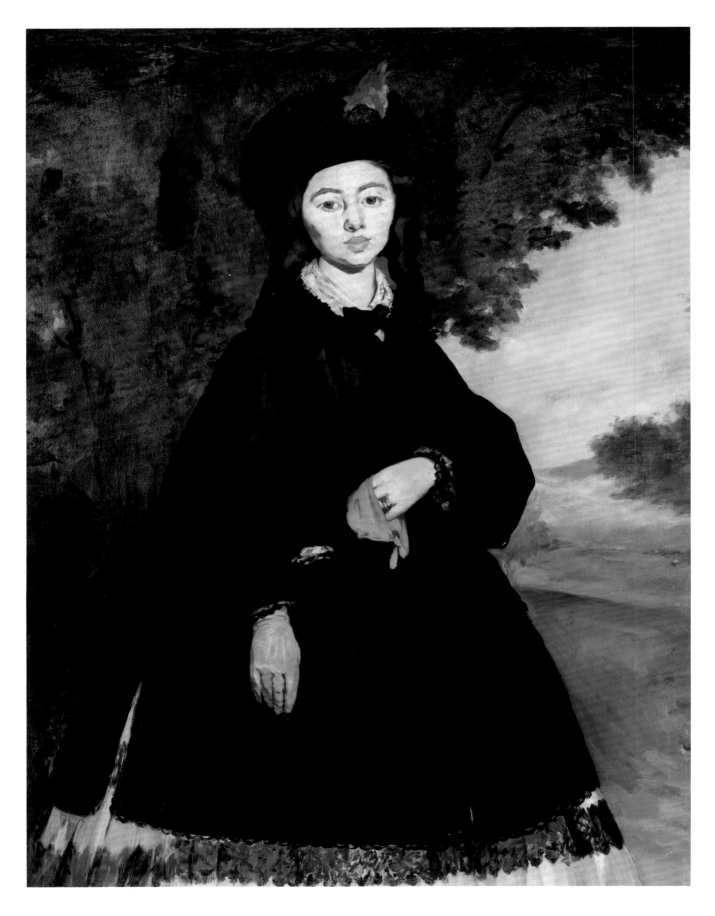

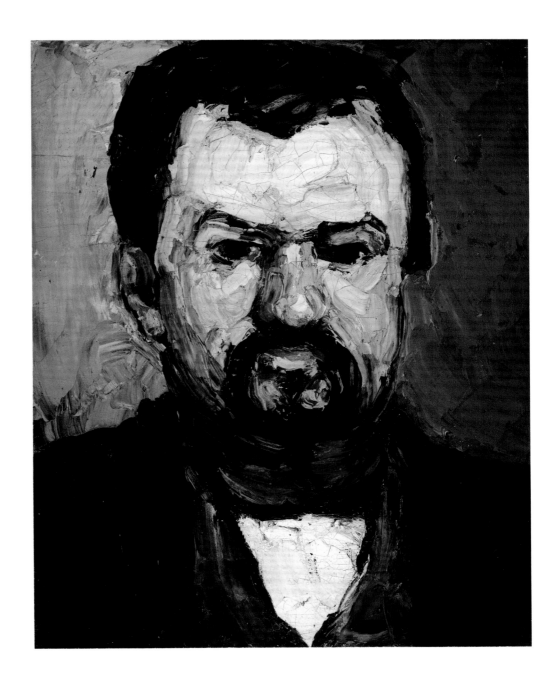

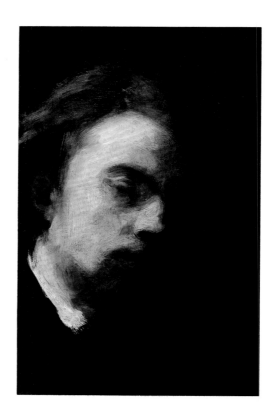

PLATE 108 (cat. 51)
Henri-Ignace-Théodore Fantin-Latour, *The Two Sisters*

PLATE 109 (cat. 52)
Henri-Ignace-Théodore Fantin-Latour, *Self-portrait*

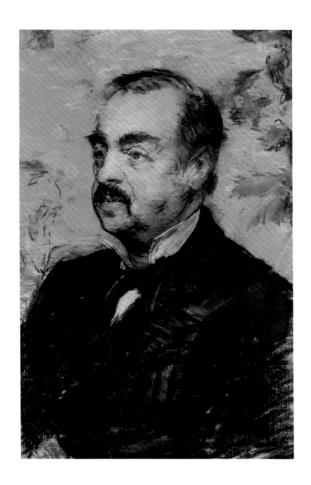

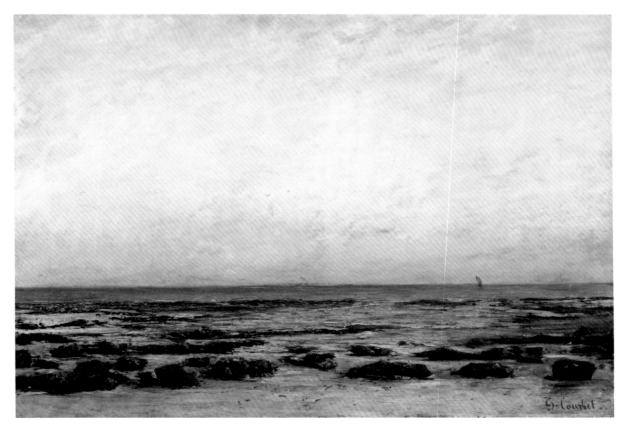

PLATE 110 (cat. 84)
Edouard Manet, *Portrait of Emile-Charles-Julien de la Rochenoire*

PLATE 111 (cat. 33)
Gustave Courbet, *Effet de Soleil, Trouville*

83

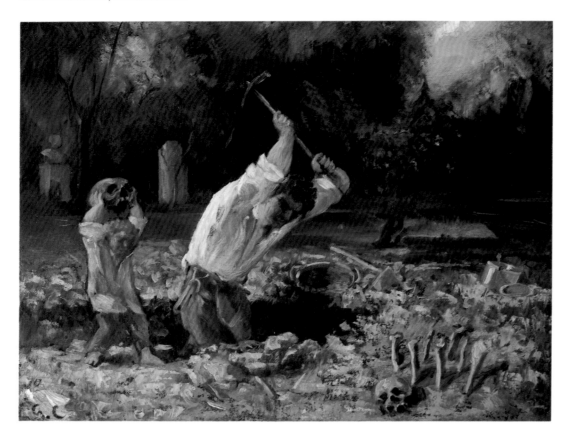

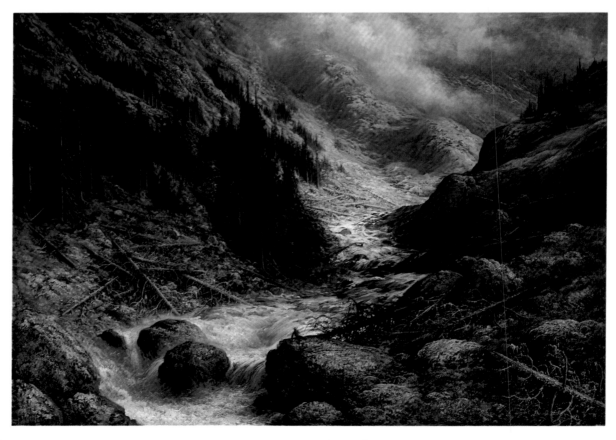

PLATE 112 (cat. 34)
Gustave Courbet, *Gravedigger and a Child with a Skull*

PLATE 113 (cat. 42)
Gustave Doré, *Torrent in the Engadine*

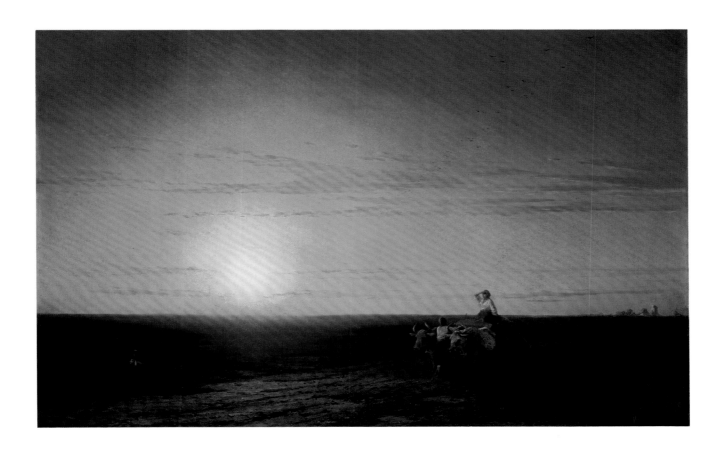

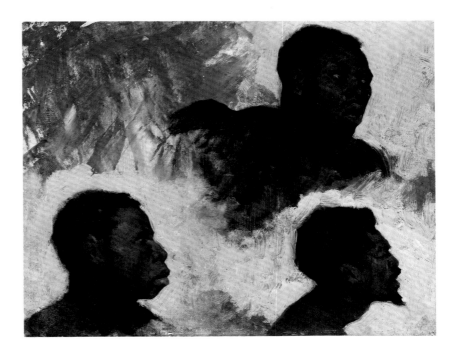

PLATE 114 (cat. 1)
Ivan Konstantinovitch Aivazovsky, *Returning from the Fields at Sunset*

PLATE 115 (cat. 120)
Henri Alexandre Georges Regnault, *Studies of Black Men*

PLATE 116 (cat. 54)
French, late 19th century, *Portrait of Edouard Detaille*

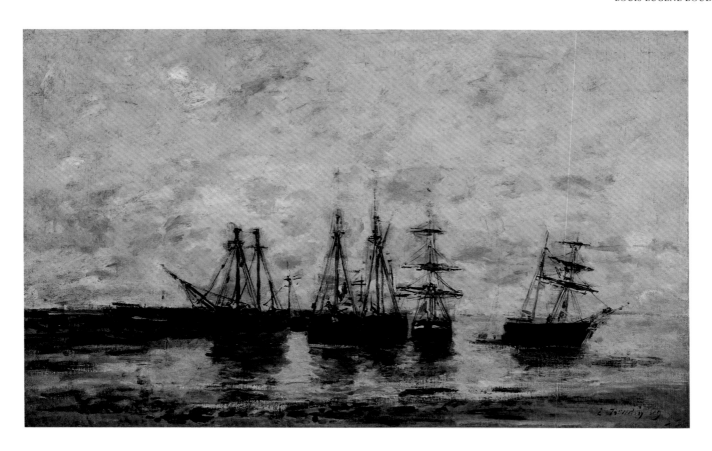

PLATE 117 (cat. 11)
Louis Eugène Boudin, *Portrieux, Low Tide*

PLATE 118 (cat. 12)
Louis Eugène Boudin, *La Rade de Villefranche (View from the Roadstead outside Villefranche)*

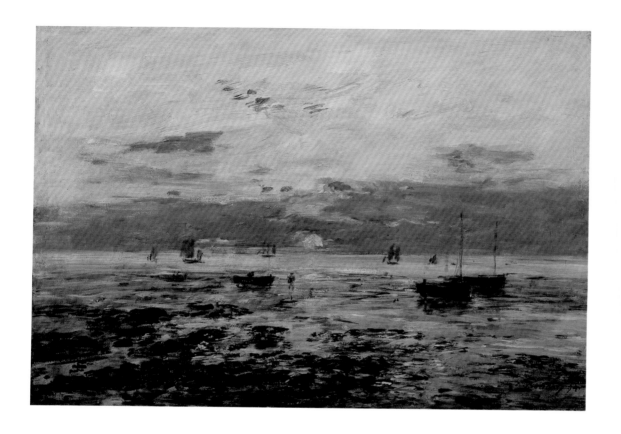

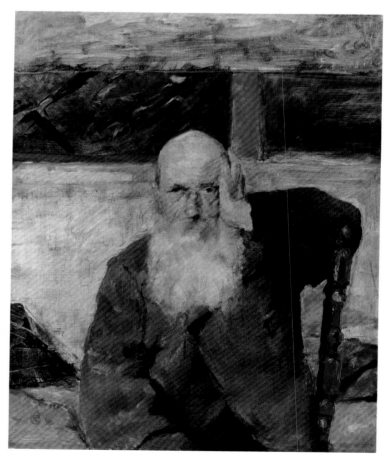

∧ PLATE 119 (cat. 13)
Louis Eugène Boudin, *Marée Basse à Sainte-Adresse. Soleil Couchant (Low Tide at Sainte-Adresse, Sunset)*

> PLATE 120 (cat. 144)
Henri Raymond de Toulouse-Lautrec-Monfa,
Old Man with a Beard

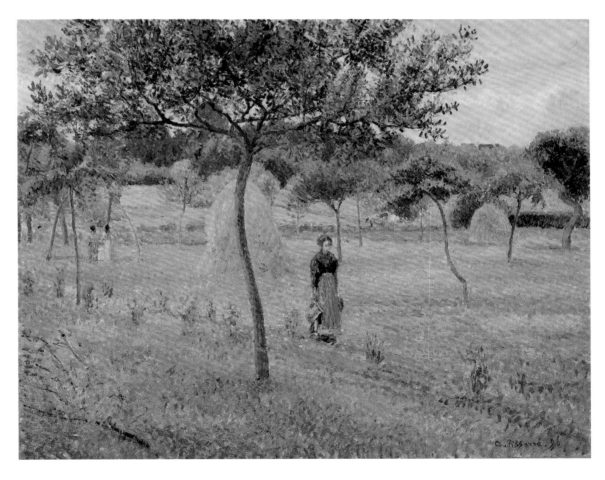

PLATE 121 (cat. 111)
Camille Pissarro, *Portrait of Père Papeille, Pontoise*

PLATE 122 (cat. 113)
Camille Pissarro, *Haystacks in a Meadow, Eragny*

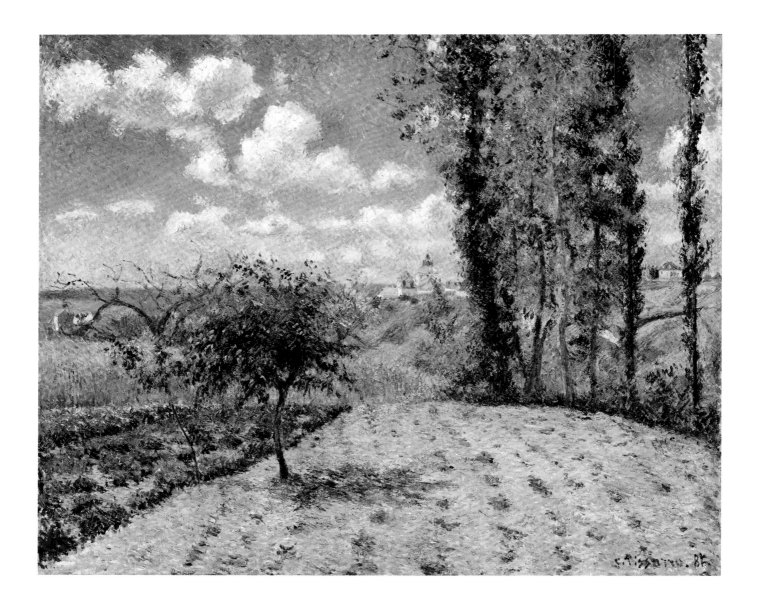

PLATE 123 (cat. 112)
Camille Pissarro, *View of the New Prison at Pontoise (Spring)*

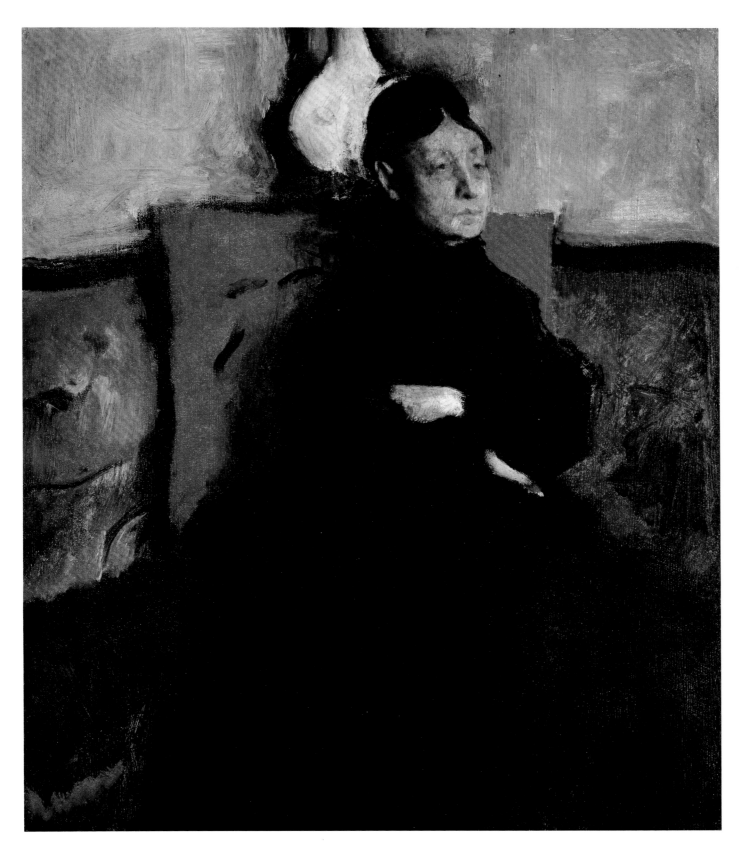

PLATE 124 (cat. 36)
Edgar Degas, *Stefanina De Gas, Duchessa Montejasi-Cicerale*

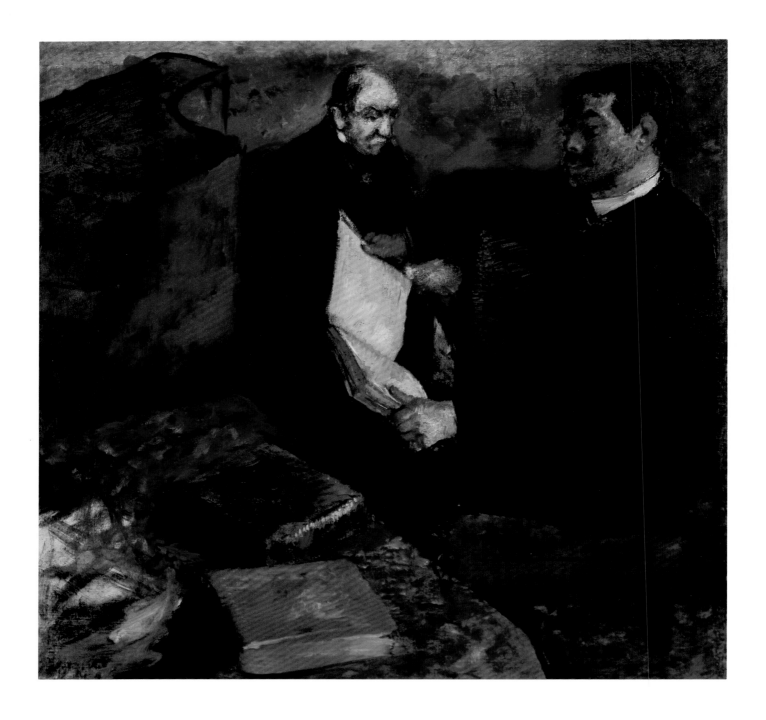

PLATE 125 (cat. 38)
Edgar Degas, *Pagans et le Père De Gas*

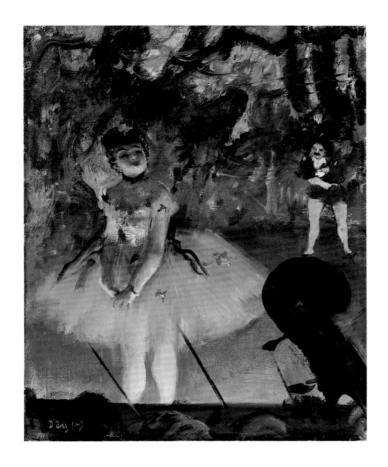

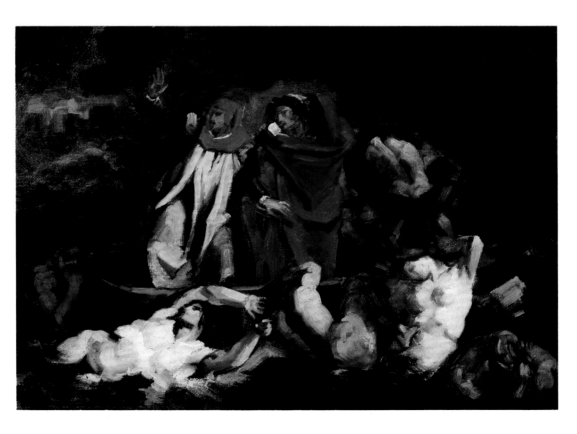

PLATE 126 (cat. 37)
Edgar Degas, *Ballet Scene*

PLATE 127 (cat. 22)
Paul Cézanne, *Barque de Dante (après Delacroix)*

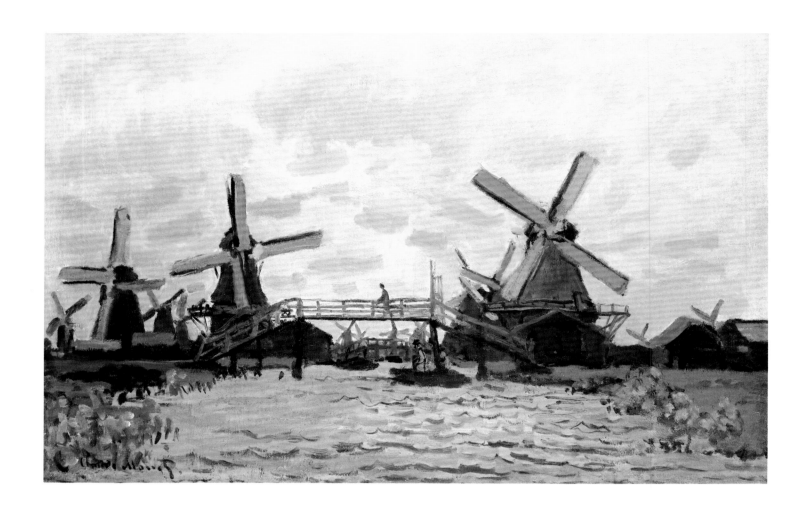

PLATE 128 (cat. 92)
Claude Monet, *Windmills in the Westzijderveld, near Zaandam*

PLATE 129 (cat. 24)
Paul Cézanne, *Study for Femme à la Cafetière*

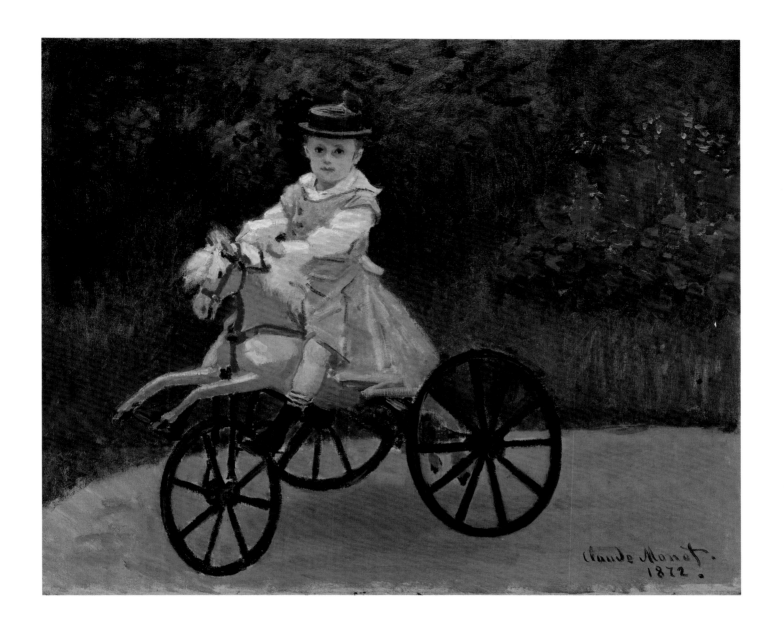

PLATE 130 (cat. 93)
Claude Monet, *Jean Monet on His Mechanical Horse*

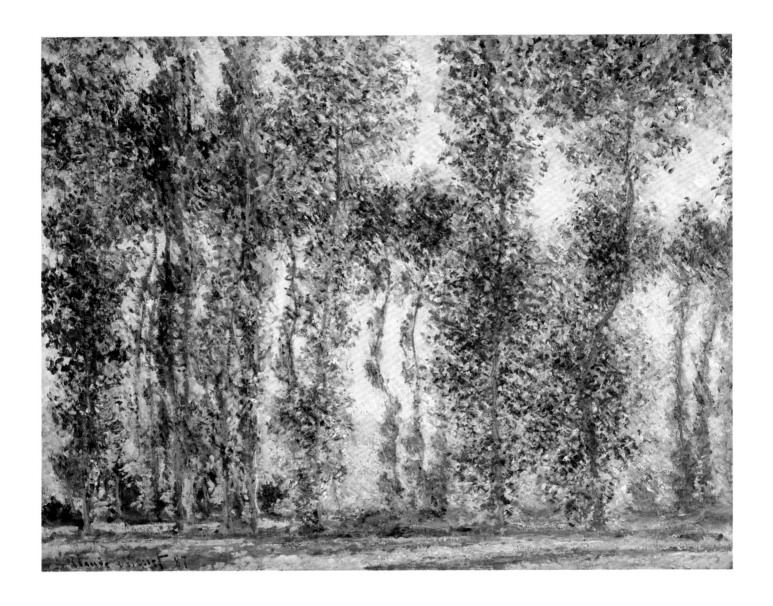

PLATE 131 (cat. 95)
Claude Monet, *Poplars at Giverny*

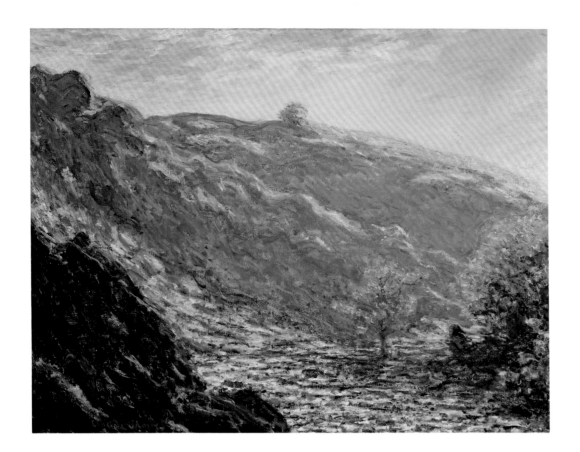

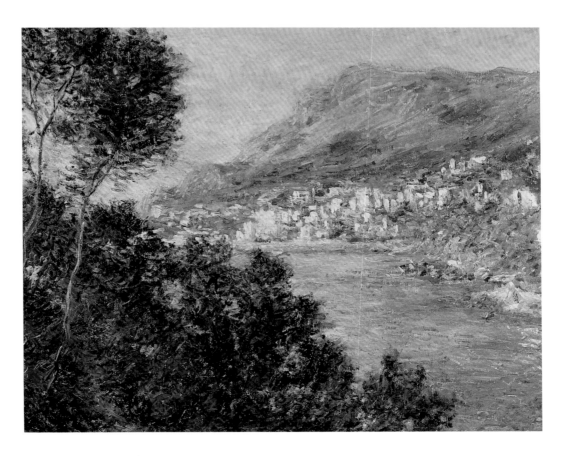

PLATE 132 (cat. 96)
Claude Monet, *The Petite Creuse (Sunlight)*

PLATE 133 (cat. 94)
Claude Monet, *Monte Carlo, View of Cape Martin*

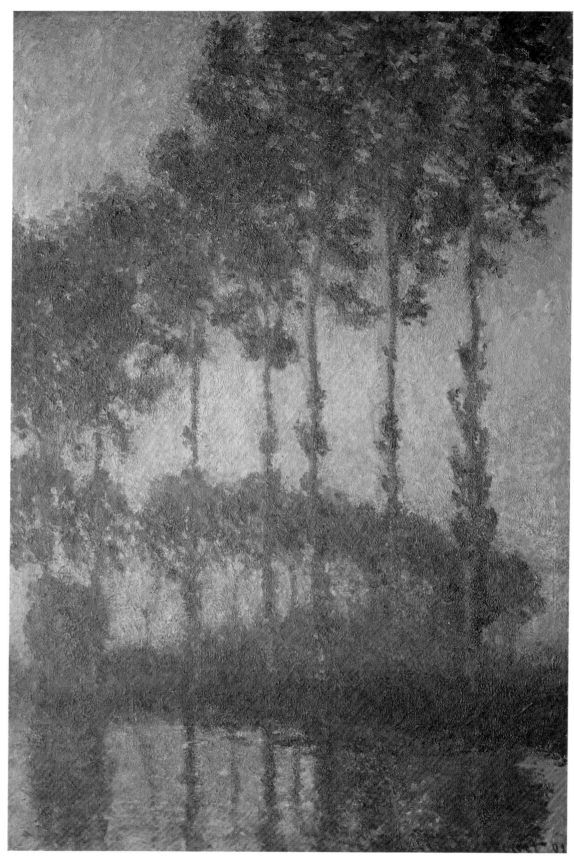

PLATE 134 (cat. 97)
Claude Monet, *Poplars on the Banks of the Epte, Sunset*

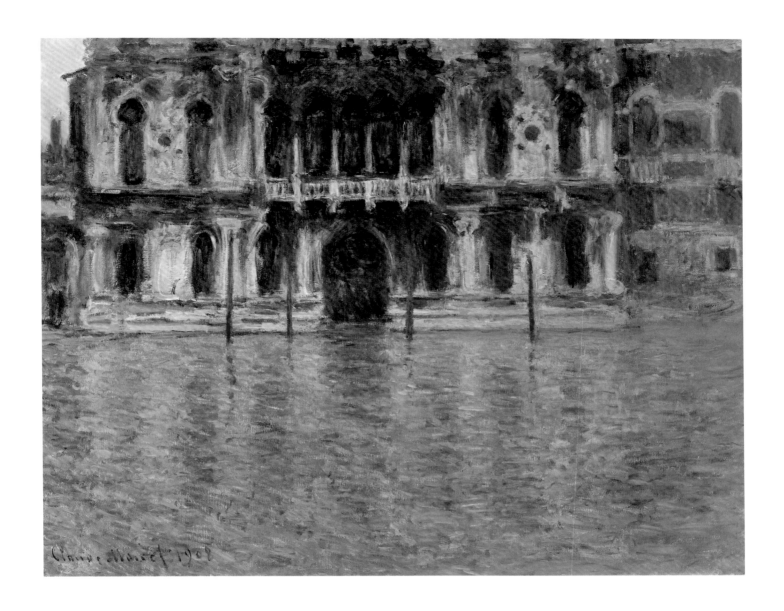

PLATE 135 (cat. 99)
Claude Monet, *Contarini Palace*

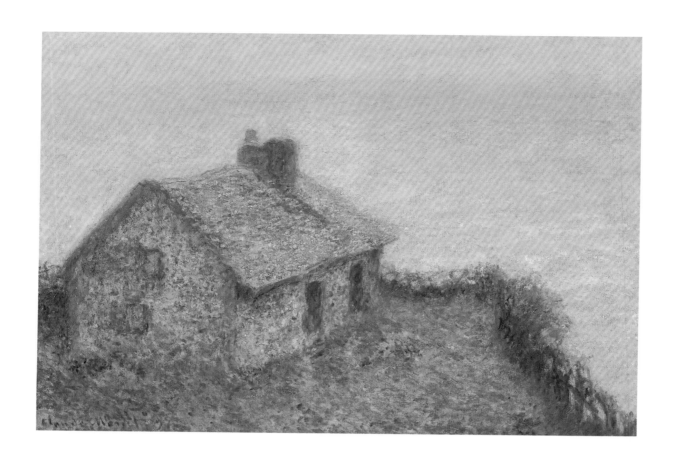

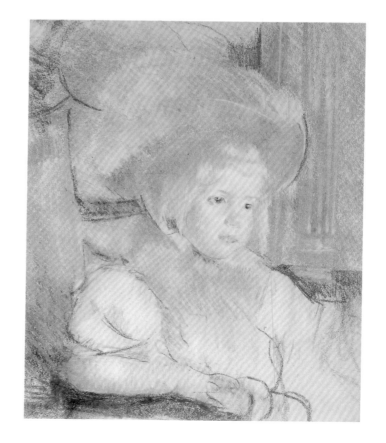

∧ PLATE 136 (cat. 98)
Claude Monet, *Customs House at Varengeville*

> PLATE 137 (cat. 20)
Mary Cassatt, *Simone in a Plumed Hat*

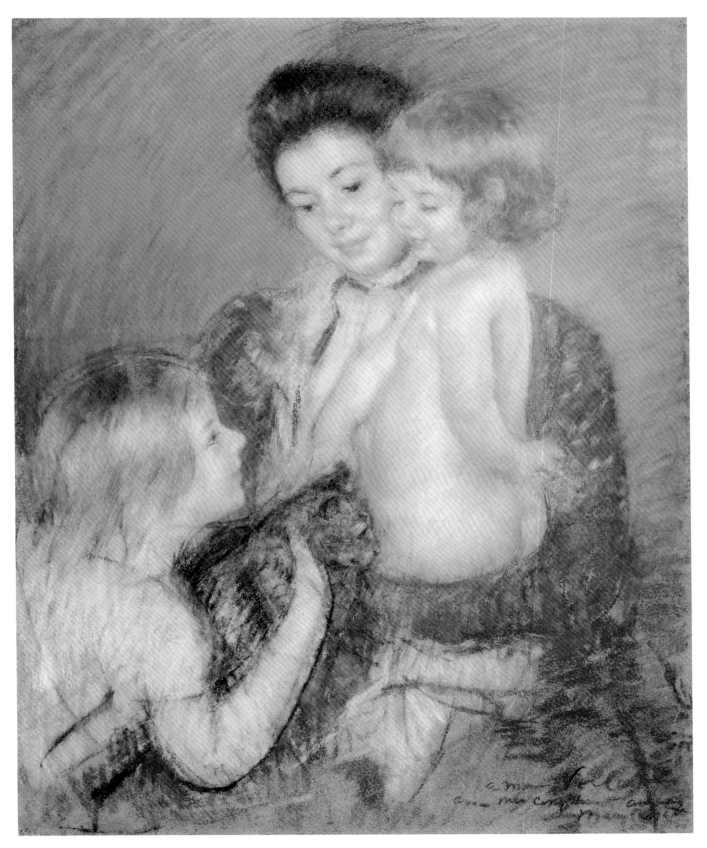

PLATE 138 (cat. 19)
Mary Cassatt, *Reine Lefebvre with a Blonde Baby and Sarah Holding a Cat*

PLATE 139 (cat. 102)
Berthe Morisot, *Young Woman Holding a Basket*

PLATE 140 (cat. 119)
Jean François Raffaëlli, *Afternoon Tea*

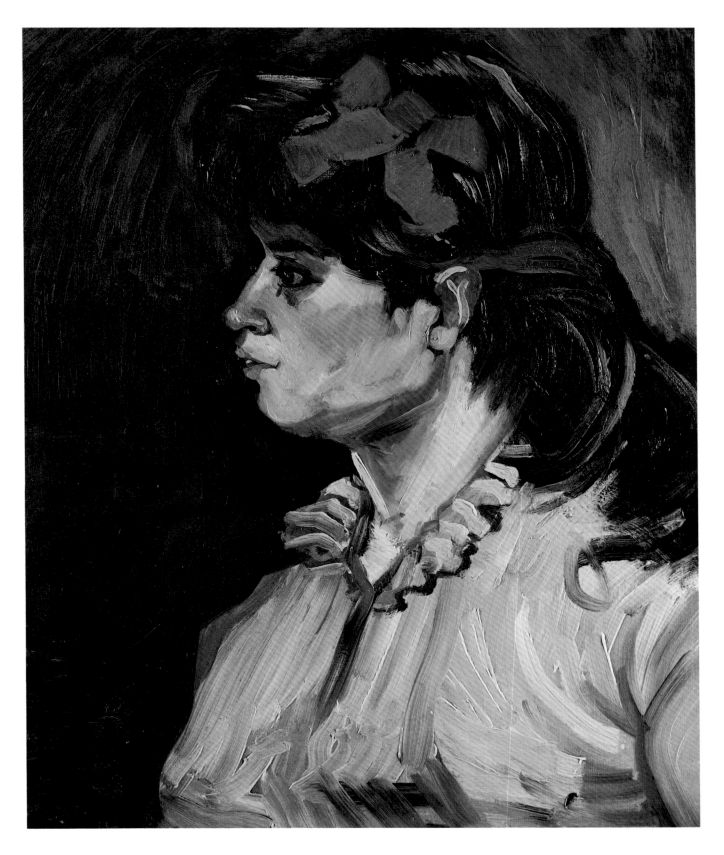

PLATE 141 (cat. 61)
Vincent van Gogh, *Young Woman with Red Bow*

PLATE 142 (cat. 131)
Théodore van Rysselberghe, *La Régate*

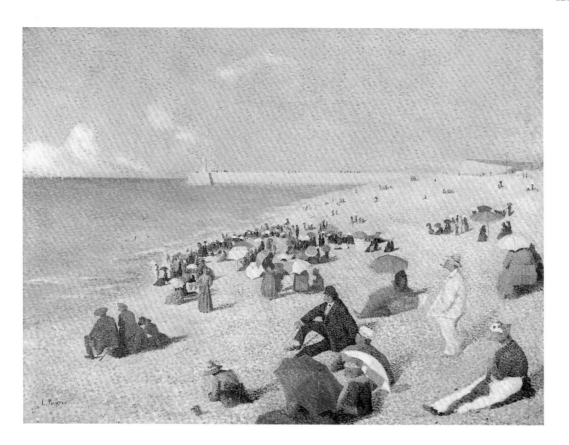

PLATE 143 (cat. 115)
Léon Pourtau, *Beach Scene*

PLATE 144 (cat. 81)
Maximilien Luce, *Eragny, Les Bords de l'Epte*

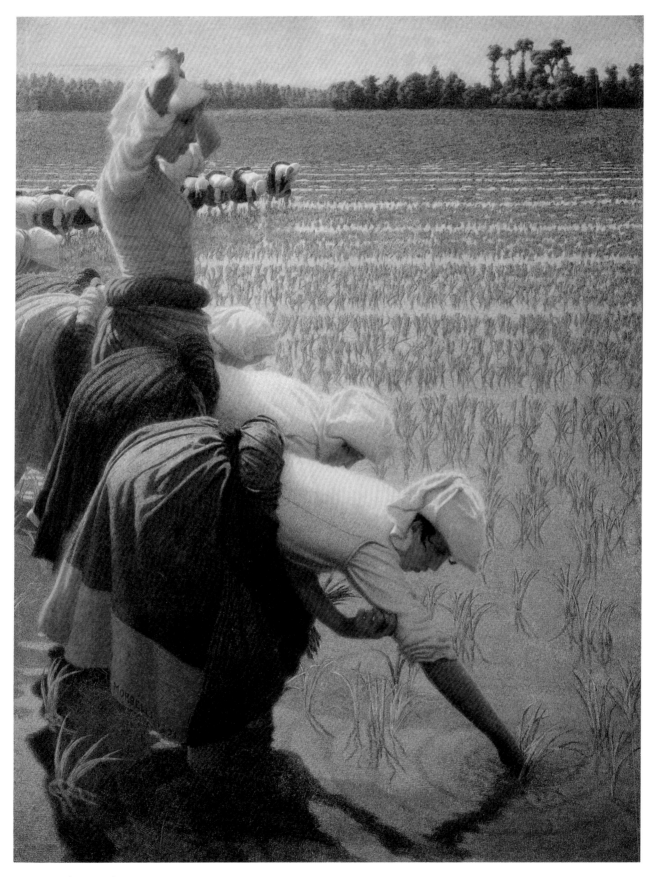

PLATE 145 (cat. 101)
Angelo Morbelli, *In Risaia (In the Rice Fields)*

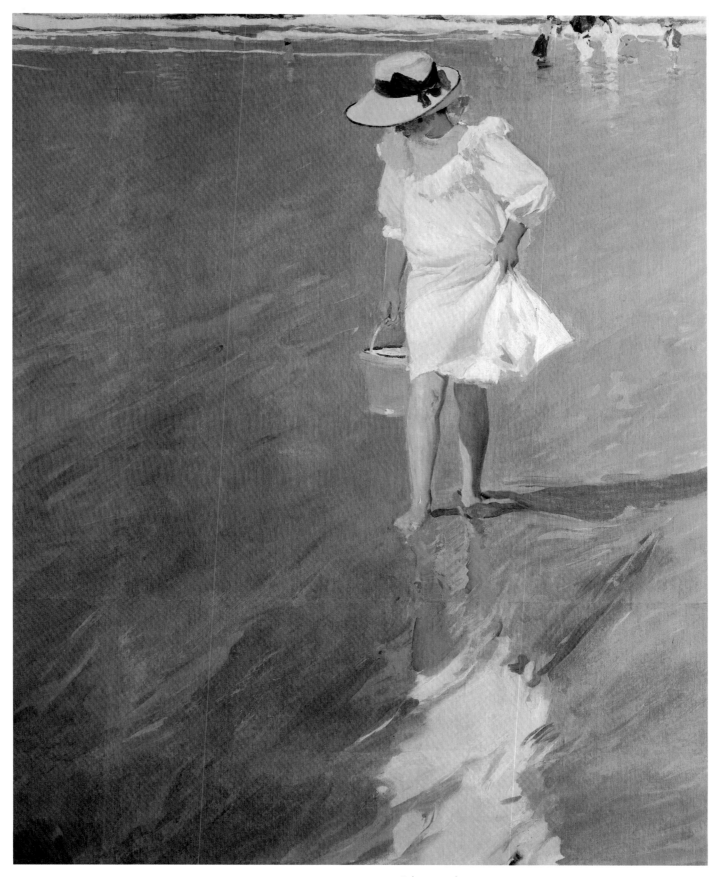

PLATE 146 (cat. 139)
Joaquín Sorolla y Bastida, *Elena on the Beach of Biarritz (Low Tide)*

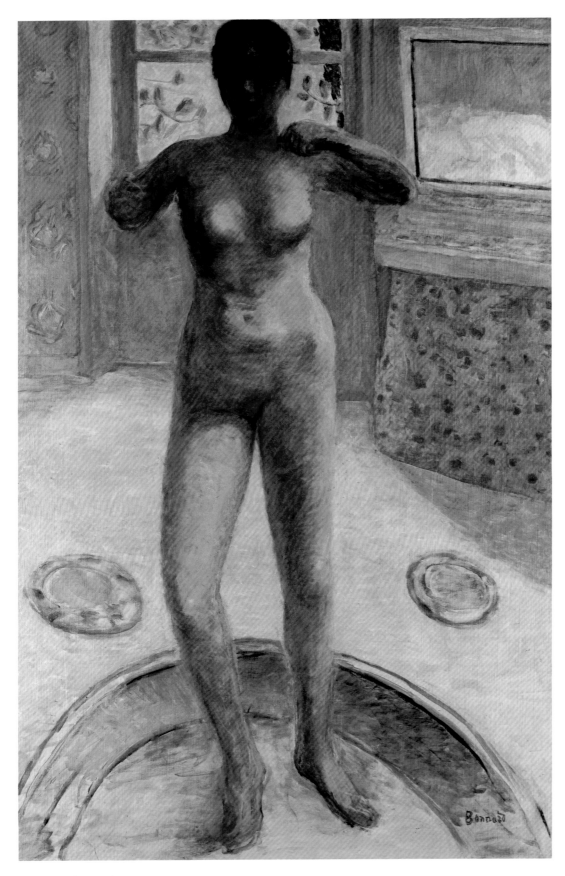

PLATE 147 (cat. 10)
Pierre Bonnard, *Standing Nude*

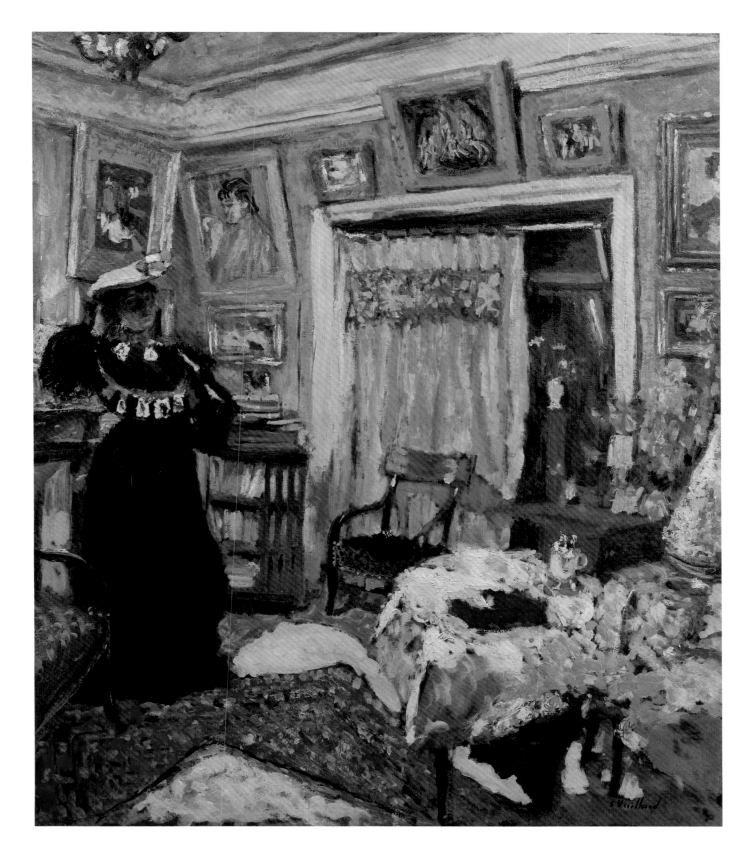

PLATE 148 (cat. 157)
Edouard Vuillard, *The Hessel Salon, rue de Rivoli*

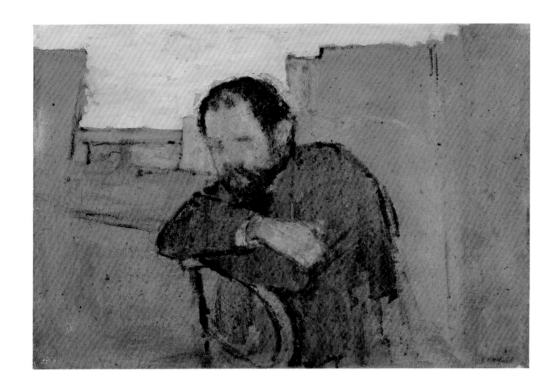

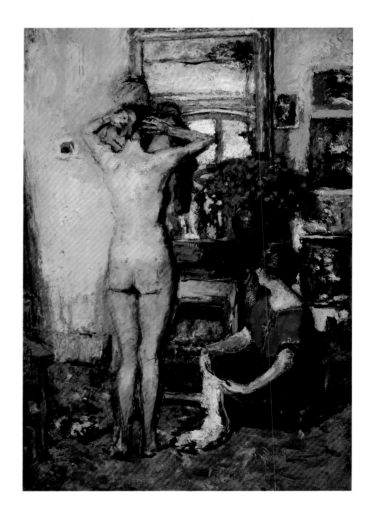

∧ PLATE 149 (cat. 156)
Edouard Vuillard, *Portrait of Ambroise Vollard*

> PLATE 150 (cat. 158)
Edouard Vuillard, *Nude in an Interior*

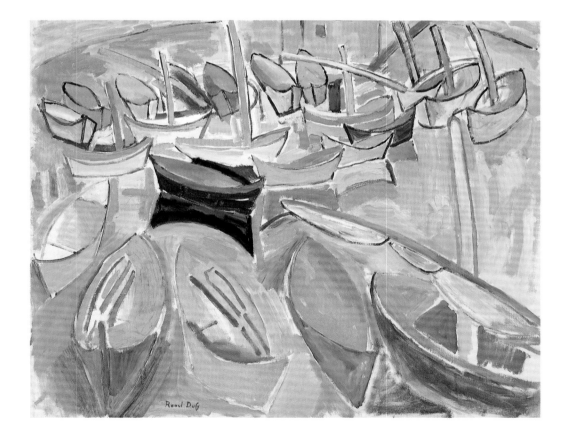

PLATE 151 (cat. 86)
Henri Matisse, *Pont Saint-Michel*

PLATE 152 (cat. 43)
Raoul Dufy, *Barques aux Martigues*

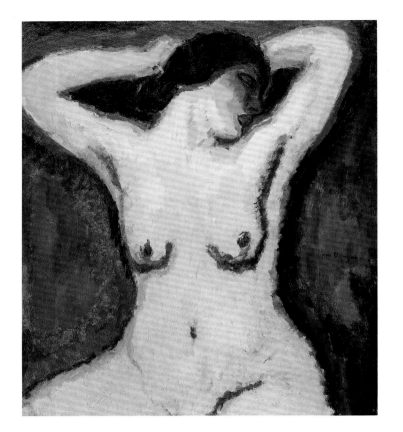

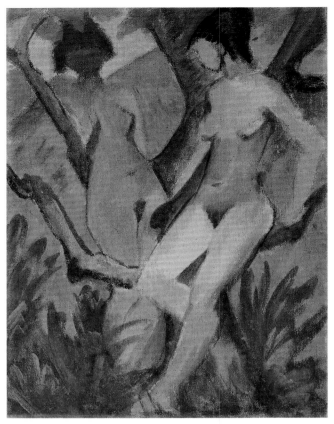

PLATE 153 (cat. 41)
Kees van Dongen, *Torse (Portrait de Guus)*

PLATE 154 (cat. 103)
Otto Mueller, *Bathers in a Landscape*

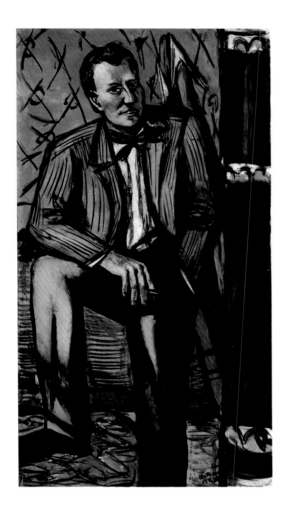

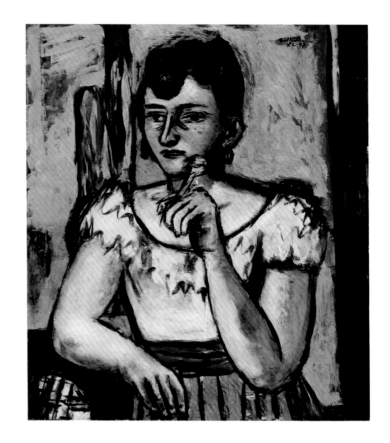

PLATE 155 (cat. 7)
Max Beckmann, *Portrait of Perry T. Rathbone*

PLATE 156 (cat. 6)
Max Beckmann, *Portrait of Euretta Rathbone*

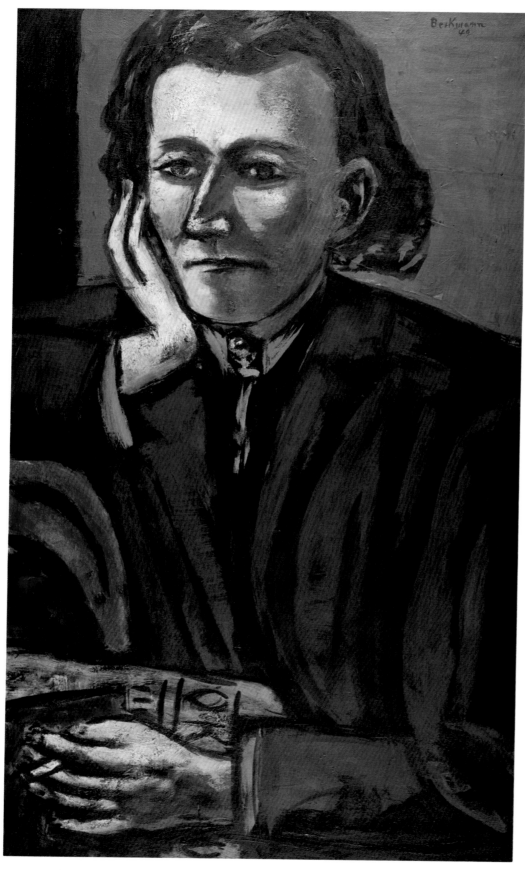

PLATE 157 (cat. 8)
Max Beckmann, *Portrait of Wolfgang Frommel*

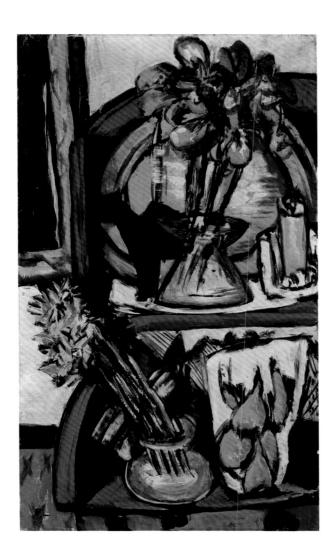

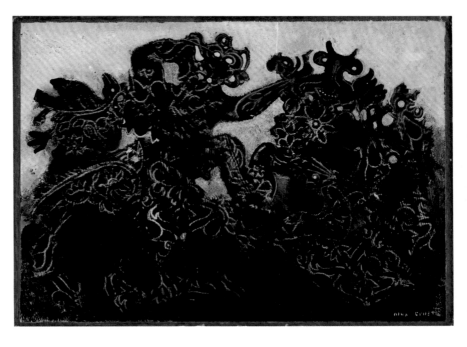

PLATE 158 (cat. 5)
Max Beckmann, *Still Life with Two Flower Vases*

PLATE 159 (cat. 48)
Max Ernst, *Barbarians Marching West*

< PLATE 160 (cat. 80)
Jules Fernand Henri Léger, *Still Life*

PLATE 161 (cat. 91)
Piet Mondrian, *Composition*

Catalogue

I PLATE 114

IVAN KONSTANTINOVITCH AIVAZOVSKY (Russian, 1817–1900)
Returning from the Fields at Sunset, 1874
Oil on canvas, 24½ x 39 in. (62.2 x 99 cm)
Signed and dated at lower left: *Aivazovsky 1874*
Inscribed on the verso: *Nice 1874*
Private collection, Brookline, Massachusetts

PROVENANCE: Sir Giles Loder; sale London (Christie's), November 27, 1981, no. 200.

Of Armenian descent, Ivan Konstantinovitch Aivazovsky was born and raised in the Crimean city of Theodosia on the Black Sea. Sent to the Academy of Arts in Saint Petersburg in 1833, he studied with the landscape painter Vorobyov but was also influenced by Shchedrin, another romantic landscape painter. After completing his studies, Aivazovsky returned to the Crimea, but he left again in 1840 to travel through Europe. In Italy, he became acquainted with the writer Gogol and also painted his earliest large masterpieces, including one called *Chaos*, which Pope Gregory XVI acquired and hung in the Vatican. In 1842 Aivazovsky met the English painter Turner, who praised the young Russian's works.

By 1844 Aivazovsky was back in Saint Petersburg, where he became a member of the academy and an official painter for the Admiralty. He joined a brilliant intellectual circle that included the painter Briullov, the composer Glinka, and the poet Pushkin. The last's lyrical writing about the sea may have made Aivazovsky homesick, and in 1845 he returned to Theodosia. There, he founded an art school and gallery and established his home. Though he continued to travel widely, to Egypt, Turkey, Spain, Germany, England, and America (where he visited Niagara Falls), he always returned home to Russia. In his highly prolific career Aivazovsky produced more than 6,000 pictures.

Although remembered today primarily for his seascapes, whether of the turbulent moods of the Black Sea or the calm bays of Naples and Constantinople, Aivazovsky throughout his life painted a number of landscapes depicting the vast Russian steppes and the peasants who inhabited them, as in *The Ox Cart Driver* and *Ukrainian Wedding* (1857 and 1891, respectively; see Nikolai Novouspensky, *Aivazovsky* [Leningrad, 1989], pls. 73 and 74). As with many of the artist's seascapes, these two works display his ability to capture, in an almost impressionistic manner, the effects of light on the atmosphere. In the present example, which he executed in Nice in 1874, the painfully brilliant sunset in the center dissolves the forms of sky and land. Only a few peasants, a windmill, and some lively birds interrupt the sweeping expanse of the seemingly endless plain.

E.M.Z.

2 PLATE 4

ALESSANDRO ALLORI (Italian, 1535–1607)
Dead Christ with Angels, about 1593
Oil on copper, 17½ x 15½ in. (44.5 x 39.4 cm)
Collection of Mrs. Benjamin Rowland

PROVENANCE: Medici Collection, Florence, 1593 (?); Thomas Agnew & Sons Ltd., London, 1965; sale London (Christie's), November 25, 1966, no. 102.

LITERATURE: A. Pigler, ed., *Museum der Bildenden Künste Szépmüvészeti Múzeum Budapest, Katalog der Galerie Alter Meister* (Tübingen, 1968), vol. I, p. 24; Vilmos Tátrai, *Cinquecento Paintings of Central Italy* (Budapest, 1983), no. 36; Piero Bigongiari et al., *Il Seicento fiorentino. Arte a Firenze da Ferdinando I a Cosimo III* (Florence, 1986), vol. 3, p. 31; Simona Lecchini Giovannoni, *Alessandro Allori* (Turin, 1991), pp. 278–79.

Alessandro Allori began his artistic training at the age of five with the Florentine Mannerist painter Angolo di Cosimo Tori, who was known as Bronzino. The young painter combined his master's style, which was remarkable for its visual and intellectual complexity, with Michelangelo's massive figure types, which Allori admired during his five-year stay in Rome beginning in 1554. After his return to Florence, the artist received many commissions for frescoes, easel paintings, and altarpieces. His most important projects were the decoration of the Montauto Chapel of Santissima Annunziata (1559–1560) and the Medici villa at Poggio a Caiano (1576–1582). In 1574, Allori became the official court painter of the Medici family — his most important and generous patrons.

Three paintings by Allori which represented "the dead Christ in the tomb with two angels" were listed in a Medici inventory dated May 24, 1593. Each was executed on copper and had the same measurements: ¾ x ⅔ *braccia*, or about 17¼ x 15⅛ inches (1 Florentine *braccia* = 23 inches). These three works were probably the present painting; a nearly identical version in the Seminario Patriarcale, Venice; and a signed example in the Szépmüvészeti Múzeum, Budapest (Giovannoni 1991, pp. 278–79).

An attendant angel removes Christ's intricately embroidered shroud while the other readies a sumptuous mantle. This subject ultimately derives from an apocryphal legend that angels (rather than disciples, as the Bible states) prepared Christ for burial on a red stone — a relic that was revered in Constantinople as the slab used to embalm Christ's body. The theme is depicted in thirteenth- and fourteenth-century Byzantine embroideries and in Venetian Renaissance paintings (Tátrai 1983, no. 36). The red cushion beneath Christ may reflect this Orthodox legend, but Allori's representation contains many more elements linking it to Catholic dogma. The altar and gold chalice in the background refer to the ceremony of the Mass, the lamps symbolize eternal life, and the crown of thorns and three nails neatly arranged in a basin in the foreground represent the crucifixion. The juxtaposition of these elements with the dead Christ alludes to the consecration of the Eucharist, when, according to Catholic doctrine, the host and wine as-

sume the form of the Savior's mystical body and blood.

The intensely spiritual theme and the highly wrought richness of the scene are characteristic of Florentine Mannerism. The existence of at least three autograph versions testifies to the popularity of such subjects. The prototype for Allori's composition may have been Rosso Fiorentino's *Dead Christ with Angels* (about 1526; Boston, Museum of Fine Arts), which the artist could have seen during his stay in Rome. In Rosso's painting, Christ's tomb is in the form of an altar, and the instruments of the Passion also occupy the immediate foreground. Other parallels exist between the two works, specifically the starkness of Christ's pose, his peaceful expression, and the backward tilt of his head.

Allori often reused figures from his own compositions. Christ's pose in *Dead Christ with Angels* appears verbatim in two pictures from the early 1580s: in one, he lies at the foot of the cross (1583; Olmütz, Cathedral); in the other, an angel presents Christ to Saint Francis (about 1583; Chantilly, Musée Condé). These are executed on canvas and on panel, respectively.

It was not until about 1590, however, that Allori began to paint small-scale pictures on copper — an expensive (and rare) support favored by northern landscape artists such as Paul Bril, who was then active in Rome. Allori's interest in surface textures and patterns and in the polished, luminous paint surface so evident in his *Dead Christ with Angels* characterize other small coppers, such as *Saint John the Baptist Preaching* (about 1595; Florence, Pitti Palace).

J.J.C.

3 PLATE 50

JAN ASSELIJN (Dutch, about 1615–1652)
Figures in the Ruins of the Forum Romanum, about 1648
Oil on panel, 28 x 24 in. (71 x 61 cm)
Monogrammed
Private collection

PROVENANCE: Sale G —— (of London), Amsterdam (Frederick Muller), May 20, 1919, no. 1, ill.; sale Stolz, Frankfurt, March 29, 1927, no. 228; collection Baron van Hugenpoth; dealer Dirven, Eindhoven; collection M. J. M. van Lieshouten, Eindhoven.

EXHIBITION: Utrecht, Centraal Museum, *Nederlandse 17e eeuwse Italianiserende landschapschilders*, 1965, no. 64 (collection Van Lieshouten).

LITERATURE: Albert Blankert, in *Nederlandse 17e eeuwse landschapschilders* (exh. cat., Utrecht, Centraal Museum, 1965; 2nd ed., Soest, 1978), pp. 136–37; Anne Charlotte Steland-Stief, *Jan Asselijn, nach 1610 bis 1652* (Amsterdam, 1971), pp. 69–70 and 133–34, cat. 66; Frederik J. Duparc, *Italian Recollections: Dutch Painters of the Golden Age* (exh. cat., Montreal, Museum of Fine Arts, 1990), p. 48.

Hunters and herdsmen take shelter from the midday sun in the shady recesses of a Roman ruin, accompanied by assorted dogs and goats. Two roughly dressed figures recline at left; their tethered dog lunges ineffectually toward the hounds that surround the two hunters relaxing in the right fore-ground. The red coat of the standing hunter adds a vibrant touch of color to the overall brown tonalities of the foreground space. The arched opening at the rear, its contours softened by a screen of scruffy undergrowth, frames a view of the Roman Forum beneath a luminous sky.

One of the most influential Dutch Italianate landscapists, Jan Asselijn traveled to Italy about 1640 and was active in Rome until 1643 or 1644. He was a member of the Bentveughels ("Birds of a Feather"), a loose social and professional brotherhood of northern artists in Rome. Even after his return to Amsterdam about 1646, Asselijn continued to paint picturesque views of classical ruins and Italianate harbor scenes flooded with the brilliant sunlight characteristic of southern climes.

Overgrown and buried beneath the debris of centuries, the Roman Forum was a popular subject for seventeenth-century landscape painters, who either transcribed the local topography precisely or created imaginative combinations of the ruined monuments. The majority of Asselijn's Italianate views fall into the latter category; the structures represented in *Figures in the Ruins of the Forum Romanum* are not readily identifiable, and the topography only generally recalls that of the Forum itself.

The compositional device of juxtaposing a cavernous foreground space against a view to a distant light-filled landscape was popular among Dutch Italianate painters. Asselijn must have considered the present work a particularly successful use of the motif, for variants of this composition exist in the Rijksmuseum, Amsterdam; in the Wadsworth Atheneum, Hartford; in the Wetzger Collection, Berlin; and in a private collection (Steland-Stief 1971, nos. 68, 72, 69, and 67, respectively). Asselijn's paintings are difficult to date, but the rather refined execution of *Figures in the Ruins of the Forum Romanum* points to a date after the artist's return to the Netherlands, probably about 1648.

M.E.W.

4 PLATE 76

BALTHASAR VAN DER AST (Dutch, 1593 or 1594–1657)
Still Life with Fruit and Shells, about 1623–1624
Oil on panel, 13¾ x 21½ in. (35 x 54.6 cm)
Signed at lower left: *B. vander Ast*
Private collection

PROVENANCE: Lord Beaconsfield (Benjamin Disraeli); sale London (Christie's), 1881 (for Gn 8); Robert Grandjean, Verviers, Belgium; Hallsborough Gallery, London; E. Hamilton-Brown, London; with John Mitchell & Sons, London, 1967.

EXHIBITION: Amsterdam, P. de Boer Gallery; and Braunschweig, Herzog Anton Ulrich-Museum, *A Fruitful Past* (cat. by Sam Segal), 1983, no. 13, ill.

LITERATURE: L. J. Bol, *The Bosschaert Dynasty: Painters of Flowers and Fruit* (Leigh-on-Sea, 1960; repr. 1980), p. 81, cat. 87, fig. 45a (with incorrect dimensions); Peter Mitchell, *The Inspiration of Nature: Paintings of Still*

Lifes of Flowers, Birds and Insects by Dutch and Flemish Artists of the Seventeenth Century (London, 1976), pp. 58–59, ill.

On the edge of a table rest apples, pears, cherries, peaches, and the twigs and fruit from a plum tree. In the foreground are seven exotic shells, a lizard, forget-me-nots, lilies of the valley, and a carnation. About the fruit are various insects, including a caterpillar, a Painted Lady (*Vanessa cardui L.*) and a Red Admiral (*Vanessa atalanta L.*) butterfly, a dragonfly, and a spider.

After he was orphaned at the age of fifteen, Balthasar van der Ast was raised and trained by his brother-in-law, the pioneering Dutch still-life painter, Ambrosius Bosschaert the Elder. Van der Ast conceived his combinations of flowers, fruit, insects, birds, reptiles, and shells in the tradition of Bosschaert, but he often painted them more thickly, in darker, more saturated hues, with a more atmospheric technique. He favored the classical tabletop still-life composition, with objects piled on top of one another and arranged horizontally. Similar designs appeared at virtually the same time in the works of Flemish painters such as Osaias Beert and Clara Peeters, and the Dutch painters Floris van Dyck and Nicolaes Gillis.

The present painting is close in conception to the somewhat simpler design of the signed but undated *Still Life with Fruit and Shells* by van der Ast in the Bayerische Staatsgemäldesammlungen, Munich (inv. 13150). The former may be dated to about 1623 or 1624 on the grounds of its stylistic relationship to *Basket of Fruit* (signed and dated 1624), which was with the dealer Abels of Cologne in 1950, as well as to the still life in the Musée des Beaux-Arts, Lille (dated 1623, no. 966-8-1). Also close in conception to the present work is an undated *Still Life with Shells, Fruit, and a Dragonfly* in the M. A. Hassid Collection, London (Bol 1980, no. 92).

Van Der Ast liked to demonstrate his expert knowledge of seashells in his still lifes, often including exotic shells from various oceans in his compositions (compare especially the still lifes of shells in Rotterdam, Museum Boymans-van Beuningen; and Hartford, Wadsworth Atheneum). In the present work, Silvard P. Kool of the Museum of Comparative Zoology at Harvard has identified the following, from left to right: *Phyllototus pomum* (Gmelin 1791; not *Hexaplex rosarium*, as first suggested in Mitchell 1976, p. 58); *Conus marmoreus* (Linnaeus 1758); *Harpa major* (Röding 1798); *Conus textile* (Linnaeus 1758); *Turbo marmoratus* (not *Turbo sarmaticus*; Linnaeus 1758); *Turbo petholatus* (Linnaeus 1758); and another *Phyllonotus pomum* (not *Harpa articularis*). Kool verifies that the shells came from various oceans, but primarily from the tropical regions of the Indo-Pacific.

The financially speculative seventeenth-century passion for shell collecting — the gathering of rare *horentjes en schelpen*, which in Dutch had evocative names such as "seadrum," "green cheese," and "very large strange doughnut" — became so obsessive that the "shell fools" (*schelpenzotten*) were condemned by moralists of the time in the same breath

as were the famous "tulipomaniacs." However, in the emblem devoted to ridiculing shell collecting in his *Sinnepoppen* (1614), Roemer Visscher warned: "A foreign shell or new flower, 'tis nothing more than gambling, but the shell fools, at least, don't have to buy and maintain expensive gardens."

P.C.S.

5 PLATE 158

MAX BECKMANN (German, 1884–1950)
Still Life with Two Flower Vases, 1944
Oil on canvas, 37½ x 22¼ in. (95.5 x 56.5 cm)
Signed and dated at lower right: *Beckmann A. 44*
Private collection

PROVENANCE: Curt Valentin, New York.

EXHIBITIONS: New York, Buchholz Gallery, *Max Beckmann*, April 1946, no. 4; City Art Museum of Saint Louis, *Max Beckmann*, 1948, no. 34; Saint Louis, Carroll-Knight Gallery, Inc.

LITERATURE: Lothar-Günther Buchheim, *Max Beckmann* (Feldafing, 1959), fig. 91; Peter Selz, *Max Beckmann, Sichtbares und Unsichtbares* (Stuttgart, 1965), p. 97; Erhard and Barbara Göpel, *Max Beckmann, Katalog der Gemälde* (Bern, 1976), vol. 1, p. 403, no. 670; vol. 2, pl. 244.

Considered the greatest German artist of the twentieth century, Max Beckmann was born in Leipzig and trained in the traditional manner. Portraits, landscapes, and still lifes were always to play an important part in his production, but in place of standard religious or mythological subjects, he created his own highly personal allegorical vocabulary of images, reflecting his response to events in his life and the world at large.

Early influences on Beckmann's style were as widely divergent as the works of Cézanne and Munch, but it was after his experience in the German medical corps during World War I that he evolved his powerful Expressionist manner, which was inspired by German Gothic painting. Beckmann enjoyed a successful international career, and held a position as professor at the Städelsche Kunstinstitut in Frankfurt until 1937. On the very day the Nazis opened in Munich the exhibition *Degenerate Art*, which included ten of his paintings, Beckmann emigrated to Amsterdam, where his wife's sister lived. When Holland was occupied by Germany, the family had to lead a difficult underground existence; nonetheless, Beckmann continued to paint and draw prolifically. With the end of the war, Beckmann moved to the United States, and he spent the remaining years of his life teaching and working primarily in Saint Louis and New York.

His boldly figurative works remained compelling to the end, displaying the element that he himself described in 1950 simply as "truth": "The work must emanate truth, truth through love of nature and iron self-discipline."

Beckmann had always had an interest in still lifes as emblems of basic human concerns, and his works in this genre became ever more emphatic as his career developed. Amid the claustrophobic setting and harsh realities of life in

Amsterdam during World War II, the bouquets of flowers assembled by his devoted wife might have proven a welcome relief to the artist, but he invested them with an explosive power. The bold strokes and angular forms suggest a yearning for escape. The black statuette of a camel adds a particularly ominous note.

E.M.Z.

6 PLATE 156

MAX BECKMANN (German, 1884–1950)
Portrait of Euretta Rathbone, 1947
Oil on canvas, 37 x 31 in. (94.5 x 78.5 cm)
Signed and dated at upper right: *Beckmann St. L 47*
Private collection

EXHIBITIONS: City Art Museum of Saint Louis, *Max Beckmann*, 1948, no. 44; City Art Museum of Saint Louis, *Federation Exhibition*, 1949; Saint Louis, Washington University, *Max Beckmann Paintings*, 1950 (no cat.); New York, Catherine Viviano Gallery, *Portraits (1925–1950) by Max Beckmann*, 1957, no. 2; Cambridge, Massachusetts, Fogg Art Museum, *20th-century Germanic Art*, 1961; Karlsruhe, Badischer Kunstverein, *Max Beckmann: Das Portrait*, 1963, no. 58; New York, Museum of Modern Art; Boston, Museum of Fine Arts; and Art Institute of Chicago, *Max Beckmann*, 1964–1965, no. 66; Frankfurter Kunstverein, *Max Beckmann*, 1965, no. 62; London, Tate Gallery, *Max Beckmann*, 1965, no. 65; Nassau County Museum of Art, *Works by Max Beckmann*, 1984–1985.

LITERATURE: Perry T. Rathbone, "Max Beckmann in America: A Personal Reminiscence," in *Max Beckmann* (New York, 1965), p. 130–31; Erhard and Barbara Göpel, *Max Beckmann, Katalog der Gemälde* (Bern, 1976), vol. 1, p. 451, no. 751; vol. 2, pl. 277; *Max Beckmann–Retrospective* (exh. cat., Saint Louis Art Museum, 1984–1985), p. 467.

Through Beckmann's American dealer, Curt Valentin, Perry T. Rathbone, then director of the City Art Museum of Saint Louis, learned of the artist's long-standing desire to come to the United States. Through Mr. Rathbone's influence, Washington University in Saint Louis invited the painter to accept a post in its School of Fine Arts. Beckmann and his wife arrived in that city in September 1947, and received enthusiastic and friendly support from Mr. and Mrs. Rathbone.

The first portrait Beckmann painted in America was that of Mrs. Rathbone. He had her pose in slightly exotic Mexican-style attire. She holds a yellow flower, continuing the association the artist had been making between flowers and attractive women since the 1920s. Beckmann achieved a direct and lively likeness free of the angst of his European works, an accomplishment that seemed to bode well for his American stay. The pristine quality of the paint, especially the purple and yellow tonalities, has been maintained, as this work, following Beckmann's wishes, has never been varnished.

E.M.Z.

7 PLATE 155

MAX BECKMANN (German, 1884–1950)
Portrait of Perry T. Rathbone, 1948
Oil on canvas, 65 x 35⁷⁄₁₆ in. (165 x 90 cm)
Signed and dated at lower right: *Beckmann St. L. 48*
Private collection

EXHIBITIONS: Saint Louis, Washington University, *Max Beckmann Paintings*, 1950; New York, Catherine Viviano Gallery, *Portraits (1925–1950) by Max Beckmann*, 1957, no. 17; Cambridge, Massachusetts, Fogg Art Museum, *20th-century Germanic Art*, 1961; Karlsruhe, Badischer Kunstverein, *Max Beckmann: Das Portrait*, 1963, no. 60; Munich, Haus der Kunst; Berlin, Nationalgalerie; Saint Louis Art Museum; Los Angeles County Museum of Art, *Max Beckmann–Retrospective*, 1984-1985, no. 118.

LITERATURE: Erhard Göpel, *Die Weltkunst* 33 (1963), p. 13, ill.; Charles S. Kessler, *Max Beckmann's Triptychs* (Cambridge, Massachusetts, 1970), fig. 29; Erhard and Barbara Göpel, *Max Beckmann, Katalog der Gemälde* (Bern, 1976), vol. 1, pp. 465–66, no. 773; vol. 2, pl. 284.

Perry T. Rathbone organized a large retrospective exhibition of Beckmann's work at the City Art Museum of Saint Louis in 1948. That show traveled around the United States, adding greatly to the artist's reputation in this country. In gratitude, Beckmann painted this exuberant and jaunty portrait. It not only captures the sensitive and spontaneous personality of the sitter, but also the American openness, which so impressed Beckmann in his last years.

Mr. Rathbone, who was also director of the Museum of Fine Arts, Boston, between 1955 and 1972, wrote (in *Max Beckmann* [exh. cat., New York, Museum of Modern Art, 1964], pp. 130–31):

> To be painted by Beckmann was an experience. As one could imagine, his approach was quite unconventional. It was his habit to make one or two drawings from life but without posing. These he sketched under informal circumstances which he nevertheless arranged. . . . These drawings Beckmann kept. They were his only guide in getting a likeness, except for the visual impressions that he stored up in his mind. While at work on the portrait, he would have made it a point to see his subject at some social gathering where, as a silent observer, sitting apart from the stream of conversation, he would fix his steadfast, almost frightening, gaze upon his subject, studying him in every light, in every mood. . . . Days or possibly weeks later, without ever having shown the painting in its various stages of development, Beckmann would announce that the portrait was done.

E.M.Z.

8 PLATE 157

MAX BECKMANN (German, 1884–1950)
Portrait of Wolfgang Frommel, begun 1945, completed 1949
Oil on canvas, 37⅜ x 22 in. (95.5 x 56 cm)
Signed and dated at upper right: *Beckmann 49*
Private collection

PROVENANCE: The artist's estate; Buchholz Gallery, New York; sale London (Christie's), June 28, 1968, no. 84; private collection, New York.

EXHIBITIONS: Zurich, Kunsthaus, *Max Beckmann 1884–1950*, 1955-1956, no. 137; The Hague, Gemeentmuseum, *Max Beckmann*, 1956, no. 105; New York, Catherine Viviano Gallery, *Portraits (1925–1950) by Max Beckmann*, 1957, no. 11; Karlsruhe, Badischer Kunstverein, *Max Beckmann: Das Portrait*, 1963, no. 62; Wuppertal, *Deutsche Bildnisse*, 1964, no. 5; New York, Catherine Viviano Gallery, *Max Beckmann*, 1973, no. 10.

LITERATURE: B. Reifenberg and W. Hausenstein, *Max Beckmann* (Munich, 1949), no. 576; Erhard Göpel, *Max Beckmann, Die Argonauten Ein Triptychon* (Stuttgart, 1957), pp. 4, 9, and 25; Charles S. Kessler, *Max Beckmann's Triptychs* (Cambridge, Massachusetts, 1970), p. 90, fig. 30; Erhard and Barbara Göpel, *Max Beckmann, Katalog der Gemälde* (Bern, 1976), vol. 1, p. 482, no. 794; vol. 2, pl. 296; *Max Beckmann–Retrospective* (exh. cat., Saint Louis Art Museum, 1984-1985), p. 465, ill.

Among the small circle of friends that Beckmann and his wife were able to establish in Amsterdam, one of the most important was the German writer and poet Wolfgang Frommel (b. 1902). Frommel had studied theology but also became involved with politics as an early opponent of the emerging National Socialist Party. He left Germany in 1937 and settled by 1939 in Amsterdam, where he had to remain in hiding throughout the war. Beckmann and Frommel had many intense conversations during their years in exile, and it has been suggested that the writer's "warm humanity and profound mind may have inspired some of the content in Beckmann's late work" (Peter Selz, *Max Beckmann* [New York, 1964], p. 75). As he often did with his friends, Beckmann began by quietly making studies of Frommel. The writer's portrait, which depicts him in the important role of a priest breaking bread, is one of the four that appear in Beckmann's oddly titled *Les Artistes mit Gemüse* (1943; Saint Louis, Washington University Gallery of Art).

According to Beckmann's *Tagebuch*, his daily diary, he began painting the solo portrait of Frommel on April 30, 1945, and finished it on June 2. When Beckmann showed it to Frommel later that month, the sitter apparently expressed displeasure ("unter Geschrei"), and the artist put it aside. Only in 1949, when he was settled in New York, did Beckmann take up the canvas again, and on September 10 of that year he recorded: "I rescued Frommel from destruction; now I have four really good portraits"; at this time he signed and dated the work.

This is in fact one of Beckmann's most sympathetic male portraits. The traditional meditative gesture of head on hand captures the warm introspection of the man, but is nicely balanced (as in so many of Beckmann's self-portraits) with the modern touch of the cigarette held in the other

hand. Under this hand is a large volume that is appropriately entitled *Orpheus*.

E.M.Z.

9 PLATE 64

CORNELIS BEGA (Dutch, 1631 or 1632–1664)
Peasants in a Tavern, n.d.
Signed at lower left: *Co. Bega*
Oil on panel, 14 x 22½ in. (36 x 57 cm)
Private collection

PROVENANCE: Château de Némiroff (Podolie); Count Grégoire Stroganoff, Rome, by 1910; with dealer Brod, London, 1962; sale London (Sotheby's), July 6, 1988, no. 104, ill. (as "attributed to Bega"); sale London (Sotheby's), May 17, 1989, no. 82, ill.

EXHIBITION: London, Brod Gallery, *Spring Exhibition*, April–May 1962, no. 59.

LITERATURE: Antonio Munoz, *Pièces de choix de la collection du Comte Grégoire Stroganoff*, vol. 2 (Rome, 1911), p. 80, pl. LXI.

Six peasants have gathered around the tables of an inn to play cards and drink. Some gesture animatedly, while others slump in a stupor. A seventh figure stands at the left beside a window, and still another huddles in the shadow at the far right by a hearth. Beneath the lighted window is a pile of simple household objects on the window seat. Above the chest in the center distance are other articles of clothing and spinning equipment.

Adriaen van Ostade is reported to have been Bega's teacher. The latter traveled in Germany and Switzerland and may have visited Italy before joining the Haarlem guild in 1654. An accomplished Dutch painter of low-life genre, Bega began his career working in a style derived from the Ostades, and had developed a more highly finished manner by the early 1660s. This painting is probably a relatively early work, since it employs the horizontal format, relatively broad technique, and loose-jointed, virtually caricatured figure types that Bega favored in the late 1650s; it can be compared, for example, with his earliest dated painting (1658; The Hague, Mauritshuis, no. 400), and an undated painting that sold in Vienna (Dorotheum, September 10–18, 1985, no. 357).

By 1661, he had begun to develop a more polished manner of execution, which probably owed something to the growing popularity of the Leiden *fijnschilders*, and had begun to supplement his low-life subjects with more socially elevated themes, musical companies, and domestic scenes. Bega died in his native Haarlem in 1664, probably from the plague.

P.C.S.

10 PLATE 147

PIERRE BONNARD (French, 1867–1947)
Standing Nude, 1924
Oil on canvas, 51 x 32 in. (129.5 x 81.3 cm)
Stamped (studio) at lower right: *Bonnard*
Private collection

PROVENANCE: Artist's estate (inv. no. 247); Wildenstein and Co.; private collection.

EXHIBITIONS: Tokyo, Nihonbashi Takashimaya Art Galleries; Kobe, Hyogo Prefectural Museum of Modern Art; Nagoya, Aichi Cultural Center; and Fukuoka, Art Museum, *Pierre Bonnard*, 1980–1981, no. 51, ill.; Geneva, Musée Rath, *Pierre Bonnard* (cat. by François Daulte), April 9–June 8, 1981, no. 52, ill.; New York, Wildenstein and Co., *The Inquiring Eye of Pierre Bonnard*, November 6–December 11, 1981, p. 24, no. 32, ill.; Madrid, Fundación Juan March; and Barcelona, Sala de la Caixa, *Bonnard*, 1983–1984, no. 31, ill.; Lausanne, Fondation de l'Hermitage, *L'Impressionnisme dans les collections romandes* (cat. by François Daulte), June 17–October 21, 1984, no. 121, ill.

LITERATURE: Raymond Cogniat, *Bonnard* (Paris, 1968), ill.; Jean and Henry Dauberville, *Bonnard: Catalogue raisonné de l'oeuvre peint, Vol. 3 (1920–1939)* (Paris, 1973), p. 233, no. 1280, ill.; Joseph Clair, *Bonnard* (Paris, 1975), n.p., ill.

Like that of his contemporary and close friend Edouard Vuillard, Bonnard's career began with intimist subjects, scenes of modern domestic life that were influenced by the stylistic precepts of the Nabis group and, in the case of Bonnard, by Japanese prints and Art Nouveau. His palette lightened appreciably in the second decade of the twentieth century, and experimentation with coloristic effects emerged as a central concern.

About the same time, the female nude, especially the theme of the woman at the bath, gained importance in Bonnard's oeuvre. Compositionally indebted to Degas's late bathers, which were on view in Paris during that artist's studio sale in 1917, and sharing their unself-conscious focus on the task, Bonnard's bathers likewise capture the awkwardness of everyday motions seen from unusual angles. With Bonnard, however, the effect is not one of voyeurism, but rather, one of intimate domesticity. That his longtime companion, Marthe, who he would marry in 1925, was invariably the model for these scenes accounts for their intimacy and casual familiarity. Considered by friends to be introverted and somewhat obsessed with her personal health and cleanliness, Marthe certainly had Bonnard's enduring love, which is so evident in the seemingly endless variations he painted of her lithe and graceful form as she performed her daily routines.

The present example dates from the later phase of Bonnard's career. Nothing mundane remains in his treatment of this everyday subject. The symbolist and classicizing elements, subdued in his early work, emerge here in full force. A standing nude with the presence of archaic sculpture and near-life-size proportions faces the viewer directly, offering the unnerving vision of a well-lit statuesque body topped by a face sunk in shadow. Her exact activity is unclear. She stands in an empty tub; both arms are bent and raised, but she holds no towel or soap. Two plates, on the floor behind her, float forward like orbs in space, adding to the steep perspective of the foreground space.

The setting bears a marked resemblance to an actual room, which was recorded in a photograph, taken by Bonnard about 1908, of Marthe kneeling in a tub. Typically, the artist altered the wallpaper, floor, and fabric patterns. The dialogue between indoor and outdoor space, which so often was a component of Bonnard's late work, is here distilled to a vignette; a strong golden light filters through elegant branches in the window behind Marthe's head, both framing and obliterating her face, leaving it a near silhouette.

Bonnard painted two variations of the present composition, both with the weight on the opposite leg (see Dauberville 1973, vol. 3, no. 1279; and vol. 4, no. 02166). A variant with Marthe kneeling in the tub (as in the photograph) is in a private Swiss collection. Cogniat assigned to the present version a date of 1920, which the Daubervilles revised to 1924.

P.S.

11 PLATE 117

LOUIS EUGÈNE BOUDIN (French, 1824–1898)
Portrieux, Low Tide, 1869
Oil on canvas, 15¾ x 25⅝ in. (40 x 65 cm)
Signed and dated at lower right: *E. Boudin 69*
Private collection

PROVENANCE: Collection M. de Villars, Paris; sale De Villars, Paris (Hôtel Drouot), May 1, 1874, no. 4 (for Fr 440); sale Paris (Hôtel Drouot), November 25, 1898, no. 2; collection Aghion, Paris; sale Aghion, Paris (Hôtel Drouot), March 29, 1918 (for Fr 2400, to Durand-Ruel); sold by Galerie Durand-Ruel, Paris, to A. Tooth & Sons, London, on November 20, 1934; collection The Hon. Earl of Crawford and Balcarres, Salisbury; Lock Galleries, New York; sale New York (Christie's), May 16, 1985, no. 309, ill. (bought in).

EXHIBITIONS: Cambridge, Massachusetts Institute of Technology, Charles Hayden Memorial Library, *From Private Collections of M.I.T.*, 1967 (lent by Mr. and Mrs. John Wilson); Boston, Museum of Fine Arts (on loan), 1968; Peabody Museum of Salem, *Boudin: Impressionist Marine Paintings* (cat. by Peter C. Sutton), 1991, no. IX.

LITERATURE: Robert Schmit, *Eugène Boudin* (Paris, 1973), vol. 1, no. 473, ill.

Five partially dismasted vessels lie aground at low tide in the little harbor of Portrieux, on the north coast of Brittany; they are separated from the viewer by a thin strip of sand in the immediate foreground. The somber, slate blue tonality perfectly captures the coastal atmosphere at nightfall on an overcast day. The village of Portrieux, near Saint Brieuc and Saint Quay, was known for its port of refuge as well as its good sea-bathing — a feature that Boudin depicted in several of his *plage* (shore) scenes.

Born into a family of modest means, Boudin worked for several years in a stationery and art supply store in the port city of Le Havre. In 1851 he received a three-year stipend from that city to study art in Paris. He returned to his

native Honfleur in 1854 and began to devote himself to marine paintings and coastal views. Throughout his career he traveled extensively along the coasts of Normandy and Brittany, and he gained particular renown for his scenes of the fashionable beach resorts of Trouville and Deauville. He was friends with the painters Jean-François Millet, Johan Barthold Jongkind, Camille Corot, and Gustave Courbet, among others, and from 1858 was the friend and mentor of Claude Monet.

Portrieux, Low Tide was painted during the summer of 1869, on Boudin's first visit to the town from his studio in Paris. The artist was clearly fascinated by the effect of the tilting silhouettes of the boats, with their slender masts and weblike rigging, looming before an ever-changing sky. He returned to Portrieux in 1873 and painted nearly twenty more closely related images of similar vessels, mostly beached or lying aground, under lighting conditions that ranged from daylight to twilight and even moonlight (see Schmit 1973, vol. 1, nos. 913–33). When, in 1874, Monet organized the first of the seven exhibitions that served as public presentations of the Impressionist movement (but that included a stylistically diverse group of artists), two of the three paintings submitted by Boudin were of Portrieux. Although Boudin never again exhibited with the Impressionists, he returned to Portrieux repeatedly, visiting at least as late as 1879.

M.E.W.

12 PLATE 118
LOUIS EUGÈNE BOUDIN (French, 1824–1898)
La Rade de Villefranche (View from the Roadstead outside Villefranche), 1892
Signed and dated at lower right
Inscribed at lower right: *Villefranche*
Oil on canvas, 19 x 30 in. (48.2 x 76.2 cm)
Private collection

PROVENANCE: Acquired by the present owner's grandfather from Galerie Durand-Ruel, Paris, in 1892.

Steep headlands rise above the mouth of the Mediterranean port of Villefranche. On the right are houses, in the distance are tall-masted ships, and nearer by is a rowboat. The sky is overcast but bright.

Early in his career Boudin had struggled, but by about 1875 had become an established and successful painter of marines. He first visited the Mediterranean coast in 1885 and returned regularly thereafter, during the 1890s spending his winters in the Midi depicting sites in and around Antibes, Beaulieu, Nice, Juan-les-Pins, and Villefranche, which is adjacent to Nice and Monaco. The artist first sojourned there in 1885 and returned several times between 1890 and 1894, devoting special attention to the stone quay, harbor, citadel, and mountainous environs in 1892. Four of Boudin's six sub-

missions to the Paris Salon of that year depicted Villefranche; one of them was purchased by the state. Reviewing that Salon in *La Vie Artistique*, the critic Gustave Geffroy wrote that Boudin executed his paintings of Villefranche in "the subtle style of patches of color bathed in a gray light that is characteristic of the artist."

This unpublished painting is very close in design and point of view to two other views of the harbor which are also dated 1892 (Nice, Musée Massena; and private collection, respectively; R. Schmit, *Eugène Boudin* [Paris, 1973], vol. 2, nos. 2895 and 2880). The painting was acquired from Boudin's dealer, Durand-Ruel, by the grandfather of the present owner in the year of its execution.

P.C.S.

13 PLATE 119
LOUIS EUGÈNE BOUDIN (French, 1824–1898)
Marée Basse à Sainte-Adresse. Soleil Couchant
(*Low Tide at Sainte-Adresse, Sunset*), 1894
Oil on panel, 13 x 18 in. (32.5 x 45.7 cm)
Signed and dated at lower right: *E. Boudin '94*
Private collection

PROVENANCE: Dealer A. Tooth & Sons, London; private collection, London.
LITERATURE: Robert Schmit, *Eugène Boudin* (Paris, 1973), vol. 3, p. 258, no. 3281, ill.

In the present work, a panoramic view of sunset at the seashore, with the sun at the very center, the horizon line bisects the scene just below the midpoint. In the foreground the low tide has left three vessels stranded. The artist recorded the blackened rocks and sands of the exposed shore with rapid shorthand strokes, cursorily indicating a few figures on the beach. The grayish waters support the silhouettes of sailing vessels. Overhead, the sky is a blaze of purple and hot orange, colors reiterated by the sparkling reflections in the shallows below.

The son of a sailor, Eugène Boudin was an acute observer of the changing maritime sky. His earliest journals are filled with meteorological notations about the changing hues and values of the sky and the sea. In the 1850s he began executing, in addition to written records, brilliantly colored pastels in which he sought to capture the most ephemeral effects of weather and the sea, often noting the day, hour, height of the sun, direction of the wind, and other such details on the backs or in the margins. When Boudin first exhibited his work, at the Paris Salon of 1859, the prescient critic Charles Baudelaire used the artist's official submission (a rather labored and halting piece depicting a pilgrimage scene) as an excuse to discuss his remarkable but as yet unexhibited pastels. Indeed, Baudelaire brought the full force of his poetry to the celebration of Boudin's ability to "understand what would seem beyond comprehension," namely, the constantly mutable sea and sky.

Though executed more than thirty years earlier, many of these early pastels were, like the present painting, "wingless" panoramic views of the ocean horizon. Boudin had executed at least one panoramic marine in oils in 1860 (see Schmit 1973, no. 212) and had painted a handful in the 1860s and 1870s (see, for example, Schmit 1973, nos. 866 [dated 1873] and 1150 [dated 1876]) but he did not paint pure panoramas consistently or in any numbers until 1880 (see Schmit 1973, nos. 1284–1287; see especially *The Sunset*, no. 1286 [dated 1880]). On the other hand, his close friend Gustave Courbet had been executing such scenes since 1854 and made a specialty of them about 1865 (see cat. 33). (In 1859 Courbet had sought out Boudin and had introduced him to Baudelaire.) Boudin never attempted works of this type on the scale or with the symphonic grandeur of Courbet's marines from the Trouville period, but the former's works have a very different effect, subtler and more intimate. In part this may have been a matter of diverging artistic personalities. The two friends could scarcely have been more different temperamentally — Boudin diffident and self-doubting, Courbet confidently egotistical and aggressively self-promoting. It is difficult to say what role Boudin may have played in influencing the atmospherics, if not the designs, of Courbet's maritime sunsets, since the former felt prepared to take up such subjects in paint only at an advanced point in his career, and then only on a self-effacingly intimate scale. His reticence is regrettable, since he brought the subtlest eye to meteorological niceties, a responsiveness that puts the lie to the modern assumption that all sunsets are pictorial clichés.

P.C.S.

14 PLATE 59
QUIRIJN VAN BREKELENKAM (Dutch, about 1620–1668)
A Lady with a Lute Player, 1662
Oil on panel, 15¾ x 11¾ in. (40 x 30 cm)
Monogrammed and dated
Private collection

PROVENANCE: Private collection, England; with Johnny van Haeften, London.

LITERATURE: Johnny van Haeften, *Dutch and Flemish Old Master Paintings*, (London, n.d.), n.p., no. 3, ill.

Quirijn van Brekelenkam was a founding member of the Saint Luke's Guild in Leiden in 1648 and was active in that city until his death in 1668. He specialized in cabinet-sized genre scenes, with works dated as early as 1644 (Rijksdienst Beeldende Kunst, inv. no. NK2924); however, the majority of his paintings date from the 1650s and 1660s. Most are interior genre scenes depicting middle-class workers (tailors, cobblers, tinkers, spinners, seamstresses, apothecaries, barber-surgeons, bloodletters, fishmongers, greengrocers, and so forth) or quiet domestic views. High-life subjects such as the present work are not so numerous in his oeuvre, but

increase in number after about 1661 (compare, for example, *Couple Drinking* [dated 1661], sale Magin, Paris, June 23, 1922, no. 9). Depicting an interior with a woman viewed full length and in profile seated at a table with a gentleman, this painting may be compared to the artist's so-called *Sentimental Conversation* (New York, Metropolitan Museum of Art, no. 32.100.19). It also resembles in style and conception two other paintings also dated 1662, *Couple Playing Cards* (Braunschweig, Herzog Anton Ulrich-Museum, no. 312) and *Toilette Scene* (Stockholm, National Museum, no. 358).

Brekelenkam's colleagues in Leiden, Gabriel Metsu (see F. Robinson, *Gabriel Metsu* [New York, 1974], p. 171, pls. 121 and 121a) and Frans van Mieris (dated 1663; see O. Naumann, *Frans van Mieris* [Doornspijk, 1981], cat. I 54) as well as Caspar Netscher (dated 1666; Wuppertal, Van der Heydt Museum) depicted elegant women with parrots in these years, and Jacob Ochtervelt (see S. D. Kuretsky, *The Paintings of Jacob Ochtervelt* [Oxford, 1979], cat. 74) and Pieter de Hooch (see P. C. Sutton, *Pieter de Hooch* [Oxford, 1980], cats. 102 [dated 1673] and 122) took up the theme in the 1670s. Parrots were above all elegant and costly pets whose presence in a genre scene underscored the rich surroundings. Like other birds, they also could have amorous or erotic associations (see E. de Jongh, "Erotica in Vogelperspectief," *Simiolus* 3 [1968–1969], pp. 43–47). The woman who holds the parrot wears an apron, suggesting that she has interrupted her domestic tasks in order to partake of the glass of wine on the table (the jug is on the floor) and to enjoy the music. Nothing in her still demeanor or in the self-absorbed concentration of the lutenist suggests that the scene is a prelude to romance. Nor is her drinking conspicuously excessive (compare the slumbering sot in Brekelenkam's so-called *Tired Drinker*, which was with the dealer Hoogsteder, The Hague, 1986, when it was exhibited in *Holland im Engadin*, no. 12).

P.C.S.

15 PLATE 87
NICOLAS-GUY BRENET (French, 1728–1792)
Bacchus and Ariadne, 1764
Oil on canvas, 25⅝ x 32⅛ in. (65.1 x 81.6 cm)
Signed and dated at lower left: *Brenet. / fecit.1764*
Private collection

A contemporary of Fragonard's, Brenet also received his early training in the studio of Boucher. As was the practice among promising students of his day, Brenet then enrolled at the Ecole des Elèves Protégés, where he studied for three years under the tutelage of Carle Van Loo and Michel-François Dandré-Bardon. Sponsored by the crown, Brenet left for Rome in 1756 along with his brother, André Brenet, the sculptor, and spent three years there at the French Academy, painting academic studies and copying earlier masters.

After Brenet returned to France, his style began to evolve away from the lively and playful Rococo of Boucher and toward a more serious approach to history painting which emulated the static monumentality of the grand tradition of Poussin and the Bolognese school.

In 1763, Brenet began exhibiting at the Salons held biannually at the Louvre, and submitted his reception piece, *Theseus Receiving the Arms of His Father* to the Royal Academy of Painting and Sculpture in 1769. In addition to filling numerous provincial church commissions, the artist played an important role in the revival of history painting being promoted by D'Angiviller, the king's *directeur des bâtiments*, through a series of large-scale public commissions. Brenet's *Death of Du Guesclin*, which was exhibited in the Salon of 1777, is an early example of the type of French national subject that began to gain favor, in the last decades of the eighteenth century, over subjects drawn from antiquity. The high degree of finish and the attention to accuracy in costume and setting that appear in Brenet's work toward the end of his career have been seen as anticipating the troubadour painters of the following century (see entry by Guy Stair Sainty in *François Boucher: His Circle and Influence* [exh. cat., New York, Stair Sainty Matthiesen, 1987, no. 68]).

The present canvas shows Brenet still somewhat under the stylistic sway of Boucher and working in the palette of the high Rococo: faded pastels dominated by blue-green. The theatricality of gesture and posture combined with the static monumentality of the figural arrangement and the closeness of the figures to the picture plane are typical of Brenet's individual approach and indicative of the direction his work was taking. His technique at this point still evoked the handling of Boucher and Pierre, but with the impasto smoothed and flattened, and the brushwork less broad.

Bacchus, the god of the vine, discovered Ariadne, the daughter of King Minos of Crete, on the island of Naxos, where she had been abandoned by Theseus after aiding his escape from the Labyrinth. Venus had hoped to relieve Ariadne's suffering by sending her an immortal lover. Bacchus's marriage gift to Ariadne was a golden crown set with jewels, which he threw into the sky upon her death, forming the constellation of the Corona Borealis. Brenet chose to depict not the more typical scene of discovery, but rather the sentimental moment, often preferred by eighteenth-century sensibilities, of Bacchus's profession of love as he kneels before Ariadne while a putto places a crown of stars on her head. Bacchus's staff and a bunch of grapes lie on the ground before him; his chariot and entourage can be seen in the left middle ground. The sea, at right, with the still-visible sails of Theseus's departing fleet, is loosely painted, its churning quality recalling the desolation just felt by Ariadne, who was abandoned in this rocky and inhospitable place.

P.S.

16 PLATE 21

HENDRICK TER BRUGGHEN (Dutch, 1588–1629)
Unequal Lovers, about 1623
Oil on canvas, 29¼ x 34½ in. (74.3 x 89.2 cm; the corners clipped)
Monogrammed on base of pewter vessel at right
Private collection

PROVENANCE: Major H. M. Salmon, Tockington Manor, near Bristol; sale London (Christie's) October 4, 1946, no. 33 (as Caravaggio, *Susanna and the Elders*); Arcade Gallery, London; Claes Philip, Stockholm, 1958; sale London (Christie's), July 8, 1983, no. 91; with Stanley Moss, New York; Shearson Lehman; acquired from Stanley Moss.

EXHIBITION: Utrecht, Centraal Museum; and Braunschweig, Herzog Anton Ulrich-Museum, *Nieuw Licht op de gouden eeuw. Hendrick ter Brugghen en tijdgenoten* (cat. by Albert Blankert and Leonard J. Slatkes), 1986–1987, no. 14, ill.

LITERATURE: Benedict Nicolson, *Hendrick Terbrugghen* (London, 1958), pp. 94–95, cat. A64, ill. 88 (1625–1628); Horst Gerson, Review of Nicolson's *Hendrick Terbrugghen*, *Kunstchronik* 12 (1959), p. 318 (about 1623); Benedict Nicolson, "Second Thoughts about Terbrugghen," *Burlington Magazine* 102 (1960), p. 469; Leonard Slatkes, in *Hendrick Terbrugghen in America* (exh. cat., Dayton Art Institute, 1965; and Baltimore Museum of Art, 1966), p. 16; P. J. J. van Thiel, "De Aanbidding der Konigen en ander vroeg werk van Hendrick ter Brugghen," *Bulletin van het Rijksmuseum* 19 (1971), p. 102 (1628 or 1629); Benedict Nicolson, *The International Caravaggesque Movement* (Oxford, 1979), p. 100; Benedict Nicolson, *Caravaggism in Europe* (2nd, expanded ed. of *The International Caraveggesque Movement*), 3 vols. (Turin, 1989), vol. 1, p. 195; vol. 3, ill. 1179.

Hendrick ter Brugghen was the most innovative Dutch follower of Caravaggio, to whom this painting was once attributed. Its type of design, with half-length, life-size genre figures, was popularized by the Italian artist. The canvas unfortunately has been cut diagonally at all four corners, along the bottom edge, where the surface had been overpainted (see the old state illustrated in Nicholson 1958, ill. 88), and possibly also, to a lesser extent, on the three other sides, but it still presents the essence of ter Brugghen's original design. Its densely compacted composition, with figures crowding the picture plane, resembles the artist's *David Saluted by Woman* (Raleigh, North Carolina Museum of Art). The partially obliterated date on the latter painting is probably 162(3) rather than 162(8), as was once assumed, and thus may provide an approximate date for this painting as well.

X-rays of the present picture indicate that the man at the left originally wore a turban, which, as Slatkes (1965, p. 16) observed, strengthens the design's connection to both a drawing (Amsterdam, Rijksprentenkabinet) and a lost painting of *Judah and Tamar* by ter Brugghen's colleague in Utrecht, Dirck van Baburen. However, the final subject of ter Brugghen's painting is surely secular, rather than biblical or historical. As Nicholson (1959, p. 318) observed, it is probably a variation on the time-honored theme of Unequal or Ill-Assorted Lovers, which alternatively pairs an old man with a young woman or an old woman with a young man, usually with an exchange of money or treasure sealing their

relationship (see Allison Stewart, *Unequal Lovers: A Study of Unequal Couples in Northern Art* [New York, 1977]; and Konrad Renger, "Alte Liebe, gleich und ungleich," in *Netherlandish Mannerism* [Stockholm, 1985], pp. 35–46). In this painting, the woman may have originally been holding a coin or other valuable object in her left hand, which has since been cut and was previously disguised by overpaint.

In discussing the theme of Unequal Lovers, Slatkes (1965, p. 16) observed that the old man's hair is brown but his beard is gray, and assumed that the former had been dyed to effect a more youthful appearance. However, close examination of the man's face, especially his eye socket, reveals that he is actually wearing a hook-nosed mask to which has been attached the gray beard — a type of disguise familiar from contemporary images of commedia del'arte figures (compare to Sarasota, Florida, Ringling Museum, no. 688; or the many widely circulated prints by Callot, Jacques de Gheyn, and Chrispijn de Passe). Figures wearing commedia del'arte costumes often mingled with figures in customary attire in genre scenes of merry companies from this period by, among others, Pieter Codde and Willem Duyster. In Caspar Netscher's later painting *A Masquerade* (1668; Kassel, Gemäldegalerie, no. 292), the humorously licentious behavior of these characters is underscored by a huge, phallic sausage held by one of the bearded maskers. Thus, ter Brugghen, in characteristically creative fashion, offered an original interpretation of a traditional theme by adding the dimension of the man's playful adoption of a persona: the viewer gradually realizes that, like his amused and compliant consort, the masker is actually a young man who only adopts the guise of the old lecher.

P.C.S.

17 PLATE 84

GIOVANNI ANTONIO CANAL (called Canaletto; Italian, 1697–1768)

Capriccio of a Pavilion with a Ruined Arcade and Colonnade on the Lagoon, 1754
Oil on canvas, 20 x 33½ in. (51 x 85 cm)
Morrison Collection

PROVENANCE: Henry Graves & Co., London, 1874; Robert Townley Parker; inherited by R. A. Tatton, Cuerdon Hall, Preston; sale London (Christie's), December 14, 1928, no. 42; purchased by Arthur Tooth & Sons, London (listed as by Bernardo Bellotto); sale London (Christie's), June 18, 1954, no. 59; Mortimer Brandt, by March 5, 1955; purchased from Mr. Brandt by Mrs. Thomas Morrison, New York, 1955; sale New York (Sotheby's), May 30, 1991, no. 64, ill.

LITERATURE: Stefan Kozakiewicz, *Bernardo Bellotto* (Greenwich, Connecticut, 1972), vol. 2, pp. 487–88, no. z 397 (as once incorrectly attributed to Bellotto); William L. Barcham, *The Imaginary View Scenes of Antonio Canaletto* (Ph.D. diss., New York University, 1974; London and New York, 1977) pp. 171–73; Lionello Puppi, *The Complete Paintings of Canaletto* (New York, 1968), p. 118, no. 312; André Corboz, *Canaletto: Una Venezia immaginaria* (Milan, 1985), vol. 1, p. 323, vol. 2; p. 724, no.

P 434; W. G. Constable, *Canaletto: Giovanni Antonio Canal 1697–1768*, 3rd ed., rev. by J. G. Links (Oxford, 1989), vol. 1, p. 147; vol. 2, p. 468, no. 512.

In this imaginary landscape, architectural remnants of diverse periods and styles are juxtaposed in a setting reminiscent of the Venetian lagoon. The once-grand but now-crumbling and overgrown buildings of the past form a backdrop for the bustling day-to-day life of the peasants and merchants who inhabit the outer reaches of the lagoon. A ramshackle brick house has been erected atop a Renaissance pavilion at the right. Washerwomen hang their laundry to dry on a ruined Antique arcade, whose function has been usurped by a rickety wooden bridge. The ruins of a colonnade at left complete this improbable combination of structures. In the distant background a stone tower and the fanciful dome of a church can be partially seen. As Barcham has noted, Canaletto's "lagoonscapes" concentrate on the immediate foreground. The only recession into space is the small glimpse of open sea framed by the archway of the arcade.

On the back of the lining canvas, an old inscription, apparently copied from the original canvas, reads "1754 Io Antonio Canaleto Pinx V. invenzione." In 1754 Canaletto was in both Venice and London; however, the provenance would argue in favor of the work having been painted in England. Canaletto made several extended trips to England between 1746 and 1756 in search of patrons. Foreign, especially English, tourists had constituted the bulk of Canaletto's clientele in Venice prior to the war of the Austrian Secession, an event that dramatically reduced such travel.

Canaletto's English production ranged from accurate topographical views to highly imaginative and occasionally bizarre capriccios. The best known of the English capriccios, the "Lovelace Capriccios," date to this same period of Canaletto's final English sojourn. Views of ruined antiquity put to plebeian use were popular throughout Europe in the eighteenth century. The juxtaposition of ancient, now decaying grandeur with the humdrum daily activities of the present were considered suitably melancholic.

An autograph replica of the present canvas is listed by Constable (1989, vol. 2, p. 468, under no. 512) as being in the United States. A variant that omits the left third of the composition exists in four versions, including one in the Baltimore Museum of Art (see Constable, 1989, vol. 2, pp. 467–68, nos. 511 and 511 a–c). The abbreviated form of the composition is also known through two wash drawings: one was reproduced by Constable (1989, vol. 2, p. 608, no. 823, as present owner unknown), and another was recently offered at Sotheby's, New York (January 14, 1992, no. 63).

In excellent condition, the present canvas is a glowing example of Canaletto's imaginative late capriccios. The luminosity of the golden masonry warmed by late afternoon sun against the pink clouds and the still water of the lagoon imbue this improbable scene with a lifelike quality rarely seen in the work of Canaletto's contemporaries. Canaletto's talent at

depicting light was remarked upon early in his career by the painter Alessandro Marchesini in correspondence in which he was offering advice to Stefano Conti, a painting collector in Lucca who wanted to buy Venetian views. Marchesini wrote that there was a "Sigr. Antonio Canale, who astounds everyone who sees his work in this city — it is like that of Carlevarijs, but you can see the sun shining in it" (quoted in Francis Haskell, *Patrons and Painters* [London, 1963], p. 228).

P.S.

18 PLATE 9

SIMONE CANTARINI (called Il Pesarese; Italian, 1612–1648)
The Risen Christ, about 1637
Oil on canvas, 88 x 70½ in. (223.5 x 179 cm)
Azita Bina-Seibel and Elmar W. Seibel

PROVENANCE: Hercolani family, Bologna, 1812 (?); private collection, Bologna; sale London (Sotheby's), December 10, 1980, no. 74; private collection, New York; sale London (Christie's), April 11, 1986, no. 72.

EXHIBITION: Washington, D.C., National Gallery of Art; New York, Metropolitan Museum of Art; and Bologna, Pinacoteca Nazionale; *The Age of Correggio and the Carracci*, 1986–1987, no. 132.

LITERATURE: Andrea Emiliani, *Mostra di disegni del seicento emiliano* (Milan, 1959), p. 32; Mario Mancigotti, *Simone Cantarini, Il Pesarese* (Pesaro, 1975), p. 266; Anna Colombi Ferretti, "Simone Cantarini: Della marca baroccesca alla bassa padanai," *Bolletino d'arte* 13 (1982), pp. 31–33, fig. 10; Paolo Bellini, *Simone Cantarini: Disegni, incisioni* (exh. cat., Comune di San Severino Marche, 1987), p. 61; Andrea Czére, *Disegni di artisti Bolognesi nel Museo delle Belle Arti di Budapest* (Bologna, 1989), p. 110.

In his native Pesaro and the surrounding Marches, Cantarini absorbed both the late Mannerist style and the new tendencies of naturalism emanating from Rome and the classicism from Bologna. He may also have visited Venice before going to Bologna about 1634 in order to study with the leading painter of that city, Guido Reni, whose important altarpiece had been installed in the Cathedral of Pesaro in 1632. Although Cantarini learned much in terms of composition and brushwork from Reni, the two artists were temperamentally at odds, and after a quarrel the younger master was expelled from the workshop. By 1639 Cantarini was in Pesaro, and then he worked in Rome. He returned to Bologna following Reni's death in 1642, and at the end of his own short life was in Verona.

This painting of the Resurrection of Christ, one of the most magnificent of all Cantarini's works, stems from his first Bolognese period, during which he assimilated the manner of Reni. The large recumbent figures in the foreground and the beautiful, heroic body set against a darkening sky streaked with long, white clouds recall such early Reni masterpieces as *David Slaying Goliath* (Lodi Collection) and *The Triumphant Samson* (Bologna, Pinacoteca Nazionale). The most obvious source of inspiration for the subject, however, came from Annibale Carracci's *Resurrection*, which was then in Bologna and is now in the Louvre. From this master, Cantarini borrowed motifs such as the right hand of Christ held

out to reveal the wound of the Crucifixion and the prominent helmets of the sleeping soldiers. As can be seen in preparatory drawings (in Milan, Naples, Venice, Stuttgart, and Budapest), Cantarini, in developing the composition, modified it greatly. He eliminated many of Annibale's subsidiary figures, relying on only one awakened soldier to witness the miracle. Cantarini also eliminated the entire heavenly host. Rather than seeming to stand upon the ground, Christ here actually flies through the air. This and the outward, rather than upward, direction of Christ's gaze endow Cantarini's painting with a remarkable immediacy. Holding his triumphant banner in a slightly awkward backward grip, Christ rises against the blue background to boldly confront the viewer, proclaiming in exuberant fashion the miracle of the Resurrection.

Cantarini's noble composition was itself to influence the treatment of the theme by later Bolognese painters, such as Giuseppe Maria Crespi and Ubaldo Gandolfi.

E.M.Z.

19 PLATE 138

MARY CASSATT (American, worked in France; 1844–1926)
Reine Lefebvre with a Blonde Baby and Sara Holding a Cat, about 1902
Pastel on paper, 31½ x 25¼ in. (80 x 64 cm)
Signed and inscribed at lower right: *à Mons. Vollard / avec mes compliments / Mary Cassatt*
Private collection

PROVENANCE: Ambroise Vollard, Paris; Paul Rosenberg & Co., New York; Mr. and Mrs. Sidney Rabb, Boston.

EXHIBITION: Waltham, Massachusetts, Brandeis University, *Boston Collects Modern Art*, 1964, cat. 13.

LITERATURE: Adelyn Dohme Breeskin, *Mary Cassatt: A Catalogue Raisonné*, (Washington D.C., 1970), p. 163, no. 404.

A dark-haired woman in a crimson dress cradles in her left arm a nude baby with blonde hair. The rosy-cheeked infant sits in a three-quarter view facing left, with her left arm placed behind her back. Both look down at an older girl, who is dressed in a yellow frock and carries a gray-striped cat in her right arm. The three figures are placed before a stark green background, which is highlighted with strokes of yellow and orange near the top edge of the composition.

Although born in the United States, Mary Cassatt was a member of the Impressionist movement in Paris during the 1870s and 1880s. Initially introduced to the circle of artists by Edgar Degas in 1877, Cassatt adapted the brilliant color and painterly technique of Impressionism to her personal style. As a female artist in fin-de-siècle France, Cassatt did not have access to the usual subjects depicted by "modern" nineteenth-century painters. Images of contemporary urban life were considered unacceptable motifs for women artists; thus, Cassatt concentrated on subjects closer to her own experience, primarily images of women in both public and private as-

pects of Parisian life. She began her studies of mothers and children in the early 1880s, and reworked the theme throughout her career. These endlessly repeated and varied images of maternity have since been transformed into depictions of secular madonnas for the modern age.

In 1901 Cassatt employed the young Reine Lefebvre to pose for her as a model. She began a series of mother-and-child images featuring Reine, usually carrying a nude baby with blonde hair. By 1902 Cassatt had added a third figure to the composition, as seen in the present pastel (see Breeskin 1970, nos. 398–406). As Cassatt explored the image throughout that year, she concentrated on the figures of Reine and the baby. Simple sketches of the heads of the two models exist, as well as completed oil paintings (see *Reine LeFebvre Holding a Nude Baby*, Worcester Art Museum); the artist also produced a smaller drawing of the nude baby with a similar pose and expression (*Little Eve*, Seattle, Charles and Emma Frye Art Museum). However, none of these early variations includes the older girl with the cat. The model for the older girl in this pastel, who is identified simply as Sara, posed for Cassatt in other works made in the early 1900s, but never again in this particular design of three figures. In 1908, Cassatt returned to the theme of Sara holding the cat in both a pastel and an oil painting, but did not include the figures of Reine and the baby.

Cassatt inscribed the painting to Ambroise Vollard, an influential and successful Parisian gallery owner (see cat. 156), who promoted and sold works by artists such as Cézanne, Gauguin, and Picasso. With the help of Degas, who occasionally made suggestions to the dealer, Cassatt sold many works to Vollard throughout her career.

K.R.

20 PLATE 137

MARY CASSATT (American, worked in France; 1844–1926)
Simone in a Plumed Hat, about 1903
Pastel over counterproof, 24 x 19¾ in. (61 x 50 cm)
Scott M. Black Collection

PROVENANCE: Sold by the artist to Ambroise Vollard, Paris; Arthur Tooth & Sons, London; A. Chester Beatty, Jr., 1954; sale London (Sotheby's), June 25, 1991, no. 2.

EXHIBITION: Liverpool, Walker Art Gallery, *American Artists in Europe, 1800–1900*, 1966–1967, no. 26.

LITERATURE: Adelyn Dohme Breeskin, *Mary Cassatt: A Catalogue Raisonné*, (Washington D.C., 1970), p. 174, no. 446.

Seated in an oversize armchair, a young blonde girl looks to the right. Dressed in a white frock, her small frame is overshadowed by a large and extravagant blue hat with a bow tied around her neck. A tan pillar stands behind her at the right, and at the left the yellow-orange upholstery of the chair contrasts sharply with the cool hues of her apparel.

In 1903 and 1904, Mary Cassatt produced numerous portraits of the young model Simone. She is usually depicted alone, dressed in luxurious outfits and hats which create a dichotomy between her obvious youth and her apparent wealth. In this instance, Simone fills the image, revealing little of her surroundings. The background is occluded, with the pillar and armchair serving as sole indicators of her interior location. Cassatt focused on Simone's face, recording its features in careful detail. Her technique became sketchier around the head, particularly toward the bottom edge.

Cassatt favored four- or five-year-old children as models because she reportedly felt they were better able to keep still and were easier to manage than younger children. As she wrote to her great patron and friend Mrs. H. O. Havermeyer in 1909: "It is not worthwhile to waste one's time over little children under three who are spoiled and absolutely refuse to allow themselves to be amused and are very cross" (quoted in E. John Bullard, *Mary Cassatt: Oils and Pastels* [New York, 1978], p. 74).

In 1903 the Parisian art dealer Ambroise Vollard offered to buy a selection of Cassatt's pastels of young girls, provided she would agree to make counterproofs of them. Such sketches were very popular at the turn of the century, as evidenced by Vollard's interest in increasing their numbers. Counterproofing duplicates a pastel in reverse by placing a damp sheet of paper on top of the original and passing both sheets through a printing press. A portion of the pastel medium on the original is transferred onto another sheet, creating a similar, but reversed, image. Cassatt's pastel strokes typically began at the upper right and moved diagonally downward to the lower left, whereas in a counterproof this direction was reversed. According to Breeskin (1970, pp. 18–19), Cassatt agreed to produce counterproofs of thirteen of her pastels, including two others depicting the same model (*Simone in a White Bonnet with Clasped Hands*, original: location unknown; counterproof: Kalamazoo, Michigan, private collection); *Simone in a Large Plumed Hat, Seated, Holding a Griffon Dog* (original: Paris, private collection; counterproof: Belgrade, National Museum).

Vollard also seems to have persuaded Cassatt to rework passages in the original which were effaced in the process of creating the counterproofs, and to retouch the counterproofs themselves. It appears that Cassatt reinforced the present counterproof. On close examination, the brilliant strokes of white and blue in Simone's dress and the vibrant yellow-orange marks on the upholstery of her chair seem to be additions. Changes are also evident in the figure's face and in the dark outlines of the chair and architecture behind her.

In Breeskin's catalogue raisonné (1970), the provenance of the counterproof was listed incorrectly in the catalogue entry for the original pastel. The original version of *Simone with a Plumed Hat* (location unknown until recently) is currently in the Allen Collection, New York. A second counterproof also surfaced (sale New York [Christie's], November 15, 1988, no. 13; present location unknown) which differs from the

first impression in both the quality of line and the amount of pastel added during retouching.

K.R.

21 PLATE 5

GIUSEPPE CESARI (called Il Cavaliere d'Arpino; Italian, 1568–1640)
Entombment of Christ, about 1615
Oil on canvas, 23½ x 28½ in. (59.7 x 72.4 cm)
Collection of Joan Nissmann and Morton Abromson

PROVENANCE: Carlo Sestieri, Rome; Mr. and Mrs. Paul Ganz, New York.
LITERATURE: Herwarth Röttgen, *Il Cavalier d'Arpino* (Rome, 1973), p. 123.

Giuseppe Cesari, better known as Il Cavaliere d'Arpino, after his native town, was born in 1568. In 1582, he traveled to Rome, where, over the course of the next forty years, he participated in the decoration of important Roman churches and palaces. His achievements include the mosaics in the cupola of Saint Peter's Basilica (1603–1612) and frescoes in the Cappella Paolina, Santa Maria Maggiore (1610–1612), as well as numerous altarpieces and easel paintings, including the *Rest on the Flight into Egypt* (about 1597; Boston, Museum of Fine Arts). During the reign of Pope Clement VIII (1592–1605), Cavaliere d'Arpino's conservative style became synonymous with the official artistic aesthetic of the Papacy; he was awarded commissions over such contemporary Baroque painters as Michelangelo Merisi da Caravaggio (who briefly worked in Cavaliere d'Arpino's studio in the early 1590s) and Annibale Carracci. Although Cavaliere d'Arpino did not die until 1640, he never fully abandoned the attenuated figure types, cluttered compositions, and decorative effects that characterize late Mannerism.

The popular subject of this painting appears in all four Gospels, which state that Joseph of Arimathea obtained Christ's body from Pilate for burial in a rock-hewn tomb. John (19:38–42) relates that a convert named Nicodemus assisted Joseph at Christ's entombment. The other accounts report that Mary Magdalene, Mary the Mother of James, and women of Galilee were present. In depicting this theme, artists often combined details from each of these sources and added figures not mentioned in them, especially the Virgin Mary and Saint John the Evangelist.

Cavaliere d'Arpino included the bereaved Virgin, dressed in blue, and Mary the Mother of James in the background of the *Entombment*, but it is difficult to identify the two male participants. The old man who supports Christ's head is dressed in the green tunic and red mantle traditionally associated with the youthful Saint John, although he most likely represents Nicodemus. The large man on the right is probably Joseph of Arimathea, who often wears yellow but is usually shown as being much older.

Cavaliere d'Arpino depicted Christ's entombment on three other occasions: in a fresco in the Sacristy of the Cer-

tosa di San Martino, Naples (about 1596–1597); in a painting of about 1606 (Olgiata, Marchese Mario Incisa della Rocchetta); and in a lost composition, which contained many figures and which is listed in the inventory of the Marques de Leganes (1655). Of the known versions, the present picture was painted last. Herwarth Röttgen (1973) suggests a date of about 1615, when Cavaliere d'Arpino preferred simpler, balanced compositions and heavier figures. Set against a white shroud, Christ's pale body appears in almost exactly the same pose in Cavaliere d'Arpino's *Entombment* of about 1606, although in the present composition he reversed the figure and emphasized the anatomy using a clear, raking light and strong shadows. Comparable features, particularly Christ's physiognomy, appear in the *Coronation of the Virgin* (1615; Rome, Santa Maria in Vallicella).

J.J.C.

22 PLATE 127

PAUL CÉZANNE (French, 1839–1906)
Barque de Dante (après Delacroix), about 1864
Oil on canvas, 8⅞ x 13 in. (22.5 x 33 cm)
Private collection

PROVENANCE: Joachim Gasquet, Aix-en-Provence; Xavier de Magallon (friend of Gasquet's), Aix-en-Provence; Alfred Gold, Berlin; Eugène Blot, Paris; sale Blot Collection, Paris (Hôtel Drouot), April 23, 1937, no. 52, pl. III; Storran Gallery, London; Kenneth Clark; Lady Clark, London; E. V. Thaw, New York.

EXHIBITIONS: London, Storran Gallery, *Paraphrases*, 1939, n.n.; Edinburgh, Royal Scottish Academy, 1954, no. 1; London, Tate Gallery, 1954, no. 1; London, Tate Gallery, *The Romantic Movement*, 1959, no. 51 (catalogued as about 1870–1873); London, Royal Academy of Arts (and traveling), *Cézanne: The Early Years 1859–1872*, 1988, no. 5.

LITERATURE: Joachim Gasquet, *Cézanne* (Paris, 1921), ill. opp. p. 96; Julius Meier-Graefe, *Cézanne und sein Kreis* (Munich, 1922), ill. p. 93; Georges Riviere, *Le Maître Paul Cézanne* (Paris, 1923), p. 198 (listed); N. Iavorskaia, *Cézanne* (Moscow, 1935), pl. 5; Albert Barnes and V. de Mazia, *The Art of Cézanne* (New York, 1939), no. 29 (listed; dated 1870–1873); E. Loran, "The Formal Sources of Delacroix's 'Barque de Dante'," *Burlington Magazine* 90 (1948), p. 231, note 12; W. Andersen, "Cézanne Self-portrait Drawing Re-identified," *Burlington Magazine*, June 1964, p. 285, note 4; S. Lichtenstein, "Cézanne and Delacroix," *Art Bulletin*, March 1964, p. 55, note 5; S. Lichtenstein, "Cézanne Copies and Variants after Delacroix," *Apollo*, February 1975, fig. 1; L. Johnson, *Eugène Delacroix — A Critical Catalogue 1816–1831*, vol. 1 (Oxford, 1981), no. 100, pp. 73–74.

This painting is a copy after Eugène Delacroix's first Salon painting, *Dante et Virgile Conduits par Plégias, Traversent le Lac Qui les Murailles de la Infernale de Dité* (1822; Paris, Musée du Louvre). The subject of Delacroix's painting is taken from Dante's *Divine Comedy*. Dante, accompanied by the Latin poet Virgil, is ferried by Phlegyas through the stygian marsh, in which the souls of the wrathful are rotting. Cézanne, like many other avant-garde painters of the second half of the nineteenth century, had enormous admiration for Delacroix. Typical of Cézanne's early work is a predilection for scenes

of violence and the macabre, which may in part explain his interest in his source in this instance.

The practice of copying after masterworks had been established as a fundamental part of the curriculum of the French Academy, which had been founded in 1666 in Rome. Advanced students were required to produce an exact replica of an Italian masterwork. This practice became a standard component of artistic instruction throughout Europe, and remained so for over two-and-a-half centuries. By the nineteenth century, however, artists increasingly produced interpretive copies after the paintings of Old Masters, of which this is an example. The interpretation was usually significantly smaller than the original. Although Cézanne's copy conforms closely to the original, he attempted not to replicate Delacroix's brushwork, but rather to master his palette and his contrasts of light and dark; these are, however, exaggerated in the copy. The grouping of forms and their relation to each other also appear to have interested the young artist (note, for example, the prominence given to the writhing figures in the foreground).

Although identified as the leading painter of the Romantic movement, Delacroix was revered by Realist as well as the nascent Impressionist painters, particularly following his death in 1863. Specifically, the master's handling of color, which involved (rather than the use of chiaroscuro) hatchings of brilliant hues woven into a texture across the surface of a canvas or a wall, was of great consequence in the development of French avant-garde painting. In 1864 Henri Fantin-Latour painted an *Homage to Eugène Delacroix* (Paris, Musée d'Orsay) that included the critics Jules Champfleury, Edmond Duranty, and Charles Baudelaire, as well as the painters James McNeill Whistler, Edouard Manet, and others, grouped beneath the artist's self-portrait. Indeed, Manet also specifically admired Delacroix's *Barque of Dante*, of which he made two interpretive copies in 1854 (Lyon, Musée des Beaux-Arts; and New York, Metropolitan Museum of Art).

Cézanne continued to copy the work of Delacroix throughout his career. Between about 1870 and 1874 he painted *Hamlet and Horatio* (Philadelphia, private collection; not recorded in Lionello Venturi's catalogue raisonné) after Delacroix's lithograph of 1828. About 1902 Cézanne executed an oil painting (*Bouquet of Flowers*; Moscow, Pushkin Museum) after a watercolor by Delacroix. During the mid-1890s, Cézanne painted a sketch for his own homage to the great Romantic painter (Aix-en-Provence, Musée Granet) which included Camille Pissaro, the collector Victor Choquet, Claude Monet, and the artist himself. In a letter to Emile Bernard dated May 12, 1904, Cézanne lamented that he might not realize a final version of this work: "I don't know whether my precarious health will ever enable me to realize my dream of creating his [Delacroix's] apotheosis" (John Rewald, trans., *Letters* [New York, 1984], p. 297).

R.J.B.

23 PLATE 107
PAUL CÉZANNE (French, 1839–1906)
Uncle Dominique, 1866
Oil on canvas, 16¹⁄₁₆ x 13 in. (40.8 x 32.7 cm)
Private collection

PROVENANCE: Ambroise Vollard, Paris?; Auguste Pellerin, Paris; Moderne Galerie (dealer Heinrich Thannhauser), Munich; Gottlieb Friedrich Reber, Lausanne; Galerie Thannhauser, Lucerne; Stephan Bourgeois Gallery, New York; Adolph Lewisohn, New York; Samuel A. Lewisohn, New York; by descent to the present owner.

EXHIBITIONS: New York, Stephan Bourgeois Gallery, 1922, n.n.?; New York, Wildenstein Galleries, *Paul Cézanne, for the Benefit . . . of the French Hospital of New York*, January 1928, no. 22; New York, Metropolitan Museum of Art, *The Lewisohn Collection*, 1951, no. 10, ill. p. 42.

LITERATURE: J. Meier-Graefe, *Paul Cézanne* (Munich, 1913), p. 55, ill. (dated about 1865); Ambroise Vollard, *Paul Cézanne* (Paris, 1915), pl. 46; J. Meier Graefe, *Cézanne—Mappe* (Munich, 1918), ill. p. 84; H. McBride, *New York Times*, March 5, 1922, p. 8; J. Meier-Graefe, *Cézanne und sein Kreis* (Munich, 1922), p. 85; Emile Bernard, *Sur Paul Cézanne* (Paris, 1925), pl. 53; F. Watson, "The Adolph Lewisohn Collection," *The Arts*, July 1926, p. 16, ill.; *Arts* 9, no. 1 (January 1926), p. 16; S. Bourgeois, *The Adolph Lewisohn Collection* (New York, 1928), pp. 176–77, ill.; S. Bourgeois et al., "The French Paintings of the XIX and XX Centuries in the Adolph and Samuel Lewisohn Collection," *Formes* (1932), ill. between pp. 302–303; K. Badt, *The Art of Cézanne* (Munich, 1956), pl. 42; *Formes*, nos. 28–29 (1932), p. 302; *Cézanne: The Early Years 1859–1872* (exh. cat., London, Royal Academy, 1988), ill. 18b, p. 104, incorrectly identified as Lewisohn Collection, New York.

During the autumn of 1866 Cézanne returned from Paris to his native Aix-en-Provence. While at Aix he painted nine portraits of his maternal uncle, Dominique Aubert. Abandoning his brush, Cézanne executed this group exclusively with a palette knife. This technique, which had been championed by Gustave Courbet just prior to the execution of the work, resulted in dense, thickly modeled surfaces. The use of the palette knife by both Courbet and Cézanne challenged conventional definitions of the appropriate degree of *fini*, which by the nineteenth century had for the French Academy become the doctrinaire conception of an appropriately finished pictorial surface. *Fini* was typified by a smooth and polished finish in which all traces of the execution of the painting were undiscernible. In the spring of 1866, upon receiving notice of the rejection of two canvases that he had submitted to the Salon, Cézanne wrote to Count Emilien de Nieuwerkerke, the Superintendent of Beaux-Arts: "I am unable to accept the unauthorized judgment of colleagues whom I have not myself appointed to evaluate my work" (J. Rewald, trans., *Cézanne: Letters* [New York, 1984], p. 109).

Cézanne's disregard for the conventions of the academy and the Salon are vividly exemplified in *Uncle Dominique*. Although Courbet used this technique, he reserved it primarily for landscapes, rather than figures or portraits. Cézanne replaced the details of the sitter's physiognomy with a pattern of gestural rhythms of paint. The dense, almost relieflike surface emphasizes the plastic mass of the sitter against a monochromatic gray background. The dramatic contrasts of hue and value in the palette reflect the artist's interest in the work

of Manet. The use of a palette knife required a swift application of paint.

The present picture is the second smallest of the portraits, and the most compact in format. Cézanne may have begun the portraits on smaller canvases, increasing them in size with his growing confidence. The other portraits of Dominique, particularly *Portrait of Uncle Dominique as a Monk* (1866; Palm Springs, Annenberg Collection) and *Uncle Dominique* (1866; New York, Metropolitan Museum of Art), are broader and more expansive in their realization, suggesting that they are the last in the sequence.

There is no record of the exhibition of this or any other of Cézanne's portraits of his uncle during the artist's lifetime. Despite his letter to Nieuwererke and the radical original character of this portrait, Cézanne continued to submit paintings to the official Salon throughout his career, though he never gained an official acceptance.

R.J.B.

24 PLATE 129

PAUL CÉZANNE (French, 1839–1906)
Study for Femme à la Cafetière, about 1893
Oil on canvas, 14⅛ x 15³⁄₁₆ in. (36 x 38.5 cm)
Private collection

PROVENANCE: Julian Tanguy (le père Tanguy), Paris?; private collection, England; Sir Kenneth Clark, Saltwood; Alan Clark, London; Reid and Lefevre, London; Collection Col. Edgar William Garbisch and Bernice Chrysler Garbisch; sale Garbisch Collection, New York (Parke-Bernet), May 12, 1980, lot 25, ill.

EXHIBITIONS: London, National Gallery, *Nineteenth-century French Paintings*, 1942, no. 65; London, Tate Gallery, Arts Council of Great Britain, *Cézanne*, 1954, no. 53.; Edinburgh, Royal Scottish Academy, 1954, no. 53; Oslo, Kunstnerforbundet, 1954, no. 22; London, Lefevre Gallery, *XIX- and XX-century French Paintings*, 1971, no. 7, ill.; Liège, Musèe Saint-Georges, 1982, no. 20.

This small unfinished painting is a preliminary study for Cézanne's *Femme à la Cafetière* (about 1893; Paris, Musée d'Orsay). The artist often returned to the same locale for his landscapes or the same group of objects for his still lifes, yet he seldom executed preparatory oil studies for a painting. This powerful work is thus not only significant in itself, but also offers a rare opportunity to assess Cézanne's working methods and the development of an idea for a major work from his oeuvre.

The identity of the sitter in the monumental portrait in the Musée d'Orsay has not been determined. The women in both the study and the finished painting do not resemble the artist's wife, who posed for nearly twenty canvases between 1885 and 1895. Rather, the sitter was probably a servant or a neighbor to Cézanne's family home, the Jas de Bouffan in Aix-en-Provence. Richard Kendall has observed of the d'Orsay painting: "Everything about the woman points to a domestic function, from the heavily accentuated hands to the plain dress and severe hairstyle, and even her apparent awk-

wardness as she sits on an unseen chair" (*Cézanne* [London, 1989], p. 50). The ruddy complexion of the woman's face is even more pronounced in the study. However, the artist imbued the face and body with a monumentality that belies the unassuming presence of a domestic servant. Theodore Reff has noted distinct affinities between the presentation of Cézanne's sitter in the d'Orsay painting and Benedetto da Maiano's busts of Filippo Strozzi and Pietro Mellini, which the artist had copied in the Louvre ("Painting and Theory in the Final Decade," in *Cézanne: The Late Work* [New York, 1977], p. 17). Cézanne also derived this small study from the drawings after da Maiano's busts.

Cézanne painted portraits throughout his career, but during the 1890s portraiture assumed a new significance in his oeuvre. The painter's earlier portraits are often more intimate in character than the monumental works of the 1890s, such as those of the individual figures for the *Cardplayers* series, including *Study for the Cardplayers* (1890–1892; Berggruen Collection, on extended loan to National Gallery, London), the portraits of *Gustave Geffroy* (1895; Paris, Musée d'Orsay) and *Ambroise Vollard* (1899; Paris, Musée du Petit Palais).

In the present study, Cézanne seems first to have outlined the head and shoulders with a thin contour. The painter then applied multiple layers of various hues in order to achieve the dense volumetric form of the woman. He composed the face with various flesh tones, and the dark dress with browns, purples, greens, and blues. The combining of these colors produced an unexpected intensity, revealing Cézanne's remarkable abilities as a colorist. The artist repeated this procedure on a larger scale in the d'Orsay painting.

R.J.B.

25 PLATE 11

GIUSEPPE BARTOLOMEO CHIARI (Italian, 1654–1727)
The Death of Saint Joseph, about 1720
Oil on canvas, 26½ x 35 in. (67.3 x 88.9 cm)
Private collection

PROVENANCE: Julius Weitzner, London.

By the age of ten, Chiari was apprenticed to Carlo Maratta in Rome. Along with Passeri, Berrettoni, and Procaccini, Chiari became one of the chief disciples of Maratta's classicizing Baroque manner. Following the master's lead, Chiari's art evolved away from the full-blown Baroque to the more intimate expressions of the early Rococo. His output ranged from small devotional pictures to history paintings and to large altarpieces and frescoed decorations. The ceiling fresco of 1715 for the nave of the Church of San Clemente in Rome is regarded as Chiari's masterpiece.

From the time of the Counter Reformation, the cult of Joseph was vigorously promoted, and in Italy and Spain he was venerated as a saint in his own right. Various apocryphal

books, such as the *Coptic History of Joseph*, described how Joseph died in the presence of Christ and the Virgin, with angels descending from Heaven. Joseph was thus often invoked as an intercessor for the terminally ill. In this example Christ sits at the foot of Joseph's bed offering his blessing. Behind him, two angels hold vigil, one kneeling attentively as the other raises a lamp. At the left, Mary stands stricken, her left arm gathering the drapery of her mantle. Her right hand is outstretched, the tension in her fingers betraying great anguish.

As Edgar Peters Bowron has observed (in correspondence of February 26, 1992): "This *Death of Saint Joseph* by Chiari derives clearly from the painting of the subject of 1676 by Maratta in the Kunsthistorisches Museum, Vienna, or from a painted variant or reproductive engraving. Although the composition of Maratta's monumental altarpiece (for the chapel of Empress Eleanora) is vertical in format and contains more than a dozen figures, Chiari has adopted from his master's painting, with little variation, both the figure of the dying saint and Christ's pose and gesture of benediction. Chiari's more modest and intimate treatment of the theme suggests that the painting was painted for private devotional purposes. Chiari's mature paintings developed so subtly as his career advanced that it is extremely difficult to assign a date to his works on the basis of style alone. The soft atmosphere and the delicate and gently attenuated figures in this composition suggest a relatively late date for the painting, probably in the early 1720s."

A.N.

26 PLATE 7

AGOSTINO CIAMPELLI (Italian, 1565–1630)
Mary's Vision of Christ's Descent into Limbo, about 1595
Oil on copper, 11½ x 8½ in. (29.2 x 21.6 cm)
Private collection

Trained by Santi di Tito, Agostino Ciampelli belonged to the group of Florentine artists who achieved success in the ambient of Counter-Reformation Rome. His works in fresco (and his rare canvases) exhibit a style then highly favored by ecclesiastical authorities, a style more sentimental than intellectual, and representative of the propagandistic glory characteristic of the age of Bernini. Overshadowed during his career in Rome by his compatriots Cigoli and Passignano, Ciampelli nevertheless managed to secure a steady stream of commissions. In the last year of his life, he was named Superintendent of Works for Saint Peter's, a position that made him responsible for overseeing all aspects of the production and care of art for the basilica.

A diminutive painting with an expansive subject, *Mary's Vision of Christ's Descent into Limbo* shares stylistic similarities with Ciampelli's fresco *Sante Martiri* in the Roman church of Sant'Agnese Fuori Le Mura, which he painted

in 1594, during his first sojourn in that city (according to a letter of September 10, 1991, from Simonetta Prosperi Valenti). Valenti also relates to the present painting a study of three figures by the artist in the Ashmolean Museum (K. T. Parker, *Catalog of the Collection of Drawings in the Ashmolean Museum*, vol. 2 [Oxford, 1956], no. 826 verso).

The iconography of Christ's descent into limbo traces its origins to the apocryphal Gospel of Nicodemus. As elaborated by later theologians, Christ's descent occurred before, not after, the Resurrection. When his body lay in the sepulcher, his spirit visited the unbaptized souls in limbo in order to deliver them into glory. Among those recognizable here are Adam and Eve, who stand behind Christ. To the right of them are King David with his harp and Saint John the Baptist, behind whom is the high priest Aaron. Seated on the cloud at the right, Judith, with the head of Holofernes, is easily identifiable among the heroines of the Old Testament. Around Christ's feet are a host of the souls of children.

Although in the trecento and the quattrocento, Duccio and Fra Angelico treated representations of the theme more somberly, showing the moment Christ first enters limbo, later depictions often focused on a slightly different moment, when the lost souls are at last led to salvation. Such is the case in Carlo La Barbera's *Il Paradiso* (Galleria Regionale della Sicilia; *Pietro Novelli e il suo Ambiente* [exh. cat., Palermo, 1990], p. 122).

Ciampelli's version of the theme, which shows the kneeling Virgin, interrupted at her prayers, on a balcony overlooking a landscape, is notable for its grace and delicacy. Christ's white cloth is decorated with small blue flowers and fleurs-de-lis. The Virgin's awe and Christ's emotional response are well conveyed; the whole panoply of the occupants of limbo seems to wait expectantly for this tender moment to pass.

A.N.

27 PLATE 56

PIETER CODDE (Dutch, 1599–1678)
A Woman Seen from Behind, Seated at a Virginal, n.d.
Oil on panel, 15¾ x 12¼ in. (40.3 x 31.7 cm)
Remnants of a monogram on the virginal
Private collection

PROVENANCE: Duc de Norbonne, Paris, 1909; sale John Wilson, Paris, March 14–16, 1911, no. 106 (as A. Palamedesz); sale Auguste de Ridder (Schönberg), Paris (G. Petit), June 2, 1924, no. 11, ill. (as P. Codde); sale Captain Evelyn Broadwood, M.C., London (Christie's), June 28, 1974, no. 117 (as W. Duyster, and signed with the initial *D*); with E. Speelman, London; private collection; sale New York (Christie's), May 31, 1991, no. 63, ill. (as Pieter Codde).

EXHIBITION: Brussels, 1873 (as A. Palamedesz), with an engraved ill. by François Flameng (1856–1923).

LITERATURE: Wilhelm Bode, *La Galerie de Tableaux de feu Monsieur A. de Ridder dans sa villa de Schönberg, près de Cronberg (Taunus)* (Berlin, 1913), p. 12, no. 38, ill. (as faintly signed "P. Codde"); P. Torresan, "Per una

Rivalutazione di Pieter Codde," *Antichità Viva* 14, no. 1 (January–February, 1975), p. 23, note 22, fig. 14 (as P. Codde); Lucas van Dijk and Ton Koopman, *Het Klavecimbel in de Nederlandse Kunst tot 1800* (Amsterdam, 1987), cats. 99 and 100, ill.

A blonde woman in a black dress and intricate white lace collar sits sideways on a chair with her back to the viewer, before a virginal decorated with a landscape on its lid. To her right is an Oriental carpet and a bass viola da gamba with a carved finial of a woman's head (comparable instruments survive; see Boston, Museum of Fine Arts, acc. no. 17.1717) and draped with a transparent black veil. Overhead is a painting of a panoramic landscape in the "tonal" style. In her hand the woman holds a piece of paper that, since it reveals crisp folds, may be a letter rather than sheet music.

Together with the Dutch artists Willem Buytewech, Dirck Hals, and Hendrick Pot, Pieter Codde played a seminal role in the history of interior high-life genre painting during the early decades of the seventeenth century. Most of Codde's paintings are merry company scenes with numerous fashionably dressed figures who make music, play games, or share a drink. His single-figure compositions are rarer but often reveal greater narrative subtlety (see, for example, the master's well-known *Young Smoker* [Lille, Musée des Beaux Arts]).

In the early twentieth century, while in the collections of the Duc de Norbonne and John Wilson in Paris, this painting was wrongly attributed to the Delft School guardroom and genre painter Anthonie Palamedesz. It was sold as the work of Willem Duyster at Christie's in London in 1974, when (as in the sale of 1991) the monogram on the virginal was deciphered as a *D*. However, Wilhelm Bode had already correctly attributed this painting to Pieter Codde in the catalogue of the De Ridder Collection (1913). The *D* deciphered by later authors is probably the remnant of the upper half of the *P* in Pieter Codde's monogram, which ligates the *P* and *C* (compare the monogram on paintings in Amsterdam, Rijksmuseum, nos. C1578, A2836, and A789).

Several versions of this composition are known, all of them traditionally given to Codde but appearing in photographs to be weaker in execution than the present example, and may, at least in the first two cases, be copies or variants by another hand: (1) oil on oval panel, 18¾ x 14¼ in. (48 x 36 cm), with the same composition, sale H. L. Carey, Lucerne (Fisher), October 25–28, 1944, no. 1562, pl. 17; (2) oil on panel, 15¼ x 11 in. (39 x 28 cm), omitting the landscape painting on the back wall and substituting a fan for the piece of paper held by the woman (with Schaeffer Gallery, Berlin, about 1930; attributed to Codde by Hofstede de Groot); and (3) a variant of the scene with the same sitter viewed from behind but turned to the left and before a table, oil on panel, 15¼ x 10¾ in. (38.5 x 27.5 cm; see *Terugzien in bewondering* [exh. cat., The Hague, Mauritshuis, February 19–March 9, 1982], p. 90, no. 26, ill.). Pentimenti (in the bass viola da gamba and at the left) in the present painting confirm that it is not a copy. Still another, freer variant, depicting the

woman in a larger room with a doorway at the left through which a man emerges, has been wrongly attributed to Hendrik Pot, Dirck Hals, and even Pieter de Hooch, but is probably only by a follower of Codde (oil on panel, 20½ x 28¼ in. [60 x 72 cm]; formerly Amsterdam, Goudstikker).

The psychological mystery of a figure viewed from behind or in lost profile was later perfected by the great Dutch genre painter Gerard ter Borch; this work clearly anticipates those achievements. Ter Borch employed the motif in paintings with both epistolary and musical themes. Later Dutch genre painters, including Johannes Vermeer, Pieter de Hooch, Emanuel de Witte, Gabriel Metsu, and Jacob Ochtervelt, also depicted women seen from behind playing or simply sitting at a virginal, but always in the company of others who accompany them or simply listen. The singularity and isolation of the woman in Codde's painting, however, is unique.

P.C.S.

28 PLATE 96

JOHN CONSTABLE (English, 1776–1837)
Cloud Study, 1822
Oil on paper, 11½ x 19 in. (29 x 48 cm)
Inscribed on verso: *28th July 12 o'clock noon very fine day, showery and [?] warm No West under the sun*
Private collection

29 PLATE 97

JOHN CONSTABLE (English, 1776–1837)
Cloud Study, 1822
Oil on paper, 11½ x 19 in. (29 x 48 cm)
Private collection

PROVENANCE: C. R. Leslie; sale 1860; W. P. Frith; Paterson Gallery, 1928; (?) Sir Farquhar Buzzard; Duveen, 1946.

EXHIBITION: Boston, Museum of Fine Arts, *Paintings, Drawings and Prints by J. M. W. Turner, John Constable and R. P. Bonington*, 1946, nos. 133 and 134.

LITERATURE: John E. Thornes, *The Accurate Dating of Certain of John Constable's Cloud Studies 1821/22 Using Historical Weather Records, Occasional Papers* (Dept. of Geography, University College), no. 34 (London, 1978), pp. 12 and 26–27; Robert Hoozee, *L'Opera completa di Constable* (Milan, 1979), p. 121, no. 332; and p. 123, no. 350; Graham Reynolds, *The Later Paintings and Drawings of John Constable* (New Haven and London, 1987), vol. 1, p. 103, no. 22.11; and p. 111, no. 22.54; vol. 2, pls. 341 and 377.

The greatest of English landscape painters, Constable was born in Suffolk, a rural region of rivers and hills that would figure profoundly in his art. His father was a mill owner and the young Constable, intending at first to pursue the same profession, did not seriously begin to study painting until he went to the school of the Royal Academy in London in 1799. Landscape quickly became his chosen field, although he did some portraiture. He developed an independent manner of making lively oil sketches in the open air in order to help him

prepare for his large, formal, finished compositions. These works, which were usually exhibited annually at the Royal Academy, included *The Hay Wain* (1821), *View on the Stour* (1822), and *Salisbury Cathedral* (1823). They quickly became known to French painters and had a profound effect on both Romantics such as Delacroix and Barbizon landscapists such as Troyon.

During the years 1821 and 1822 Constable spent his summers in the village of Hampstead, north of London. From there, on October 23, 1821, he wrote to his clergyman friend John Fisher, apparently in response to criticism that had been leveled by critics against the overdramatic sky in his painting *Stratford Mill* (London, National Gallery): "I have done a good deal of skying — I am determined to conquer all difficulties and that most arduous one among the rest. . . . That landscape painter who does not make his skies a very material part of his composition — neglects to avail himself of one of his greatest aides. . . . The sky is the *'source of light'* in nature — and governs everything." (*John Constable's Correspondence*, ed. R. B. Beckett [Suffolk Records Society, 1962–1968], vol. 6, pp. 76–77). For Constable the result of this intensive "skying" was nearly a hundred oil-on-paper studies of the sky in which appeared changing patterns of the forms, colors, and moods of clouds, with an occasional bird or treetop. The artist inscribed many of these remarkable small works with the date and exact time of day, providing a sort of meteorological diary. Although none seems to have been specifically adopted for a finished landscape painting, they did provide Constable with the knowledge to improvise freely the often-dramatic cloud-filled skies in future works.

Constable's cloud studies are now widely scattered, with notable examples being at the Victoria and Albert Museum; the Yale Center for British Art, Paul Mellon Collection; The National Gallery of Victoria, Melbourne; the Courtauld Institute Galleries, London; and many private collections. One study was recently sold (London [Sotheby's], November 13, 1991, no. 72). The two studies exhibited here are of the larger size that the artist was producing in 1822, and they tellingly contrast the dark rain clouds and the clear patches of blue sky.

E.M.Z.

30 PLATE 99
JEAN-BAPTISTE-CAMILLE COROT (French, 1796–1875)
A Small Farmyard in Normandy, about 1845
Oil on canvas, 17¼ x 13 in. (43.7 x 33.1 cm)
Signed lower at left: *COROT*
Private collection

PROVENANCE: J. Warnier, Reims, about 1905; acquired from Dudley Tooth, London, by William A. Coolidge of Manchester, and later Topsfield, Massachusetts.

LITERATURE: Alfred Robaut, *L'Oeuvre de Corot: Catalogue raisonné et illustré*, vol. 2 (Paris, 1905), p. 192, no. 532, ill. (of Robaut's drawing after the painting).

At the side of a brick farmhouse is a half-timbered shed possibly used as a smithy's or ferrier's shop; the light of a fire is visible through the window. A chestnut horse with a saddle stands at the right by a low stone wall, in front of which is a large grinding stone and behind which is a woman in a white bonnet. Chimneys rise in the center middle distance, and tall, green trees appear beneath a blue, cloud-swept sky beyond.

Some of Corot's earliest paintings were of simple farmyards (see, for example, *Farmyard in Fontainebleau* of about 1824–1825; Robaut 1905, no. 24) and throughout much of his career these unpretentious little local subjects continued to occupy him alongside his more ambitious "historical" landscapes with biblical or mythological staffage, and his classical Italianate landscapes. While visiting the Toutain farm in Honfleur, he executed several small canvases of farmyard subjects, of which this may be one (compare, for example, *Farmyard with Two Cows*, about 1845; Robaut 1905, no. 403). Robaut dates the present work to about 1845 to 1850.

P.C.S.

31 PLATE 98
JEAN-BAPTISTE-CAMILLE COROT (French, 1796–1875)
Clair de Lune sur les Eaux, about 1874
Oil on canvas, 35½ x 46½ in. (90 x 116 cm)
Signed at lower right: *COROT*
Private collection

PROVENANCE: M. Brame; sale John Saulnier (of Bordeaux), Paris, June 5, 1886 (for Fr 16,000), to Th. Revillon; sale London (Christie's) 1927, to William A. Coolidge of Manchester, and later Topsfield, Massachusetts.
EXHIBITIONS: Paris, Salon, 1874, no. 460; Paris, Ecole des Beaux-Arts, 1875, no. 30; Paris, *Maîtres du siècle*, May 1886, no. 58.
LITERATURE: Alfred Robaut, *L'Oeuvre de Corot: Catalogue raisonné et illustré*, vol. 3 (Paris, 1905), p. 316, no. 2190, ill.

In a nocturnal river landscape with both banks visible, the water fills the foreground and recedes to the left. Tall, darkened trees rise to the top of the picture, and moonlight reflects off the water. At the lower right, a seated figure is hunched over in the darkness. In the moonlight in the left middle ground is a silhouette of the prow of a rowboat with two other figures, one of which seems to hold a torch, and on the distant bank appears a dark profile of a turreted building. Stars fleck the night sky, which is colored with tones of pale blue and rose.

This brooding painting is a late work that Corot exhibited at the Paris Salon in 1874. The artist had often included specific religious and mythological subjects in his earlier landscapes as well as (increasingly) unidentifiable Arcadian idylls and Elysian fantasies. Though the subject here is unexplained, it conjures a literary world of romantic nocturnal

reverie, which is reminiscent of the painter's roots in the Romantic movement that had flourished decades earlier in the nineteenth century, and underscoring Corot's ongoing commitment to a timeless, imaginary realm of landscape. The night, the huddled figure, and the tiny vessel just setting off from the shore imply a narrative even in the absence of a literary source. The hazy, Claudian landscapes that Corot had perfected by midcentury became still dreamier and more diaphanously melancholic in his later years. Forms dissolved and the outlines of shapes blurred in a vaporous atmosphere articulated only by scattered highlights and the accents of foliage. Clearly products of the studio and the imagination, these works often derived from designs developed years and even decades earlier; indeed, Corot boasted of his ability to recall designs at will. The present composition may be compared to Corot's twilit *Souvenier of Riva*, which he exhibited in 1850 (Marseilles, Musée des Beaux Arts), and which in turn was based on a painting of about 1835 from his early Italian period, *View of Riva, Lake of Garda* (Munich, Bayerische Staatsgemäldesammlungen; ill., respectively, in Jean Leymarie, *Corot* [Geneva, 1979], pp. 62 and 101). In the present work, however, Corot applied the design to a visionary internal realm.

By the late 1850s the artist's reputation and acceptance were improving, as hostile art critics redirected their wrath toward Courbet and the new realist painters. For some critics *Clair de Lune* was a triumph; Castagnary wrote in *Le Siècle* (May 5, 1874): "Avez-vous rencontré souvent des trouées plus profondes, des limpidités d'air, de ciel et d'eaux plus frissonnantes?" ("Have you often encountered recesses more profound, such limpidness of atmosphere, sky, and water shuddering so?") However, the picture also was honored by Stock in *Revue du Salon* (1874) with a ridiculing caricature captioned: "Effet de nuit par Corot, ou le bon fromage 'à la pie'" ("Night effect by Corot, or good cheese 'à la pie'). Corot's tenebrous palette and dissolution of form still unsettled the conservatives; Comte de Nieuwekerke, Director of Fine Arts during the Second Empire, wrote of Corot: "He's an unfortunate who goes over the canvas with a sponge dipped in mud."

This painting was the first picture ever acquired by collector William A. Coolidge and served to introduce him to Dudley Tooth, who became one of Coolidge's favorite dealers.

P.C.S.

32 PLATE 105

GUSTAVE COURBET (French, 1819–1877)
The Guitar Player, 1844
Oil on canvas, 21⅝ x 16⅛ in. (55 x 41 cm)
Signed and dated at bottom right: *Gustave Courbet / 1844*
Private collection

PROVENANCE: Sale Henri de St——D, Lille, March 8–9, 1878, lot 25 (as *Troubadour préludant*); Binand, Paris (1882); Faure, Paris; Prince de Wagram, Paris, before 1920; sale Dikran Khan Kelekian, New York (Plaza Hotel), January 30, 1932, lot 133, ill. (for $2,700) to Prendergast; Mrs. Edith Wetmore; Mrs. Walter Wood Hitesman, Jr., of New York and Massachusetts; Richard L. Feigen, New York; private collection.

EXHIBITION: Paris, Salon, 1845, no. 379 (as *Le Guitarrero, Jeune Homme dans un Paysage*); Paris, Ecole National des Beaux-Arts, *Expositions des oeuvres de Gustave Courbet*, May 1882, no 155; Paris, New York, Cairo, *Collection Kélékian: Tableaux de l'Ecole Française Modern*, 1920; New York, Brooklyn Museum, April 1921, no. 48; San Francisco, *The Kélékian Collection*, 1921; New York, Marie Harriman Gallery, *Courbet et Delacroix*, November 7–25, 1933, no. 8; San Francisco, California Palace of the Legion of Honor, June–July 1934, no. 82; New York, Knoedler Gallery, *Figure Piece*, March–April 1937, no. 3; Baltimore Museum of Art, *Paintings by Courbet*, May 3–29, 1938, no. 1; New York, Wildenstein Gallery, *Loan Exhibition of Gustave Courbet*, December 2, 1948–January 8, 1949, no. 1, p. 32; Fort Worth Art Association, March–April 1949, no. 6; Philadelphia Museum of Art; and Boston, Museum of Fine Arts, *Gustave Courbet, 1918–1877*, 1959–1960; New York, Brooklyn Museum, *Courbet Reconsidered*, November 4–January 16, 1989, no. 3, pp. 83 and 91.

LITERATURE: Théophile Silvestre, *Histoire des Artistes Vivantes* (Paris, 1856), p. 254; Alexander Estingnard, *Courbet, sa vie et ses oeuvres* (Besançon, 1897), p. 150; George Riat, *Gustave Courbet, peintre* (Paris, 1906), pp. 35–36; Léonce Bénédite, *Courbet* (Paris, 1911), p. 19; *Les Peintre illustrés*, ed. Henry Roujon (Paris, 1913), no. 34, p. 20; Théodore Duret, *Courbet* (Paris, 1918); André Fontaines, *Courbet, Art et esthétique* (Paris, 1921), p. 4; Charles Léger, *Courbet* (Paris, 1925), p. 26 (1929 ed.), p. 32; Giorgio de Chirico, *Gustave Courbet* (Rome, 1925); Pierre Courthion, *Courbet* (Geneva, 1931); André Ferran, *Le Salon de 1845 de Charles Baudelaire* (Toulouse, 1933), p. 20; Jules Baillods, *Courbet vivant* (Paris, 1940), pp. 22–23; René Huyghe, René Bazin, and Hélène Jean Adhemar, *Courbet, L'Atelier du peintre, allégorie réelle, 1855* (Paris, 1944), p. 1; Charles Léger, *Courbet et son temps* (Paris, 1949), p. 26; Gerstle Mack, *Gustave Courbet* (London, 1951), pp. 36–37 and 43; Pierre MacOrlan, *Courbet* (Paris, 1951); Marcel Zahar, *Courbet* (Geneva, 1952), p. 29; André Fermigier, *Courbet, étude biographe et critique* (Geneva, 1971), p. 19; *Autoportraits de Courbet* (exh. cat., Paris, Musée du Louvre, 1973), no. 33, p. 29; T. J. Clark, *Images of the People: Gustave Courbet and the Second French Republic, 1848–1851* (London, 1973), pp. 39–40; Jack Lindsay, *Gustave Courbet, His Life and Art*, 1973, p. 27; Robert Fernier, *La vie et l'oeuvre de Gustave Courbet, catalogue raisonné* (Geneva, 1977), vol. 1, no. 52, p. 32; Hélène Toussaint, *Gustave Courbet* (exh. cat., Paris, Grand Palais, September 30, 1977–January 2, 1978), pp. 86–87, under no. 9; Anthea Callen, *Courbet* (London, 1980), p. 43.

Although Gustave Courbet's parents sent him to Paris in 1839 to study law, he had already decided to become a painter. Following a brief period of training with the successful academic painter Charles Steuben, Courbet left his atelier to begin an intense period of independent study. He made copies after the Spanish, Venetian, and Dutch masters whose works hung at the Louvre. Courbet frequented the Académie Suisse, where, unsupervised by any master, he was able to make drawings of a live model. Fiercely independent, Cour-

bet claimed to be his own teacher and disavowed the importance of artistic instruction. In 1861 the painter wrote: "I cannot teach my art, nor the art of any school whatever, since I deny that art can be taught, or, in other words, I maintain that art is completely individual, and is, for each artist, nothing but the talent issuing from his own inspiration and his own studies of tradition" (Pierre Courthion, ed., *Courbet raconté par lui-même et par ses amis* [Geneva, 1950], vol. 2, p. 206).

Despite Courbet's assertions of artistic independence, his work throughout the 1840s demonstrates a distinct relationship not only to the Old Masters, but also to contemporary trends in French nineteenth-century painting. Prior to 1848, Courbet had submitted eighteen entries to the jury of the Paris Salon. Only three paintings were accepted: his debut canvas in the Salon of 1844, *Portrait of the Author, entitled Courbet with a Black Dog* (Paris, Musée du Petit Palais); the present picture, *The Guitar Player*, which was exhibited in the Salon of 1845; and *Portrait of M. xxx*, which was shown in the Salon of 1847 and is most certainly the work now called *Portrait of the Artist, entitled Man with a Leather Belt* (1845–1846, Paris, Musée d'Orsay). Courbet was discouraged by the numerous rejections of his submissions by the Salon, but the acceptance of these three pictures points to the painter's ability to satisfy the conservative jury. The solitary musician in colorful costume posed beneath a tree in *The Guitar Player* reflects elements of the so-called Troubadour style popular at this time. The picturesque and sentimental qualities of this painting are related to the conventional Romanticism of the 1840s.

This painting has often been mistakenly identified as a self-portrait. As early as 1861 Théophile Silvestre identified the subject as Courbet, an analysis accepted by many subsequent commentators. Although Hélène Toussaint (1977, p. 86) convincingly argued that the sitter is actually Alphonse Promayet, a violinist and childhood friend of Courbet, the erroneous identification of the painting as a self-portrait is consistent with the artist's complex and sometimes contradictory ambitions. From the beginnings of his career, Courbet intentionally conflated his art and life. Not surprisingly, his first work to be accepted by the Salon was a stylistically timid yet pretentously titled self-portrait. Other evidence suggests that Courbet was obsessed with his own image. Yet this was not a straightforward obsession, since he consistently recast himself in the guise of an other; hence, he created a sequence of self-portraits in which he became *The Desperate Man* (1843; Luxeuil, private collection), *The Wounded Man* (1844–1854; Paris, Musée d'Orsay), *Man with a Pipe* (about 1848–1849, Montpellier, Musée Fabre), and *The Cellist* (Stockholm, Nationalmuseum), which was exhibited at the Salon of 1848. These pictures and others, including *The Guitar Player* (even though it is not actually a self-portrait), form a group of works that can be interpreted as an effort by Courbet to imbue his art and persona with ambiguity.

Courbet's career during the 1840s was characterized by struggle and confusion. At various moments he imitated Rembrandt, Guercino, Caravaggio, and Adriaen Brouwer. Yet he was not merely imitating them, for he mixed their styles and those of other artists and as well as incorporating less specific references to their works. Further, he freely borrowed other identities in his search for a personal iconography. Thus, *The Guitar Player* was perceived as a self-portrait for many years.

The Guitar Player is believed to have a pendant called *The Poet*, which is also known as *The Sculptor* (New York, private collection). Dressed in colorful costume, the figure depicted is believed to be Courbet himself. Since the picture shares with *The Guitar Player* a date of 1844 and they are of identical dimensions, it is possible that they were conceived as a pair. Toussaint (1977, p. 86) suggests that the paintings form a diptych showing the two old friends from Franche-Comté shortly after their arrival in Paris. Of importance, however, is that in *The Sculptor* Courbet once again disguised himself in someone else's garb. It might be speculated that in the 1850s, after the painter had grown a full beard and Silvestre had identified the subject of *The Guitar Player* as the artist himself, Courbet neither identified the sitter nor challenged Silvestre's attribution. This would have been in keeping with his intentions in the actual self-portraits.

It is ironic, of course, that the great French Realist painter disguised himself behind theatrical artifice, thus preventing a stable interpretation of his own likeness and his art — that is, until 1854 and 1855, when Courbet painted *The Painter's Studio: A Real Allegory Summing Up Seven Years of My Artistic Life* (Paris, Musée d'Orsay). Alphonse Promayet was again included in Courbet's work, this time as the first figure to the right of the nude model; however, Promayet appears not as a troubadour (as he had in *The Guitar Player*), but as a violinist, his actual profession, just as his friend Courbet represented himself, undisguised, for the first time, as a painter.

R.J.B.

33 PLATE III
GUSTAVE COURBET (French, 1819–1877)
Effet de Soleil, Trouville, about 1865
Signed at lower right: *G. Courbet*
Oil on canvas 28 x 40 in. (71.1 x 101.6 cm)
Private collection

PROVENANCE: With Newhouse Galleries, New York; with Bruno Meissner, Zurich.

The horizon of a panoramic view of the seashore and sky divides the scene about one-third of the way up the canvas. In the foreground, low black rocks appear in the calm water, which becomes an intense, cerulean blue as it approaches the horizon. Overhead, the immense sky fades from a pale peach

at the horizon to a mottled off-white. The broad application of paint, which in places the artist apparently dragged across the surface with a palette knife, creates shimmering effects of atmosphere. Two lone sails figure on the horizon.

Although he had depicted the mouth of the Seine earlier in his career, Courbet had his first important encounter with the sea in 1854, when he went to meet his patron, M. Bruyas, and visited Palavas-des-Flots on the Mediterranean. The artist documented that first encounter with a now-famous painting, *Les Bords de la Mer à Palavas* (*Seaside at Palavas*; signed and dated 1854; Montpellier, Musée Fabre, no. 431), which depicts a broad panoramic view of the sea, with the horizon virtually bisecting the scene, and a tiny self-portrait figure taking off his hat in a salute to the sea. This gesture has been interpreted as an instance of self-promotion, specifically, as an illustration of the oft-quoted words that Courbet wrote to Jules Vallès at this time, ostensibly recording his first reaction to the ocean: "Oh Sea, your voice is great, but it will never drown the voice of Fame calling my name to the entire world."

In 1854 Courbet had painted several medium-size canvases depicting panoramic views of Palavas (see Robert Fernier, *La vie et l'oeuvre de Gustave Courbet, catalogue raisonné* [Lausanne and Paris, 1977], vol. 1, nos. 150–55), and returned to the theme in earnest when he visited Trouville in 1865. In the meanwhile, he had made the acquaintance of the marine painter Eugène Boudin, who made a specialty of beach scenes and marines with subtle effects of atmosphere, (see cats. 11–13), and the two artists, though they were so different in character, probably had a mutual effect on one another.

The present painting is not in the catalogue raisonné that Fernier assembled in 1977, but has traditionally been titled *Effet de Soleil, Trouville* and closely resembles the panoramic sunsets at Trouville which Courbet painted during the summer of 1865 (for example, Fernier 1977, nos. 493, 496, and 512, all dated 1865; and the undated nos. 498–502). The darkened forms of the rocks in the foreground and the dramatic sky may also be compared to *Marine à Trouville, Les Roches Noires* (signed and dated 1865; Fernier 1977, no. 511). Courbet returned to panoramic marines in 1867, 1869, 1873, and 1874 (see Fernier 1977, nos. 607, 712, 914, and 977), but his campaign at Trouville remained his most significant exploration of the theme. Courbet's pupil James McNeill Whistler documented the importance of this period for his teacher in a painting of 1865, *Courbet in Trouville* (Boston, Isabella Stewart Gardner Museum), appropriating the design of *Seaside at Palavas*, which Courbet had painted eleven years earlier. Not all of the artist's panoramic marines were received so respectfully, however; the humorist Randon poked fun at them in *Le Journal Amusement* in 1867, printing a caricature of one with the mocking caption "Marine. Just as God made heaven and earth from nothing, Courbet creates his seascapes from nothing or next to nothing; three tones on his palette,

three strokes of the brush — how he knows how to apply them — and voilà, an infinite sea and sky! Prodigious! prodigious! prodigious!"

P.C.S.

34 PLATE 112
GUSTAVE COURBET (French, 1819–1877)
Gravedigger and a Child with a Skull, 1870
Initialed and dated at lower left: *G.C. 70*
Oil on canvas, 11¾ x 15¾ in. (30 x 40 cm)
Private collection

PROVENANCE: Acquired from Artemis, London.

LITERATURE: *Artemis 90–91: Annual Report* (January 1992), p. 31, cat. 12, ill.

A gravedigger thigh deep in a hole digs with a small pick or hammer held in midswing over his head. Behind him stands a child, who with a similar gesture holds aloft a skull, and seems about to fling it toward a stand of bones and a skull set in the earth as in tenpins. Around the grave are the digger's grub hoe, sieve, and lunch pail. At the back left are other graves and a terminus monument, and at the back right a kneeling figure dressed in the black of mourning.

Painted by the realist Courbet late in his life, this remarkable little picture embodies, indeed summarizes, several of the major themes of his artistic career. It was conceived in the same year (1870) in which Courbet's childhood friend and fellow socialist sympathizer, Max Buchon, had died in the painter's arms. This also was the fateful year of the Paris Commune, when Courbet was briefly appointed president of the commission for the protection of works of art threatened by the bombardment, only to be imprisoned later for his purported role in the toppling of the Vendôme column. The painting thus may be seen as a personal statement of grief, an ironical eulogy for the Second Empire, or possibly, though less plausibly, an anxious commentary on the artist's own mortal bravado in assuming a political role in the precarious new republican government.

Beyond the potentially autobiographical implications of the painting, it alludes to themes — among them, images of labor, graveyards, and death — that first established Courbet's public role as leader of the Realists. Courbet's vast painting *Burial at Ornans* (Paris, Musée du Louvre), which he had executed in 1849, the year of pan-European revolution, presented the Parisian bourgeoisie with an unapologetic image of rural social fragmentation and seeming indifference to death. As the mourners mill around distractedly, the kneeling gravedigger in the *Burial at Ornans*, like the workman in the present painting, ignores a skull that he has unearthed and set casually aside on the edge of the hole. The sympathetic critic Proudhon wrote, in defending the *Burial at Ornans* against charges of sacrilege: "We have lost the religion of the dead; we no longer understand that sublime poetry with which

Christianity, at one with itself, surrounded it. We have no faith in prayers and make fun of the Life Beyond. The death of man today, in universal thought, is like that of an animal." A similar spirit of aggressive irreverence is at work in the present image.

As Linda Nochlin observed in her discussions of the Realist movement, images of graves, graveyards, and dead and dying people multiplied in the mid-nineteenth century with the realization that death was the paradigm of the Realist artist's desire to objectively record fact; indeed, the finality of death was regarded as the ultimate fact for both Realist writers and artists (see Linda Nochlin, "Death in the Mid-nineteenth Century," in *Realism* [Baltimore, 1971], p. 51ff.). The man raising the small sledgehammer (note that it is not a hoe with a broad blade used for digging, like the one that rests beside the hole, but a tool used to break and smash) also assumes a pose with a tool reminiscent of Courbet's famous *Stonebreakers* (1851; formerly Dresden, Gemäldegalerie; destroyed 1945), which was regarded as the ultimate Realist portrayal of anonymous physical labor — a theme Courbet himself described as the "complete Gustave Courbet expression of destitution." Yet the present work also contains the macabre and darkly comical detail of the child apparently playing tenpins or skittles with the disinterred bones. Death was deliberately trivialized by the Realists, but here the perversely playful motif is virtually Shakespearean. The popularity of *Hamlet* among French audiences in the mid-nineteenth century inspired many artists; for example, one of Delacroix's favorite subjects for illustration from the play, which he treated repeatedly between 1827 and 1859, was that of Hamlet and Horatio in the graveyard with the skull. In Courbet's painting, however, the child with a skull has a much earlier pictorial lineage, in traditional *vanitas* subjects of western painting (see, for example, seventeenth-century prints such as H. Goltzius's *Homo Bulla*).

P.C.S.

35 PLATE 26

AELBERT CUYP (Dutch, 1620–1691)
Portrait of a Woman as a Huntress, 1651
Oil on oval panel, 33 x 27 in. (83.8 x 68.5 cm)
Signed and dated at left: *Ætatis. 21 / A.cuyp.fecit. / 1651*
Private collection

PROVENANCE: Sale M. J. Alexander, London (Sotheby's), December 18, 1935, no. 118 (for £245, to A. Asscher); collection L. van Santen, 1936; Galerie Sanct Lucas, Vienna; collection Neuman, France, by 1938; seized by Germany, 1941; collecting point Munich, inv. 1363/2; returned to France, October 1946; by descent to the present owner.

LITERATURE: Rijksmuseum, *Catalogue of Paintings* (Amsterdam, 1960), p. 79; Claus Virsch, *Paintings in the Collection of Charles and Edith Neuman de Végvár* (New York, 1970), p. 6; Alan Chong, "New Dated Works from Aelbert Cuyp's Early Career," *Burlington Magazine* 133 (September 1991), p. 617, fig. 55; Alan Chong, "Social Meanings in Aelbert Cuyp's Paintings" (Ph.D. diss., New York, Institute of Fine Arts, 1991), no. 95.

The sitter is depicted at half length against a neutral background; in one hand she holds dead birds fastened together by a split willow branch, and in the other, a spear. The young woman's bejeweled and gold-trimmed blue satin gown and her elaborately trimmed cap are imaginative interpretations of historical costume and not accurate reflections of current fashion. Similarly historicizing garb is worn by the sitter in the pendant to the present painting, *Portrait of a Man with a Rifle*, in the Rijksmuseum, Amsterdam (oil on panel, 32¼ x 27½ in. [82 x 70 cm.]; inv. C120). The two pendants were separated sometime prior to 1839.

Son and nephew, respectively, of the painters Jacob Gerritsz Cuyp and Benjamin Gerritsz Cuyp, Aelbert Cuyp is best known as a painter of landscapes and livestock, seascapes, and city views. His mature works are characterized by a peerless rendering of golden sunlight effects. Cuyp's portrait oeuvre is less well known. Although stylistically indebted to works by his father Jacob, Aelbert's portraits are more thickly painted and bolder in their palette. The two artists collaborated on group portraits as early as 1641, and the existence of several portraits by the younger Cuyp dated in the years around 1650 suggests that he may have been called upon to complete works commissioned of the elder artist which, for reasons of ill health, the latter was unable to execute prior to his death in 1652.

Popular in the Netherlands from about 1640, hunting portraits were specific expressions of the wealth and status of the sitter, as hunting was a pastime closely regulated and strictly limited to the upper classes (see Scott A. Sullivan, *The Dutch Gamepiece* [Totawa and Montclair, 1984], esp. pp. 33–45). Several artists — including Jacob and Aelbert Cuyp — portrayed family groups together with hunters and their booty, in landscapes graced by large country estates. The pseudohistorical costumes of *Woman as a Huntress* and *Man with a Rifle* suggest that these may also be interpreted as *portraits historiés*, depicting the couple in the guise of classical or mythological hunters such as Dido and Aeneas. In an episode from Vergil's *Aeneid* (Book 4, lines 124–69), Dido and Aeneas go hunting, and during a storm take shelter in a cave, where their love is consummated.

M.E.W.

36 PLATE 124

EDGAR DEGAS (French, 1834–1917)
Stefanina De Gas, Duchessa Montejasi-Cicerale, about 1868
Oil on canvas, 17¾ x 14¾ in. (45 x 37.5 cm)
Private collection

PROVENANCE: Degas family, Naples; Mrs. Millicent A. Rogers, New York; Mr. and Mrs. Leigh B. Block, Chicago; Wildenstein and Co., New York; Mr. and Mrs. Paul Mellon, Upperville, Virginia, acquired in 1960; sale New York (Christie's), November 14, 1989, no. 2.

EXHIBITIONS: New York, Wildenstein and Co., *Degas*, 1960, no. 15, ill.; Washington, D.C., National Gallery of Art, *French Paintings from the Collections of Mr. and Mrs. Paul Mellon and Mrs. Mellon Bruce*, 1966, no. 50, ill.

LITERATURE: "Living with the Great," *Vogue*, October 1952, p. 119, ill.; Jean Sutherland Boggs, *Portraits by Degas* (Berkeley, 1962), p. 124; idem, "Edgar Degas and Naples," *Burlington Magazine*, June 1963, p. 275; Philippe Brame and Theodore Reff, *Degas et Son Oeuvre: A Supplement* (New York and London, 1984), p. 54, no. 52, ill.; *Degas* (exh. cat., Paris, Galeries Nationales du Grand Palais; Ottawa, National Gallery of Canada; and New York, Metropolitan Museum of Art, 1988–1989), p. 254.

Given the quintessentially French nature of much of Degas's subject matter, the impact of Italy on his artistic formation has often been overlooked. The artist's grandfather, René-Hilaire De Gas, emigrated in 1793 from France to Naples, where he married an Italian woman and opened a successful bank. During his youth, Edgar Degas spent considerable time in Naples with his father's large family, with whom he maintained lifelong close ties. Portraits of the artist's Italian relatives, which he painted over several extended visits and which include the ambitious *Bellelli Family* (1858–1867; Paris, Musée d'Orsay), form a major component of his production in that genre. Later, as a successful leader of the Impressionist movement, Degas gave special encouragement to Giuseppe de Nittis and Federico Zandomeneghi, young Italian artists working in Paris.

The present portrait depicts the youngest sister of the artist's father. Stefanina De Gas (1819–1901), who was known as Fanny, married her cousin Gioacchino Primicile Carafa, Marchese di Cicerale e Duca di Montejasi. Jean Sutherland Boggs (1963, p. 275) noted that "in the family papers, she [Fanny] appears as the highly indulged, party-loving youngest child, an image almost immediately shattered when one sees Degas's painting of her as an older woman." The sympathy evident in Degas's somber image of his aunt— dressed in black, staring off to the side, and with her arms folded — recalls his similar characterization of her older sister Laura in *The Bellelli Family*. Among Degas's Italian relatives, Aunt Fanny and her daughters, Elena and Camilla, seem to have fascinated him particularly, as they figure in a half-dozen works painted between 1865 and 1880.

Perhaps preparatory to the present work is a painting of slightly larger dimensions which shows just the head and shoulders of the duchess (Cleveland, Museum of Art). Both works have been dated about 1868, although the style of the present portrait would also be consistent with Degas's style of the early 1870s. The sitter's black costume, which may signify that she was in mourning, does little to substantiate the dating, as the De Gas family lost several members during the 1860s and 1870s.

As is typical of Degas's portraits of this period, geometric interior elements add structure and interest to the composition. Here, the duchess's gently sloping shoulders are set off against the rigid corners of the red pillow that props her up. The rounded form of the white vase directly behind the sofa throws into relief the blackness of her hair while echoing the shape of her head. In its limited palette of gold, deep red, and black, Degas's portrait is certainly pre-Impressionist, evoking instead the richness of early Italian Renaissance painting.

P.S.

37 PLATE 126

EDGAR DEGAS (French, 1834–1917)
Ballet Scene, about 1878
Signed at lower left: *Degas*
Oil on canvas, 10¼ x 8¼ in. (26 x 21 cm)
Private collection

PROVENANCE: With Durand-Ruel, Paris; collection of Jules Claretie, Paris; his sale, Paris, May 8, 1914, no. 10; with Bernheim-Jeune, Paris; collection of Adolphe Lewisohn, New York; collection of Samuel A. Lewisohn, New York.

EXHIBITIONS: Paris, Musée de l'Orangerie, *Degas*, 1937, no. 29; New York, Caroll Carstairs Gallery, *The 1870s in France*, 1938; New York, Jacques Seligmann Galleries, *The Stage*, 1939, no. 17; New York, Wildenstein Gallery, *Degas*, 1949, no. 42, p. 53; Boston, Museum of Fine Arts, *Degas: The Reluctant Impressionist*, 1974, no. 16.

LITERATURE: Forbes Watson, "The Adolphe Lewisohn Collection," *The Arts* (July 1926), pp. 15–48; Stephan Bourgeois, *The Adolph Lewisohn Collection of Modern French Paintings and Sculptures* (New York, 1928), pp. 100–01; *L'Amour de l'Art* 12 (July 1931), p. 306; Camille Mauclair, *Degas* (Paris, 1937), p. 154; *Town and Country*, October 1937, p. 64; *Art News*, December 3, 1938, p. 11; P. A. Lemoisne, *Degas et son oeuvre* (Paris, 1946–1949), vol. 2, no. 470; Lillian Browse, *Degas Dancers* (Boston, 1949), no. 52, p. 355.

Standing *sur point* onstage at the opera, a ballet dancer faces her audience. Dressed in pink tulle with red flowers in her hair, she clasps her hands as she pauses in her dance. Gaslight illuminates her figure from below, highlighting the lower half of her body. Her partner, who is attired in green and white, waits for his cue before a theatrical backdrop in the distance. In the foreground, the backs of three male heads and several musical instruments appear in the pit, implying the presence of an orchestra. The unusually low vantage point silhouettes two violin bows and a large double bass against the space occupied by the dancer on stage.

Edgar Degas had become a specialist in scenes of the ballet by 1874. This interest began as an aspect of his portraits from the late 1860s and early 1870s, and grew into a lifelong interest with the female form in motion. His first painting to include ballet dancers at work is *The Orchestra of the Opera* (1868–1869; Paris, Musée d'Orsay), which focuses primarily on the bassoonist in the orchestra and includes the dancers only marginally. By 1872, however, Degas's interest had shifted to the dancers themselves, as he began to produce compositions that juxtaposed images of male musicians and patrons with the performing female dancers (see *Musicians of the Orchestra*, 1872; Frankfurt, Städelisches Kunstinstitut). The wealthy patrons of the ballet were traditionally given

unlimited access to all areas of the theater, including dressing rooms and rehearsal halls. Degas produced several compositions that exposed the questionable social relationships that occurred between dancers and male members of the audience (see *L'Etoile*, 1878; Paris, Musée d'Orsay).

The opening of Charles Garnier's new Paris Opera in January 1875 inspired Degas to study the theme of dancers in greater depth. At the same time, his style evolved to a focus on fewer figures in more extreme compositions. The view from below in the present painting is utilized in several other compositions from the same period. Degas explained his motivation with disarming simplicity: "Having done portraits seen from above, I will do them seen from below — sitting very close to a woman and looking at her from a low viewpoint" (Theodore Reff, *Degas' Notebooks* [New York, 1985], vol. 1, no. 30, p. 29). It has been suggested that the juxtaposition of the artificial world of the stage and the natural world of the orchestra in his ballet scenes of the 1860s and 1870s may have been inspired by the lithographs of theatrical performances produced by Honoré Daumier in the 1850s (see Theodore Reff, *Degas: The Artist's Mind* [New York, 1976], pp. 77–80).

In this version, the musicians have been minimized to simple shapes, only adumbrations of their heads and instruments. Their dark, somber forms contrast with the bright and colorful costume of the dancer, whose beauty is emphasized through the jewellike tones of her figure and the brilliant stage lighting. Degas experimented with a similarly low viewpoint with the dominating silhouette of a double bass in a pastel over monotype in 1878 (sale New York [Sotheby's], November 6, 1991, no. 7).

K.R.

38 PLATE 125

EDGAR DEGAS (French, 1834–1917)
Pagans et le Père De Gas, about 1882–1883
Oil on canvas, 42¾ x 44 in. (81 x 84 cm)
Scott M. Black Collection

PROVENANCE: Sale Henri Fevre, Monte Carlo, 1925; Galerie Durand-Ruel, Paris; Sam Salz, Inc., New York; Henry Ford Collection; sale New York (Sotheby's), November 12, 1990, lot 9.

EXHIBITIONS: Paris, Galerie Durand-Ruel, *Degas*, 1926; New York, Durand-Ruel Gallery, *Degas*, 1932; Detroit Institute of Arts, 1957; Portland (Maine) Museum of Art, *Impressionism and Post-Impressionism: The Collector's Passion*, July–October 1991, no. 8, p. 31.

LITERATURE: Paul André Lemoisne, *Degas et son oeuvre*, vol. 2 (Paris, 1946–1949), no. 345, p. 182; Franco Russoli and Fiorella Minervino, *L'opera completa di Degas* (Milan, 1970), no. 387; Jean Sutherland Boggs, "Degas at the Museum: Works in the Philadelphia Museum of Art and John G. Johnson Collection," *Bulletin* 81, no. 346 (Spring 1985), p. 25; Jean Sutherland Boggs, *Degas* (exh. cat., New York, Metropolitan Museum of Art [and traveling], 1988, p. 534.

Portraiture was one of Degas's major preoccupations, comprising approximately one fifth of his oeuvre. During the 1860s and 1870s, portraiture provided the painter with some of his most challenging subject matter. Carol Armstrong has described Degas's early interests and intentions in this genre: "The body of Degas's early portrait work was conceived in the spirit of recuperation: of the minutely descriptive, fully costumed and accoutremented likeness, and its various traditions, northern, Italian and French, royal, aristocratic, and bourgeois" (*Odd Man Out: Readings of the Work and Reputation of Edgar Degas* [Chicago, 1991], p. 110).

An independent income made it unnecessary for Degas to support himself at the beginning of his career by selling his work. Although the failure of his family's bank in 1874 diminished his resources, he nevertheless continued to enjoy modest financial security. Traditionally, portraits were commissioned, requiring the artist to present a flattering or at least sympathetic likeness of the sitter. Degas was not bound by this constraint. Unlike Renoir, who profited handsomely by painting the images of his patrons, Degas did not accept portrait commissions, depicting instead his family and friends. He eschewed the blank, nondescript backgrounds found in much nineteenth-century portraiture, choosing instead to present his subjects in the context of their actual experience. For example, the artist depicted his friend and patron, the industrialist and amateur painter Henri Rouart, silhouetted against a factory (about 1875; Pittsburgh, Museum of Art, Carnegie Institute). Degas's ambition was not simply to secure the likeness of his subject, but rather to convey the physical, social, and psychological character of each sitter. A remark jotted in one of his notebooks reads: "Do portraits of people in familiar and typical attitudes; above all, give to their faces the same choice of expression that one gives to their bodies." In keeping with these intentions, the artist read both traditional and modern theories of physiognomic expression.

The subjects of *Pagans et le Père De Gas* are the artist's father, Auguste De Gas, the head of the Paris branch of the family-owned bank, and Lorenzo Pagans, a Spanish tenor and guitarist. Pagans had performed at least one role at the Paris Opera, but his fame and popularity derived from his performances of Spanish songs at various Paris soirées, including those held at the homes of the senior De Gas, Manet, and the de Nittises. This painting is the last in a sequence of three oil portraits of the same sitters. The first version offers a frontal view of Pagans playing his guitar, with Degas's father sitting in profile behind him (about 1869; Paris, Musée d'Orsay). The next picture presents the sitters in a more compact space (about 1869–1872; Boston, Museum of Fine Arts). In the version in Boston, Pagans, again playing his guitar, is seen in profile, but the senior De Gas's pose remains virtually unchanged from the first version in the Musée d'Orsay. In the present picture, the last of the sequence, Degas made significant revisions from the earlier portraits. Unlike the two prior versions, here he applied the paint freely, in broad and loose strokes, and placed the figures in a much

larger interior space. Rather than hold a guitar, the Spanish tenor reads a book. The artist replaced the guitar with a piano, which occupies the space adjacent to his father, and that is the only reminder of music. The foreground is occupied by a cloth-covered table with books placed upon it. The composition is more complex and asymmetrical than in the two earlier versions, deploying an unusual spatial scheme in which the viewer assumes a position above the figures. Degas further complicated the space by placing furniture in the foreground; this functions as a barrier between the viewer and the figures. The artist's father, who had died in 1874, again appears in the background. Although his pose is virtually identical to that in the first version (which hung in the artist's bedroom throughout his life), he appears to be lost even deeper in contemplation, unaware of the presence of Pagans. By the mid-1890s, according to Jean Sutherland Boggs (1988, p. 483), Degas "confronted loneliness and pain more boldly, conveying both alienation and anguish in works — whether portraits or landscapes, dancers or bathers — of great visual and emotional power."

Opinions as to the date of *Pagans et le Père De Gas* vary from 1874 to 1895. Since Degas dated few of his paintings and often later reworked them, it is frequently difficult to be precise about their dates. Paul-André Lemoisne assigned a date of about 1874 to this work in his catalogue raisonné (1946, vol. 2, no. 345, p. 182). In Boggs's study *Portraits by Degas* ([Berkeley, California 1962], p. 56), she ascribed a date of 1882 to this painting, revising Lemoisne's earlier date in part on the basis of a letter of August 5, 1882, from Degas to his friend Albert Bartholome in which the artist had written: "Monday morning sitting with Pagans before he leaves for Spain." Recently, Boggs (1985, p. 25) changed the date from 1882 to 1895 for both this painting and a preparatory pastel in the Philadelphia Museum of Art, writing: "Now I feel that in sheer drama and startling power they [the pastel and this painting] must be closer to Degas's remarkable portraits of his friend Henri Rouart and his son Alexis, which can be dated 1895." Since Lorenzo Pagans had died in 1883 and had not been among Degas's closest friends, it would be curious for the artist to have executed a posthumous portrait of the Spaniard twelve years later. Therefore, Boggs's first date of 1882 is more credible than her recent revision to 1895. Despite the painting's stylistic relationship to *Henri Rouart* (dated 1895, pastel and charcoal on paper; location unknown), which is known only through reproduction and was executed in different media, this evidence is not compelling enough to assign such a late date to this painting, although Boggs is right about its "startling power."

R.J.B.

39 PLATE 100
EUGÈNE DELACROIX (French, 1798–1863)
Autumn — Bacchus and Ariadne, about 1856
Oil on canvas, 24 x 19¹¹⁄₁₆ in. (61 x 50 cm)
Private collection

PROVENANCE: Sale Paris (Delacroix estate), February 17–29, 1864, no. 106; Dauzats; Haro, by August 1864; sale Paris (Haro père & fils), Paris, May 30, 1892, no. 81; sale Paris (Haro père), April 2, 1897, no. 121; P. A. Cheramy; sale Paris, May 5, 1908, no. 155; Javal; E. V. Thaw and Co., New York, 1966.

EXHIBITIONS: Paris, Boulevard Italiens, 1864, no. 55; Paris, Ecole des Beaux-Arts, *Eugène Delacroix*, 1885, no. 106; Berlin, Galerie Paul Cassierer, 1907, no. 55.

LITERATURE: A. Robaut, *L'oeuvre complet de E. Delacroix* (Paris, 1885), p. 383, no. 1431; J. Meier-Graefe and E. Klossowski, *La Collection Cheramy* (Munich, 1908), p. 103, no. 214, ill.; J. Meier-Graefe, *Eugène Delacroix* (Munich, 1922), ill. p. 234; Luigina Rossi Bortolatto, *L'opera pittorica completa di Delacroix* (Milan, 1972), p. 129, no. 727; Lee Johnson, *The Paintings of Eugène Delacroix: A Critical Catalogue* (Oxford, 1986), vol. 3, p. 65, no. 246; vol. 4, pl. 64.

Near the end of his life, Delacroix was preparing several major series of decorative paintings, including the *Four Seasons* for the textile manufacturer Henry Hartmann. This commission dates to at least as early as January 9, 1856, when the artist recorded in his *Journal* the mythological subjects he was considering for the seasons, which already included *Bacchus trouvant Ariane* for *Autumn* (*Journal de Eugène Delacroix*, ed. André Jobin [Paris, 1932], vol. 2, p. 419). In the final scheme each season is represented by a different mythological couple: spring by Orpheus and Eurydice; summer by Diana and Acteon; autumn by Bacchus and Ariadne; and winter by Juno and Aeolus.

Delacroix was apparently at work on the oil sketches for these on May 8, 1856, when he wrote the following color notes (*Journal*, vol. 2, pp. 445–46):

Charmant ton demi-teinte de fond de terrain, roches, etc. Dans le rocher, derrière l'Ariane, le ton de *terre d'ombre naturelle et blanc* avec *laque jaune.*

Le ton local chaud pour la chair à coté de *laque* et *vermillon: jaune de zinc, vert de zinc, cadmium,* un peu de *terre d'ombre, vermillon.* Vert dans le même genre: *chrome clair, ocre jaune, vert émeraude.* Le *chrome clair* fait mieux que tout cela, mais il est dangereux alors, il faut supprimer les zincs.

He continued working on the sketches at Champrosay in late May, but by the end of June had become dissatisfied with them (*Journal*, vol. 2, p. 460) and did not return to the project until 1860. He brought the final paintings close to completion in the winter of 1862 and 1863, but died before he could finish them. These works, possibly with finishing touches by Delacroix's assistant Andrieu, are now in the Museu de Arte, São Paulo. The four preliminary oil sketches have become separated and are now scattered as follows: *Spring* at the Musée Fabre, Montpellier; *Summer* at the Mahmoud Khalil Museum, Cairo; *Winter* in the Reemtsma collection, Hamburg; and *Autumn*, exhibited here.

A set of four small oil sketches on cardboard of the seasons, including *Autumn*, which were in Andrieu's possession were sold in 1892 as by Delacroix and are now in the Museum of Fine Arts, Boston. They have been convincingly identified by Professor Johnson as reduced copies by Andrieu of Delacroix's oil sketches.

The oil study for *Autumn*, the location of which had been unknown for some time, depicts the god Bacchus discovering his bride to be, Ariadne, abandoned on the island of Naxos. She reclines on the shore, as Bacchus, stepping from his lion-drawn chariot, reaches out to her. A Cupid with a wreath flies above them, symbolizing their happy union. Bacchus, the god of wine, was an appropriate embodiment of autumn, since that is the season of the grape harvest.

The oil sketch is significant, because it preserves the bright colors and bold modeling with which Delacroix first conceived his composition in the 1850s. Particularly of note is the harmonic balance of the vivid blue, white, and red patches, which the artist freely painted in to frame the voluptuous torso of Ariadne. The primary changes he made in the final painting, aside from the greater clarity of the landscape setting, are the elimination of the charioteer at the right, the addition of the thyrsus, the staff in Bacchus's hand, and a string of pearls around the neck of Ariadne.

E.M.Z.

40 PLATE 63

ABRAHAM DIEPRAAM (Dutch, 1622–1670)
Tavern Interior, about 1665
Oil on panel, 16⅜ x 19¼ in. (41.5 x 49 cm)
Signed with monogram
Collection of Martin Crane

PROVENANCE: With dealer Willem Lormier, The Hague, by 1754 (storeroom catalogue, no. 77); his sale, The Hague, July 4, 1763, no. 78 ("Een speelende Boere Gezelschap," for Fl 142, to Moltke); collection Count Adam Gottlob Moltke, Copenhagen; by descent to Count F. C. Moltke, Bregentved; his sale, Copenhagen, June 1, 1931, no. 27 (for Skr 5600); sale London (Christie's), May 14, 1965, no. 83 (to Hoogsteder); with dealer John Hoogsteder, The Hague; with dealer Hoogsteder–Naumann Ltd., New York, 1985.

LITERATURE: Pieter Terwesten, *Catalogus of Naamlyst van Schilderyen, met derzelver pryzen zedert den 22. Augusti 1752 tot den 21. November 1768* (The Hague, 1770), p. 318; *Fortegnelse over den Moltkeske Malerisamling* (Copenhagen, 1905), no. 49; Peter C. Sutton et al., *Masters of Seventeenth-century Dutch Genre Painting* (exh. cat., Philadelphia Museum of Art; Berlin, Gemäldegalerie, Staatliche Museen Preussischer Kulturbesitz; and London, Royal Academy of Arts, 1984), p. 180, note 4.

Holding a glass in one hand and a pewter *kan* in the other, a man seated at the rough wooden table cackles with infectious laughter. On the table before him are cards, some bread, and a clay pipe; a tobacco box lies on the seat of the chair to the right. His companion has interrupted the card game in order to relieve himself into a wooden tub. In the background in the center of the composition is an embracing couple; at the left two men play tric-trac while a third looks on. The overall olive-brown tonality of the composition is enlivened by the vibrant red of the cap of the man in the foreground, and by the shaft of light that highlights the objects on the table before him.

Little is known about the Rotterdam painter Abraham Diepraam; according to Houbraken (*De Groote Schouburgh der Nederlantsche Konstschilders en Schilderessen* [The Hague, 1718–1721; reprint Amsterdam, 1976], vol. 3, p. 244), he studied with Hendrick Sorgh in Rotterdam and entered the Dordrecht guild of Saint Luke in 1648. Neither of these statements can be documented, although like Sorgh, Cornelis Schaack, Cornelis Saftleven, and other Rotterdam painters, Diepraam painted low-life genre scenes influenced by the works of Adriaen Brouwer and David Teniers. His earliest work is dated 1648; other extant works are dated through the 1660s. *Tavern Interior* can be dated to the mid-1660s, based on its close relationship with dated works such as the *Barroom* of 1665 (Amsterdam, Rijksmuseum, inv. A1574) and the *Drummer with Drinkers* of 16[6]7 (sale Paris [Charpentier], December 2, 1952, no. 68).

Diepraam's genre scenes are set within dilapidated taverns or humble dwellings, with peasants engaged in a catalogue of exuberant activities: drinking, smoking, dancing, gaming, making music, embracing, and pissing. An elevated and slightly skewed perspective affords a detailed view of the various objects scattered across the floor. Diepraam so individualized the faces of his figures that they are almost caricatured, echoing the intense expressions studied by Adriaen Brouwer in many of that artist's paintings. Diepraam often reused the same models in different compositions; many works feature at least one figure convulsed with laughter.

M.E.W.

41 PLATE 153

KEES VAN DONGEN (Dutch, worked in France; 1877–1968)
Torse (Portrait de Guus), 1905
Oil on canvas, 35¾ x 31½ in. (92 x 81 cm)
Signed at middle right: *van Dongen*
Private collection, courtesy Melas Kyriazi Family

PROVENANCE: George Grammont; Charles Auguste Girard; M. and Mme Pomaret.

EXHIBITION: Paris, Salon, Fall 1905, cat. 1548; Paris, Galerie Bernheim-Jeune, *Van Dongen*, 1908, cat. 50; Nice, Galerie des Ponchettes, *Van Dongen*, 1959, cat. 11; Paris, Musée National d'Art Moderne; and Rotterdam, Museum Boymans-van Beuningen, *Van Dongen*, 1967–1968, cat. 21; Marseille, Musée Cantini, *Van Dongen*, 1969, cat. 16; Rotterdam, Museum Boymans-van Beuningen, December 1989–February 1990, cat. 5.

LITERATURE: André Lejard, *Le Nu dans la peinture Française* (Paris, 1947), p. 1; L. Chaumeil, *Van Dongen. L'homme et l'artiste — La vie et l'oeuvre*, ed. P. Cailler (Geneva, 1967), p. 111.; Jean Melas Kyriazi, *Van Dongen et le Fauvisme* (Lausanne and Paris, 1971), p. 74; Jean Melas Kyriazi, *Le Nu*

feminin dans l'Ecole de Paris (Lausanne, 1975), p. 63; M. Giry, *Le Fauvisme, ses origines, son évolution* (Neuchâtel, 1981), p. 134.

Born in Voorhaven at Delfshaven, near Rotterdam, on January 26, 1877, Kees van Dongen studied at the Academy of Fine Arts in Rotterdam from 1892 to 1897. He made a brief trip to Paris in 1897, and moved to the French capital in 1900. Initially, the artist supported himself by producing illustrations, many of them satirical, for *La Revue Blanche, L'Assiette au Beurre,* and other periodicals. Van Dongen's involvement in anarchist politics brought him into contact with the influential theorist and critic Félix Fénéon and the painter Maximilian Luce, both of whom the artist befriended. In 1904 he exhibited at the Salon des Indépendants, where he met André Derain and Maurice Vlaminck. The following year van Dongen exhibited two paintings, including *Torse,* in the notorious Salon d'Automne of 1905. In 1906, he moved to the "Bateau-Lavoir," which, nicknamed by the poet Max Jacob, was the building in which Pablo Picasso also had a studio. Van Dongen became affiliated with the dealer Daniel-Henry Kahnweiler and the Galerie Bernheim-Jeune in 1907 and 1908, respectively. Following the First World War, the artist's work as a society portraitist provided him with a lucrative income for the rest of his life. Like the patrons for his portraits, he traveled between Paris and fashionable resorts. Van Dongen died in Monaco in 1968.

During the artist's first years in Paris, he painted mainly landscapes, first in an Impressionist, and then in a tachiste style. Derived from Pointillism, the tachiste method involved the application of large dabs of pure color directly onto the canvas. *Torse* is a masterful example of van Dongen's development of an original, distinctly personal style during 1905. Figure pieces and portraits became his subjects of choice thereafter. The uninhibited pose of the nude model, the painter's wife Augusta (Guus) Preitinger, is explicitly sensual, with her body occupying most of the surface of the picture. The bold intensity of unmixed colors and the dense impasto surface relate this picture to the Fauve style of Matisse, Derain, and Vlaminck, with whom van Dongen exhibited in 1905. The highly charged, sensual quality of the present work differs from the interests of the other Fauve painters, who primarily worked in the genre of landscape during 1905 and 1906. Cabaret singers, actresses, acrobats, high-society ingenues, and Oriental dancers all fascinated van Dongen. He continued to paint sensual representations of women with an energized palette, sometimes crossing the boundaries of Belle Epoque propriety, as in 1913, when the police removed a work by him from the Salon d'Automne after judging it too provocative. The painting *Le Chale Espagnol* (Paris, Musée National d'Art Moderne, Centre Georges Pompidou) and *Torse* are among van Dongen's most accomplished works.

R.J.B.

42 PLATE 113
GUSTAVE DORÉ (French, 1832–1883)
Torrent in the Engadine, about 1881–1882
Oil on canvas, 50 x 69 in. (127 x 175.3 cm)
Signed at lower left in red paint: *G. Doré*
Private collection

PROVENANCE: William Schaus, New York; Charles A. Whittier; American Society for Friendship with Switzerland; sale New York (Parke-Bernet), April 29, 1965, no. 110; Central Picture Galleries, New York.

EXHIBITIONS: Syracuse Museum of Fine Arts, *Inaugural Exhibition,* 1900–1901; Boston, Museum of Fine Arts, 1991, *Romantic and Fantastic Landscapes.*

Gustave Doré was born in Strasbourg, and it has often been suggested that the Gothic elements of his art stem from his having spent his early years in the shadow of the great cathedral in that city. He was a compulsive draftsman from the beginning, and after his family had moved to Paris in 1847, he made his debut at the Salon with an ink drawing of a landscape. He soon became a popular contributor to the satirical *Journal pour rire.* He launched his successful and prolific career as a book illustrator in 1854 with an edition of a volume by Rabelais, and there followed his well-known editions of works by Balzac, Dante, Cervantes, and Milton, as well as of the Bible.

Doré's style was vivid, direct, often grotesque, but always exuberant, this last, a natural expression of his personality. Among his wide circle of friends were Rossini, whom Doré sketched on the composer's deathbed, and Sarah Bernhardt, whom he taught to sculpt.

Doré found a receptive audience for his paintings in England, which he visited for the first time in 1868. After this trip, the Doré Gallery, which was devoted to displaying his works, opened in London. Doré was referred to as the "Preacher-Painter" because in the 1870s he produced a series of huge theatrical canvases on the life of Christ. In 1892, after being seen by 2.5 million people, the remaining contents of the Doré Gallery were sent to America for exhibition in New York and Chicago.

Doré's large religious paintings have always evoked mixed critical reactions, but his many landscapes in both oil and watercolor show his greatest originality. The artist's wide travels in Europe and England were reflected in his landscape compositions. He was most taken with mountainous regions, whose stagelike spaces gave him room to exercise fully his romantic imagination. From his early period dates a series of six Alpine views now in the Musée d'Art Modern, Strasbourg. Doré continued to paint mountain landscapes of Switzerland through the 1850s and 1860s, and, following a trip in 1873 to the Scottish Highlands, he produced a remarkable group of Scottish views, many of which are now in American collections (see Robert Simon, "Doré in the Highlands," *Journal of the Walters Art Gallery* 47 [1989]).

One of the most exciting of all Doré's Swiss landscapes, this work shows the aftermath of a violent storm that

caused cataclysmic destruction of vegetation high in the Alps. The view down a central alley of rocks was a frequent device in Doré's landscapes. Here, he filled it most effectively with the cascading water that leads the eye up to the fog-shrouded heights of the mountains. This vista, although undated, would appear to have been made about the time of another monumental view, *Torrent in the Mountains* (Museum of Toulon; see Annie Renonciat, *La vie et l'oeuvre de Gustave Doré* [Paris, 1983], p. 238), painted in 1881, after he had journeyed that year to the Alps instead of to England. Doré wrote that he had spent more than three months in the Cantons of Engadine, Saint-Moritz, and Pontresina, and remained until the first snow chased him away. He went on to say: "I wished that winter would never come, so that I might be able to rest in that disposition of calm and peacefulness which this majestic nature always inspires in me" (quoted in Blanche Roosevelt, *Life and Reminiscences of G. Doré* [New York, 1885], p. 449). Doré also painted a powerful watercolor, *Paysage d'Engadine*, of a rock-strewn valley set before a mountainous backdrop (see *Gustave Doré 1832–1883*, [exh. cat., Strasbourg, 1983], no. 211). Like the oil painting, it is unusual in his oeuvre for including tiny human figures perched on the rocks at the center. This jarring juxtaposition is a forceful illustration of the romantic conception of the helplessness of man before the sublime forces of nature.

E.M.Z.

43 PLATE 152

RAOUL DUFY (French, 1877–1953)
Barques aux Martigues, 1907
Oil on canvas, 25⅝ x 31⅞ in. (65.1 x 81 cm)
Signed at bottom, left of center: *Raoul Dufy*
Scott M. Black Collection

PROVENANCE: Germaine Dufy, Paris; Maurice Laffaille, Paris; Artemis Group, London (acquired from Laffaille, 1986); Arnold and Anne Gumowitz; sale New York (Sotheby's), November 6, 1991, lot 17.

EXHIBITIONS: Saint-Tropez, Musée de l'Annonciade, *Les Oeuvres Fauves de Raoul Dufy*, 1987, no. 18; Los Angeles County Museum of Art; New York, Metropolitan Museum of Art; and London, Royal Academy of Arts, *The Fauve Landscape*, 1990–1991.

LITERATURE: Pierre Schneider, "Dufy, le fauve sage," *L'Express International*, no. 1888 (September 18, 1987); Dora Perez-Tibi, *Dufy* (Paris, 1989), no. 29, p. 323; *Sunday Times Magazine* (London), June 9, 1991.

Born in Le Havre on June 3, 1877, Raoul Dufy was raised on the coast of Normandy. In 1892 he began studying at the Ecole Municipal des Beaux-Arts in Le Havre, meeting Othon Friesz there during the following year. After obtaining a municipal scholarship in 1900, Dufy went to Paris, where he enrolled, along with Friesz, in Leon Bonnat's studio at the Ecole des Beaux-Arts. After exhibiting at the Société des Artistes Français in 1901 and 1902, Dufy switched to the Salon des Indépendants in 1903, participating in a group show at Berthe Weill's gallery during the same year. The artist had

befriended Kees van Dongen and Albert Marquet by 1904. At the Salon des Indépendants of 1905, Dufy was greatly impressed by Matisse's *Luxe, Calme et Volupté* (1904; Paris, Musée d'Orsay). The painter later recalled the importance of this work for his own art: "I understood the new raison d'étre of painting, and Impressionist realism lost its charm for me as I beheld this miracle of the creative imagination at play, in color and drawing" (quoted in John Elderfield, *Fauvism* [New York, 1976], p. 65). By 1906 Dufy, along with Friesz and Georges Braque, was painting in a Fauve style, yet the three painters from Le Havre had formed a distinct group within the Fauve circle, remaining attached to the Normandy seacoast, particularly its ports and resorts, as the inspiration for their art.

Dufy painted *Barques aux Martigues* during a visit to the Mediterranean coast in autumn. Although he had adopted a Fauve palette of brilliant unmixed hues, his subject matter and compositions remained indebted to Impressionism. Prior to traveling to the south of France, Dufy had seen the large posthumous retrospective of Cézanne in 1907 at the Salon d'Automne, where he himself had exhibited two paintings. The example of Cézanne and the brighter light of the South deeply affected Dufy's painting. Although this motif harks back to the artist's earlier paintings from Honfleur, Le Havre, and other locales along the coast of the English Channel, the present painting offers a radically new interpretation of the marine. The boats occupy a steeply tilted space and are arranged in two arcs that dynamically enliven the design. Although the diminishing scale of the boats in the upper half of the painting suggests recession, the broad, flat areas of color accentuate the two-dimensional surface of the canvas. Dufy enhanced the dynamic of the overall design with both individual forms and colors (note the rhythmic sequences of the colors of the individual boats). Moreover, the boats themselves are arced forms, thus reiterating the structure of the larger composition. Dufy reduced the descriptive details, hastening a tendency toward abstraction that hitherto had not been evident in his oeuvre. Despite the artist's new liberties with color and simplification of forms, the subjects of works painted earlier in the year are still identifiable from details as Trouville or Honfleur. Even his series of paintings entitled *Pecheurs à la Ligne* (*Fishermen Angling*), which presage the abstraction of the present picture, contain more topographical description than the series of fishing boats that he painted at Martigues. Dufy had replaced the tight, often architectonic structure of much of his earlier work with a looser, more schematic design.

The bold spatial scheme of the present picture reflects a sophisticated understanding of the work of of Cézanne, particularly his latter still lifes, several of which Dufy must have seen in the restropective at the Salon d'Automne of 1907 a few weeks prior to his southern trip. In particular, the artist's rendering of a group of boats against a tilted plain recalls Cézanne's depictions of fruit and pottery upon tabletops. Dur-

ing the summer of 1908, Dufy and Braque painted together inland at L'Estaque. Abandoning the bright palette of Fauvism, they painted landscapes in neutral hues of green, ocher, and black. The tendency to treat forms as simplified quasigeometric shapes in these landscapes represents the beginnings of a Cubist idiom in Dufy's work. Despite the artist's radical stylistic innovations of 1907 and 1908, he ultimately abandoned the experimental possibilities of abstraction, of which *Barques aux Martigues* is a major example, in favor of cheerfully decorative paintings of popular leisure and sport. He worked in this conventional manner until his death in 1953.

R.J.B.

44 PLATE 65

DUTCH SCHOOL, 17th century
Soldiers Gaming, n.d.
Oil on panel, 14¼ x 12 in. (36.2 x 30.5 cm)
Signed on edge of bench at left: *cuyp 16..*
Private collection

PROVENANCE: With dealer Rafael Valls, London, 1986.

Four soldiers are gathered in the shelter of a crumbling wall; in the corner, the remains of a gun rack suggest that the structure was once a barracks. Seated on a bench or a chunk of rubble, three of the soldiers are engaged in throwing dice, using a drum as an impromptu table. The man at the far left holds an earthenware jug in one hand, and with the other absentmindedly empties his glass of beer. The two figures on the right pass a clay pipe. Keyed to shades of brown and brownish gray, the somber hues of the painting echo the monotonous, barren, and often tragic life of the seventeenth-century soldier.

The military was a ubiquitous presence in the Netherlands throughout the first half of the seventeenth century, when the young republic (apart from the brief respite of the Twelve-year Truce, 1609–1621) was engaged in countless battles against Spain in the effort to maintain and defend its sovereignty. In response to these events, there developed in the late 1620s a genre of *kortegaartjes*, or guardroom paintings, which depicted almost exclusively the more restful moments in a soldier's life: drinking or smoking, gaming, wenching, and divvying captured booty. The most prolific painters of guardroom scenes were Pieter Codde, Willem Duyster, and Simon Kick in Amsterdam; Jacob Duck in Utrecht and The Hague; and Anthonie Palamedesz in Delft, although many other artists also experimented in this genre.

The depiction of gambling soldiers was not only a reasonably accurate reflection of how they spent their off-hours (soldiers were notorious for being gamblers and cheats), but there is a symbolic dimension to these scenes as well. Dice (or cards, or a tric-trac board) allude to the soldiers' unenvi-

able lot as the victims of capricious Fortune. A number of these gaming scenes (including the present painting) take place at night, conceivably on the eve of a battle; as they while away the hours, the soldiers are also anxious to know their fate. Works such as Michiel Sweerts's *Soldiers Playing Dice* (Lugano, collection Thyssen Bornemisza, inv. 1930.108) may also be cited in this context.

Although *Soldiers Gaming* is signed "cuyp" and has until now been attributed to Benjamin Gerritsz Cuyp (Dordrecht, 1612–1652), it is impossible to reconcile this work with Cuyp's known oeuvre. Cuyp typically used a very liquid paint and rapid, loaded brushwork to create an idiosyncratically sketchy effect, with emphatically highlighted contours; his figures are stockier, with almost caricatured features (compare his *Guardroom* [Cologne, Wallraf-Richartz-Museum, inv. 1011] or *Card-playing Peasants* [collection F. C. Butôt]). The smoother, more controlled execution of the present work and the rather elongated proportions of the figures, as well as the subject matter itself, reflect a more immediate influence from guardroom paintings by Willem Duyster (1598 or 1599–1635) or Jan Olis (Amsterdam, about 1610–1676).

M.E.W.

45 PLATE 68

PIETER DUYFHUYSEN (Dutch, 1608–1677)
Young Boy with Bowl of Porridge, n.d.
Oil on panel, 8¼ x 5⅜ in. (20.8 x 13.5 cm)
Private collection

PROVENANCE: Private collection, Paris; with Christophe Janet, New York; with Johnny van Haeften, London.

A young boy seated on a low chair cradles an earthenware bowl of porridge as he looks directly at the viewer. His white chemise has been pulled off one shoulder, revealing the contrasting ruddy complexion of his hands and face, which have no doubt been exposed to the weather. Beneath his red cap is the suggestion of close-cropped blond hair. The knee of his baggy trousers has been mended, and he has kicked off his right shoe, revealing a darned sock. His other well-worn shoe is lined with straw. The neutral gray of the background suggests that the picture is an unfinished oil sketch.

This disarming little painting carried an unconvincing traditional attribution to Karel Dujardin when acquired by its present owner. A previously advanced alternative attribution to Jan Baptist Weenix acknowledges the light tonality of the work, which, in fact, is largely the result of its being an oil sketch with an incomplete background. A more likely attribution can be made to the little-known Rotterdam painter Pieter Duyfhuysen.

Duyfhuysen painted a few portraits, history paintings, and still lifes, but the majority of his works are low-life genre scenes in the tradition of fellow genre painters of Rotterdam

Pieter de Bloot, Cornelis Saftleven, and Hendrick Sorgh. The artist's small known oeuvre (twenty-one paintings) was recently reassembled by Willem van der Watering from misattributions to Pieter van Slingelandt, David Teniers the Younger, and others (see *Holländische Genremalerei im 17. Jahrhundert, Symposium Berlin 1984, Jahrbuch Preussischer Kulturbesitz*, Sonderband 4 [Berlin, 1987], pp. 357–84). The son and the brother of notary publics, Duyfhuysen was born and died in Rotterdam but may have been trained in Haarlem; a sale catalogue of September 6, 1730, from Amsterdam included "A Portrait of the celebrated painter Duifhuize [sic], by his Teacher Torrentius," the infamous Haarlem painter who in 1627 was arrested on charges of blasphemy and sorcery, and is today known by only one still-life painting (Amsterdam, Rijksmuseum, no. A8213). From 1625 to 1671 Duyfhuysen appeared regularly in documents of Rotterdam, and in 1652 he made a will there; however, as early as 1656, paintings by his hand also appeared in inventories of Leiden collections. The subject and figure type of the present painting closely resemble Duyfhuysen's low-life characters; indeed, the same model seems to reappear in several works (see van der Watering 1987, figs. 6, 9, 14, and 15).

P.C.S.

46 PLATE 66

GERBRAND VAN DEN EECKHOUT (Dutch, 1621–1674)
Two Soldiers in a Guardroom, 1662
Oil on canvas, 21½ x 17¼ in. (54.5 x 43.5 cm)
Signed and dated at lower right: *G V Eeckhout.f. / An 1662*
Private collection

PROVENANCE: Sale London (Sotheby's), November 30, 1938, no. 94, ill.; private collection, Murnau, 1960; acquired from Johnny van Haeften, London, 1984.

LITERATURE: E. Plietzsch, *Holländische und flämische Maler des XVII Jahrhunderts* (Leipzig, 1960), p. 181, pl. 332; Ranier Roy, "Studien zu Gerbrand van den Eeckhout" (Ph.D. diss., Vienna, 1972), no. 118; Werner Sumowski, *Gemälde der Rembrandt-Schüler*, vol. 2 (London and Pfalz, 1983), no. 517, ill.

In the shadowed interior of a guardroom, two soldiers at their ease are seated on a bench and table as they converse. The blond soldier on the left wears a cuirass and gestures as he speaks; his comrade on the right wears a broad-brimmed hat and is armed with a sword. The latter smokes a long clay pipe as he listens thoughtfully. In the shadows at the left are a ceramic beer jug, a musket rack, and tall pikes leaning against the wall.

Gerbrand van den Eeckhout was one of Rembrandt's most gifted and inventive pupils, and his paintings date from at least as early as 1644 (see Budapest, Szépmüvészeti Múzeum, no. 543). He was schooled in a tenebrous, painterly style of history painting espoused by his teacher, and continued to execute works in his own personal interpretation of that manner throughout his career. More versatile and independent-minded than many of Rembrandt's pupils, he also tried his hand at landscape and genre painting. After 1650 van den Eeckhout played an important role in revitalizing that subcategory of the genre painting tradition known as guardroom painting — depictions of the life of bivouacking soldiers common in the Netherlands during the war of independence with Spain. Although the Treaty of Münster concluded that confrontation in 1648, the Dutch continued to war with their neighbors (they engaged the English three times in the 1650s and 1660s, and fought the French disastrously in 1672) and knew the constant presence of soldiers.

Van den Eeckhout began painting guardroom scenes in 1651 or 1653 (see the painting formerly owned by William Miesegas, New York; W. R. Valentiner, *P. de Hooch* [London and New York, 1930], ill. p. 152, as dated 1651; but Sumowski 1983, no. 505, as dated 1653). The artist's chief contribution to the tradition was the adoption of an upright painting format with only a few large-scale figures. This painting is a relatively late example of his investigation of the theme of the life of soldiers; most of his dated paintings of this type are from the early and mid-1650s (see, for example, sale Amsterdam, November 15, 1938, no. 30 [dated 1652]; Strasbourg, Musée des Beaux-Arts, [dated 1654]; private collection, Petworth [dated 1655]; and Saint Petersburg, Hermitage [dated 1655]; see, for these and additional examples, Sumowski 1983, nos. 501–516).

P.C.S.

47 PLATE 103

MARIE ELLENRIEDER (Swiss, worked in Germany; 1791–1863)
The Baptism of Lydia, 1861
Oil on panel, 13¾ x 18½ in. (35 x 47 cm)
Signed and dated on verso: *Marie Ellenrieder / pinx 1861*
Inscribed on verso: *Die Taufe der Lydia / del 1861*
Private collection, Brookline, Massachusetts

PROVENANCE: Mrs. J. Latzer, Kreuzlingen.

EXHIBITION: Constance, Wessenberg-Galerie, *Gedächtnisausstellung zur 100. Wiederkehr des Todestages*, 1963, no. 67.

LITERATURE: F. von Boetticher, *Malerwerke des 19. Jahrhunderts* (1891; 2nd ed., Leipzig, 1941), p. 262, no. 36; K. Siebert, *Marie Ellenrieder als Künstlerin und Frau* (Freiburg im Breisgau, 1916), p. 113; M. Zündorff, *Marie Ellenrieder: Ein deutsches Frauen- und Kunstlerleben* (Constance, 1940), p. 124; Friedhelm W. Fischer and Sigrid Von Blanckenhagen, *Marie Ellenrieder* (Constance and Stuttgart, 1963), pp. 50 and 147, no. 313, fig. 56; Ann Sutherland Harris and Linda Nochlin, *Women Artists: 1850–1950* (New York, 1976), p. 50, fig. 28.

Called by Harris and Nochlin "the foremost woman painter of Germany in the early nineteenth century," Marie Ellenrieder was born in Constance, and after training with a local miniaturist, she studied at the Munich Academy from 1813 to 1815. From 1822 to 1824 and again from 1838 to 1840, she

was in Rome, where she associated with the Nazarene school of German painters, especially Overbeck.

The stylistic and spiritual quality of the work of these painters, combined with Ellenrieder's study of Italian painters such as Fra Angelico, Perugino, and Raphael, resulted in paintings of highly refined sentiment and delicate form. Upon completion of a *Stoning of Saint Stephen* for the high altar of the Saint's Church in Karlsruhe, she was made a Bavarian court painter in 1829. Grand Duchess Sophie of Baden gave her numerous commissions for both portraits and religious subjects. Many of the artist's works can be found in the Museum of Karlsruhe.

This late example of her painting is very much in the spirit of Raphael: the carefully balanced figures, the delicate trees in the landscape, and the intimate scale give it the appearance of a predella panel by that master. The subject is taken from Acts 16:14, in which it is told that Saint Paul came to the Macedonian city of Philippi in order to preach the Gospel, and Lydia, a prosperous seller of purple-dyed textiles, was moved to conversion and baptism along with her whole household. Being the first Christian convert in Europe made the somewhat obscure Lydia a significant woman for Ellenrieder to depict.

E.M.Z.

48 PLATE 159

MAX ERNST (German, worked in France and United States; 1891–1976)
Barbarians Marching West, 1935
Oil on paper mounted on board, 9 x 12½ in. (22.5 x 31.5 cm)
Signed at lower right: *max ernst*
Private collection

PROVENANCE: Galerie Der Spiegel, Cologne; Galerie Dieter Brusberg, Hanover; sale London (Christie's), March 30, 1987, no. 35.

EXHIBITIONS: Stuttgart, Kunstverein, *Künstler in Deutschland 1900–1947*, 1947; Cologne, Galerie der Spiegel, *Max Ernst, Neun Bilder, Offerte 1*, 1961; Munich, Haus der Kunst; and Berlin, Nationalgalerie, *Max Ernst, Retrospective*, February–July 1979, no. 249.

LITERATURE: W. Spies, *Max Ernst, Oeuvre-Katalog, Werke 1929–1938* (Cologne, 1979), no. 2230.

Max Ernst was born in Bruhl, Germany, on April 2, 1891. In 1909 he enrolled in the university at Bonn to study philosophy, but shortly thereafter abandoned his academic studies in order to pursue a career as an artist. Prior to the First World War, Ernst was active in avant-garde circles in Bonn, Cologne, and Paris. Although conscripted into military service during the war, he continued to paint, and he exhibited at Der Sturm in 1916. Following the war, Ernst returned to Cologne, where he helped found an outpost of the Dada movement. By 1922 the artist had moved to Paris, and in 1924 he became a founding member of the Surrealist group, along with André Breton and Paul Eluard. Ernst was an ac-

tive member of the group, collaborating with Joan Miró on theater designs (1926), publishing collage-novels such as *La Femme 100 Têtes* (1929), and working on the film *L'Age d'Or* with Dalí and Luis Buñuel (1930).

In 1936 Ernst was represented in the major exhibition *Fantastic Art, Dada, Surrealism* at the Museum of Modern Art in New York. Following the outbreak of the Second World War, Ernst was interned three times in France before he fled to the United States in 1941 with the assistance of Peggy Guggenheim, whom he married in 1942. Guggenheim's gallery in New York, Art of This Century, represented Ernst and other European members of the Surrealist movement who were refugees of the war.

Simply characterized, Surrealists experimented with new techniques such as automatism, accident, biomorphism, and the use of found objects, all within a program committed to social revolution. The results obtained from several of these techniques are evident in Ernst's *Barbarians Marching West*. Interested in Freud's theory of the unconscious, private mythology, and childhood memories, Ernst created a personal iconography typified by the threatening biomorphic forms that traverse the surface of this work. Such imagery was intended to evoke strangeness and alienation, thus questioning the values of contemporary culture. Ernst pioneered two techniques related to automatism which he utilized in creating *Barbarians Marching West*. With *frottage* (rubbing), he covered his paper or canvas with several layers of paint. He then placed objects and textured surfaces underneath the support, drawing another layer of paint over it with a palette knife, thus revealing unexpected forms. He subsequently obtained unusual linear patterns by means of *grattage* (scraping), an extension of the frottage technique. Ernst's application of both techniques involved overpainting in order to isolate and develop his imagery. He used several different layers of pigment in this painting, in areas covering the menacing black forms with a decorative floral pattern that contributed to the macabre appearance of the painting. The ominous biomorphic forms in *Barbarians Marching West* are related to those in Ernst's earlier series *The Hordes* (late 1920s). In the present painting, Ernst carefully painted the upper portions of the humanoid forms in a manner similar to his execution of those found in *The Hordes*. The multiple layers of paint and the close relationship to Ernst's earlier imagery suggest, however, that chance and accident often played a greater role in Surrealist theory than in Surrealist art. According to Sidra Stich: "In his *Barbarians (Barbares)* paintings of 1935 to 1937, Ernst strongly manifests the fascist menace by suggesting the destructive, oppressive — that is to say, tyrannical — dynamics of familial, national, and species rule" (*Anxious Visions: Surrealist Art* [New York, 1990], p. 157).

R.J.B.

49 PLATE 70

CAESAR VAN EVERDINGEN (Dutch, about 1617–1678)
Violinist (Self-portrait?) with a Woman Singing, about 1650(?)
Oil on canvas, 41¾ x 32⅞ in. (106 x 83.5 cm)
Private collection

PROVENANCE: Sir Arthur Wheeler, Hampshire, England; sold by Mr.
A. B. Ryne to Agnew's, London, 1926; Mr. W. G. McBeath, 1933; un-
known dealer, Australia; acquired from Agnew's, London, about 1987.

LITERATURE: Peter C. Sutton, "Recent Patterns of Public and Private Col-
lecting of Dutch Art," in *Great Dutch Paintings from America* (exh. cat.,
The Hague, Mauritshuis; and San Francisco, Museum of Fine Arts,
1990–1991), p. 115, fig. 16.

A young musical couple appears behind a stone balustrade.
The man holds a violin and looks out directly at the viewer,
and the woman holds a sheet of music and appears to be sing-
ing, her hand raised to beat time. The violinist wears a volu-
minous plum-colored velvet cape and a bright red beret. The
violin rests on an olive-colored velvet cushion and is deco-
rated with a bright yellow ribbon. In the shadowed back-
ground, there is a column and a swag of drapery.

When this painting was first acquired by the London
dealer Agnew's from an English private collection, it was
tentatively assigned to the Haarlemer Jan de Bray. Indepen-
dently of one another, Albert Blankert and the present author
both assigned the work to Caesar van Everdingen. Although
Everdingen was born and died in Alkmaar, he studied in
Utrecht and is usually associated with the circle of Haarlem
Classicists which included Pieter de Grebber, the de Brays,
the architect-painter Jacob van Campen, and others. Caesar's
brother, Allart van Everdingen, with whom he lived, was fa-
mous for painting dramatic northern landscapes, but Caesar
painted history subjects, often with nudes, and portraits in a
serenely personal interpretation of international classicism
which featured a characteristically even, soft light. Blankert
has evocatively (if apocryphally) likened Everdingen's
smooth surfaces to those of Ingres.

Everdingen's *soigné* style even attracted the noble pa-
tronage of Amalia van Solms, for whom he painted several
large canvases between 1648 and 1650 for the Oranjezaal in
the Huis ten Bosch. The artist also enjoyed the official pa-
tronage of the Hooghheemraadschap (dijk-reeve) of Rijn-
land, which in 1655 commissioned *Duke Willem II Granting
Privilege to the High Office of the Dijk-reeve in 1255* (Leiden,
Gemeenlandhuis). The treatment of several subsidiary figures
in that scene is quite close to that of the couple in the present
work. The technique of Everdingen's few surviving portraits
is also comparable (see, for example, *Portrait of a Child with a
Bird* [dated 1665; Bornemouth, Russell-Cotes Art Gallery and
Museum]), which, however, has a thicker execution. The
artist employed the time-honored balustrade device (which
descended from Italian Renaissance painting) in at least one
other painting, his lost *Portrait of Allart van Everdingen*, which
is known through a drawing after it by J. Stolker (Weimar,
Schlossmuseum, no. 5459; see H. van Hall, *Portretten van*

Nederlandse Beeldende Kunstenaars [Amsterdam, 1963], p. 95,
no. 622).

Everdingen depicted the violinist in half-length and at a
right angle to the picture plane; his ample sleeve forms a tri-
angular base on which his head turns and looks out pointedly
at the viewer. This became a popular pose for artists' self-
portraits, in part because of the belief that Titian's *Portrait of a
Man* (also known as *Portrait of Aristo*; London, National Gal-
lery, no. 1944), which passed through the Lopez Collection
in Amsterdam in the 1630s, was a self-portrait by the famous
Italian master. Rembrandt etched (in 1639) and painted (in
1640) his own image in this pose, as did many of his students
and colleagues, including Ferdinand Bol and Aert de Gelder
(see also the many other self-portraits by the Dutch masters
Adriaen Hanneman, Frans van Mieris, and Godfried
Schalcken; reproduced and discussed in H. J. Raupp, *Unter-
suchungen zu Künstlerbildnis und Künstlerdarstellung in der Nie-
derlanden im 17. Jahrhundert* [Hildesheim, Zurich, and New
York, 1984]). Furthermore, the theme of music and musical
attributes often appeared in Dutch artists' self-portraits (see
H. J. Raupp, "Musik in Atelier. Darstellungen musizierender
Künstler in der niederländischen Malerei des 17. Jahrhun-
derts," *Oud Holland* 92 [1978], p. 106ff.).

If it is assumed on stylistic grounds that this painting
was executed about 1650, Everdingen would have been about
thirty-three years of age. The sitter here frankly appears
younger; however, Everdingen's figures generally have a
youthful appearance. The artist's only certain *Self-portrait*
(Alkmaar, Stedelijk Museum; repr. *Oud Holland* 52 [1935], p.
41) is undated, but was undoubtedly executed much later in
his career and depicts the artist as an elderly gentleman with a
full beard, but with a similar nose and a steady gaze.

P.C.S.

50 PLATE 18

FOLLOWER OF JAN VAN EYCK (Flemish, 15th century)
Madonna of the Fountain, n.d.
Oil on panel, 8¼ x 7½ in. (21 x 19 cm)
Private collection

PROVENANCE: Sir Alec Douglas Hume, Prime Minister of Great Britain;
Rosenberg and Stiebel, New York.

LITERATURE: Larry Silver, "Fountain and Source: A Rediscovered Eyckian
Icon," *Pantheon* 41 (April–June 1983), pp. 95–104, ill. p. 97.

Holding the Christ Child to her cheek, the Madonna is
shown full length and dressed in long blue robes. She stands
before a red embroidered "cloth of honor" held aloft by two
angels, in a flower garden with a low wall and a gilded
fountain.

This painting is an exceptionally faithful early copy of
Jan van Eyck's *Madonna of the Fountain*, which is dated 1439
and has virtually identical dimensions (oil on panel, 7½ x 4¾
in. [19 x 12.2 cm]; Antwerp, Koninklijk Museum voor

Schone Kunsten, no. 411). Copies with changes also exist, including one set in a niche of painted Gothic architecture (New York, Metropolitan Museum of Art) and another that omits the angels and cloth of honor (Berlin, Gemäldegalerie, Staatliche Museen Preussischer Kulturbesitz). There is also a faithful drawn copy in pen and brown ink on paper in Berlin. Dendrochronological dating by Peter Klein of the University of Hamburg of the wood used in the present panel proves that it was probably painted soon after van Eyck executed the original, since the rings indicate that the tree was felled in about 1419. If the wood had been left to age the customary ten years, the panel would have been available for use as early as 1429 or shortly thereafter, thus it was probably painted soon after 1439, the date on the original. Other physical features of the picture, such as "barbs" of gesso on the top and bottom indicating that it was painted in an attached frame (now lost), confirm fifteenth-century practices. Finally, the back is marbleized in the fashion of other van Eyck panels.

Early Netherlandish copies are often of considerably higher quality and of greater interest than later copies because, as Larry Silver (1983) has shown in discussing this work, the masterful replication of sacred prototypes often inspired pictorial cults similar to those that favored the repetition of icons. Images such as the "Holy Face" (*vera icon*; see, for example, the work by Hans Memling in the Coolidge Collection, Boston, Museum of Fine Arts), Saint Luke's legendary "Notre Dames des Graces" (see cat. 85; the "tüchlein" Madonna and Child in the present catalogue), and other *Gnadenbilder* (images believed to be inherently infused with divine grace) inspired extensive repetitions of fourteenth- and fifteenth-century prototypes, which in turn were often based on Byzantine formulae or other "ancient" pictures.

The Madonna of the Fountain was an ideal candidate for such veneration because of her tender typology (the *Eleusa* — the Madonna and Child in intimate embrace) and rich symbolism. The Virgin was likened to a fountain in several Biblical sources (see, for example, Song of Songs 4:15) and, especially when viewed in the context of the "enclosed garden" (*hortus conclusus*) adumbrated here by the low stone wall, was regarded as the personification of the "Fountain of Gardens" or the "Well of Living Waters." As the new Eve, the Virgin had the potential to restore mankind to the garden of paradise lost in the first Fall. The garden itself thus is filled with flowers associated with Marian imagery. The copying of such supercharged religious images undoubtedly was designed to elicit special devotion from the pious.

The value of the fidelity of the painting to its prototype is witnessed in minute passages such as the Christ Child's wonderfully alert little face and the decorative border of the cloth in which he is wrapped — details that have been abraded and lost in the original. As Silver (1983) has observed, the copist's own artistic personality is expressed in the crisper, slightly harder execution of the present work; however, his faithfulness to van Eyck's exact surfaces and

bright palette is a tour de force. Before learning the results of the dendrochronological tests, Silver (1983) had suggested that the painter could be the Master of the *Pearl of Brabant* triptych (Munich, Alte Pinakothek), who is often identified as Dieric Bouts the Younger, and that the work was executed in Bouts's circle in the second half of the fifteenth century. The new technical evidence suggests that the painting probably was executed considerably earlier (artists were unlikely to use timber that was as much as 60 years old); indeed, it makes the most sense to ascribe it to an immediate follower of van Eyck, very possibly one working in the master's shop. As such it is an exceptionally rare and important image.

P.C.S.

51 PLATE 108

HENRI-IGNACE-THÉODORE FANTIN-LATOUR (French, 1836–1904)
The Two Sisters, 1859
Oil on canvas, 14½ x 19½ in. (37 x 50 cm)
Signed and dated at lower left: *Fantin 59*
Private collection

PROVENANCE: Guillaume Régamey, Paris; sale Paris, June 1907; M. J. Strauss; Fenwick, London; Denise Boas, Paris; Arthur Tooth, London; Hirschl and Adler, New York; acquired by the present owner in 1965.

EXHIBITIONS: New York, Hirschl and Adler Galleries, *French Nineteenth-century Paintings*, 1965; Northampton, Massachusetts, Smith College Museum of Art, *Henri Fantin-Latour, 1836–1904*, 1966, no. 2, ill.

LITERATURE: Mme Fantin-Latour, *Catalogue de l'oeuvre complet (1849–1904) de Fantin-Latour* (Paris, 1911), p. 18, no. 115.

In painting portraits, Fantin-Latour preferred subjects who were close at hand. Especially in his early career, the majority of his portraits depicted either himself or his immediate family, a selection consistent with what is known of the artist's social timidity. According to his wife (Mme Fantin-Latour 1911, p. 18), the present oil sketch was the *première pensée* for the larger, more finished version in the Saint Louis Art Museum. The Saint Louis version was one of three portraits that comprised Fantin's first submission to the official Salon. All three were rejected. Two of these *refusés* were later included in an exhibition in Bonvin's atelier. The present sketch was most likely given by Fantin to Guillaume Régamey, a fellow artist in whose sale it appeared in 1907.

The sitters were the artist's two younger sisters. Nathalie, on the left, pauses in her work, resting her hand on the embroidery frame. Her blank gaze does not focus on the viewer, but extends into the distance. Her melancholic reverie is given further resonance by the knowledge that she was committed later in the same year to the insane asylum at Charenton, where she remained until her death in 1903. In contrast, Marie, at the right, shown fully absorbed in reading, is steeped in normalcy and domestic tranquillity. Indeed, it is the dichotomy of the two figures, closely related spatially but distant emotionally, which gives the subject its psycho-

logical impact. Other treatments of the subject include a small oil version (formerly in the Philippe Burty collection); two drawings (Paris, Cabinet des Dessins, Musée du Louvre), one reversed, after the Saint Louis painting; and an etching done in 1862.

Shortly after Nathalie's internment, Marie married and left France, settling permanently in Russia. There was a hiatus of two decades before the artist returned to the theme of two sisters. In *Reading* (1877; Lyons, Musée des Beaux-Arts), Fantin substituted Victoria Dubourg, his wife of one year, and her sister Charlotte in a composition that closely parallels the present work.

Technically, Fantin treated the domestic genre scene in much the same way as he did his still lifes. Lacking internal drama or outward engagement, his figures appear dryly sketched against a flat backdrop. In their shallow frontality and sense of emotional isolation, the artist's domestic portraits have much in common with those of his contemporaries. *The Two Sisters* has often been compared with Degas's *Bellelli Family* (begun 1859; Paris, Musée d'Orsay) and Whistler's *At the Piano* (begun 1858; Cincinnati, Taft Museum). As in these works, *The Two Sisters* contains an underlying psychological tension; here, the tension is reinforced by the subtle skewing of right angles in the wainscoting and the picture frames, which invokes a physical instability in an otherwise tranquil scene.

P.S.

52 PLATE 109
HENRI-IGNACE-THÉODORE FANTIN-LATOUR
(French, 1836–1904)
Self-portrait, n.d.
Oil on canvas, 12 x 8 in. (30.5 x 20.3 cm)
Signed at lower right: *Fantin*
Private collection

PROVENANCE: Tesse, Donai; Thevenet, Paris; E. V. Thaw and Co., New York; private collection.
LITERATURE: To be included in the forthcoming catalogue raisonné by Philippe Brame and Bernard Lorenceau.

In the early years of his career, Fantin-Latour executed a large group of self-portraits. More sketches than finished paintings, these works of 1854 through 1861 form an inventory of the artist's preoccupations, both personal and painterly, during this period. Fantin described this solitary, yet clearly highly regarded, pursuit in a letter to James McNeill Whistler in June 1859: "I derive a certain solace in finding myself here in my corner, aloof from the world and painting for myself. . . . Oh what a beautiful thing nature is! . . . [F]rom five until eight in the evening I set myself before my mirror and in a tête-à-tête with nature we tell each other things worth a thousand times more than anything the most charming woman could say" (quoted in National Gallery of Canada,

Fantin-Latour, essay by Douglas Druick (Ottawa, 1983), p. 72).

Yet, in spite of Fantin's frequent mention of nature, this early group displays little of the realist approach that came to dominate his portraits and still lifes after 1861. In fact, Jules Castagnary, an early champion of Realism, upon seeing one of these early self-portraits at the *Salon des Refusés*, complained: "His portrait is vague and rather haggard-looking, dusted with powder, moreover, and pallid like a twilight effect. Good lord! my friend, come back to health, vigor, and a clear, sharp eye" ("Salon des Refusés," *L'Artiste*, August 15, 1863, p. 74). However, these romantic, moody explorations of the artist's psyche did find their advocates elsewhere, notably in Gustave Courbet, who admired a group of them in Otto Scholderer's studio in Frankfurt.

The present canvas may be among the later examples, perhaps of 1860 to 1861, as it exhibits considerable mastery of modeling and chiaroscuro effects. Vigorously brushed in over a warm siena ground and lit from the left, the artist's face only partially emerges from the darkness. The right half of his face, his hair, his clothing, and the background all recede into deep shadow, punctuated only by the sharp white of his collar. Fantin depicted himself as detached and mysterious, with his eyelids droopy and his head tilted back. This group of portraits, which value the exploration of personality and expressive light effects over the achievement of a close likeness, recall Rembrandt's early self-portraits, which Fantin clearly had studied and admired.

P.S.

53 PLATE 6
LAVINIA FONTANA (Italian, 1552–1614)
The Holy Family with Saints Francis and Margaret, 1578
Oil on canvas, 50 x 41 in. (127 x 104.1 cm)
Signed and dated at edge of tablecloth: *LAVINIA FONTANA DE ZAPPIS FACIEBAT MDLXXVIII*
Mrs. Selma Postar

LITERATURE: Linda Cheney, "Lavinia Fontana, Boston Holy Family," *Woman's Art Journal* (Spring–Summer 1984), pp. 12–15.

Like Ludovico Carracci and Giovanni Paolo Zappi (whom she married in 1577), Lavinia Fontana was trained by her father, Prospero Fontana, a leading painter of Bologna whose Mannerist style reflected that of the Florentine master Vasari. Lavinia Fontana is famous for being one of the first women to enjoy a successful career as an artist. Her contemporaries greeted her work with polite enthusiasm, but her paintings have stimulated greater interest in recent years. Of her nearly sixty surviving works, most are religious subjects and a few are portraits. (For discussions of the parameters of the artist's oeuvre, see Donna G. Bachmann and Sherry Piland, *Women Artists: An Historical, Contemporary and Feminist Biography* [London, 1978], p. 58; Maria Teresa Cantaro, *Lavinia Fontana*

bolognese, "pittora singolare" [Milan, 1989], pp. 344–47; Vera Fortunati Pietrantonio, *Pittura Bolognese del 500* [Bologna, 1986], pp. 736–37).

This major but little known *Holy Family* was painted in 1578, only a year after Fontana's marriage — a year that also saw the birth and death of her first two children. It returns to a theme that she had first painted three years earlier and to which she would return regularly. Other versions are in the museums of Stockholm, Dresden, Madrid, Bologna, and Rome. Another unpublished example was recently sold at Christie's, New York (January 11, 1989, no. 7). Fontana usually conceived paintings of the Holy Family as *sacre conversazioni*. Her approach to the genre was always a gentle one. In the present painting, the Madonna places the Child upon his crib. He offers a blessing to Saint Margaret, who kneels to his right with her arms folded. Positioned behind her, Saint Francis presents her to the Savior. In back and to the left of Mary, Saint Joseph counterbalances Saint Francis. Following the artist's customary practice, the drapery behind both men was probably painted by her husband (Bachman and Piland 1978, p. 58; Cheney 1984, p. 12).

The figures are connected not only by design, but also by iconography. Central to their interpretation is the theme of Christ's birth, death, and resurrection. Sleep was long regarded as a metaphor for death, and here Christ stands upon his crib, which alludes by its form to a Roman sarcophagus. This metaphorical tomb is countered by Christ's pose, which prefigures one that was often employed for the Resurrection. Saint Francis contemplates Christ's death in the form of the crucifix he clutches, but Saint Margaret ponders his birth. Her attribute, the dragon with its mouth agape, appears at the extreme left-hand corner. According to Jacobus de Voragine's *Golden Legend*, Margaret was tortured and imprisoned for insisting on remaining a Christian virgin. Satan then appeared to her as a dragon, swallowing her whole, but she was able to free herself by the use of the Cross. Women in childbirth thus traditionally called upon Saint Margaret for assistance. Given the date of the painting, her inclusion may have had personal significance for the artist.

A.N.

54 PLATE 116

FRENCH, late 19th century
Portrait of Edouard Detaille, n.d.
Oil on canvas, 18 x 12¾ in. (45.7 x 32.4 cm)
The Simpson Family Collection

PROVENANCE: Didier Aaron, New York.

This lively portrait has been identified as the famed nineteenth-century military painter Edouard Detaille (1848–1912). As the American art writer Earl Shinn (under the pseudonym Edward Strahan; *Etudes in Modern French Art* [New York, 1882], p. 27) observed: "Detaille is Parisian born, in appearance naught better than a fashionable boulevard lounger, a figure fit to be paid money by the manager to loll gracefully in an opera box on an opening night. Stylish, elegant, and citified as he looks, however, Detaille is no vapid dandy. He has served with courage and perseverance in the war with Germany."

Such a dandified gentleman does indeed confront the viewer here. Although no absolute identification has yet been made, it can be pointed out that in a depiction of Detaille at work on the scaffolding in front of a large military painting, he also sports a moustache and smokes a cigarette (see Frédéric Masson, *En Campagne, tableaux & dessins de Edouard Detaille* [Paris, n.d.], p. 1). Further, in a photograph from a set of posed studio photographs of the period (reproduced in *Portrait de l'artiste* [Paris, 1991], p. 165) and in a print after the photograph in John Milner's *The Studios of Paris* [New Haven, 1988], p. 173, fig. 201), Detaille alone among all the artists wears a bowler indoors. This may then have been something of a trademark for him. These details, as well as the several military subjects in the background, combine to make the identification of the sitter as Detaille fairly convincing.

As to who among the wide circle of Detaille's artist acquaintances might have painted it, there are no clear candidates. The vivacious quality, however, does recall that of some of the Spanish artists such as Madrazo, who were then active in Paris, but the portrait painter Jean-Joseph Weerts (1847–1927), who painted many celebrities of the era, also on occasion exhibited a similarly lively touch.

E.M.Z.

55 PLATE 78

HENDRICK DE FROMANTIOU (Dutch, 1633 or 1634–after 1694)
Flowers in a Glass Vase, 1668
Oil on copper, 11 x 7⅝ in. (27.8 x 19.4 cm)
Signed and dated: *HDFromantiou 1668* (the first three letters in ligature)
Private collection

PROVENANCE: Private collection, Paris; J. O. Leegenhoek Gallery, Paris, 1969; private collection, Paris; sale Monsieur G ——, Paris (Ader, Picart & Tajan), April 14, 1989, no. 217, ill.; with Peter Mitchell, London, from whom it was purchased by the present owners.

EXHIBITIONS: Ghent, *Bloem en tuin in de vlaamse kunst*, 1960, cat. 62, ill.; The Hague, Mauritshuis, *The Mauritshuis in Bloom*, April 16–June 19, 1992, no. 12, ill.

LITERATURE: Laurens J. Bol, *Höllandische Maler der 17. Jahrhunderts nahe den Grossen Meistern. Landschaften und Stilleben* (Braunschweig, 1969), p. 332, fig. 301; Peter Mitchell, *Great Floral Painters: Four Centuries of Floral Art* (London, 1973), p. 115; Walter Bernt, *Die Niederländischen Maler und Zeichner des 17. Jahrhunderts* (Munich, 1984), vol. 1, no. 420 (incorrectly as on wood panel); Sam Segal, *Flowers and Nature, Netherlandish Flower Painting of Four Centuries* (The Hague, 1990), pp. 222–23, no. 55, ill.

The still-life painter and picture dealer Hendrick de Fromantiou was active in Amsterdam before moving to The Hague

in 1658. He became a court painter to the Elector of Branden-burg in 1670, and seems to have worked as his curator of collections. Fromantiou later traveled to London (1682) and Danzig (1684), and he died in Berlin. He was a pupil of his father-in-law, Philips Wouwermans, but the younger artist's known work reflects little or nothing of that great landscap-ist's style. Rather, Fromantiou's signed still lifes mostly de-pict dead game in the style of the Delft artist Willem van Aelst and of Melchior de Hondecoeter. These range in date from 1660 to 1679.

The present work, a beautifully polished little painting on copper, is one of the artist's few still lifes of flowers. Sam Segal has published another flower still life by Fromantiou in a private collection, signed and dated 1665 (1990, p. 223, fig. 57a), and has attributed several additional works to him which presently carry assignments to Willem van Aelst and Jan van Huysum in various museums and private collections (see Segal 1990, p. 223, note 9; see also another unsigned, undated example, in the Herzog Anton Ulrich-Museum, Braunschweig, no. 436). The date on the present work indi-cates that Fromantiou executed it before he went to Ger-many. The picture employs a relatively restrained, assymetri-cal composition of an unusually varied group of flowers — including (from top left center and moving clockwise), a tu-lip, an African marigold, the leaf and blossom of a viburnum (snowball), a passion flower, a pink rose with a fritillary but-terfly, and, in the center, possibly a flower from the genus *Geum* (commonly called "avens") and almost certainly a member of the rose family (kindly identified by David E. Boufford, Harvard University Herberia). Segal (1990, p. 222), who has independently identified the flowers, regards the last mentioned as a yellow rose (*Rosa foetida Herrm.*), and remarks on the rarity of passion flowers in Netherlandish still lifes. He notes that though most sorts of passion flowers are American, they were mentioned in Europe at least as early as 1579. The name of the flower refers to the belief that its var-ious parts resembled the attributes of Christ's Passion: the flower itself was compared to the crown of thorns, the five stamens to his wounds, the three styles to the nails, and so forth. Thus, it had strong Christian associations.

The bouquet is arranged in a footed glass vase, before which are drops of water and a fly. Although small floral still lifes on copper depicting few blooms in a glass vase had al-ready been executed in the second decade of the century by painters such as Ambrosius Bosschaert the Elder and Jacques de Gheyn, this work was painted in a style reminiscent of more recent works by Jan Davidsz de Heem and Willem van Aelst. Yet this remarkable little picture and its highly per-sonal, even idiosyncratic, choice of blooms ultimately defies comparisons, leaving the viewer wishing that the artist had left more examples of his work in this area.

P.C.S.

56 PLATE 89

THOMAS GAINSBOROUGH (English, 1727–1788)
Wooded Landscape with Figures, Cows, and Distant Flock of Sheep, about 1746–1747
Oil on canvas, 28¼ x 36¾ in. (71.7 x 93.3 cm)
Morrison Collection

PROVENANCE: William Garnett, Quenmore Park, Lancaster, 1888; with Agnew's, London, 1921; with Knoedler's, New York; with John Levy Galleries, New York; Robert Cluett, New York; sale New York (Amer-ican Art Association), May 26, 1932, no. 90, ill.; purchased by L. Miller; private collection.

EXHIBITIONS: London, Grosvenor Gallery, *The Works of Thomas Gainsbor-ough, R.A.*, winter–spring 1885, no. 302; Lancaster, Storey Institute, *First Loan Collection of Pictures*, October 1891, no. 112.

LITERATURE: Ellis Waterhouse, *Gainsborough* (London, 1958), p. 40, no. 846; *European Paintings in the Collection of the Worcester Art Museum* (Worcester, Massachusetts, 1974), pp. 33–34; Martin Butlin and Evelyn Joll, *The Paintings of J. M. W. Turner* (New Haven and London, 1977), pp. 27–28; John Hayes, *The Landscape Paintings of Thomas Gainsborough* (Ithaca, New York, 1982), vol. 1, pp. 45–46; vol. 2, no. 15, pp. 340–41.

After an early apprenticeship with Hubert François Grave-lot, a French designer and illustrator working in London, Thomas Gainsborough established his own studio in London about 1745. His earliest works include small portraits set in landscapes, a genre originated by Hogarth, and indepen-dent landscapes in the style of Jacob van Ruisdael and Jan Wijnants. Dated by Hayes (1982, p. 341) to 1746–1747, *Wooded Landscape with Figures* is the first large canvas of this early group, and was painted when the artist was about nine-teen years old.

Gainsborough's early mastery of the compositional principles of Dutch naturalistic landscape painting is evident in the present canvas. Recession into space is clearly delin-eated by the use of such devices as alternating light and dark planes; a curving, rutted path that disappears behind the bank of trees functioning as a repoussoir at the right; and the di-minishing scale of figures and animals. The tight handling of foliage and textures in the foreground dissolves into a loose, painterly treatment, probably gleaned from the French Ro-coco, for the distant view of a flock of sheep grazing on a sunny hillside. Like the slightly later and much better known painting known as *Gainsborough's Forest* (London, National Gallery), the present scene is marked by the highlight of a chalky bank in the foreground and the inclusion of unrelated peasant and animal motifs scattered throughout the com-position.

Even in this early phase of Dutch-inspired naturalism, Gainsborough should not be characterized simply as an imi-tator of Ruisdael. Dutch pictorial elements are fused with a Rococo rhythm and handling to create a personal and dis-tinctly British view of landscape, which is characterized at this stage by its pale tonality and sensitive treatment of atmo-sphere. A dappled play of light animates the present scene, and the cascading clouds which echo the landscape forms give it emotive force.

Although the early provenance of the picture is unknown, it may have been in an accessible English collection or have been known through an engraving, as several early copies exist. One version (Worcester Museum of Art), with the composition truncated along the bottom edge and extended along the top, has been attributed to John Crome (1768–1821), who is known early in his career to have copied Gainsborough's compositions. A version by Turner (London, Tate Gallery) is much more loosely based on Gainsborough's original. Very broadly handled, Turner's version is enlivened by the addition of a windmill placed atop the bank at the right and a rainbow vanishing into the trees at the left. Only the staffage and the white cow are carried over virtually unchanged.

P.S.

out, however, the origins of independent still-life painting are hazy, with interconnections among France, Italy, Spain, and Holland.

Fede Galizia was certainly in the forefront of the development of this subject matter, but it is only fair to say that her oeuvre has not been definitively established, and that other contemporary Italian masters, such as Ambrogio Figino and Panfilo Nuvolone, also produced a number of similar still lifes with peaches (see Caroli 1989, p. 13; and F. Zeri, ed., *La Natura Morta in Italia* [Milan, 1989], vol. 1, p. 203, pl. 224). Nevertheless, the present example does exhibit the refined sensibility, mastery of textures, and brilliance of reflective surfaces that are characteristic of the finest of Galizia's works.

E.M.Z.

57 PLATE 10

FEDE GALIZIA (Italian, about 1578–about 1630)
Peaches in a Silver-gilt Bowl, n.d.
Oil on panel, 12¾ x 17⅛ in. (32.4 x 43.5 cm, including added strips on all four sides)
Mrs. H. John Heinz III

PROVENANCE: Private collection, Paris; private collection, London; sale London (Christie's), April 21, 1989, no. 74; Otto Naumann Ltd., New York.

Fede Galizia, the daughter of a painter and a miniaturist from Trent, was probably born in Milan. Contemporary accounts attest that she painted portraits and religious subjects, and worked for Emperor Rudolph II. Today she is best known as a painter of remarkable realistic still lifes. About twenty have been attributed to her based on a signed and dated example of 1602 (formerly Amsterdam, Anholt collection). Galizia was one of the earliest Lombard still-life painters, and these works display a slightly naive approach, with a usually symmetrical composition of fruits and flowers placed in a container against a dark background and viewed from below.

These elements are evident in the present work, which, like another, weaker version on canvas (see Michel Faré, *Le Grand siècle de la nature morte en France, le XVIIe siècle* [Fribourg and Paris, 1974], p. 26, pl. 74), was formerly attributed to the French painter Jacques Linard. The Dutch specialist in still life, Sam Segal (in a written statement, 1989) argued for an attribution to Fede Galizia based on the use and method of preparation of an Italian poplar panel as a support. He also pointed out the similarity to another *Peaches in a Bowl* (Cremona, Museo Civica), which has been accepted as an authentic Galizia (Flavio Caroli, *Fede Galizia* [Turin, 1989], pl. 10) and shows a similar speckling of decay on the fruit. In addition, it can be noted that the device of showing a split fruit, whether it be a peach, a pear, or an apple, alongside a large bowl on a stand appears frequently in other accepted works (see Caroli 1989, pls. 17 and 21). As Segal himself pointed

58 PLATE 81

CORRADO GIAQUINTO (Italian, 1703–1765)
Saint Simon Stock and the Virgin Interceding for Souls in Purgatory, about 1740
Oil on canvas, 25 x 17 in. (63 x 43 cm)
Azita Bina-Seibel and Elmar W. Seibel

PROVENANCE: Mr. S. Christopherson; sale London (Sotheby's), June 23, 1976, no. 80; purchased by Leggatt for David B. Goodstein; sale London (Sotheby's), December 10, 1986, no. 17.

LITERATURE: *The David B. Goodstein and Edward C. Goodstein Collection,* 1983, n.p., no. 10.

From his birthplace of Molfetta on the Adriatic coast, Giaquinto went in 1719 to Naples, where his first teacher was a pupil of Solimena's, Nicola Maria Rossi. He then went on to work directly with Solimena, thus achieving a solid foundation in the fluid Neapolitan style of painting. This Giaquinto brought with him when he settled in Rome in 1723, working with another, older transplanted Neapolitan, Sebastiano Conca. Although carrying out commissions for Naples, Giaquinto was based in Rome, aside from two sojourns in Turin, until 1753, when he was invited by Ferdinand VI of Spain to succeed Amigoni as court painter and director of the Academy San Fernando in Madrid. In Spain Giaquinto was viewed as the heir of Giordano, and he carried out frescoes in the forthright, rapid manner of the earlier master. Gradually, however, the artist developed the brighter and more refined Rococo quality that was to influence the young Goya. In 1762, following the abdication of Ferdinand in 1759 and the arrival of Mengs, who was to work for Charles III and his German queen, Giaquinto left Spain. He worked in his hometown of Molfetta and in Rome before settling in Naples, where he collaborated with the architect Vanvitelli on major projects, including the painted decorations of the now-destroyed San Luigi di Palazzo.

This painting, in its size and loose handling, appears to be a *bozzetto* for a large altarpiece. It is comparable to the

work Giaquinto carried out in the early 1740s at San Gio-
vanni Calabita in Rome; this has a similar representation of
the Trinity, as does a highly finished devotional painting,
The Holy Trinity with Souls in Purgatory (Minneapolis Insti-
tute of Arts). The Virgin and saints placed on clouds and
adoring the Trinity also occurs in another painting by
Giaquinto (sale New York [Sotheby's], January 11, 1990,
no. 113).

In the present case the Virgin, kneeling on the clouds,
implores the Trinity and Heavenly Host to help the souls in
Purgatory, who are guided upward by a seated angel. As she
looks heavenward, the Virgin holds out the scapular to the
praying Saint Simon Stock, an English Carmelite friar of the
thirteenth century. He wears the traditional Carmelite habit,
a white mantel over a dark brown tunic. The scapular, a mi-
raculous apron worn over a monk's tunic, given to Saint Si-
mon by the Virgin endowed the wearer with the means to
escape the Inferno, and thus it is to Saint Simon that the
middle soul addresses his prayer. It would seem likely that
the work was commissioned by a Carmelite church.

E.M.Z.

59 PLATE I

GIOVANNI DI PAOLO (Italian, about 1403–1483)
The Death of Saint Catherine of Siena, about 1461
Tempera on panel, 9¾ x 10½ in. (24.8 x 26.1 cm)
Private collection

PROVENANCE: Siena, Hospital of Santa Maria della Scala; Johann Anton
Ramboux Collection, Trier and Cologne by 1842; Fürstlich Hohenzol-
lern'schen Museum, Sigmaringen, about 1871; Adolphe Stoclet Collec-
tion, Brussels, by 1922; John Russell Vanderlip, Minneapolis, about
1930; bequeathed to the Minneapolis Institute of Arts, 1935; deaccess-
ioned 1958; E. V. Thaw & Co., Inc., New York.

EXHIBITION: New York, Metropolitan Museum of Art, *Painting in Renais-
sance Siena, 1420–1500*, 1988–1989, no. 38.

LITERATURE: Giovan Girolamo Carli, *Notizie di Belle Arti* (Siena, Biblio-
teca Comunale, ms., about 1775) cod. vii–20, f. 86v; *Primitifs italiens de
la Renaissance* (exh. cat., Brussels, Musées Royaux des Beaux-Arts,
1921); Bernard Berenson, *Italian Pictures of the Renaissance* (Oxford,
1932), p. 245; idem, *Pitture Italiane del Rinascimento* (Milan, 1936), p. 211;
John Pope-Hennessy, *Giovanni di Paolo* (London, 1937), pp. 130–33;
Bernard Berenson, *Italian Pictures of the Renaissance* (New York, 1968), p.
178; H. W. van Os, "Giovanni di Paolo's Pizzicaiuolo Altarpiece," *Art
Bulletin* 52 (1971), pp. 289–302; Hayden B. J. Maginnis, Letter, *Art Bul-
letin* 57 (1975), pp. 208–209; Federico Zeri and Elizabeth E. Gardner,
*Italian Paintings: A Catalogue of the Collection of the Metropolitan Museum of
Art: Sienese and Central Italian Schools* (New York, 1980), pp. 24–27;
John Pope-Hennessy and Laurence Kanter, *Italian Paintings in the Robert
Lehman Collection* (New York, 1987), pp. 130–31; Carl B. Strehlke, in
Painting in Renaissance Siena (exh. cat. New York, Metropolitan Museum
of Art, 1988), p. 239, no. 38a–m; Miklós Boskovits and Serena Padov-
ani, *Early Italian Painting 1290–1470: The Thyssen Bornemisza Collection*
(New York, 1990), pp. 17, 104–13.

Trained in Siena, possibly in the workshop of Taddeo di Bar-
tolo, Giovanni di Paolo was one of the most original painters
of the quattrocento. In his early period he exhibited stylistic
similarities with the artists Gentile da Fabriano, Paolo di

Giovanni Fei, and Sassetta. Beginning about midcentury, the
period during which the artist executed the present panel, his
painting reveals a harsher, more anxious approach in both
color and composition.

This panel is one of ten from an altarpiece devoted to
the life of Saint Catherine of Siena. Dispersed among several
collections, the others are: *Saint Catherine Taking the Domini-
can Habit* and *Saint Catherine and the Beggar* (Cleveland Mu-
seum of Art); *Mystic Marriage of Saint Catherine* and *Saint
Catherine Exchanging Her Heart with Christ's* (New York, pri-
vate collection); *Saint Catherine Receiving the Stigmata* and
Saint Catherine Beseeching Christ to Resuscitate Her Mother
(New York, Metropolitan Museum of Art, Lehman Collec-
tion); *The Miraculous Communion of Saint Catherine* (New
York, Metropolitan Museum of Art); *Saint Catherine Dic-
tating Her Dialogues* (Detroit, Institute of Fine Arts); *Saint
Catherine before the Pope at Avignon* (Lugano, Thyssen-
Bornemisza Collection).

This work is set in a chapel with an altar at the extreme
left. Nine of Saint Catherine's fellow Dominicans mourn her
death, a few of them covering their faces in grief. Two are
kneeling, one kissing her left hand, the other gently touching
her right foot. The monk who stands with arms upraised is
an obvious quotation from Giotto's *The Death of Saint Francis
and the Verification of the Stigmata* (Florence, Bardi Chapel of
Santa Croce). Behind the figure at the extreme right, a door
is partially opened. This is mirrored by another opened door
at the extreme left which reveals a patch of blue sky.

A section, nearly three inches wide on the right side of
the painting, from a point near the raised right hand of the
gesturing monk to the right edge of the panel, is not original
but a modern addition filling in for a section that apparently
was lost when the panels were separated.

The provenance recorded here has been accepted by
most scholars. According to an eighteenth-century descrip-
tion by Abate Carli (Strehlke 1988, p. 239), the panel was
part of a large altarpiece formerly in the cemetery of the Hos-
pital of Santa Maria della Scala, Siena. Controversy continues
concerning the exact commission, the precise placement of
the panels, and even which surviving panels by Giovanni di
Paolo were included. In 1447, the Guild of the Pizzicaioli
(spice merchants) hired Giovanni to paint an altarpiece for the
hospital, but the document neither specified the inclusion of a
predella nor made any reference to Saint Catherine. The
scenes from the saint's life may not have been part of the
original commission but rather, may have been added to the
altarpiece years later, or even, as Boskovits suggests, may
have related to an entirely different commission.

Of still greater complexity is the issue of the placement
of the panels on the altarpiece. If part of the original commis-
sion, they would probably have been arranged as a predella
beneath the central panel, which is Giovanni's masterful *Puri-
fication of the Virgin* (Siena, Pinacoteca); however, on stylistic
and hagiographic grounds, some reject this theory (Pope-
Hennessy 1937; Boskovits and Padoni 1990). It has been ar-

gued logically that the panels could have been placed in a location of honor — that is, to the left of the main image — within an altarpiece depicting Saint Catherine (van Os 1971); a *Saint Catherine* in the Fogg Art Museum has been suggested (Pope-Hennessy 1937; Strehlke 1988) but also rejected (van Os 1971; Boskovits and Padoni 1990) as the work so placed. Further disagreements have centered on the inclusion of panels representing other saints, as well as on the legitimacy of incorporating a Cruxifixion (Utrecht, Rijksmuseum Het Catharijneconvent) as the central scene of the predella. *The Death of Saint Catherine* was probably positioned as the last scene on the right end of the predella, on the base of the right pilaster.

A.N.

60 PLATE 101

MARC-GABRIEL-CHARLES GLEYRE (Swiss, 1806–1874)
Cléonis et Cydippe, about 1845
Oil on panel, 15⅜ x 11⅜ in. (39 x 29 cm)
Private collection, Brookline, Massachusetts

PROVENANCE: Arsène Houssaye; sale Paris (Hôtel Drouot), April 16, 1875 (?); Alexandre Denuellé, Galerie Meissner, Zurich.

EXHIBITION: Grey Art Gallery, New York University; and University of Maryland Art Gallery, *Charles Gleyre, 1806–1874*, 1980, no. 74.

LITERATURE: G. Clément, *Gleyre, Etude biographique et critique* (Geneva and Paris, 1878), pp. 188 and 404, no. 50; *Charles Gleyre ou les illusiona perdues* (exh. cat., Winterthur, Oskar Reinhart Museum), 1974, p. 174.

Gleyre was Swiss by birth and maintained contact with his homeland throughout his life. By 1825 he had made his way to Paris via Lyon. He entered the studio of Louis Hersent, where he learned academic techniques, and also studied watercolor with the English artist Richard Parkes Bonington. In 1828 Gleyre traveled to Rome, remaining there for four years and joining a distinguished intellectual circle that included the painter Horace Vernet (then in charge of the Villa Medici) and the composer Hector Berlioz. Vernet recommended Gleyre to a traveling Bostonian, John Lowell, Jr., who was going to the East and wished an artist to accompany him. Gleyre agreed and for the next two years was in Greece, Turkey, and Egypt. After a disagreement with Lowell, the artist continued on his own to Khartoum. There, he contracted an eye disease and with great difficulty made his way first to Cairo and then to Beirut before arriving back in France in 1837. The works he painted after his recovery show a debt in their brilliant technique to Vernet and are filled with reminiscences of the artist's Egyptian expedition. The many drawings he did for Lowell are now on deposit in the Museum of Fine Arts, Boston.

Gleyre first exhibited at the Salon in 1840, but it was not until the showing of *Le Soir* (*Evening*), later known as *Lost Illusions*, in 1843 that he received recognition. The brooding melancholic character of this work apparently reflected Gleyre's own personality. The painting won a second-class medal and was purchased for the Musée de Luxembourg. Gleyre later painted a replica, which is now in the Walters Art Gallery, Baltimore.

In 1843, Gleyre also took over the atelier that Delaroche had had before departing for Rome. He soon established himself as one of the most popular studio masters in Paris, providing a congenial, inexpensive working place for the young artists — Bazille, Sisley, Monet, and Renoir — who were to form the core of the Impressionist movement.

In the late 1840s, Gleyre painted a series of religious works, most notably *The Parting of the Apostles*, which won a first-class medal at the Salon of 1845 and was purchased by the state. That same year, the artist returned to Italy. There, he studied Byzantine mosaics and the works of Giotto and the Venetian school, with the result that his color became richer and his technique freer. In 1849 Gleyre exhibited *Dance of Bacchantes*, one of several classical subjects he produced during this period. It was to be his last appearance in the Salon, which he felt put too much pressure on artists. Such independence was typical of him and, as a staunch republican, he even refused the Cross of the Legion of Honor.

Gleyre worked slowly, and he painted relatively few works in the second half of his career. In the late 1840s he received commissions from the city of Vaud, Switzerland, to depict themes of Swiss patriotic history (*Le Major Duval* and *The Romans in Bondage*), on which he labored for nearly a decade. Gleyre also completed several large-scale mythological works, including *Hercules and Omphale* and *Pentheus Persecuted by the Maenads* (1863). The last series of works by the artist — all statuesque female nudes — presents more lyrical compositions of happier classical themes: *Minerva and the Graces*, *Sappho*, and *Le Bain* (Norfolk, Chrysler Museum).

The painting *Cléonis et Cydippe* was engraved by A. Nargeot and published in *L'Artiste* in 1862, but dates from the mid-1840s, following the artist's return from Italy. Its small scale and somewhat free treatment suggests it is a preliminary study, but no other version is known. Equally unknown is the subject matter. Clearly a licentious mythological scene, it shows a bacchante, identified by her vine wreath and the thyrsus and tambourine at the back, seducing a youth whose pose is derived from that of an ancient depiction of Narcissus. There are two Cydippes of note in classical legends, but neither conforms to the incident shown here. Clement, who credited Gleyre with a formidable knowledge of antiquity, describes it as "the story of Potiphar's wife translated into Greek."

Gleyre did enjoy inventing his own slightly bizarre variations on ancient themes, as in the equally sketchy and sexually charged images of *Nero and Agrippina* and *The Nymph Echo*. The present work remains, in the words of William Hauptman, "a private classical painting — a caprice perhaps suggested by Arsène Houssaye, to whom Gleyre gave the painting as a gift" (*Gleyre* [New York, 1980], p. 28).

E.M.Z.

61 PLATE 141

VINCENT VAN GOGH (Dutch, active in France; 1853–1890)
Young Woman with Red Bow, 1885
Oil on canvas, 23⅝ x 19¾ in. (60 x 50.2 cm)
Private collection

PROVENANCE: Mentioned by van Gogh in a letter to his brother, December 28, 1885 (letter 442; see lit.); presented by van Gogh to the artist Emile Bernard (1868–1941), Paris (inscribed on the reverse, "reconnu de Vincent van Gogh / Emile Bernard / le 18 fev. 1927"); Ambroise Vollard (1868-1939), Paris; A. Bauchy, Livry; Justin K. Thannhauser, Lucerne and New York; sale Thannhauser, New York (Parke-Bernet), April 12, 1945, no. 104, ill.; Alfred Wyler, Rye, New York.

EXHIBITIONS: Paris, Thannhauser Galleries, 1939; Antwerp, Feestzaal Meir, *Vincent van Gogh*, May 7–June 19, 1955, no. 122, ill.; New York, Solomon R. Guggenheim Museum, *Van Gogh and Expressionism in Modern Art*, July 1–September 13, 1964.

LITERATURE: G. Coquiot, *Vincent van gogh* (Paris, 1923), p. 309 (about 1886–1888); *The Letters of Vincent van gogh to His Brother, 1872–1886*, 3 vols. (Boston and New York, 1927), vol. 2, p. 585, letter 442; J.-B. de la Faille, *Oeuvre de Vincent van gogh: Catalogue raisonné* (Paris and Brussels, 1928), vol. 1, p. 62, no. 207; vol. 2, pl. LV, fig. 207; J.-B. de la Faille, *Vincent van gogh* (Paris, 1939), p. 179, no. 223, ill. p. 179; M. E. Tralbaut, *Vincent van gogh in zijn Antwerpse periode* (Amsterdam, 1948), pp. 200–202, pl. XVII; C. Nordenfalk, *The Life and Work of Vincent van gogh* (New York, 1953), ill. opp. p. 83, fig. 27; A. M. Hammacher, *Genius and Disaster: The Ten Creative Years of Vincent van gogh* (New York, 1968), ill. p. 24; J. Leymarie, *Qui était van gogh?* (Geneva, 1968), ill. p. 53; M. E. Tralbaut, *Van Gogh le mal aimé* (Lausanne, 1969), ill. p. 175; J.-B. de la Faille, *The Works of Vincent van gogh: His Paintings and Drawings* (rev. ed., New York, 1970), p. 108, no. F207; p. 619, no. F207; ills. pp. 108 and 146; P. Lecaldano, *L'Opera pittorica completa di Van Gogh*, vol. 2 (Milan, 1971), pp. 107–8, no. 235, ill. p. 107; J. Lassaigne, *Vincent van gogh*, trans. from French by M. P. de Benedetti (Milan, 1972), ill. p. 25, fig. 2; Jan Hulsker, *The Complete Van Gogh: Paintings, Drawings, Sketches* (New York, 1977), p. 214, fig. 979; p. 216, ill. p. 215; figs. 979 and 221; pl. XIII; Jan Hulsker, *Vincent and Theo Van Gogh: A Dual Biography* (Ann Arbor, Michigan, 1990), pp. 213–14.

A young woman with long black hair is turned in profile to the viewer's left. She wears a red bow in her hair and a white blouse with a ruffled collar.

After living for two years in the village of Nuenen, Vincent van Gogh moved in late November 1885 to Antwerp, where he stayed for barely three months before departing for Paris. During this period he struggled daily against poverty and the effects of malnutrition, but managed to enjoy the society of the city, benefit from its museums and galleries, and advance his art. His letters to his brother Theo in these months were even more extensive than usual, providing an almost constant record of his observations. They offer, for example, his first mention of an interest in Japanese prints, and they record his efforts to draw from casts and a live model while he was enrolled briefly in the local academy. They also express his growing interest in portraiture, to which he was drawn both as a way of mastering figure painting and as "the way to earn the means for greater things" (letter 438). He also remarked that "dealers say . . . women's heads are most likely to sell" (letter 440), and that "there seem to be a lot of beautiful women in this city, and I feel sure money is to be earned by painting women's portraits or

women's phantasy heads and figures" (letter 441). To pursue these aims he found that he needed larger canvases because those "which I have brought with me were too small for the heads, because by using the colors I need more space for the surroundings" (letter 439).

However, van Gogh found few takers for his portraits. He went so far as to offer his painting services to a portrait photographer, despite regarding photography as "waxy," "lifeless," and "conventional." Moreover, he could not afford to pay models, so he decided as a last resort to "have them paid by posing" (letter 437), which is to say, he would give the portrait to his model if he or she agreed to pose again.

This practice may explain why the predecessor of the present work apparently is lost, although in this case the artist reported having paid the sitter to pose. Van Gogh described both paintings and the female sitter in a letter (no. 442) dated December 28, 1885, saying the model "is a girl from a café chantant. . . . When [she] came, she had been apparently very busy the last few nights, and she said something that was rather characteristic. 'Pour moi le champagne ne m'égaye pas, il me rend tout triste' ['champagne doesn't cheer me up, it makes me sad']. . . . Then I understood, and I tried to express something voluptuous and pathetic at the same time." Van Gogh described the lost portrait somewhat cryptically as having a "rather *Ecce Homo*-like" expression.

The present painting has undoubtedly been correctly identified by Hulsker (1990, pp. 213–14) as the second portrait of the same sitter, a painting of which the artist simply said: "From the same model, I began a second study in profile." It is clear from van Gogh's description of the first painting — "a well-toned flesh color, in the neck rather bronze like, jet black hair . . . [with] a touch of scarlet" (letter 442) — that he had executed it with a similar palette and technique. The artist explained that he had had to make the black with carmine and Prussian blue. Changes in van Gogh's palette from dark, monochrome colors to lighter, purer hues, which began late in his Nuenen period and accelerated during his stay in Antwerp and subsequent move to Paris, had him very excited about new pigments in these months. He wrote: "Cobalt is a divine color, and there is nothing so beautiful to bring atmosphere around things. Carmine is the red of wine, and it is warm and witty like wine" (letter 442).

A strong influence on van Gogh's new color scheme and technique in these years was the great seventeenth-century Flemish painter Peter Paul Rubens, whose art he could study in Antwerp better then ever before. Just before painting the present work van Gogh wrote: "Rubens certainly makes a strong impression on me, I think his drawing tremendously good, I mean the drawing of heads and hands in themselves. I am fairly carried away by his way of drawing the lines in a face with dashes of pure red I know he is not as intimate as Hals and Rembrandt, but they are so alive, those heads themselves" (letter 439). In the same letter he commended Rubens's "open-hearted way of painting, his

working with the most simple means," and reported discussing and analyzing the master's technique with a local paint manufacturer named Tyck. When van Gogh went the next month to see Rubens's altarpieces in Antwerp cathedral, he seemed to be put off by the Baroque artist's rhetorical conventions of expression: "Nothing touches me less than Rubens when he expresses human sorrow" (letter 444); however, he went on to reiterate: "Heads and figures of women, these are his specialty. There, he is deep and intimate too. And how fresh his pictures remain by the very simplicity of his technique" (letter 444). This robust and freely executed painting is surely one of the most Rubensian in van Gogh's oeuvre.

Although van Gogh reported that his brunette model "had promised as soon as possible to let me paint a study of her in her room, in a dancer's dress," she refused to pose nude, so he enrolled the next month in a life-drawing class at the academy in Antwerp. However, he had clearly been smitten by the woman, who he said "has a characteristic face and is witty" and who he imagined would be "splendid" in the nude. Indeed, she was for him a topical if rather vague symbol of "*la fin d'un siècle . . .* women have a charm like this in a time of revolution . . . one would be outside the fashion if one kept her outside one's work." In an observation that has a surprisingly modern ring for 1885, he concluded: "It is everywhere the same, in the country as well as in the city; one must take the women into account if one wants to be up-to-date" (letter 442).

P.C.S.

62 PLATE 93

FRANCISCO JOSÉ DE GOYA Y LUCIENTES (Spanish, 1746–1828)
A Woman, Her Clothes Blowing in the Wind, 1824 or 1825
Carbon black and gray-blue wash on ivory, touched with red and green, heightened with graffito, $3\frac{1}{2}$ x $3\frac{3}{4}$ in. (9 x 9.5 cm)
Private collection

PROVENANCE: According to tradition, the series was taken to Madrid by Goya's son after the artist's death in Bordeaux in 1828; sale Paris (Hôtel Drouot), February 22, 1937, no. 56–1; Tomás Harris, London; Mr. and Mrs. R. Kirk Askew, Jr., New York.

EXHIBITIONS: London, The Spanish Art Gallery, *From Greco to Goya*, 1938, no. 28; The Art Institute of Chicago, *Paintings, Drawings and Prints: The Art of Goya* (cat. ed. by Daniel Catton Rich), 1941, no. 157; Los Angeles, UCLA, The Art Galleries, Dickson Art Center, *Spanish Masters*, 1941, no. 5; Los Angeles, UCLA, The Art Galleries, Dickson Art Center, *Spanish Masters*, 1960, no. 21; London, Royal Academy of Arts, *Goya and His Times*, 1963–1964, no. 122.

LITERATURE: Alfred M. Frankfurter, "45 Draftsmen of 400 Years Annual Show," *Art News* 34 (November 16, 1940), p. 16; Elizabeth du Gué Trapier, *Eugenio Lucas y Padilla* (New York, 1940), p. 42; Jane Watson, "News and Comment," *Magazine of Art*, 1941, p. 395; Martín Sebastián Soria, "Las miniaturas y retratos — miniaturas di Goya," *Cobalto* 49, no. 2 (1949), no. 7; Eleanor A. Sayre, "Goya's Bordeaux Miniatures," *Bulletin: Museum of Fine Arts, Boston* 64, no. 337 (1966), p. 120, no. 20; Pierre

Gassier and Juliet Wilson, *The Life and Complete Work of Francisco Goya* (New York, 1971), p. 362, no. 1690; José Gudiol, *Goya* (New York, 1971), vol. 1, p. 348, no. 742; Rita De Angelis, *L'opera pittorica completa di Goya* (Milan, 1974), p. 136, no. 682; José Camon Aznar, *Fran. de Goya* (Caja de Ahorros de Zaragoza, Aragón y Rioja, 1980[?]), vol. 4, p. 218.

63 PLATE 94

FRANCISCO JOSÉ DE GOYA Y LUCIENTES (Spanish, 1746–1828)
Boy Staring at an Apparition, 1824 or 1825
Black wash on ivory, heightened with vermilion and brown, $2\frac{3}{8}$ x $2\frac{3}{8}$ in. (5.9 x 6 cm)
Private collection, Cambridge, Massachusetts

PROVENANCE: According to tradition, the series was taken to Madrid by Goya's son after the artist's death in Bordeaux in 1828; sale Paris (Hôtel Drouot), February 22, 1937, no. 56–4; anonymous; London art market.

LITERATURE: Martín Sebastián Soria, "Las miniaturas y retratos — miniaturas di Goya," *Cobalto* 49, no. 2 (1949), no. 13; Eleanor A. Sayre, "Goya's Bordeaux Miniatures," *Bulletin: Museum of Fine Arts, Boston* 64, no. 337 (1966), p. 122, no. 23 (as tentatively accepted as by Goya); Pierre Gassier and Juliet Wilson, *The Life and Complete Work of Francisco Goya* (New York, 1971), p. 363, no. 1693; José Gudiol, *Goya* (New York, 1971), vol. 1, p. 349, no. 755; Rita De Angelis, *L'opera pittorica completa di Goya* (Milan, 1974), p. 136, no. 685; José Camon Aznar, *Fran. de Goya* (Caja de Ahorros de Zaragoza, Aragón y Rioja, 1980[?]), vol. 4, p. 219.

The reinstatement of Ferdinand VII to the Spanish throne in 1823 initiated a new wave of censorship and oppression. For Francisco Goya, who had just completed the plates for the *Disasters of War* series, this development brought not only dismay, but also anxiety over his personal safety. Thus, at the age of seventy-eight, Spain's greatest living artist left to spend his final years in voluntary exile in Bordeaux. There, in the winter of 1824 and 1825, Goya turned his attention for the first time to the production of miniatures. He described the project in a letter written to his friend Joaquín Ferrer in Paris on December 20, 1825: "It is true that last winter I painted on ivory, and I have a collection of some forty experiments, but it is a new kind of miniature which I never saw before, because it is not done with stippling — things which look more like the brushwork of Velázquez than of Mengs" (quoted in Sayre 1966, p. 84).

Just over half of these "experiments" are known today. Their subjects, broadly painted in a tiny format, are often as enigmatic and disturbing as Goya's *Capriccios* and the "black paintings" in the Quinta del Sordo.

Not inclined toward the labored and minute stipple technique favored for miniatures in the eighteenth century, Goya invented a negative process in which ivory was blackened with wash, then dabbed with water. Occasional additions of color and scratches revealing white highlights further articulate these small scenes. It was perhaps his familiarity with the etching process that led him to develop this analogous dark-to-light technique for miniature painting.

It has been suggested that Goya's experiments in this area were intended as lessons and encouragement for Mari-

quita Weiss, the ten-year-old daughter of Leocadia Weiss, the tempestuous companion of Goya's later years. Goya spoke of Mariquita in correspondence with Ferrer: "This much-talked-of child wants to learn to paint in miniature, and I also wish it, as she is perhaps the greatest phenomenon in the world to be doing what she does at her age. . . . I would like to send her to Paris for a while, but I would like you to take her as though she were my own daughter, offering you either my work or my goods in repayment"(quoted in Sayre 1966, p. 112). However, it seems Mariquita never went to Paris, and perhaps Goya himself took on the task of teaching her the art of miniature painting.

A Woman, Her Clothes Blowing in the Wind is seen from behind, stalwart against the formidable gusts that flap her dark skirt and mantilla and throw her red hair across her face. Only her left foot and the tip of her nose are visible. A similar figure appears in the etching *Mala Noche* from Goya's *Capriccio* series, as well as in two earlier drawings. Sayre relates these three works to a contemporary proverb: "Business is bad when the wind, and not money, hoists the skirts of fine wenches." The identification of the wind-blown women as prostitutes is reinforced, according to Sayre, by their exaggeratedly turned-out toes, a mark of their profession (unpublished manuscript).

The subject of *Boy Staring at an Apparition* is likely to remain more of a mystery. Goya carefully rubbed free of ink the profile of a young, androgynous face at right. However, the central figure, which the artist probably meant to represent an older man, is lost in blotchy shadows. Parallel white striations may indicate upraised hands; broad strokes along the bottom edge may represent an open book. In spite of the Biblical overtones suggested by the contrast between the spot-lit, open-mouthed figure and the older man in shadow (as in an *Inspiration of Saint Matthew*), the subject could just as easily have been drawn from everyday life, as were the majority of the miniatures. Two other works from the series which probably depict Biblical scenes are *Young Woman (Judith?) Beheading a Sleeping Man* and *Young Woman Bathing, as Two Men Watch (Susannah and the Elders?)* (Sayre 1966, nos. 9 and 10). *Young Woman Kneeling in the Darkness* and *Two Moors* (Sayre 1966, nos. 21 and 22) share the ambiguous qualities of the present ivory, in which, as in much of Goya's work, the power of the image is only heightened by its highly enigmatic character.

P.S.

64 PLATE 34

JAN VAN GOYEN (Dutch, 1596–1656)
Farmhouses with Peasants, 1630 or 1636
Oil on panel, 14⅛ x 20¼ in. (36 x 51 cm)
Monogrammed and dated on the fence at lower right:
VG 1630 [or 6]
Private collection

PROVENANCE: British art market; dealer A. S. Drey, Munich; collection W. Duschnitz, Vienna, by 1918; private collection, France; collecting point, Munich, 1945–1946; dealer A. Brod, London, Spring 1962; dealer S. Nystad, The Hague, 1962; collection Sidney J. van den Bergh, Wassenaar; Gallery K. & V. Waterman, Amsterdam, 1982.

EXHIBITIONS: Leiden, Stedelijk Museum "de Lakenhal," *17de eeuwse meesters uit Nederlandse particulier bezit,* 1965, no. 18; Amsterdam, Rijksmuseum; Boston, Museum of Fine Arts; and Philadelphia Museum of Art, *Masters of 17th-Century Dutch Landscape Painting* (cat. by Peter C. Sutton et al.), 1987–1988, pp. 323–24, no. 34.

LITERATURE: C. Hofstede de Groot, *A Catalogue Raisonné of the Works of the Most Eminent Dutch Painters of the Seventeenth Century,* trans. by Edward G. Hawke (London, 1908–1927), vol. 8, no. 385a (as dated 1639); A. B. de Vries, *Verzameling Sidney J. van den Bergh* (Wassenaer, 1968), pp. 46–47, ill.; Hans-Ulrich Beck, *Jan van Goyen 1596–1656, Ein Oeuvreverzeichnis,* vol. 2 (Amsterdam, 1973), no. 1141, ill.; vol. 3 (Doornspijk, 1987), p. 274; *Tableau* 4 (Summer 1982), p. 521, ill. (as dated 1630).

Three peasants — two seated and one standing — converse by a cluster of humble farm buildings. To the right is a rough plank fence; to the left, two travelers make their way across an undulating dune landscape. At the far left are other low buildings nestled in the dunes. The thatched roof of the foreground structure has crumbled in disrepair, exposing the skeletal frame of wooden supports.

Like his fellow Haarlem landscapists Salomon van Ruysdael, Pieter de Molijn, Pieter van Santvoort, and others, van Goyen experimented in the late 1620s and 1630s with tonal landscapes depicting the native Dutch countryside, particularly the craggy dunes surrounding the city of Haarlem. For the most part, these landscapes focus on specific simple motifs: a gnarled tree, the sweep of a sandy track through the dunes or, as here, unpretentious huts or other rural structures (compare, for example, cats. 90 and 128).

Van Goyen painted a number of compositions similar in theme to the present work throughout the early 1630s, for example, *Landscape with Cottage and Barn* of 1632 (Manchester, City Art Gallery), *Landscape with Thatched Farmhouse* of 1631 (Carcassonne, Musée des Beaux-Arts) and *Children before a Farmhouse* of 1631 (Saint Petersburg, Hermitage); all feature modest farm buildings by the side of a diagonally receding road or track. The same dilapidated thatched hut appears in a drawing attributed to van Goyen in the Musée des Beaux-Arts, Besançon.

On the basis of comparison with these works, Sutton (1987–1988, p. 324) suggests the date on *Farmhouses with Peasants* be read as 1630, noting, however, that the slightly more colorful palette may indicate a somewhat later date.

M.E.W.

65 PLATE 36

JAN VAN GOYEN (Dutch, 1596–1656)
Winter Landscape with Skaters near a Town Wall, 1638
Oil on panel, 15½ x 24¼ in. (39.5 x 61.5 cm)
Monogrammed and dated: *1638*
Private collection

PROVENANCE: Sale Rietmulder, The Hague, July 12, 1773, no. 13 (with a pendant; for Fl 46.5); sale Nicolaes de Bruijn and John Alenzoon, Leiden (Delfos), May 10, 1774, no. 57 (with a pendant; for Fl 77, to Delfos); sale Pieter de Waart, The Hague, September 29, 1779, no. 8 (possibly with the pendant; for Fl 25.5, to Fraterman); sale Amsterdam, October 30, 1780, no. 20 (for Fl 39, to Wubbels); sale Amsterdam, August 14, 1793, no. 51 (for Fl 47); with Hans W. Lange, Berlin, about 1942; with Edward Speelman, London, 1959; with Philips of Hitchin, 1961; with John Mitchell, London, 1961; with Galerie Sanct-Lucas, Vienna, 1982–1983; with X. Scheidwimmer, Munich, 1983–1984; private collection; sale London (Christie's), December 14, 1990, no. 89, ill.

LITERATURE: C. Hofstede de Groot, *A Catalogue Raisonné of the Works of the Most Eminent Dutch Painters of the Seventeenth Century*, trans. by Edward G. Hawke (London, 1908–1927), vol. 8 (1927), no. 1175; Hans-Ulrich Beck, *Jan van Goyen 1596–1656, Ein Oeuvreverzeichnis*, vol. 2 (Amsterdam, 1973), p. 27, no. 53, ill.; vol. 3 (Doornspijk, 1987), p. 144.

Van Goyen dated winter landscapes with a circular format as early as 1621, and with a rectangular format two years later. By 1638, when he dated this picture and three other winter scenes (Beck 1973, nos. 50–52), he had fully developed his atmospheric effects and had introduced a rich variety of amber and rust hues to his earlier, "tonal" palette. The horizontal format and diagonal composition, which juxtapose the large, blunt forms of an unidentified city wall in the right foreground with a low horizon filled with distant skaters and the faint shapes of buildings on the left, was one that van Goyen continued to favor in his winter scenes of the 1640s (compare, for example, the well-known *Winter Landscape with a Distant View of Dordrecht and Merwede Castle*, 1642; London, National Gallery, no. 1327). In the present painting, however, the rapid recession is enhanced by a daringly empty triangle of ice in the central foreground — a passage that, as Beck (1987, p. 144) observed, until 1982 had been obscured by two pairs of overpainted children skating. Presumably, these later additions were ordered by someone who foolishly misunderstood van Goyen's restraint and understatement, preferring a more conventionally populated skating scene.

In 1773, 1774, and 1779, the painting was sold with a pendant by van Goyen of a *River Landscape*, which unfortunately has remained untraced since then.

P.C.S.

66 PLATE 38

JAN VAN GOYEN (Dutch, 1596–1656)
View of Rhenen, 1640
Oil on panel, 21¼ x 17⅛ in. (43 x 54 cm)
Signed and dated at lower right: *VG 1640*
Private collection

PROVENANCE: Collection Edgar Speyer, London, 1914; sale Robert Hewitt, New York, February 29, 1956, no. 14, ill.; sale Sidney J. Lamon (of New York), London (Christie's), June 29, 1973, no. 24, ill.; dealer Richard Green, London, 1974; sale London (Christie's), July 8, 1988, no. 43, ill.

EXHIBITIONS: London, Guildhall, 1903, no. 151; London, Whitechapel, 1904, no. 148; London, Richard Green, 1974, no. 14.

LITERATURE: C. Hofstede de Groot, *A Catalogue Raisonné of the Works of the Most Eminent Dutch Painters of the Seventeenth Century*, trans. by Edward G. Hawke (London, 1908–1927), vol. 8 (1927), no. 207; Hans-Ulrich Beck, *Jan van Goyen 1596–1656, Ein Oeuvreverzeichnis*, vol. 2 (Amsterdam, 1973), p. 183; vol. 3 (Doornspijk, 1987), p. 186; Peter C. Sutton et al., *Masters of 17th-Century Dutch Landscape Painting* (exh. cat., Amsterdam, Rijksmuseum; Boston, Museum of Fine Arts; and Philadelphia Museum of Art, 1987–1988), p. 330, ill.

Situated on the rough, sloping banks of the Rhine, the city of Rhenen is seen in profile against a towering, cloud-filled sky. Three figures rest on a spit of land in the immediate foreground; at the right a horse-drawn cart and two other figures make their way along a rutted track. At the left a ferry, heavily laden with passengers and animals, pushes off from the river bank, while a second boat glides across the water beyond. A level panorama fills the distance.

Rhenen, a walled city on the north bank of the Rhine, southeast of Utrecht, is surrounded by low hills on three sides. Its picturesque setting made it a popular site for seventeenth-century Dutch landscape painters, including Hercules Segers, Rembrandt, Jacob van Ruisdael, and Aelbert Cuyp. Van Goyen himself painted several views of the city from a variety of vantage points between 1636 and 1655. The tall, elegant tower of the late Gothic church of Saint Cunera (1442–1531) is the city's most prominent landmark; seen just left of center in van Goyen's painting are the twin towers of the Rijnpoort, and the windmills at the extreme right mark the northern reaches of the city. In addition to their picturesque qualities, such city depictions also evoked the historical associations of the site: in this instance, Rhenen was a crucial outpost in defending the bishopric of Utrecht throughout the Middle Ages.

Although van Goyen's *View of Rhenen* is a reasonably accurate topographical account of the town and its environs, the artist altered several details: for example, he exaggerated the height of the tower and the other monuments in order to present a more imposing silhouette. The composition is closely related to his larger *View of Rhenen* (1646; Washington D.C., Corcoran Gallery of Art, William A. Clark Collection, inv. 26.95), in which the town is seen from a more distant remove, and the rolling terrain receives greater prominence.

M.E.W.

67 PLATE 37

JAN VAN GOYEN (Dutch, 1596–1656)
Old Buildings with a Tower beside a River, 1643
Oil on panel, 17 x 25¼ in. (43 x 65.2 cm)
Signed and dated at lower left
Private collection

PROVENANCE: Edward Bok, Philadelphia; with dealer Anthony Stuempfig, Philadelphia, from whom it was acquired by the present owner in 1990.

LITERATURE: Hans-Ulrich Beck, *Jan van Goyen 1596–1656, Ein Oeuvreverzeichnis,* vol. 3 (Doornspijk, 1987), p. 232, no. 749A, ill.

In the left foreground a crumbling wall and a six-sided tower with steepled roof rise above a river. Behind the first is a second, square tower with gabled roof and dovecote. Along the shore are many tiny figures and small sailing vessels. In the water in the lower-right corner, a shadowed barrel and old pilings serve as a repoussoir.

Van Goyen painted more than 150 river and canal scenes with various stone buildings (watchtowers, castles, bulwarks, windmills, churches, and ruins) rising from a diagonally retreating bank bordering still water. Some of these structures — for example, Fort Lillo on the Scheldt River, the Pelkussenpoort near Utrecht, and Montfoort and IJsselstein Castles — can be identified, but most are imaginary, as is the case in the present picture. A close variant of the image which has an additional pointed tower in the left distance and includes other architectural changes was last recorded as being with the Amsterdam dealer van Wisselingh in 1917, and was said to be signed and dated 164[2]; thus, it may have been van Goyen's first conception of the present composition (see C. Hofstede de Groot, *A Catalogue Raisonné,* vol. 8 [London, 1922], nos. 795 and 916; Beck 1987, vol. 2, no. 739, ill.; and vol. 3, p. 231). In the late 1630s and through the mid-1640s, van Goyen was especially interested in these themes and designs.

P.C.S.

68 PLATE 8

GIANFRANCESCO BARBIERI (called Il Guercino; Italian, 1591–1666)
Cupid Burning His Bow and Arrows, 1666
Oil on canvas, 41¾ x 33 in. (106 x 84 cm)
Private collection

PROVENANCE: Sale New York (Christie's), May 31, 1979, no. 133; Central Picture Galleries, New York.

LITERATURE: Denis Mahon and Nicholas Turner, *The Drawings of Guercino in the Collection of Her Majesty the Queen at Windsor Castle* (Cambridge, 1989), p. 173.

Following the death of Guido Reni in 1642, Guercino established himself as the leading painter of Bologna. He fortunately kept an account book (*Libro dei Conti,* published in 1808 and 1841), which has allowed many of his works to be documented. On May 18, 1666, he received 325 lire for a painting described as "un puttino in atto di abbruciare gli strali" ("a Cupid in the act of burning his arrows"). In the present work, a Cupid in a dark landscape holds two broken arrows and burns others, along with his bow and quiver. In the left background, there is a castle fortress and a woman in a peaked hat with a child, both seen from the back.

The subject of the virtuous Cupid was a popular one in Bologna. Bartolomeo Cesi painted an *Amor Virtuoso* (see Adriano Cera, *La pittura emiliana del '600* [Milan, 1982], pl. 13), and Guercino himself (as was pointed out by Rafael Fernandez in a letter of 1981 to the owner) painted two in 1654. One of these is now in the collection of the Prado (see Luigi Salerno, *I Dipinti del Guercino* [Rome, 1988], p. 372, no. 303).

A now-lost drawing by Guercino, of which there is a copy by Bartolozzi and which was subsequently engraved by the latter, shows a kneeling Cupid facing right, watching his bow and arrow burn (Mahon and Turner 1989, no. 591, fig. 361). Only a mid-nineteenth-century photograph of the original drawing is known (see Prisco Bagni, *Il Guercino e il suo falsario, I disegni di figura* [Bologna, 1990], p. 118, fig. 97).

The present painting was sold as a work by Benedetto Gennari the Elder at Christie's, New York, in 1979. Sir Denis Mahon and Nicholas Turner, describing it (on the basis of a reproduction in the catalogue of that sale) as a work of Guercino's school evidently related to his late period, have pointed out (1989, p. 173) that the attribution to this Gennari was untenable, since that artist had died as early as 1610. They have further noted that the existence in 1841 of a painting of this precise subject was recorded in the Casa Tiazzi at Cento as being by Guercino's nephew Cesare Gennari (editorial footnote by Gaetano Atti to Malvasia, *Felsina Pittrice* [1841], vol. 2, p. 305, no. 86).

The painting was first attributed to Guercino by the present owner. Having seen the painting, Sir Denis Mahon observed that it "does not have the characteristics of Cesare Gennari, but rather that its considerable delicacy indicates that it must be the lost work from the last year of Guercino's life; further, its size is consistent with the price paid for that painting."

Although the surface is somewhat abraded, the handling of the purple drapery and of certain other passages, such as the Cupid's raised hand, displays brilliance and subtlety typical of the master.

E.M.Z.

69 PLATE 49

JORIS VAN DER HAAGEN (Dutch, 1613 or 1617–1669)
View of the Swanenturm, Kleve, 1660s
Oil on canvas, 35½ x 44⅛ in. (90 x 112 cm)
Signed at lower middle: *JHagen* (J and H ligated)
Private collection

PROVENANCE: Sale N. de Bruyn, Leiden, May 10, 1775, no. 27 (not sold); sale K. R. Mackenzie, London, June 4, 1917, no. 127; sold by the dealer Thompson to M. J. W. F. van der Haagen, The Hague, 1919; sale Amsterdam (Sotheby-Mak van Waay), March 14–15, 1983, no. 20; dealer S. Nijstad, The Hague, 1985.

EXHIBITIONS: The Hague, *Het Hollandse waterlandschap*, 1932, no. 26; Arnhem, Gemeentelijk Museum, *Twee eeuwen kunst in en om Arnhem, 1600–1800*, 1952, no. 10; Amsterdam, Rijksmuseum; Boston, Museum of Fine Arts; and Philadelphia Museum of Art, *Masters of 17th-Century Dutch Landscape Painting* (cat. by Peter C. Sutton et al.), 1987–1988, no. 40.

LITERATURE: H. Schneider, in Ulrich Thieme and Felix Becker, *Allgemeines Lexikon der bildenden Künstler von der Antike bis zur Gegenwart* (Leipzig, 1907–1950), vol. 15 (1922), p. 463; J. K. van der Haagen, *De schilders Van der Haagen en hun werk* (Voorburg, 1932), p. 42, no. 143S, fig. XXIV; Friedrich Gorissen, *Conspectus Cliviae: Der klevische Residenz in der Kunst des 17. Jahrhunderts* (Kleve, 1964), no. 109, ill. (collection C. J. Noothoven, Arnhem); Heinrich Dattenberg, *Die Niederrheinansichten holländischer Künstler des 17. Jahrhunderts* (Düsseldorf, 1967), no. 197, ill.

At the left, beyond a still expanse of water, the dramatic silhouette of the Swanenturm, the fortified castle at Kleve, rises from a tree-studded promontory. In the foreground, a drover urges cows and sheep along the sandy road, while other animals graze in a field on the far shore. Stately trees flank both sides of the river at the right, filtering the angled rays of the sun, which dramatically accent the cloud-filled sky.

The city of Kleve, on the lower Rhine, was a popular subject among seventeenth-century artists. Nestled in a hilly forested area with open fields to the north, Kleve's majestic profile was complemented by its picturesque setting. Artists depicted the city from a variety of angles, although the view from the Kermisdal (as in van der Haagen's painting) was perhaps the most popular. It was in addition a significant historical site. Formerly the residence of the Elector Palatinate, Kleve had since 1647 been under the stadholdership of Johan Maurits van Nassau, who modernized and rebuilt the city, making it an important economic outpost for the Dutch inland shipping trade.

A resident of The Hague for much of his adult life, the well-traveled van der Haagen was a painter and a draftsman of topographical views, woodlands, and panoramas; the identifiable locales depicted in his work include sites throughout the Netherlands, near Brussels, and along the lower Rhine near Elten and Kleve. Van der Haagen depicted Kleve and its environs on numerous occasions throughout the 1660s. A topographical drawing related to the present painting (Besançon, Musée des Beaux-Arts) presents a less complex view of the city, omitting the wooded grove that occupies the right half of the painting; the drawing may have served as a preparatory study for the painted composition.

Other views of Kleve close to the exhibited work include a *View of the Swanenturm, Kleve* formerly on loan to the Szépmüvészeti Múzeum, Budapest (about 1920), and a painting of the same subject in the Rijksmuseum, Amsterdam (inv. C 138). The general composition of the latter differs from the present painting in only minor details, for example, the massed trees at the right and the foreground staffage.

M.E.W.

70 PLATE 24

CORNELIS CORNELISZ VAN HAARLEM (Dutch, 1562–1638)
Idealized Portrait of a Historical or Mythological Figure, 1632
Oil on panel, 5⅛ x 4⅛ in. (13 x 10.5 cm)
Monogrammed and dated: *1632*
Private collection

PROVENANCE (kindly provided by P. J. J. van Thiel): Sale Brussels (Fiévez), December 6, 1937, no. 18; sale Amsterdam (F. Muller), June 8, 1948, no. 14; with dealer P. de Boer, Amsterdam, 1948; private collection, France; sale London (Phillips), December 6, 1988, no. 70, ill.; acquired from Johnny van Haeften, London.

Cornelis Cornelisz van Haarlem, together with Karel van Mander and Hendrick Golzius, was a leader of the influential Mannerist movement in Haarlem. However, in his mature and later works, Cornelis gradually relaxed the torsion and extreme artifice of his earlier manner and turned to a gentler, weighted classicism. A later work, executed a half-dozen years before his death, the present painting eschews the nervous animation of the Mannerists for dignity and calm.

Although identified only as *A Young Man Wearing a Crown of Leaves* when it was sold in 1988, this small, bust-length figure is probably a historical or mythological figure. The laurel wreath, open-necked collar, and other cursory indicators of an antique costume link the figure with the literary realm of history, and his generalized features probably rule out the possibility of a *portrait historié* — the depiction of an actual person in the guise of a historical one. Idealized bust-length series of the first twelve Roman emperors were commissioned in the sixteenth and seventeenth centuries by princely patrons, presumably in order to legitimize their own power by association with antique predecessors. Titian created the most influential cycle, and in the North one of the most famous series was probably painted for Prince Frederik Hendrick of Orange between 1616 and 1625 and presented by 1680 to his son-in-law, the Grand Duke of Brandenburg; it is now preserved in the Jagdschloss Grunewald, Berlin (see Helmut Börsch-Supan, *Die Gemälde im Jagdschloss Grunewald* [Berlin, 1964]; and Peter van Duinen, "Keizers in de Republiek; een serie Romeinse Keizersportretten door twaalf Nederlandse schilders [c. 1615–c. 1625]" [Ph.D. diss., Amsterdam, Vrije Universiteit, 1989]). Among the twelve artists who collaborated on the series were many of the leading history painters from Antwerp (including Rubens), Amster-

dam, Utrecht (Gerard van Honthorst, Dirck van Baburen, Hendrick ter Brugghen, and Abraham Bloemaert), and Haarlem (Hendrick Goltzius and Cornelis van Haarlem, whose *Portrait of Augustus* [oil on canvas, 26¾ x 20⅞ in. (68 x 53 cm)] is signed and dated 1622). Cornelis's *Augustus* preceded the present work by a full decade; however, both works are of handsomely idealized young men, depicted bust-length and wearing a laurel wreath.

A potentially important clue to the subject's identity is provided by a probable pendant, of the bust-length image of a woman, which is also signed and dated 1632 and is of virtually the same dimensions (oil on panel, 5⅛ x 3¹⁵⁄₁₆ in. [13 x 10 cm], sale Christopher Norris et al., London [Christie's], July 4, 1952, no. 9 [to P. de Boer]; later in a Swedish private collection). This painting depicts the subject in a complementary pose, turned to the viewer's left but looking out directly at the viewer and wearing a low-cut historical costume with short, white headdress. A pair of slightly smaller, but similarly conceived, bust-length pendants by Cornelis van Haarlem, again featuring a man with an open collar and a laurel wreath, and a woman in similar historical attire, passed through a sale in London (Christie's, May 15, 1936, no. 9), and later were sold in Berlin (H. W. Lange, December 3, 1940, nos. 48 and 49); P. J. J. van Thiel (in a letter of March 3, 1992) dated this pair to about 1633. Although Cornelis occasionally depicted Adonis wearing a laurel wreath and being seduced by Venus (see, for example, sale Berlin, April 30, 1930, no. 40, ill.; signed and dated 1630), the fully clothed couple depicted here cannot be certainly identified with the mythological lovers.

P.C.S.

71 PLATE 53
DIRCK HALS (Dutch, 1591–1656)
Merry Company, 1625
Oil on panel, 15¼ x 20¼ in. (38.7 x 51.5 cm)
Signed and dated at right, on column: *DHALS. an 1625*
Private collection

PROVENANCE: Acquired by the present owner from Richard Green, London.

On an elegant terrace that recedes, from left to right, toward a still body of water, a standing couple listen to the music of a man playing a bass viola da gamba and a woman playing a lute. The two couples are both dressed in colorfully fashionable attire. Behind them on the left a serving boy sets a large pie on a table beside which is a wine cooler on a shelf. Above the boy is an elaborate bird pie and a richly decorated covered cup.

Following David Vinckboons, Willem Buytewech, and Esaias van de Velde, who pioneered the subject in the first two decades of the seventeenth century, Dirck Hals was an early practitioner of outdoor genre scenes of merry compa-

nies on a terrace. One of his earliest dated works, the painting of 1621 formerly in the Städtische Galerie, Frankfurt (inv. no. 825), and last seen in a sale in London (Christie's, April 21, 1989, no. 32, ill.), already included all of the major elements of the present painting's composition, including a horizontal format with a terrace and musicians on the left, and water on the right. In a painting of an interior genre scene dated 1623, in the Hermitage, Saint Petersburg (no. 2814), the bass viola da gamba player also appears, suggesting the artist reused motifs that had no doubt been recorded in drawings. The composition of the present painting can also be compared to that of an undated work in the John G. Johnson Collection, Philadelphia (no. 435). Hals's best works seem all to date from the early and mid-1620s or about 1623 to 1625, after which his painting style became broader, his figure types more generalized, and his designs formulaic.

The design of this painting closely resembles those of several scenes in Hals's *Five Senses*, a series of 1623 which was engraved by Cornelis Kittensteyn. Indeed, the possibility ought to be considered that the present work was also originally part of a series on the Senses, specifically, the one embodying Hearing. In the seventeenth century the Senses were still often regarded as reprehensible faculties; though they might have added to one's empirical understanding of the world, they had to be controlled and tempered. Thus, cautionary inscriptions appear on the prints after Hals's *Five Senses*. In his interior genre scene of musicians embodying Hearing, the Latin inscription warns: "The song that is sung appeals to Hearing, and the sounds of the strings delight the ear with refreshing sweetness. Who would deny it? Yet I must condemn an excessively keen interest in the arts that distracts the spirit from higher aspirations." Like other artists of this period, Hals also depicted all five Senses in the allegorical guise of merry company scenes (see sale Laren [Christie's], October 30, 1978, no. 38; for discussion, see E. de Jongh et al., *tot Lering en Vermaak* (exh. cat., Amsterdam, Rijksmuseum, 1976, pp. 122–23).

P.C.S.

72 PLATE 22
FRANS HALS (Dutch, 1581 or 1585–1666)
Portrait of a Man, 1637
Oil on canvas, 36½ x 26½ in. (93 x 67 cm)
Inscribed at upper right: *AETAT.SVAE 37- / AN° 1637-*
Private collection

73 PLATE 23
FRANS HALS (Dutch, 1581 or 1585–1666)
Portrait of a Woman, 1637 (the pendant)
Oil on canvas, 36½ x 26½ in. (93 x 67 cm)
Inscribed at upper left: *AETAT.SVAE 36. / AN°.1637.*
Private collection

PROVENANCE: Comte de Thiènnes, 19th century; by descent to his grand-daughter, Comtesse de Limburg Stirum, Warmond, Holland; M. E. van Gelder, Château Zeecrabbe, Uccle, Belgium, by 1912; Sir William van Horne, Montreal, by 1915; Miss Adaline van Horne, by 1936; Mrs. William van Horne, by 1970; acquired by the present owner from Wildenstein's, New York, March 1973; sale London (Sotheby's), December 10, 1986, nos. 52 and 52a, ills. (bought in).

EXHIBITIONS: Montreal, Art Association, *Inaugural Loan Exhibition*, 1912, nos. 66 and 67; Montreal, Art Association, *A Selection from the Collection of Paintings of the Late Sir William van Horne, K.C.M.G. 1843–1915*, 1933, nos. 30 and 31; Montreal, Art Association, *Five Centuries of Dutch Art*, 1944, no. 34 and 35; Rijksmuseum, Amsterdam, 1973–1979 (on loan); Fogg Art Museum, Harvard University, Cambridge, 1979–1986 (on loan).

LITERATURE: C. Hofstede de Groot, "Twee nieuw aan het licht gekomen portretten van Frans Hals," in *Onze Kunst* vol. 20 (1911), pp. 172–73 (French trans. in *L'Art Flamand et Hollandais* [1912], pp. 1–2); *L'Art Flamand et Hollandais* 20 (1913), p. 120; W. von Bode and M. J. Binder, *Frans Hals: His Life and Work* (Berlin, 1914), vol. 2, no. 162, pls. 98a and 98b; W. R. Valentiner, *Frans Hals* (*Klassiker der Kunst*; Stuttgart and Berlin, 1921), nos. 155 and 156, ills.; W. Drost, *Barockmalerei in der germanischen Ländern* (Potsdam, 1926), pp. 136–40; W. R. Valentiner, *Frans Hals Paintings in America* (Westport, Connecticut, 1936), pp. 60–61; C. D. Gratama, *Frans Hals* (1943), p. 56, nos. 68 and 69, ills.; R. H. Hubbard, *European Painting in Canadian Collections: Earlier Schools* (Toronto, 1956), pp. 81 and 151, pls. 38 and 39; S. Slive, *Frans Hals* (London, 1970–1974), vol. 2, pls. 178 and 179; vol. 3, pp. 60, 181, and 190, nos. 109 and 110; Claus Grimm, *Frans Hals* (Berlin, 1972), pp. 97, 203, 215, and 216, nos. 86 and 87; S. Slive, in *Harvard Gazette*, February 29, 1980, p. 3; Claus Grimm, *Frans Hals: The Complete Works* (New York, 1990), pp. 48, 143, and 184, pls. 39a and 39b, cats. 87 and 88.

A couple are portrayed as traditional companion pieces, or pendants, with the man on the viewer's left (dexter) and the woman on the right (sinister). The artist depicted the two figures in three-quarter length and turned slightly toward one another, although they both look directly at the viewer. The man wears a brown beard, a bristling mustache, and relatively close-cropped brown hair. Over his black costume with fashionable slinged sleeve he wears a white ruff, and he holds a pair of light gray gloves in his left hand. His right hand rests on his chest. The woman also wears a conservative but costly black-and-white outfit with a broad millstone ruff and a starched white cap and cuffs. In her right hand she too holds gloves.

Pendant portraits of married couples were produced in great numbers in the Netherlands in the seventeenth century, not only because the Dutch enjoyed self-images that seemed to verify their domestic and social aspirations, but also because of the simple practical advantage that pendants had over double portraits for the relatively intimately scaled domestic architecture in Holland: two smaller paintings might fit where one large one would not. Frans Hals was one of the most successful portraitists of his day, undoubtedly in part because he invested his subjects with such vitality and immediacy even while observing the age's conservative standards of dress and deportment and the pictorial conventions and typology of portraiture. The couple depicted here remain unidentified, but they could, like many of Hals's other patrons,

have come from the class of wealthy local merchants in Haarlem.

Hals had painted pendant portraits since his earliest years of activity (see *Portrait of the Man Holding a Skull*, about 1610–1615, Birmingham, Barber Institute of Art; and its pendant, collection of the Duke of Devonshire, Chatsworth, National Trust), but the present works, both dated 1637, are mature efforts. They may be compared in technique and design to other pendants by Hals from the mid to late 1630s, including *Lucas de Clerq* and *Feyntje van Steenkiste*, both of which are dated 1635 (Amsterdam, Rijksmuseum, nos. C556 and C537), and to *Portrait of a Woman*, which is dated the same year (New York, Frick Collection, no. 10.1.12). Hals's masterfully broad but controlled brushwork and his limited but powerfully contrasted palette may in the present works be appreciated in all of their authority and subtlety.

Typically, the woman in this portrait is given a somewhat more restrained pose than that of her spouse, but Hals was exceptional among his fellow Dutch portraitists in imbuing his depictions of female sitters with the same illusion of immediacy and personality he gave those of the men. The gloves that both of the sitters hold, like the rest of their costumes, were expensive accessories but also carried strong social connotations. Gloves were, for example, often presented to guests at a wedding as a token and remembrance of the marriage ceremony. Although these items of apparel were common enough in portraits by 1637 that they need not have carried the weight of symbol, the gesture of removing one or both gloves was commonly associated with candor and openness — a notion complemented by the rhetorical gesture of the man placing his hand on his heart. (On the symbolism and associations of gloves, see David R. Smith, *Masks of Wedlock: Seventeenth-century Dutch Marriage Portraiture* [Ph.D. diss., Columbia University; Ann Arbor, 1982]).

As Hofstede de Groot observed (1911, p. 172), the fact that the figures occupy and fill their canvases so tightly suggests the two paintings probably were cut down slightly on all sides. However, all the salient features of the designs remain intact, and the surfaces are in a very good state. The provenance of the paintings has been romantically extended by legends (first reported by Hofstede de Groot) that placed them in Hals's own circle, but Comtesse de Limburg-Stirum refuted these claims in 1912.

P.C.S.

74 PLATE 31

GIJSBERT GILLISZ D'HONDECOETER (Dutch, 1604–1653)
Landscape with Animals, 1643(?)
Oil on canvas, 32¼ x 46½ in. (82 x 118 cm)
Signed and dated at bottom, left of center: *GJ*. (in ligature)
DHondecoetere. (D and H in ligature) *A° 164[3?]*
Private collection

PROVENANCE: Dealer W. Paech, Amsterdam; collection Dr. J. A. van
Dongen, Amsterdam, by 1931; dealer Charles Roelofsz, Amsterdam; ac-
quired from dealer Robert Noortman, 1987.

EXHIBITIONS: Dordrecht, Dordrechts Museum, *Nederlandse Landschappen
uit de zeventiende eeuw* (cat. by Laurens J. Bol), July–August 1963, no. 52
(collection Van Dongen; as dated 1641); Bolsward, Stadhuis, *Het Neder-
landse landschap in de 17de eeuw*, 1967, no. 21; Amsterdam, Museum Wil-
let van Holthuysen, *De verzameling Van Dongen*, 1968, no. 10.

LITERATURE: Laurens J. Bol, *Holländische Maler des 17. Jahrhunderts nahe
den Grossen Meistern* (Braunschweig, 1969), pp. 132–33 (as dated 1641);
Kurt J. Müllenmeister, *Meer und Land im Licht des 17. Jahrhunderts* (Bre-
men, 1978–1981), vol. 2, p. 76 (as dated 1641); Jan Briels, *Vlaamse
Schilders in de Noordelijke Nederlanden in het begin van de Gouden Eeuw*
(Antwerp, 1987), pp. 203–204, ill.

A dapple-gray Frisian horse with flowing mane and tail com-
mands center stage among a group of sheep, goats, and
horses gathered in a small clearing. Beyond the shadowed re-
poussoir of a tree-topped hillock at the left, a tumbledown
gate blocks passage to a pathway that winds up the wooded
hillside through a tangle of undergrowth. A piebald horse
inches down the precipitous drop leading to a rocky valley at
right; at far right, ducks frolic on a mossy rock in the middle
of a rushing stream. On a plateau in the middle distance is a
herdsman with his cows.

Son of the landscapist Gillis de Hondecoeter (about
1575 or 1580–1638) and father of the bird and still-life painter
Melchior de Hondecoeter (1636–1695), Gijsbert emulated his
father's minutely detailed wooded and mountainous land-
scapes during the 1630s. By the 1650s, influenced by the
landscapes and animal paintings of Aelbert Cuyp (1620–
1691), Hondecoeter had developed a freer, more naturalistic
style, as evident in his *Landscape with Hunters* of 1652 (Am-
sterdam, Rijksmuseum, inv. A 751) or his *Landscape* in
Enschede, Rijksmuseum Twenthe; the latter in fact may have
been executed in collaboration with Cuyp.

Landscape with Animals documents the progress of this
development in Hondecoeter's oeuvre. The setting recalls
imaginary landscapes by his father and by Roelandt Savery
(1576 or 1578–1639). The horses particularly are rendered in
the fanciful and archaizing manner favored by Savery, and
may have been derived from a print by the latter artist. The
dense overlapping of landscape forms at the left contrasts
with the more open atmospheric perspective at the right,
where the more softly rendered forms of the landscape dis-
solve into the horizon.

Although the date of this work has previously been
published as 1641, the last digit is most convincingly read
as a "3."

M.E.W.

75 PLATE 80

JAN VAN HUYSUM (Dutch, 1682–1749)
Floral Still Life with Hollyhock and Marigold, n.d.
Oil on canvas, 15⅞ x 12⅞ in. (40.2 x 32.8 cm)
Signed on ledge at lower right: *Jan Van Huysum*
Private collection

PROVENANCE: Sale London (Christie's), May 11, 1923, no. 122, with pen-
dant (as "Flowers in Glass Vases — a pair, 15 x 12 1/2 in."; for Gn 95, to
Spink); (possibly) collection T. W. H. Ward, London, 1930; sale New
York (Christie's), January 16, 1992, no. 98.

LITERATURE: (Possibly) M. H. Grant, *Jan van Huysum 1682–1749* (Leigh-
on-Sea, 1954), no. 241 (as "*Vase of Flowers*. Standing upon a stone table
in a vase a small bunch of flowers, a snail crawls on the table top. Can-
vas, 16 1/2 x 12 1/2 in. [41.9 x 31.8 cm.], coll. T. W. H. Ward, London,
1930").

Modest in size but lush in its immediacy, a small bouquet of
flowers rests on a stone ledge or table. Light from the left
highlights the texture of the foliage and passes through the
glass vase, casting a soft reflection on the tabletop. The infor-
mal arrangement is dominated by the diagonal axis created
by a stalk of pink hollyhocks and the single oversized mari-
gold pulled downward by the weight of its bloom. Just in
front of the vase, a snail inches onto the tabletop.

Son of the still-life and decorative painter Justus van
Huysum the Elder (1659–1716), Jan van Huysum is known
primarily as a painter of flower and fruit still lifes, but he also
painted Arcadian landscapes in the manner of Gaspard
Dughet. Though van Huysum lived his entire life in Amster-
dam, his works were avidly collected throughout Europe.
His earliest biographers note that he was obsessively secretive
about his working process and permitted no one to enter his
studio. Van Huysum almost certainly painted his flowers di-
rectly from nature. In a 1742 letter to A. N. van Haften,
agent for the Duke of Mecklenberg in Schwerin, the artist
noted: "The flower piece is very far advanced; I could not
procure a yellow rose last year, otherwise it would have been
finished" (published in F. Schlie, "Sieben Briefe und eine
Quittung," *Oud-Holland* 18 [1900], p. 141). Several of van
Huysum's paintings have two dates on them, indicating that
he was forced to await the availability of certain specimens in
order to complete those works.

It has been suggested that van Huysum turned to paint-
ing small, simple still lifes such as the *Floral Still Life with
Hollyhock and Marigold* toward the end of his career (Sam
Segal, in *Flowers and Nature, Netherlandish Flower Paintings of
Four Centuries* [The Hague, 1990], p. 243). However, works
dated throughout the artist's career vary considerably be-
tween flamboyant rococo compositions and more conserva-

tive designs, the latter often — as in the present work — including dark backgrounds reminiscent of works by earlier still-life artists such as Rachel Ruysch or Jan Davidsz de Heem.

Although the catalogue of the 1923 sale refers to a pair of paintings, no pendant to the present work has been traced.

M.E.W.

76 PLATE 25
THOMAS DE KEYSER (Dutch, 1596 or 1597–1667)
Portrait of a Woman Holding a Balance, about 1634
Oil on panel, 9 x 6¾ in. (23 x 17.4 cm)
Private collection

PROVENANCE: Private collection, Holland; dealer K.W. Bachstitz, The Hague, 1926, until at least 1940; Von Pannwitz collection, Heemstede.

EXHIBITION: New York, National Academy of Design, *Dutch and Flemish Paintings from New York Private Collections* (cat. by Ann Jensen Adams), 1988, no. 28, ill.

A woman appears in half-length holding a balance that is cropped by the lower-left edge of the image. She wears a conservative but well-tailored and costly black dress, a white ruff, and a headdress.

The painting is neither signed nor dated and was not included in Ann Jensen Adams's dissertation ("The Paintings of Thomas de Keyser [1596/97–1667]: A Study of Portraiture in Seventeenth-Century Amsterdam" [Ph.D. diss., Harvard University, 1985]), but has since been accepted by her in the catalogue of the exhibition held in New York in 1988 as a work by Thomas de Keyser, and dated to about 1634. Adams feels it comes closest in technique to three portraits dated 1634 in the museums in Stockholm and Brussels (Adams 1985, nos. 52, 56, and 57).

Scales held by figures in Dutch genre paintings and portraits had a variety of associations. Old men and women with scales (and usually with treasures) often personified the sin of Avarice, and younger figures might embody *vanitas* because of the weighing of souls at the Last Judgment, or Justice and her message of restraint and equanimity; the fact that the only partially visible scales apparently rest in balance suggests that the last associations are most apposite. Adams has rightly promoted the interpretation of the scales as a symbol and an attribute of temperance. Moreover, she has observantly noted that, despite the unusual truncation of the motif at the bottom edge, the image was not cut down (the back of the panel indicates that it is intact), adding that the cropping of motifs has precedents in other portraits by de Keyser (such as The Hague, Mauritshuis, no. 806; Adams 1985, no. 8).

P.C.S.

77 PLATE 73
THOMAS DE KEYSER (Dutch, 1596 or 1597–1667)
Saint John in a Landscape, n.d.
Oil on panel, 24½ x 18½ in. (62 x 47 cm)
Private collection

PROVENANCE: Sale New York (Sotheby's), November 7, 1985, no. 87 (as Adriaen van de Velde); with Otto Naumann, Ltd., New York (as Thomas de Keyser).

Wearing dark russet and taupe-colored drapery and holding his attribute, a reed cross with a pennant, the youthful Saint John is seated in a wooded, twilit landscape. He inclines his head, looks directly at the viewer, and points toward the lamb.

This painting sold in 1985 as the work of Adriaen van de Velde. Although history paintings by van de Velde offer some stylistic points of comparison, his figure types are usually more thickly painted and display more fully rounded, generalized forms (see, for example, van de Velde's *Mercury and Argus* [Vaduz, Princes of Liechtenstein Collection, no. 689] and *Saint Jerome* [dated 1668; Schwerin, Gemäldegalerie, inv. no. 2675]). The individualized features of the figure of Saint John in the present work accord better with the rare history paintings by the Amsterdam portraitist and history painter Thomas de Keyser (compare, for example, the treatment of the figures in his history paintings from 1637, *Flagellation of Christ* [Utrecht, Rijksmuseum het Catharijneconvent] and *Crucifixion on Calvary* [Moscow, Pushkin Museum of Fine Arts]; Ann Jensen Adams, "The Paintings of Thomas de Keyser [1596/97–1667]: A Study of Portraiture in Seventeenth-Century Amsterdam" [Ph.D. diss., Harvard University, 1985], nos. 71 and 72, respectively). The treatment of the foliage and landscape background may also be compared to de Keyser's later equestrian portraits (compare, for example, the background in the *Portrait of a Couple on Horseback* [signed and dated 1660; Worms, Stiftung Kunsthaus Heylshof]).

Saint John the Baptist is regarded as an important link between the Old and New Testaments because he was the last of the prophets in the former and the first of the saints in the latter. Depiction of the saint alone in a woodland setting is a traditional pictorial allusion to his ascetic life and retreat to the wilderness, which is described in the Bible only as "the deserts" (Luke 1:80). Pointing to the lamb, his gesture embodies the phrase "Ecce Agnus Dei" frequently inscribed on his pennant (John 1:36): "John looked toward [Jesus] and said, 'There is the Lamb of God'."

Depictions of the saint in the wilderness are not as plentiful in Dutch art as representations of him baptizing Christ, preaching, or being beheaded. However, the subject had been treated by earlier history painters, notably the influential Amsterdam history painter Pieter Lastman (for two examples, see: dated 1616, Amherst [Massachusetts] College Collection, no. 1970.9; and dated 1618, Kurt Friese, *Pieter Lastman, Sein*

Leben und seine Kunst [Leipzig, 1911], no. 47), whose work de Keyser copied (see *King Cyrus Returns the Vessels from the Temple of the Lord to the Jews*, inscribed "P Lasman inventor / TD Keyser pinxit 1660"; Paris, Institut Néerlandais, inv. no. 6781).

The dark brown foliage in this painting probably was once more greenish in hue. Greens were notoriously fugitive colors in the seventeenth century; indeed, in 1676 the art theorist Samuel van Hoogstraten complained about the technical problems associated with them. An interesting detail in this painting is the pentimento around the saint's right foot, where the artist adjusted its position as he sought to give the figure his gracefully relaxed pose.

P.C.S.

78 PLATE 72

THOMAS DE KEYSER (Dutch, 1596 or 1597–1667)
Equestrian Portrait of a Man with a Page, n.d.
Oil on canvas, 37¼ x 30⅜ in. (94.6 x 77.2 cm)
Private collection

PROVENANCE: Possibly with the dealer Slaes, Brussels, 1862 (see Thoré); sale London (Robinson and Fisher), April 1, 1897, no. 117 (for £525, to Colnaghi's and the dealer A. Wertheimer); collection Ogden Miller, who bequeathed it to the Metropolitan Museum of Art, New York, 1929 (acc. no. 29.1801); sale New York (Sotheby's) January 12, 1989, no. 33 (as "Attributed to Thomas de Keyser").

LITERATURE: (Possibly) Theophile Thoré (W. Bürger), "Galerie Suermondt VII. Theodore de Keyser," *Gazette des Beaux Arts*, 2ième pér., vol. 1 (1869), p. 35; R. Oldenbourg, *Thomas de Keysers Tätigkeit als Maler, ein Bertrag zur Geschichte des holländischen Porträts* (Leipzig, 1911), no. 86; Algernon Graves, *Art Sales*, vol. 2 (London, 1921), p. 212; J.M.L., "The Cavalier by Thomas de Keyser," *Bulletin of the Metropolitan Museum of Art 25* (1930), pp. 252–53, ill.; *Bulletin of the Metropolitan Museum of Art*, vol. 33 (1938), p. 34; J. L. Allen and E. E. Gardner, *A Concise Catalogue of the European Paintings in the Metropolitan Museum of Art* (New York, 1954), p. 56; Katherine Baetjer, *European Paintings in the Metropolitan Museum of Art* (New York, 1980), vol. 1, p. 101; vol. 3, ill. p. 403; *In het zadel. Het Nederlands Ruitersportret van 1550 tot 1900* (exh. cat., Leeuwarden, Fries Museum, 1979–1980), no. 162; Ann Jensen Adams, "The Paintings of Thomas de Keyser (1596/97–1667): A Study of Portraiture in Seventeenth-Century Amsterdam" (Ph.D. diss., Harvard University, 1985), cat. D-4.

An elegantly dressed equestrian appears in an open landscape with a twilight sky. On foot in the right background a hunter's valet or page carries a musket and leads two dogs, while another hound appears in the left foreground. The sitter wears long brown hair and an elegant costume in blue and red. His horse rises on its back legs in a levade, one of the more difficult positions in equitation, and one that in portraiture had become the attribute of noble grace and control.

Together with Paulus Potter, the Amsterdam painter Thomas de Keyser helped perfect the small-scale equestrian portrait in Dutch art. The portrait type had descended from Titian, Rubens, and van Dyck, and had initially been the province of princely and military sitters, but in the second half of the seventeenth century it also became popular with affluent burghers and merchants. In such portraits hunting is typically the pretext for the equestrian activity. Among de Keyser's finest examples of this genre are the *Equestrian Portrait of Pieter Schout Muylman* (dated 1660; Amsterdam, Rijksmuseum, no. A697) and *Equestrian Portrait of Two Men* (dated 1661; Dresden, Gemäldegalerie, no. 1543).

The painting exhibited here closely resembles these works in conception and design but was more freely executed. It also relates formally to two of the figures as well as the dog in *Portrait of the Burgomaster de Graeff and His Family* (Dublin, National Gallery of Ireland, no. 287), which has been regarded as a collaboration between Jacob van Ruisdael for the landscape and de Keyser for the figures (see Homan Potterton, *Dutch Seventeenth-Century Paintings in the National Gallery of Ireland* [Dublin, 1986], no. 287, fig. 144); although the degree of finish again differs from that of the present work, the young horseman at the far right is also posed in a levade, the same bearer appears in the right background, and the same dog is in the center left.

Attribution of the present painting to de Keyser was supported before and after it entered the collection of the Metropolitan Museum of Art; however, in 1989, after Ann Jensen Adams had catalogued the picture in her dissertation (Harvard University, 1985) under the category of "Questionable and Doubtful Attributions," the museum deaccessioned the painting and Sotheby's offered it as only "Attributed to Thomas de Keyser." It subsequently was cleaned by Alain Goldrach, and the surface proved to have been extensively overpainted, partly in a effort to create a more finished image. Areas such as the landscape seem never to have been completed, and the freely painted figure of the horseman reveals many pentimenti, features that suggest the painting may have originally functioned as a working oil sketch or may have been left unfinished by the artist. In a letter dated September 2, 1990, to the dealer Otto Naumann, Adams withdrew her earlier doubts, accepting the attribution to de Keyser.

The present painting may be the picture by de Keyser which Thoré (Bürger; 1869, p. 35) mentioned as being with a Belgian dealer in 1862: "Gentilhomme à cheval . . . suivi d'un valet de chasse tenant en laisse deux lévriers. Fond de paysage au soleil couchant."

P.C.S.

79 PLATE 86

MAURICE-QUENTIN DE LA TOUR (French, 1704–1788)
Portrait of Claude-Charles Deschamps, about 1768
Pastel on paper, 12⅝ x 9⅛ in. (32 x 23 cm)
Private collection

PROVENANCE: Madame R——; sale Paris (Hôtel Drouot), March 16, 1923, no. 86 bis; David Weill Collection, Paris; sale London (Sotheby's), June 10, 1959, no. 101 (as "the property of a gentleman"); to Harry Sperling, New York; acquired from Sperling.

EXHIBITIONS: Paris, Musée du Louvre, August–October 1922.

LITERATURE: Gabriel Henriot, *Collection David Weill* (Paris, 1927), vol. 2, pp. 33–34; Paul Jamot, "Notes sur l'Exposition des Pastels français des XVIIe et XVIIIe siècles," *Le Bulletin de l'art ancien et moderne* (July–August 1927), pp. 209–12; Albert Besnard, *La Tour, la vie et l'oeuvre de l'artiste* (Paris, 1928), no. 97, p. 139.

The preeminant portraitist of the mid-eighteenth century, La Tour worked exclusively in pastel, a medium that enjoyed tremendous popularity in Paris following the visit of the Venetian pastellist Rosalba Carriera in 1720 and 1721. La Tour was a vigorous draftsman, and his strength lay in his close observation of physiognomic nuance and in the immediacy of his execution. Often informal in pose and dress, his pastels evinced the aesthetic of the natural, which came to dominate French portraiture in the second half of the century.

La Tour left his native city of Saint-Quentin at the age of fifteen to study art in Paris. He worked first in the studio of Jean-Jacques Spöede, a Flemish-born professor at the Academy of Saint Luc, and then with Dupouch, a lesser-known artist who was associated with the same academy. After brief visits to Saint-Quentin, Reims, Cambrai, and London in the years 1723 to 1725, La Tour returned to establish his studio in Paris. *Agréé* (accepted) by the Royal Academy of Painting and Sculpture in 1737, the artist began regularly exhibiting in the yearly Salons held at the Louvre. In 1746 he was granted an apartment in the Louvre, and in the following year was *reçu* (received) at the Royal Academy, submitting as his reception piece a pastel portrait of Jean Restout, a senior academician who was La Tour's mentor.

Unlike his younger rival Jean-Baptiste Perroneau, La Tour was patronized by the highest level of French society. He depicted not only the king, the royal family, and Madame de Pompadour, but also luminaries in the fields of arts, letters, theater, and finance. After five productive decades, La Tour's oeuvre included a veritable pantheon of enlightenment figures. In 1784, at the age of eighty and increasingly mentally unstable, La Tour returned to his native city, where he died four years later.

According to an old inscription on its verso, the present portrait depicts Claude-Charles Deschamps, the Canon of Laon and a first cousin of the artist. La Tour presumably was on friendly terms with Deschamps, as the artist left his cousin one hundred pistoles in his first will, which was executed the same year as the portrait. Ultimately, Deschamps predeceased La Tour, dying in Laon in 1779. With its closely cropped composition and faint smile, this portrait of Deschamps has the simplicity and intimacy characteristic of the artist's best work. La Tour once proclaimed in a conversation recounted by Diderot that "the passion for embellishing and exaggerating nature diminishes in proportion to one's experience and skill" (*Diderot Salons*, ed. by Jean Seznec [Oxford, 1967], vol. 4, p. 85).

A second version of the portrait, of slightly larger dimensions (Paris, Musée du Louvre), carries an inscription dating it to 1768 and giving the sitter's age as sixty-nine. The present example must have been done about the same time, perhaps to provide Deschamps with an extra or La Tour with a memento. Paul Jamot (1927, p. 210), who saw both versions in 1927, considered the Louvre one unusually free in its execution and the other slightly worn and perhaps trimmed from its original dimensions, although much more in keeping with La Tour's characteristic style and handling.

P.S.

80 PLATE 160

JULES FERNAND HENRI LÉGER (French, 1881–1955)
Still Life, 1929
Oil on canvas, 36¼ x 25¾ in. (92.1 x 65.5 cm)
Signed and dated at bottom right: *F. LEGER -29*
Scott M. Black Collection

PROVENANCE: Galerie Europe, Paris; Simone Herman, Prunay-sous-Ablis; Paul Haim, Paris; Richard Grey Gallery, Chicago; Arnold Herstand Gallery, New York; sale New York (Christie's), May 11, 1988, lot 53.

EXHIBITIONS: Zürich, Kunsthaus, *Juan Gris, Fernand Léger*, April–May 1933; Paris, Musée des Arts Décoratifs; Brussels, Palais des Beaux-Arts; and Munich, Haus der Kunst, *Exposition Fernand Léger*, 1956–1957, p. 85, no. 56, and p. 210, no. 70.

Jules Fernand Henri Léger was born on February 4, 1881, in Argentan, Normandy. He served as an apprentice to an architect in Caen from 1897 to 1899 and moved to Paris in 1900. Although refused admission to the Ecole des Beaux-Arts, he attended classes under Gérôme and Ferrier while working as an architectural draftsman. The Cézanne retrospective at the Salon d'Automne in 1907 and the early Cubism of Picasso and Braque had a profound effect upon Léger. Mobilized into the Corps of Engineers in 1914, he later attributed his interest in machine forms and social themes to his experience in the war. Following his discharge, Léger continued to pursue his personal version of Cubism and abstraction. He opened a school with Ozenfant in 1924 and became associated with the Purist movement. In 1925 the artist exhibited works at Le Corbusier's Pavillon de l'Esprit Nouveau in Paris. Léger lived in the United States during the Second World War. Returning to France in 1945, he worked on wide-ranging projects, including monumental figure paintings and murals, set and costume designs, and ceramic sculpture, until his death on August 17, 1955. A year before the artist died, Clement Greenberg wrote: "Léger belongs with Matisse, Picasso and Mondrian among the very greatest painters of the century" ("Master Léger," *Partisan Review* 21, [January–February 1954], p. 90).

Before the First World War, Léger had developed his own version of Cubism nearly to the point of nonobjective abstraction in his series *Contrasts of Forms*. His experiences in the war changed his aesthetic priorities, however. Fascinated by machines and modern technology, he began to incorpo-

rate into his paintings geometric elements loosely derived from mechanical forms. In his essay "The Aesthetics of the Machine" (1924) Léger wrote: "Every object, picture, piece of architecture, or ornamental organization has a value in itself; it is strictly absolute and independent of anything it may happen to represent." Nowhere did the artist's attitude toward objects have greater consequence than in the genre of still life. Although the aesthetic agenda articulated in Léger's writings remained relatively consistent, his pictorial style was characterized by calculated refinement. At least a decade of stylistic revisions and modifications preceded the present painting. The bold simplicity and confident execution of this *Still Life* are the result of a sustained and often subtle consideration of the pictorial status of objects, a focus that can be traced back to 1918.

Between that year and 1923 Léger titled many of his still lifes *Mechanical Elements*, making direct reference to his fascination with modern technology. Paintings from this series are typified by seemingly interchangeable geometric shapes — the cone, cylinder, and disk — which cover the surface of the canvas in an animated pattern of varied colors. Despite its title, in one of these *Mechanical Elements* (1920; New York, Gelman Collection) it is possible to discern a tabletop, a bottle, and an ashtray among the interlocking geometric forms. Léger, of course, did not compose his still lifes literally of machines or their parts. Although the title and style of these works were intended to evoke twentieth-century technology and its possibilities, the Gelman picture remains restricted to the familiar range of objects associated with still life. *Still Life with a Beer Mug* (1921–1922; London, Tate Gallery) more explicitly exemplifies a traditional still-life format — tiled floor, table, beer mug, pipe, and plate of fruit — recast in a colorful design of flat surface pattern.

However, the artist wrote in 1924 of his intention to create paintings in which "every object . . . has a value . . . strictly absolute and independent of anything it may happen to represent" ("The Aesthetics of the Machine"). In a series of paintings done between 1925 and 1927, Léger realized this goal. In *L'Accordéon* (1925; Eindhoven, Stedelijk van Abbe Museum) he reduced the elements; created a shallower, virtually flat spatial scheme; and painted the entire surface in a manner that favored no single component of the design over another. The radical simplification and rigid horizontal and vertical scheme that characterize *L'Accordéon* have an overwrought quality that bespeaks the effort required of Léger to surmount the conventions that had informed the still-life tradition.

In this *Still Life* the artist combined his radical formal innovations of 1925 to 1927, and the dynamic and animated surfaces of his still lifes from the first half of the 1920s. Léger virtually eliminated horizontal and vertical lines from the composition. This painting has almost a playful quality. Although the surface patterning creates a two-dimensional design, the shading of the drill-like form offers the illusion of a

spatial envelope. Again in "The Aesthetics of the Machine" Léger wrote: "Beauty is everywhere, in the arrangement of your kitchen, more perhaps than in your eighteenth-century salon or in the official museum." Even within the rarefied context of a museum, however, Léger's fundamentally optimistic conception of the twentieth century continues to suggest new possibilities of seeing.

R.J.B.

81　PLATE 144

MAXIMILIEN LUCE (French, 1858–1941)
Eragny, Les Bords de l'Epte, 1899
Oil on canvas, 31⅞ x 45¾ in. (81 x 116 cm)
Signed and dated at bottom right: *Luce-99*
Scott M. Black Collection

PROVENANCE: Arthur Tooth & Sons, London (acquired by the father of the present owner in 1961); sale London, (Sotheby's), June 28, 1989, no. 106.

EXHIBITIONS: Paris, Galerie Durand-Ruel, *M. Luce*, 1899, no. 38; Paris, *xxième Salon des Artistes Independants*, 1904, no. 1530; Portland (Maine) Museum of Art, *Impressionism and Post-Impressionism: The Collector's Passion*, July–October 1991, no. 19.

LITERATURE: *Illustrated London News*, April 8, 1961, p. 594; Jean Bouin-Luce and Denise Bazetoux, *Maximilien Luce, Catalogue de l'oeuvre peint* (Paris, 1986), vol. 2, p. 31, no. 98.

Less well known than Georges Seurat or Paul Signac, Maximilian Luce was regarded, following the exhibition of his Pointillist paintings at the Salon des Indépendants of 1887, as a leader of the Neo-Impressionist movement.

Born the son of a poor clerk in 1858, he was by the age of fourteen apprenticed to an engraver. From 1876 through 1883 he worked intermittently in the print shop of Eugène Fromet, producing woodcuts for *L'Illustration*, the *Graphic* of London, and other periodicals. After the invention in 1883 of zinc lithography, which replaced traditional techniques, Luce's work at Fromet and Auguste Lacon's shops declined, and he devoted himself increasingly to painting, studying with Carolus-Duran. An ardent anarchist, Luce continued to produce illustrations for journals of this movement, including *La Révolte*, *Le Père Peinard*, and *Les Temps Nouveaux*. After seeing Seurat's *A Bathing Place, Asnières* (London, National Gallery) at the Salon des Indépendants in 1884, Luce began experimenting with Pointillist technique. From 1887 through the 1890s Luce painted in a Neo-Impressionist style. By the time Signac had published his divisionist manifesto *From Eugène Delacroix to Neo-Impressionism* (in serial form in *La Revue Blanche* in 1898 and as a book in 1899), the movement was already in decline.

Luce's *Eragny, Les Bords de l'Epte* exemplifies the loosening of his orthodox Pointillism. The painter was no longer basing his color scheme upon a system, but upon his intuition. Indeed, in 1895 he spoke in a letter of the advantages of a more intuitive than systematic approach to color. The artist

replaced the tight dots of divisionism with a looser handling and broader strokes.

Painted while he visited Camille Pissarro, who had briefly experimented with divisionism, *Eragny, Les Bords de l'Epte* little resembles the factory landscapes of Marchiennes and Charleroi, which the artist had recently painted. Pissarro had befriended Luce earlier in his career. In 1898 Pissarro wrote to his son Lucien that, among the entries to the Salon des Indépendants that year, two pictures by Luce were the "best things." (J. Bailly-Herzberg, ed., *Correspondance*, vol. 4 [Paris, 1989], p. 474) The environs of Pissarro's home in the village of Eragny, on the Epte River, had none of the industry found around his previous residence at Pontoise. The bucolic setting of Luce's modern pastoral is both reminiscent of his mentor's *A Bathing Place, Asnières* and of earlier imagery celebrating contemporary leisure, such as Frédéric Bazille's *Summer Scene* (1869; Cambridge, Harvard University Art Museums).

Eragny, Les Bords de L'Epte differs in subject from Luce's earlier images, of industrialization and of the life of laborers, themes related to his political beliefs. From late 1895 through 1899, he had traveled to the "Region Noire" ("Black Country") in Belgium, executing dozens of canvases depicting laborers and factories. Luce's *A Slag Heap near Marchiennes* (1898; Indianapolis Museum of Art) is typical of his programmatic commitment to modern working-class motifs. The present painting was exhibited for the first time, along with over thirty other paintings from the Region Noire, at Luce's large retrospective at the Galerie Durand-Ruel from October 16 through 31, 1899. After first praising the Region Noire pictures in his review of the exhibition for *La Revue Blanche*, critic Emile Verhaeren commented approvingly on paintings such as *Eragny* for keeping Luce's art from being "monotonously somber" (*Slatkine Reprints* 20 [September–December 1899; Geneva, 1968], p. 310). In the same review Verhaeren wrote favorably of Luce's slackening of his Neo-Impressionist technique: "Today his style is freer, his process less the slave of theories." In *Mercure de France* André Fontainas responded positively to this retrospective: "M. Luce's art commands positive regard, admiration because it gives proof of disinterested and ceaseless toil, it reveals qualities of rare and precise observations, it is genuine and sincere like the artist himself" (vol. 32, no. 118 [October 1899], p. 815).

R.J.B.

82 PLATE 77

CARSTIAEN LUYCKX (Flemish, 1623–about 1670)
Banquet with a Monkey, 1650s
Oil on canvas, 32⅝ x 41¼ in. (83.5 x 105 cm)
Mrs. H. John Heinz III

PROVENANCE: Collection Duc de Berry, Paris; collection Duchesse de Berry, Paris; (probably) exhibited with the De Berry collection in a private sale, London (Christie's), 1834; collection M. Hume, London; purchased from Hume by George Lucy, Esq., London, 1836; collection Sir Montgomery Fairfax-Lucy, Bt., Charlcote Park, Warwick, England; his sale, London (Christie's), June 1, 1945, no. 31 (for £714, to Welker); collection J. Perez de Cuellar, Peru; Newhouse Galleries, New York, 1971; private collection, United States (on all occasions as a work by Jan Davidsz de Heem).

EXHIBITIONS: Washington, D.C., National Gallery of Art; and Boston, Museum of Fine Arts, *Still Lifes of the Golden Age: Northern European Paintings from the Heinz Family Collection* (cat. by Ingvar Bergström, Arthur K. Wheelock, Jr., et al.), 1989, no. 24 (as by Luyckx).

One of the most accomplished seventeenth-century Flemish still-life painters, Carstiaen Luyckx remains, surprisingly, virtually unknown. Many of his works have long passed under the names of other artists; until recently, in fact, *Banquet with a Monkey* was known as a work of the Dutch still-life painter Jan Davidsz de Heem (1606–1683 or 1684). A native of Antwerp, Luyckx studied with Philippe de Marlier (active about 1640–1677) from 1639 to 1642. The artist made a brief journey to Lille in 1644, but was back in Antwerp by 1645, when he married and became a master in the guild of Saint Luke. In a document of 1646, Luyckx is designated having been "in the service of His Majesty the King of Spain." There is no further archival mention of the artist after the baptism of a son in 1653; Luyckx is thought to have died about 1670.

Although Luyckx painted a number of smaller, more modestly conceived still lifes, *Banquet with a Monkey* is surely the artist's masterpiece in the field of elaborate *pronk* (sumptuous) still lifes. It is closely related to a smaller *Still Life* (oil on panel, 17⅞ x 28 in. [45.5 x 71 cm]; Gallery Peter Tillou, Litchfield, Connecticut, 1988; see Delft, Stedelijk Museum "het Prinsenhof"; Cambridge, Fogg Art Museum; and Fort Worth, Kimbell Art Museum, *A Prosperous Past* [exh. cat. by Sam Segal], p. 164 and cat. 47). The two paintings share a number of motifs, particularly the spectacular array of metalware vessels: at the left, a silver-gilt pocket watch rests on an engraved silver *puntschotel* (scallop-edged dish); just behind is a silver tazza comparable to one made by the Delft silversmith Cornelis Jansz van der Burch about 1600. To the left of the tazza, a *bekerschroef* (glass stand), comparable to one made in 1609 by the Amsterdam goldsmith Leendert Claesz van Emden (now in the Amsterdams Historisch Museum), supports a rummer of white wine trailing a thick lemon peel. A silver-gilt covered goblet similar to the one in the present painting was made by Hans Endres in Augsburg about 1654. At the right edge of the table is a heavily chased silver pitcher tipped on its side, its metallic glitter juxtaposed against the softer sheen of a nautilus shell. Other objects crowding the

tabletop add color, texture, and variety to the display: succulent fruits and leafy vines, flaky pastry bursting with rich fillings, delicate porcelain, crabs and lobster, a velvet-covered chest for tableware, and an almost transparent glass flute.

The mischievous monkey clutching a stolen morsel is a motif found also in the works of Luyckx's contemporary Frans Snyders (1597–1657), and was surely included as a piquant contrast to the "still" life spread before him. In fact, Luyckx's composition is anything but still; the varied angles of the objects, as well as the rumpled table coverings and the extravagant billows of drapery in the background, animate the entire composition. Luyckx's *Banquet with a Monkey* is indeed a sensual feast.

M.E.W.

83 PLATE 106

EDOUARD MANET (French, 1832–1883)
Portrait of Mme Brunet, 1860–1867?
Oil on canvas, 51⅛ x 38⅝ in. (130 x 98 cm)
Signed at lower left: *Manet*
Private collection

PROVENANCE: Estate of the artist, inv. no. 14; Manet sale, Paris, February 4–5, 1884, no. 15; purchased by Théodore Duret for Galerie Durand-Ruel, Paris; Jacques-Emile Blanche; M. Knoedler & Co., New York; Mrs. Charles S. Payson, New York; Sandra Payson, New York; sale New York (Christie's), May 16, 1984, no. 22.

EXHIBITIONS: Paris, Galerie Martinet, 1863, no. 133; Paris, Avenue de l'Alma, *Tableaux de M. Edouard Manet*, 1867, no. 20; Paris, Hôtel Drouot, *Succession Edouard Manet*, 1884, no. 15; Paris, Galerie Georges Petit, 1910, no. 120; Paris, 18 rue de la Ville-l'Evêque, 1922, no. 105; Paris, La Renaissance, 1928, no. 20; Paris, Orangerie des Tuileries, *Manet (1832–1883)*, 1932, no. 6; New York, Knoedler & Co., 1937, no. 16; New York, Galerie Durand-Ruel, 1940, no. 14; New York, Metropolitan Museum of Art, 1941, no. 79; New York, Wildenstein and Co., *A Loan Exhibition of Manet for the Benefit of the New York Infirmary*, February 26–April 3, 1948, no. 8; New Haven, Yale University Art Gallery, 1960, no. 47; New York, Metropolitan Museum of Art, *Paintings from Private Collections*, July 6–September 4, 1960, no. 65; New York, Metropolitan Museum of Art, 1968, no. 93; *New York Collects: Paintings, Watercolors, and Sculpture from Private Collections*, July 3–September 2, 1982, no. 5; Paris, Galeries Nationales du Grand Palais; and New York, Metropolitan Museum of Art, *Manet (1832–1883)*, 1983, no. 5; Copenhagen, Ordrupgaard, *Manet*, September 15–November 26, 1989, no. 4.

LITERATURE: Théodore Duret, *Histoire d'Edouard Manet et de son oeuvre* (Paris, 1902), no. 20; J. Meier-Graefe, *Edouard Manet* (Munich, 1912), p. 112; Théodore Duret, "Les Portraits peints par Manet et refusés par leurs modèles," *Renaissance de l'art français et des industries de luxe* 1 (July 1918), pp. 149–50; Jacques-Emile Blanche, *Manet* (Paris, 1924), p. 31; Etienne Moreau-Nélaton, *Manet raconté par lui-meme*, vol. 2 (Paris, 1926), pp. 44 and 47, ill.; Jacques-Emile Blanche, *De David à Degas* (Paris, 1927), pp. 148–49; Adolphe Tabarant, *Manet: Histoire catalographique* (Paris, 1931), p. 58; Paul Jamot and Georges Wildenstein, *Manet* (Paris, 1932), no. 39; Adolphe Tabarant, *Manet et ses oeuvres* (Paris, 1947), p. 57, no. 60; Nils Gösta Sandblad, *Manet: Three Studies in Artistic Conception* (Lund, 1954), p. 83; Pierre Courthion, *Edouard Manet* (New York, 1954; repr. 1984), p. 15, ill.; Alain de Leiris, "Manet's 'Christ Scourged' and the Problem of His Religious Paintings," *Art Bulletin* 41 (June 1959), p. 200, note 11; John Rewald, *The History of Impressionism* (New York, 1961), pp. 32, 34, ill.; Merete Bodelsen, "Early Impressionist Sales 1874–1894 in the Light

of Some Unpublished 'Proces verbaux,'" *Burlington Magazine* (June 1968), p. 341, no. 15; Sandra Orienti and Phoebe Pool, *The Complete Paintings of Manet* (New York, 1967), p. 56; Sandra Orienti and Denis Rouart, *Tout l'oeuvre peint d'Edouard Manet* (Paris, 1970), no. 55; Denis Rouart and Daniel Wildenstein, *Edouard Manet: Catalogue raisonné* (Lausanne, 1975), vol. 1, p. 50, no. 31; Richard Wollheim, *Painting as an Art* (London, 1987), pp. 168–69, ill.

After studying for several years with the Academic painter Thomas Couture, Manet continued his education by copying paintings in the Louvre, where he began an infatuation with the Spanish school, Velázquez in particular, which would culminate in a study trip to Spain in 1865. Manet's work throughout the early 1860s shows borrowings from seventeenth-century Spanish masters; he adopted not only their style, but often their subject matter, recasting Parisian types into a Spanish idiom. Initiating this genre of monumental full-length figures in a Velázquez-influenced style was *The Absinthe Drinker* (1859; Copenhagen, Ny Carlsberg Glyptotek), which was Manet's first submission to (and rejection by) the Salon jury.

Portrait of Mme Brunet seems to have been painted in the following year. The identity of the sitter was long a matter of speculation, as Manet had two friends with the surname Brunet; this mystery has recently been resolved based on evidence provided by a photograph in Manet's private album showing Eugène-Cyrille Brunet with his wife, whose features and clothes bear a strong resemblance to those of the woman in the present painting. Monsieur Brunet was a Brittany-based sculptor who had studied together with Manet in Florence in 1857. Mme Brunet, whose clothing reveals a less than au-courant sense of fashion, apparently did not share her husband's appreciation of Manet's talent. According to Théodore Duret, she burst into tears upon seeing her portrait and vowed never to look at it again (Duret 1918, pp. 149–50). Manet was apparently unfazed by this display, as he kept the painting in his studio and exhibited it twice during his lifetime.

A caricature drawn about the time of the Martinet exhibition in 1863 suggests that the picture was originally full-length, with a neutral background. A second caricature, which was drawn in connection with the exhibition of 1867, shows the portrait in its present state, with the sitter cut off at the knees and with a loosely sketched landscape background. Manet often cut and added pieces of canvas to his paintings, even over a period of years, as he continued to rework their compositions. The addition of the landscape, on the other hand, seems to have been directly inspired by his study of Velázquez. In 1862 the Louvre acquired the full-length portrait *Philip IV as Hunter*, which is now considered to be a copy by Velázquez's student Mazo, and which Manet copied several times.

The loosely brushed landscape background of *Mme Brunet* may have been borrowed directly from that source, resulting in a stylistic tension between the atmospheric naturalism of the seventeenth-century landscape and the harsh

lighting and lack of halftones typical of Manet's distinctive figural style. By placing Mme Brunet in a landscape setting, Manet may have sought to transform a rejected portrait commission into a more generalized provincial "type," a figure clearly more at home in her country surroundings than she would be in a Parisian nightclub. Although not a sufficiently flattering likeness to please its sitter, *Mme Brunet* — with her starkly lit direct gaze set off by the monumental triangular mass of her voluminous black coat — is a forceful example of Manet's early portrait style.

P.S.

84 PLATE 110

EDOUARD MANET (French, 1832–1883)
Portrait of Emile-Charles-Julien de la Rochenoire, 1882
Pastel on canvas, 21¾ x 13⅞ in. (55.2 x 35.2 cm)
Signed at lower right: *Manet*
Josefowitz Collection

PROVENANCE: Emile-Charles-Julien de la Rochenoire, Paris; acquired by J. Nicolas, April 28, 1894; Maurice Joyant, Paris; M. G. Dortu, by 1955; private collection, Switzerland; Wildenstein and Co., New York.

EXHIBITIONS: Paris, Ecole des Beaux-Arts, *Exposition des oeuvres d'Edouard Manet*, January 1884, no. 149; Paris, Galerie Manzi-Joyant, *Exposition d'art moderne*, June–July 1912, no. 34; Tokyo, Wildenstein and Co., *Masterpieces of French Painting*, July 27–31, 1986, ill.

LITERATURE: Etienne Moreau-Nélaton, *Unpublished Manuscript Catalogue of Manet's Works* (Paris, Bibliothèque Nationale, 1906), no. 392; Julius Meier-Graefe, *Edouard Manet* (Munich, 1912), p. 303, ill.; Arsène Alexandre, "Exposition d'art moderne à l'hôtel de la revue 'Les Arts'," *Les Arts*, no. 128 (August 1912), p. viii, ill. (installation photograph); Théodore Duret, *Histoire de Edouard Manet et de son oeuvre* (Paris, 1926), p. 297, pastel no. 70; Etienne Moreau-Nélaton, *Manet raconté par lui-même* (Paris, 1926), vol. 2, p. 98, ill.; Adolphe Tabarant, *Manet: Histoire catalographique* (Paris, 1931), p. 507, no. 84; Paul Jamot and Georges Wildenstein, *Manet* (Paris, 1932), vol. 1, p. 181, no. 520, ill.; Adolphe Tabarant, *Manet et ses oeuvres* (Paris, 1947), p. 464, ill.; John Rewald, *Edouard Manet: Pastels* (Oxford, 1947), p. 48, note 2, and p. 59, no. 25, ill.; Marcello Venturi and Sandra Orienti, *L'Opera pittorica di Edouard Manet* (Milan, 1967), p. 121, no. 415, ill.; Denis Rouart and Sandra Orienti, *Tout l'oeuvre peint d'Edouard Manet* (Paris, 1970), p. 121, no. 421, ill.; Denis Rouart and Daniel Wildenstein, *Edouard Manet: Catalogue raisonné* (Lausanne and Paris, 1975), vol. 2, p. 26, no. 66, ill.; Sophie Monneret, *L'Impressionnisme et son époque*, vol. 1 (A–L; Paris, 1978), p. 312; vol. 4 (Index; Paris, 1981), p. 322.

Manet's final years were marked by deteriorating health and a diminished capacity for work. Easily tired and finding difficulty in walking and standing, the artist increasingly turned to smaller formats and less-taxing media. He especially favored pastel during these years, and used it for a series of more than sixty bust-length portraits of friends, models, and society figures.

The artist executed the present work in 1882, one year before his death, as he was bringing to completion his final large-scale masterpiece, *Bar aux Folies-Bergère* (London, Courtauld Institute). The sitter, Emile-Charles-Julien de La Rochenoire (1825–1899) was a close friend of the artist's and

probably received the portrait as a gift. La Rochenoire was himself a painter of animals and landscapes, and his work fell squarely within the academic tradition that Manet and many of his fellow Impressionists had rejected. Yet, in spite of artistic differences, La Rochenoire sustained close friendships with many of the Impressionists and actively agitated for reform in the French Academy and the official Salon.

La Rochenoire is depicted by Manet in a bust-length three-quarter view against a pale, floral-patterned backdrop. A freshness of handling is apparent throughout. The sitter's face in particular is articulated with a network of vigorous, unblended strokes. In a manner typical of his style, Manet gave the figure solidity using the strong contrast of creamy pink flesh tones with the near-black of shadows, hair, and occasionally outlines — an aesthetic possibly inspired by early black-and-white photography.

Unlike the majority of Manet's pastels of this period, which portray high-society women in a flattering, powdery style evocative of eighteenth-century pastel portraits, the present work, with its rapid execution and graphic handling, shares something of Degas's innovative use of the medium. In its coloring, *La Rochenoire* is consistent with the characteristic palette of Manet's oil paintings. High-toned hues of bisque, pink, and blue are juxtaposed with large areas of subtly modulated deep blacks. That *La Rochenoire* was executed on white-primed canvas, as were many of the late pastels, offers further evidence of Manet's conception of the pastel not as a preparatory medium, but as a finished work.

P.S.

85 PLATE 17

MASTER OF THE DIJON MADONNA (Flemish, active around 1500)
Madonna and Child, n.d.
Tempera on linen, 11¹³⁄₁₆ x 9¹⁄₁₆ in. (30 x 23 cm)
The Estate of Mrs. Fiske Warren

PROVENANCE: Sale Mrs. S. D. Warren, New York, January 9, 1903, no. 84, ill. (to H. C. Wilson); Mrs. Fiske Warren, Boston.

EXHIBITION: Boston, Museum of Fine Arts, *Art in New England*, June 9–September 10, 1939, no. 43, pl. xxv.

LITERATURE: Rijksmuseum, *Middeleeuwse Kunst der Noordelijke Nederlanden* (Amsterdam, 1958), p. 42 (as Flemish, about 1500); P. Vandenbroeck, "Laatmiddeleeuwse Doekschilderkunst in de Zuidelijke Nederlanden. Repertorium der nog bewaarde werken," *Jaarboek van het Koninklijke Museum voor Schone Kunsten, Antwerpen* 21 (1982), p. 46; Diane Wolfthal, *The Beginnings of Netherlandish Canvas Painting: 1400–1530* (Cambridge, 1989), pp. 56–57 and 211, cat. 32, fig. 92.

Depicted half length, the Madonna holds the sleeping Child before a diapered, rose-colored background framed by a flat arch of gold. Held by three strings of pearls with a cross of four pearls on her forehead, her light brown wavy hair descends over each shoulder to her waist. She inclines her head toward the Child, who nestles against her left arm. Her long,

slender hands are crossed in an embrace of the Child, who grasps the thumb of her right hand. The Virgin's robes are blue edged with a gold border decorated with pearls, lined with green, and worn over a red dress. The Child wears gold garments, the folds of which are outlined in red. Overall, the drawing is exceptionally precise and delicate, qualities that may be seen, for example, in the articulation of the Madonna's attenuated fingers.

When the painting sold in 1903 and when it was exhibited in 1939, it was described simply as "Flemish XV Century"; however, in private it had been improbably attributed to either van Eyck or Memling. In a letter dated April 12, 1938, to W. G. Constable, the former curator of the Museum of Fine Arts, Boston, Max J. Friedländer first connected it with a virtually identical composition (with minor changes in the Virgin's costume) entitled *Madonna and Sleeping Child* which was also painted with tempera on linen and is of similar dimensions (13 x 16⁹⁄₁₆ in. [33 x 42 cm]; now Dijon, Musée des Beaux-Arts [Maciet bequest, 1901]). The anonymous master of that work was subsequently christened the "Master of the Dijon Madonna" by Diane Wolfthal (1989, p. 56). Friedländer mentioned two other variants (with dealer Bonjeau, Paris, 1912; and sale Paris [Mercier], 1906, as "école Française xve."), and Wolfthal catalogued five versions and two variants (1989, cats. 31–35; figs. 91–95, and figs. 96 and 97, respectively) in her comprehensive study of the rise of canvas painting in the Netherlands in the fifteenth and early sixteenth centuries.

The Dijon Master must have been Flemish and active at or about the turn of the sixteenth century. No panels by him are known, and he may have been one of the early specialists in canvas. Like the Dijon painting and two of the other versions, the present painting was executed in tempera on a very finely woven linen. Paintings on canvas were introduced as inexpensive substitutes for panel paintings and, indeed, were the subjects of early lawsuits filed by Flemish panel painters who were concerned about competition. Colin Eisler (see Wolfthal 1989, p. 211, note 19), aptly described a related work (Williamstown, Massachusetts, Clark Art Institute, inv. 937) as a "sort of small, bargain-basement devotional painting." Despite initially being cheaper, canvases were often, as in the present work, executed with exquisite delicacy. Wolfthal speculated that the popularity of the composition might reflect the belief that the original was an especially holy picture, "perhaps believed to be miracle-working or by the hand of St. Luke" himself. In 1454 Petrus Christus and Hayne de Bruxelles copied no less than fifteen times a *Madonna and Child* that had been attributed to Saint Luke.

P.C.S.

86 PLATE 151

HENRI MATISSE (French, 1868–1954)
Pont Saint-Michel, about 1900
Oil on canvas, 18 x 21½ in. (45 x 55 cm)
Signed at bottom left: *Henri Matisse*
Scott M. Black Collection

PROVENANCE: Michael and Sarah Stein, Paris, by 1907; Trygve Sagen, Norway, by whom it was bought from the Steins, about 1919; Consul Peter Krag (late husband of Mrs. Sigri Welhaven), Oslo and Paris; Mrs. Sigri Welhaven, Oslo; sale London (Christie's), June 24, 1991, lot 14.

EXHIBITION: Berlin, Galerie Gurlitt, *Henri Matisse*, July 1914; Paris, Musée National d'Art Moderne, *Les Sources du xxe siècle*, November 1960–January 1961, no. 425; Paris, Grand Palais, *Henri Matisse, Exposition du Centenaire*, April–September 1970, no. 37.

LITERATURE: A. H. Barr, *Matisse, His Art and His Public* (New York, 1966), p. 540 (as dated 1902); L. Gowing, *Matisse* (London, 1979), p. 27.

In 1898, after Matisse had undergone nearly a decade of academic training in Paris, briefly under William Bouguereau at the Académie Julian and then unofficially in the studio of Gustave Moreau at the Ecole des Beaux-Arts, the artist and his new wife, Amelie Parayre, left the French capital, visiting London, Corsica, and Toulouse during the next twelve months. Upon his return to Paris in February 1899, the thirty-two-year-old Matisse resumed residence at 19 quai Saint-Michel. This fascinating painting is one of a series of views depicting the Pont Saint-Michel which Matisse painted as he looked out the window of his apartment.

Although the artist achieved a measure of success exhibiting four paintings at the Salon du Champ-de-Mars in 1896, his entry of the following year, *The Dinner Table* (1897, private collection), was badly hung and adversely received. Beginning in 1897, Matisse's artistic interests and ambitions were increasingly at odds with the standards of officially sanctioned instruction and exhibition. The period between 1897 and 1903 is often described as one of struggle for the middle-aged artist. Rejecting academic art, Matisse wrestled with the stylistic possibilities of Impressionism, Neo-Impressionism, the Nabis, and the work of Cézanne. Matisse's art from about the turn of the century is characterized by experimentation. Between 1899 and 1903 he explored many styles in both figure paintings and cityscapes. This small painting is an important example of the latter.

Matisse's apartment offered views to the east of the Petit Pont, the Hôtel-Dieu, and Notre Dame, and to the west of the Pont Saint-Michel and the Palais de Justice, with the tower of Sainte-Chapelle in the distance. Both views became favored motifs of the artist. This work employs a palette of both brilliant and dark hues, and explores various approaches to the handling of paint. Although some passages conform to the actual colors of the site, others are boldly subjective, such as the blazingly orange trees. The buildings beyond the Pont Saint-Michel the artist rendered with a dense impasto, and other areas he painted thinly; the surfaces of the latter show some evidence of having been scraped with the butt of a brush. The complex and varied palette, which Lawrence

Gowing described as "congested" (1979, p. 27), suggests that this work was probably executed at the midpoint of the sequence. In one of the first versions of this subject (*Pont Saint-Michel*, about 1899–1900; Zurich, Bürhle Collection), the silver-gray palette and handling are still indebted to the Impressionists.

On the basis of style, a chronology may be proposed for this group of paintings, the later works being characterized by an increasingly expressive, rather than empirical, approach to color and form. These stylistic experiments are often cited as having anticipated the painter's Fauve style. For the later versions of this subject Matisse simplified the composition, and deployed the hues in broad, flat areas of unmixed color. In one of the last variants of this view (*Pont Saint-Michel*, about 1901; Ludington Collection), he rendered the bridge in cool jade and the buildings in chrome orange and vermilion. The absence in the present painting of the window jamb, which is common to the later versions, also supports it dating from the midpoint of the explorations of this motif.

Combining the view out his window and the interior of the studio became a favorite motif for Matisse. Nicholas Watkins has observed: "Exterior space became inseparable from interior space, and the window acts more as a metaphysical divide between the artist's private and public worlds than as an actual barrier" (*Matisse* [New York, 1985], p. 47). This early painting presages Matisse's lifelong questioning of the nature of the medium of painting, and his complex relationship to both the fidelity of resemblance and the subjective expressive possibilities of representation.

R.J.B.

87 PLATE 12

PAOLO DE MATTEIS (Italian, 1662–1728)
Assumption of the Virgin, 1707
Oil on canvas, 40 x 29½ in. (101.6 x 74.9 cm)
Signed and dated at lower right: *Paolo dei Matthias fe 1707*
Azita Bina-Seibel and Elmar W. Seibel

PROVENANCE: Sale London (Christie's), December 10, 1948, no. 105; Wiggins; John Mortinson Co., London.

Born near Naples, Paolo de Matteis studied with the preeminent painter of that city, Luca Giordano. The artist moved to Rome in the early 1680s and is recorded to have worked there with Giovanni Maria Morandi, a follower of Marrata. De Matteis enjoyed the patronage of the Spanish ambassador to Rome, the marchese del Carpio, and this arrangement continued even after the artist's return to Naples, where he was again associated with Giordano.

De Matteis developed an individual style combining elements of the exuberant Neapolitan Baroque with the classicism he had learned in Rome. According to his biographer, de Dominici, the artist was in Paris between 1702 and 1705,

and received commissions from both the duc d'Estrées and the dauphin. Eventually, de Matteis's fame was such that he had important patrons all over Europe, including Pope Benedict XIII (for whom he returned to Rome); Count Daun, the Austrian viceroy in Naples; Admiral Byng, Commander of the British Navy; Prince Eugene of Savoy; and Lord Shaftesbury (for whom the artist executed a notable series of Arcadian mythological paintings). The artist was known for his virtuoso handling of paint, and he is said to have worked even faster than his mentor, "Fra Presto" Giordano.

Painted after his Parisian sojourn, this *Assumption*, with its clearly classical forms, shows de Matteis in the process of moving away from his earlier, purely Giordanoesque style. De Dominici (*Vite dei Pittori*, Naples, 1846, vol. 4, p. 326) recorded only one *Assumption* by the artist — that painted for the Church of the Nunziatella in Naples. G. Filangieri (*Documenti per la storia de Arti* [Naples, 1891], vol. 6, p. 149), however, mentions another as having been in the church of Monte Cassino.

The noble posture of the Virgin seen here may derive from Solimena (see F. Bologna, *Francesco Solimena* [Naples, 1958], fig. 141). De Matteis used this pose in *The Martyrdom of Saint Catherine of Alexandria* (1708; formerly New York, Lewine Collection) and also much later for a *Saint Joseph in Glory* (Naples, Certosa di San Martino). In this *Assumption* there is also an element of ecstasy, perhaps recalling Titian's famous prototype but here converted to an exuberant Baroque vision.

E.M.Z.

88 PLATE 75

WILLEM VAN MIERIS (Dutch, 1662–1747)
Portrait of a Man with a Sword, 1686
Oil on panel, 9 x 7⅛ in. (23 x 18 cm), with arched top
Signed and dated at lower left: *W.van / Mieris. / Fe' An° 1686*
Private collection

PROVENANCE: Sale J. Caudri, Amsterdam, September 6, 1809, no. 50 (for Fl 100, to Thomassen); (possibly) sale Ralph Thomason, London, February 25, 1822, no. 22 (as "W. Mieris, Portrait of himself, elaborately finished"); collection Jan Kleinenbergh; his sale, Leiden, July 19, 1841, no. 125 (for Fl 500, to L'Andry for Nieuwenhuys); sale Baron van Varange, Paris, May 26, 1852, no. 27 (as "Portrait of Admiral Tromp;" for Fr 1175); sale Is. Pereire, Paris, March 6, 1872, no. 134 (as "Portrait of Admiral Tromp;" for Fr 8500); collection C. G. de Candamo; sale De Candamo, Paris (Charpentier), December 14, 1933, no. 37 (as "presumably Admiral Tromp"; for Fr 37,000, to Cotnareanu); art market, 1986.

LITERATURE: John Smith, *A Catalogue Raisonné of the Works of the Most Eminent Dutch, Flemish, and French Painters*, vol. 9 (suppl.; London, 1842), p. 55, no. 8; E. W. Moes, *Iconographia Batavia* (Amsterdam, 1897–1905), vol. 2, p. 480 (as not a portrait of Cornelis Tromp); C. Hofstede de Groot, *Beschreibendes und kritisches Verzeichnis der Werke der hervorragendsten holländischen Maler des XVII. Jahrhunderts* (Esslingen and Paris, 1907–1928), vol. 10 (1928), p. 208, no. 396 (as dated 1688; erroneously as in sale Thomas Patureau, Paris, April 20, 1857, no. 7 [as "Portrait of Admiral Tromp;" for Fr 1180, to Van Cuyck]; thence collection Van Cuyck, 1858); Th. H. Lunsingh Scheurleer, C. W. Fock, and A. J. van

Dissel, *Het Rapenburg, Geschiedenis van een Leidse gracht*, vol. 5b (Leiden, 1990), pp. 672 and 711 (citing the *boedelinventaris* of Jan Kleynenberg, March 9–19, 1841: "120: 1 dito door W. van Mieris [1 heer in 1 hof]").

Posed beside a stone balustrade draped with a plush Oriental carpet, the unidentified sitter presents an image of gentlemanly élan that epitomizes the ideals of patrician society in the Netherlands at the close of the seventeenth century. His ruddy, weather-beaten face, together with his plain doublet and the silver-hilted sword held in his gloved right hand, testifies to a life spent in the outdoors. The attributes of an active life are counterbalanced by the sitter's extravagant lace jabot and sleeve ruffles, the languid gesture of his impossibly attenuated hand, and the classicizing architecture behind him. This juxtaposition of aristocratic elegance and vigorous masculinity caused the work to be identified during the nineteenth and twentieth centuries as a portrait of Admiral (Cornelis) Tromp (1629–1691), although the sitter does not resemble any of the documented likenesses of this naval hero (compare, for example, Jan Mijtens's portrait of 1668 [Amsterdam, Rijksmuseum, inv. A 284] or David van der Plaes's portrait of a later date [Amsterdam, Rijksmuseum, inv. A 1413]).

Willem van Mieris was the son of the Leiden *fijnschilder* (literally, "fine painter") Frans van Mieris (1635–1681), and like him, specialized in small, minutely detailed paintings executed with brush strokes so fine as to be virtually invisible. Paintings by the *fijnschilders* (including, in addition to the van Mierises, Gerard Dou and Adriaen van der Werff) were prized for their enamel-like finish and virtuoso illusionism of surfaces and textures. Although Willem van Mieris produced primarily genre scenes and histories, his meticulous technique was perfectly suited to fashionable portraiture in the latter part of the seventeenth century. His likenesses are enhanced by the inclusion of exquisite material objects, which tangibly express the wealth and status of the sitter. The small format and costly *fijnschilder* technique further elevated these works to the realm of precious cabinet pieces.

M.E.W.

89 PLATE 57

JAN MIENSE MOLENAER (Dutch, about 1610–1668)
Young Woman Seated by a Table, about 1630
Oil on panel, 20½ x 16⅛ in. (52 x 41 cm)
Private collection

PROVENANCE: Sir William van Horne, Montreal; E. J. Traver; sale La Salle College et al. (E. J. Traver), New York (Christie's), January 18, 1983, no. 192, ill.

EXHIBITION: Art Association of Montreal, *A Selection from the Collection of Paintings of the late Sir William van Horne K.C.M.G. 1843–1915*, October 16–November 5, 1933, no. 49.

A young woman seated beside a table holds a sheet of paper and gestures expressively, with her hand outstretched. She has kicked off her shoe and rests her foot on a foot warmer. Her dress is a lemony yellow (probably lead-tin yellow) over a red underlayer, giving the garment the shimmer of *changeant* silk. The table is covered with a brown and rust Turkish carpet. On it rests a wooden flute and an open jewel box, out of which dangle pearls. Although the sheet of paper the woman holds appears to contain only words and not music, the flute, the gesture of her hand, and her open mouth suggest that she may be singing. Overhead on the right is a swag of drapery.

Jan Miense Molenaer is today less well known than his wife, the artist Judith Leyster, but was in his own right a creative genre painter, especially in his early works of the late 1620s and 1630s. He adapted the scenes of merry companies pioneered by Willem Buytewech to a somewhat larger format with a brighter, clearer palette, partly in imitation of his fellow Haarlemers Frans and Dirck Hals. Enthusiastically exploring bumptious peasant and low-life subjects, Molenaer also offered a new, more naturalistic interpretation of such time-honored iconographic themes as "Vrouw Wereld" ("Dame World" — the embodiment of all terrestial and material appetites — as in his painting in the museum in Toledo). His contributions to the history of genre painting included a new focus on full-length, single-figure compositions. Paintings in this format would have their triumph twenty to thirty years later in the unparalleled accomplishments of painters such as Gerard ter Borch and Gabriel Metsu. Molenaer's innovations in this area followed on those of artists such as Pieter Codde, Willem Duyster, and Dirck Hals, but the artist achieved a new pictorial éclat, which was only partly the result of his larger-scale and freer brushwork.

This painting resembles in style *The Duet* (New York, Peter Eliot Collection), and can be compared to a few single-figure subjects by Molenaer, such as *Man Tuning His Lute* (sale London, July 11, 1980, no. 112, ill.; with Galerie Sanct Lucas, Vienna, 1990). Very similar in conception is Dirck Hals's *Flute Player* (signed and dated 1630; Haarlem, Frans Halsmuseum, cat. 1924, no. 122), in which a young woman is again depicted, full length and seated by a table, playing a flute and gaily kicking out her foot (a pose probably descended from Buytewech). Although the older Hals probably originated this conception, the style of Molenaer's painting does not significantly differ from that of his earliest dated works (1628 and 1629; see Mainz, Mittelrheinisches Landesmuseum, no. 831; and London, National Gallery, no. 5416, respectively); thus, it could conceivably have predated the Hals.

P.C.S.

90 PLATE 32

PIETER DE MOLIJN (Dutch, 1595–1661)
River Landscape, early 1630s
Oil on panel, 11 x 17¹/₁₆ in. (27.9 x 43.3 cm)
Private collection

PROVENANCE: Sale London (Sotheby's), April 21, 1982, no. 8, ill.; dealer Richard L. Feigen & Co., New York.

Born in London of Flemish parents, Pieter de Molijn became a master in the Haarlem guild of Saint Luke in 1616. Together with Jan van Goyen and Salomon van Ruysdael, he was instrumental in the creation of a more naturalistic style of Dutch landscape painting in the mid-1620s. Centered in Haarlem, these landscape artists painted unpretentious views of the Dutch countryside in a muted tonal palette of sandy golden browns and soft grayed greens and blues. Molijn's *Dune Landscape* of 1626 (Braunschweig, Herzog Anton Ulrich-Museum), among the earliest experiments in this genre, has been termed "one of the corner-stones of Dutch landscape painting" (W. Stechow, *Dutch Landscape Painting of the Seventeenth Century* [London, 1966], p. 23) for its simplicity and bold realism.

In *River Landscape*, two figures in a small fishing boat make their way down the river; one man's red jacket lends a vibrant accent to the otherwise subdued colors of the landscape. On the far bank is a cluster of farm buildings flanked by trees and, toward the center of the composition, a figure poised on the crest of a low hill. A distant church steeple pierces the horizon at the far left.

Although the strong diagonal organization is characteristic of Molijn's early landscape compositions, the use of a body of water to create this effect is relatively unusual in his work. This motif may reflect the influence of Jan van Goyen's river views of the 1630s; compare, for example, the latter's *River Landscape* dated 1631 (Glasgow City Art Gallery and Museum). Molijn's drawing of a *River Landscape with Fishing Boat* (Berlin, Kupferstichkabinet der Staatlichen Museen, inv. 5395; Hans-Ulrich Beck, *Künstler um Jan van Goyen* [Doornspijk, 1991], p. 281, no. 776, ill.) depicts a scene similar to that in *River Landscape*, albeit framed by a coulisse of gnarled tree trunks in the foreground.

River Landscape probably dates to about 1630 or slightly later, toward the end of the earliest and most inventive phase of the artist's career. The thick application of paint and vigorous bold brush strokes are typical of works from this period.

There are several inscriptions on the reverse of the panel. The oldest inscription, which may date from the seventeenth century (and is visible only with infrared reflectography), reads: "J [or S?] . . van / Gooyen [or Gooyer]." It should be noted that the painting shares stylistic affinities not only with works by Jan van Goyen, but also with early works by Salomon van Ruysdael, who in 1623 had joined the painter's guild in Haarlem under his original name, Salomon de Gooyer; he stopped using this name soon thereafter. A

later (eighteenth-century?) French inscription on the back of the panel reads: "PEINT PAR P. / MOLYN / PIERRE MOLYN Pⁱᵗ / EN I.6.2.O. / cabinet de Mʳ. . . ." Despite the early inscription, however, the painting is closest in style to Molijn.

M.E.W.

91 PLATE 161

PIET MONDRIAN (Dutch, 1872–1944)
Composition, 1939–1942
Oil on canvas, 29⅝ x 25¾ in. (72.7 x 65.4 cm)
Signed on back of frame: *Piet Mondrian*
Initialed at lower left and dated at lower right
Private collection

LITERATURE: Michel Seuphor, *Piet Mondrian: Life and Work* (New York, 1957), p. 393, no. 413; and p. 430, no. 546.

Piet Mondrian was born Pieter Cornelis Mondriaan on March 7, 1872, in Amersfoort, The Netherlands. He received early informal instruction from his father, an amateur draftsman, and his uncle, Frits Mondriaan, a painter. Mondrian was raised in the Calvinist faith, and considered joining the clergy. However, in 1892 he moved to Amsterdam, where he studied at the Rijksakademie van Beeldende Kunsten until 1896. Following his academic instruction, he remained in Amsterdam, working in an Impressionist and then a Symbolist style through 1908. In 1909 Mondrian joined the Theosophic Society. The Theosophist tenet of the existence of a spiritual world and a universal order beyond those of natural appearances would have profound consequences for Mondrian's art. In 1910, the artist helped found the Moderne Kunstkring, a group that the following year organized an exhibition of French avant-garde painting, including Cubist works by Braque and Picasso. In December 1911, Mondrian moved to Paris. During the following two years he acquainted himself with Cubism, and by 1912 had begun incorporating into his work a linear grid derived from this style.

Visiting in Holland when the First World War began, Mondrian was unable to return to Paris. In 1917 he collaborated with Theo van Doesburg and Bart van der Leck in founding de Stijl. In its journal of the same name, Mondrian and the other members of the group promulgated the doctrine of Neo-Plasticism, calling for nonobjective abstraction based upon straight lines, right angles, and primary colors, not only for painting and sculpture but also for architecture and graphic and industrial design. In 1919 the artist returned to Paris, where he exhibited with de Stijl in 1923. In reaction to van Doesburg's reintroduction of diagonal elements into his work, Mondrian resigned from the group in 1925. He then exhibited with Cercle et Carré in 1930, and in 1931 joined Abstraction-Création. The threat of war prompted Mondrian to move to London in 1938. After the destruction of his studio in an air raid, he moved to New York in October 1940. In 1942 he had his first one-man show, at the Val-

entine Dudensing Gallery. Mondrian died on February 1, 1944, in New York.

Composition is composed of a series of black horizontal and vertical bands that cross the white field of the canvas to the edges of the composition. Five squares and rectangles painted blue, yellow, and red are the only colored elements of the composition. The stark simplicity of this painting belies both the metaphysical intentions of the painter and the careful deliberation involved in its conception. Despite his limited formal vocabulary, no two paintings by Mondrian are alike. Subtle changes and refinements characterize the artist's mature work. Noteworthy in the present picture is the deployment of blue and red areas directly against the white field, rather than bound by black bands. Mondrian introduced this innovation during the later 1930s. For this picture he also designed the frame, which was intended to negate any illusion of depth. In 1942 the artist wrote: "The first aim in a painting should be universal expression. What is needed in a picture to realize this is an equivalence of vertical and horizontal expressions."

Despite Mondrian's claims for his art, Modernist critics have considered the works from an exclusively formalist view. Rosalind Krauss has written: "The grid announces, among other things, modern art's will to silence, its hostility to literature, to narrative, to discourse. . . . The barrier it [the grid] has lowered between the arts of vision and those of language has been almost totally successful in walling the visual arts into the realm of exclusive visuality and defending them against the intrusion of speech" ("Grids," in *The Originality of the Avant-Garde and Other Modernist Myths* [Cambridge, Massachusetts 1985], p. 9). Yet by the artist's metaphysical standards Krauss's reductivist account preempts the possibility of critical interpretation, and impoverishes the reading of Mondrian's work.

R.J.B.

92 PLATE 128

CLAUDE MONET (French, 1840–1926)
Windmills in the Westzijderveld, near Zaandam, about 1870–1871
Oil on canvas, 18½ x 28¾ in. (47 x 73 cm)
Signed at lower left: *Claude Monet*
The Simpson Family Collection

PROVENANCE: Max Liebermann, Berlin, about 1920; Mrs. Riezler-Liebermann, New York, 1935; Mr. and Mrs. Harry N. Abrams, New York, about 1956.

EXHIBITIONS: City Art Museum of Saint Louis; and Minneapolis Institute of Arts, *Monet*, 1957, no. 14; Palm Beach, Society of Four Arts, *Monet*, 1960, pp. 90, 91, ill.; Amsterdam, Rijksmuseum Vincent van Gogh, *Monet in Holland* (exh. cat.), October 17, 1986–January 4, 1987, cat. 13, ill.

LITERATURE: E. Waldmann, *Sammler und Ihresgleichen* (Berlin, 1920), p. 27; Daniel Wildenstein, *Claude Monet: Biographie et catalogue raisonné*, vol. 1 (Lausanne and Paris, 1974), no. 181, ill.

Large windmills with white and orange sails stand on either side of a canal and are silhouetted against a leaden overcast sky. A simple wooden pedestrian bridge straddles the canal, which recedes perpendicularly from the viewer and in which small boats ply the choppy waters.

After the war between Prussia and France was declared, Monet, his wife, and his young son fled to London in the fall of 1870, and in June of the following year traveled to the Netherlands, settling in Zaandam, near Amsterdam. There they remained until October 8. In the four months during which Monet resided in Zaandam, he executed numerous landscapes — river views as well as cityscapes — of the flat and watery Dutch countryside. When he wrote to his friend the artist Camille Pissaro, Monet gave his address as the Hôtel de Beurs and praised his surroundings, claiming there was "enough in Zaandam to paint for a lifetime." Also staying at the Hôtel de Beurs was the French art historian Henry Havard (1838–1921), who wrote about Dutch seventeenth-century painting and produced a guide to Holland (1881), and the French painter Henri Michel-Lévy (d. 1914). The three compatriots visited Dutch painting collections together, and strolled and worked side by side in the countryside.

Monet depicted many views of the waters of the Zaan River and Het IJ as well as its side canals. This is one of the most striking of those paintings. The precise site cannot be specified, but it is certainly one of the canals in the Westzijderveld, which is studded with large windmills. Monet filled his sketchbooks (now in Paris, Musée Marmottan) with cursory little sketches of these mills and the outlines of their cartwheeling sails (see Amsterdam 1986–1987, p. 129, fig. 20). A very similar image and design, but with a setting sun and the onset of the calm of evening, confirms that the view is to the west (see Wildenstein 1974, no. 182; Amsterdam 1986–1987, no. 14). Wildenstein assumed that the season was autumn, but the authors of the exhibition catalogue *Monet in Holland* (Amsterdam 1986–1987, under cat. 13) rightly cautioned that the time of year could not be specified. They also likened the bold technique in the treatment of the windmills to the earliest landscapes of the famous twentieth-century abstractionist Piet Mondrian.

The earliest certain owner of this painting was the German painter Max Liebermann, who no doubt would have appreciated its bold and painterly technique. When he acquired the work is unknown, but he too was in Holland in 1871 and, like Monet, signed the guestbook at the Trippenhuis in Amsterdam.

P.C.S.

93 PLATE 130

CLAUDE MONET (French, 1840–1926)
Jean Monet on His Mechanical Horse, 1872
Oil on canvas, 23⅜ x 28¹⁵⁄₁₆ in. (59.5 x 73.5 cm)
Signed and dated at lower right: *Claude Monet. 1872.*
Private collection

PROVENANCE: Blanche Hoschedé-Monet (Mme Jean Monet), Giverny; Wildenstein and Co., Paris and New York; Mrs. Huttleson H. Rogers, New York, about 1948; Mr. and Mrs. Nathan Cummings, Chicago, about 1952–1983; P. & D. Colnaghi, Ltd., New York, 1983.

EXHIBITIONS: Paris, Musée de l'Orangerie, *Claude Monet*, 1931, no. 20; Paris, Galerie Durand-Ruel, *Monet de 1865 à 1888*, 1935, no. 11; Zürich, Kunsthaus, *Monet*, 1952, no. 27, ill.; Paris, Galeries des Beaux-Arts, no. 21; The Hague, Gemeentemuseum, *Claude Monet*, 1952, no. 23, ill.; Edinburgh, Royal Scottish Academy; and London, Tate Gallery, *Claude Monet*, 1957, no. 23, p. 44, ill.; Palm Beach, Florida, Society of the Four Arts, *Paintings by Claude Monet: Paintings from the Collection of Mrs. Mellon Bruce*, 1958, no. 7, ill.; Washington, D.C., National Gallery of Art; and New York, Metropolitan Museum of Art, *Selections from the Nathan Cummings Collection*, 1971, no. 11, ill.; Art Institute of Chicago, *Major Works from the Collection of Nathan Cummings*, 1973, no. 3, ill.; Art Institute of Chicago, *Paintings by Monet*, 1975, p. 84, no. 30, ill.; New York, Acquavella Galleries, Inc., *Claude Monet*, 1976, no. 14, ill.

LITERATURE: M. Malingue, *Claude Monet* (Monaco, 1943), pp. 58, 146, ill.; Otto Reuterswärd, *Monet* (Stockholm, 1948), p. 279; George Besson, *Monet* (Paris, n.d.), ill.; "Outstanding Exhibitions," *Apollo* (September 1970), p. 230, ill.; Daniel Wildenstein, *Claude Monet: Biographie et catalogue raisonné*, vol. 1 (Lausanne and Paris, 1974), no. 238, ill.; Paul Hayes Tucker, *Monet at Argenteuil* (New Haven and London, 1982), pp. 131 and 139, ill.; John House, *Monet: Nature into Art* (New Haven and London, 1986), p. 34, ill.; Karin Sagner-Düchting, *Claude Monet: Ein Fest für die Augen* (Cologne, 1990), p. 75, ill.; Denis Rouart, *Monet* (Zurich, 1990?), p. 47, ill.

For Claude Monet, the 1870s were a decade marked by settled domesticity and newfound prosperity. With the conclusion of the Franco-Prussian War in 1871, Monet, his wife, Camille, and their young son, Jean, returned from voluntary exile in England and Holland, and rented a large house in Argenteuil, a prosperous suburb on the Seine, northwest of Paris. The struggling bohemian existence of the previous nine years was replaced by a more comfortable life, as sales of Monet's paintings at Durand-Ruel met with increasing success.

The sense of tranquillity and attainment associated with these changed circumstances is reflected in a group of figure and garden scenes that record the artist's family at leisure and play in the garden and surrounding meadows of Argenteuil. Long considered to constitute a classic phase in Monet's Impressionism, the Argenteuil canvases moved away from traditional artistic concerns in order to stress the heightened color, broken brushwork, and fleeting effects of nature that would occupy Monet for the remainder of his career.

Painted during the first summer the family spent at Argenteuil, Monet's portrait of his son, Jean, riding a mechanical horse is unusual in its emphasis on the figure as distinct from the landscape. This evocative portrait must have had special meaning for the artist; Jean had been born out of wedlock in 1867, at a time when destitution had forced Claude

and Camille to live apart. Five years later, his parents now married, Jean is shown decked out in his best clothes and riding a fanciful, and certainly expensive, tricycle in his own garden — he is clearly not the son of a starving artist.

Paul Tucker (1982, p. 131) has compared *Jean Monet on His Mechanical Horse* to Velázquez's *Infante Don Baltasar Carlos on Horseback* (Madrid, The Prado), which was known in Paris through an engraving of 1869, seeing Monet's painting as a bourgeois reformulation of the aristocratic tradition of equestrian portraiture. However, as John House (1986, p. 34) has pointed out, such an appropriation, in 1872, on the part of a highly innovative painter, undoubtably contained an element of parody. Stylistically, *Jean Monet on His Mechanical Horse* straddles the artist's darker style of the 1860s and his brighter, broken brushwork of the 1870s. The predominant palette of beige and dark green suggests an overcast day. The child and his horse, united visually by their pale bisque coloring, stand out from the flat backdrop of dark foliage, an effect counterbalanced in the lower third of the composition by the pattern of the dark wheels against the flat, beige ground, giving the image a two-dimensional, abstracted quality evocative of the Japanese prints that Monet and his contemporaries collected.

During the remainder of the 1870s, Jean featured frequently as an incidental and self-absorbed element in Monet's landscape paintings. In contrast, the present canvas is more aptly designated a portrait, as interest in the landscape is subdued and the child directly engages the viewer. However, Monet stopped short of providing a narrative accompaniment, depicting Jean with an opaque gaze that betrays little emotion.

P.S.

94 PLATE 133

CLAUDE MONET (French, 1840–1926)
Monte Carlo, View of Cape Martin, 1884
Oil on canvas, 35¼ x 41¾ in. (65.5 x 81.5 cm)
Signed at bottom, left of center: *Claude Monet*
Scott M. Black Collection

PROVENANCE: Mr. and Mrs. Potter Palmer, Chicago; Wildenstein & Co., Inc., New York; Somlo, New York; sale New York (Christie's), May 14, 1986, lot 15.

EXHIBITION: Portland (Maine) Museum of Art, *Impressionism and Post-Impressionism: The Collector's Passion*, July–October 1991, no. 24, p. 52.

LITERATURE: Daniel Wildenstein, *Claude Monet, Biographie et catalogue raisonné*, vol. 2 (Lausanne and Paris 1979), p. 128, no. 892.

Of all the painters associated with the Impressionist movement, only Claude Monet continued to explore the stylistic possibilities of the idiom throughout his entire career. By the 1880s, the other leading members of the original group, particularly Renoir, Pissarro, and Cézanne, had either abandoned Impressionism or significantly revised the style. Impressionism is not easily characterized by a simple defini-

tion, but rather derives from empirical observations of light and color. The practice of sketching directly from nature had been an established artistic practice prior to the nineteenth century, yet it had been regarded as preliminary to a "finished" work, with the sketch being revised and embellished in the artist's studio. By the 1870s Monet and the Impressionists had made painting *en plein air* the basis of much of their work. Monet subsequently remained faithful to plein-air painting, despite changes in his style. *Monte Carlo, View of Cape Martin* is an example of the artist's revision of Impressionism during the early 1880s.

A native of Le Havre, Monet often depicted coastal motifs in his early career. These marines reflect the importance of Eugène Boudin and J. B. Jongkind to the artist. By the mid-1860s Monet was also deeply affected by the art of Courbet and Manet, resulting in a new emphasis in his work: he was now painting "la vie moderne" in a new style. Monet's paintings of Trouville from the summer of 1870, for example, typify his preoccupation with representing modernity in a boldly original mode. Monet executed *The Beach at Trouville* (1870, National Gallery, London) completely *en plein air* in a single afternoon: grains of sand are detectable on its surface. Whether painting the luxurious new resort *Hotel des Roches Noires, Trouville* (1870; Paris, Musée d'Orsay) or fashionably dressed strollers on *The Broadwalk at Trouville* (1870; Hartford, Wadsworth Atheneum), Monet was preoccupied by "la vie moderne." A decisive change in his expression of modernity and Impressionism is evident in works done as early as 1884, such as *Monte Carlo, View of Cape Martin*.

During the fourteen years between the works from Trouville of 1870 and *Monte Carlo*, Monet worked primarily in the Paris suburb of Argenteuil, producing more than 170 canvases of the progressive *banlieue* and its environs. By the 1880s, however, Monet had "abandoned the challenges of painting contemporary subjects" (Paul Tucker, *Monet in the '90s* [New Haven, 1989], p. 18). The artist made a brief visit to the Côte d'Azur with Renoir in December 1883, and decided to return there in January 1884, staying in the Italian town of Bordighera. He followed this with a brief soujourn to Menton in April of that year, before returning to his recently purchased home in Giverny. By the 1880s Monet's interests had evolved almost exclusively to formal concerns. The artist continued to paint *en plein air* and to be interested in the visual effects of weather and light, but not as subjects proper; rather, he used them as pretexts to explore texture, hue, and their arrangement on the canvas as a means of producing a unified pictorial surface.

Monte Carlo, View of Cape Martin was painted during the latter part of Monet's southern excursion, while he was staying in Menton. His point of view was from the Corniche road, looking toward Monte Carlo. John House has persuasively suggested that Monet's subjects away from home were often the much favored sites that were noted in guidebooks or had been suggested by local inhabitants. These popular tourist vistas would probably have been recognizable to some of his prospective patrons viewing the paintings in Paris. Although Monte Carlo, with its casino, and the scenic Côte d'Azur had become popular resorts, southern counterparts to Trouville, Monet consistently omitted from his later Mediterranean paintings the references to contemporary culture that had figured so prominently in his earlier work. Monet's *Monte Carlo* is closer to a timeless coastal town than to a contemporary luxury resort.

He built up the surface of the painting with a series of *taches* (colored patches or strokes). The intricate surface bespeaks the artist's pursuit of the Impressionist conviction that there are no contours in nature. Monet deployed a variety of strokes, some small and irregular, and others broad and fluid. The intense light of the Mediterranean provided him with a new challenge compared to that of the Norman coast and Argenteuil. He responded with an intense and varied palette, capturing the effects of bright light upon forms. The surface of *Monte Carlo* is characterized by a densely woven texture of strokes and colors that coalesces into an allover optical unity. Based upon the complex manufacture of this picture, it is reasonable to speculate that Monet began the canvas *en plein air*, and then reworked it in his studio.

R.J.B.

95 PLATE 131
CLAUDE MONET (French, 1840–1926)
Poplars at Giverny, 1887
Oil on canvas, 29¼ x 36 in. (74.9 x 91.4 cm)
Signed and dated at lower left: *Claude Monet 87*
Private collection

PROVENANCE: Sold by Monet to Galerie Durand-Ruel, 1890; acquired by Robert Treat Paine, 2nd, of Boston, 1911.

EXHIBITIONS: Paris, Georges Petit, *Monet-Rodin*, 1889, no. 97; Saint Louis, Museum of Fine Arts, *Paintings by the French Impressionists*, 1907, no. 56; Pittsburgh, Carnegie Institute, *Paintings by the French Impressionists*, 1908, no. 48; New York, Durand-Ruel Gallery, *Monet*, 1911, no. 4; Boston, Museum of Fine Arts, *Monet*, 1911, no. 29; Boston, Museum of Fine Arts, *Impressionist and Barbizon Schools*, 1919–1920; Boston, Museum of Fine Arts, *Monet*, 1927, no. 73.

LITERATURE: Gustave Geffroy, *Claude Monet, sa vie, sons temps, son oeuvre* (Paris, 1922), p. 118; Marthe de Fels, *La Vie de Claude Monet* (Paris, 1929), p. 235; Otto Reuterswärd, *Monet* (Stockholm, 1948), p. 286; Daniel Wildenstein, *Claude Monet: Biographie et catalogue raisonné*, vol. 3 (Lausanne and Paris, 1985), no. 1155, p. 98; Paul Tucker, *Monet in the '90s* (New Haven and London, 1989), fig. 48, p. 108.

Two rows of poplar trees line the banks of a river near the artist's home in Giverny. Composed virtually as a screen, the image offers a view of the trees on both sides of a barely discernible river. The poplars in the foreground extend the entire width of the canvas, filling the picture plane with vibrantly colored leaves and branches. From the viewer's vantage point across the river, the background trees appear more

fully resolved. At the base of the trees, an area of pink suggests the onset of twilight.

In the 1880s Monet became dissatisfied with the themes and techniques he had favored in the previous decade, and sought to expand his subject matter by traveling to different locales. His interest in new subjects can be seen in his canvases from Bordighera and Antibes on the Mediterranean coast, and from Belle-Isle off the coast of Brittany. When not traveling, he would return to subjects near his home in Giverny, where he could explore familiar local motifs.

This important painting marks Monet's first experiment with the graceful theme of the poplar, which he would develop into a major series in 1891. A close variation on this particular subject (*Poplars at Giverny, Sunrise*, New York, Museum of Modern Art) differs only in coloration. Monet often returned to a motif, reworking images repeatedly. No longer concerned, as in the previous decade, with depicting the landscape of modern life, he focused here on a specific but paradoxically timeless moment.

Although the later paintings of poplars have a clearer historical context (see cat. 97), this work is an example of Monet's emerging interest in more emotional, personal landscapes through the use of heightened color. He created a deliberate ambiguity in the interplay of spacial relationships and in the application of paint as he recorded form, causing the pinks, purples, greens, and blues to vibrate on the canvas. Though still a relatively early work, this painting emphatically celebrates the painter's touch as an aesthetic increasingly free of the descriptive imperative, as the moist atmosphere, colorful leaves, and sinuous, swaying trunks become virtually indistinguishable on the surface of the work. Filling his canvas with dramatically cropped and colored trees, Monet again challenged the parameters of traditional landscape painting.

K.R.

96 PLATE 132

CLAUDE MONET (French, 1840–1926)
The Petite Creuse (Sunlight), 1889
Signed at lower left: *Claude Monet*
Oil on canvas, 28¾ x 36¼ in. (73 x 92.1 cm)
Private collection

PROVENANCE: J. B. Faure, Paris; sale American Art Association, New York (Chickering Hall), April 25–30, 1895, no. 127; Durand-Ruel; Brooks and Reed, Boston; Robert Treat Paine, 2nd, 1916.

EXHIBITIONS: New York, Union League Club, *Monet*, 1891, no. 72; Pittsburgh, *First Pittsburgh International Exhibition*, 1896; Boston, Copley Hall, *Monet*, 1905, no. 23; New York, Durand-Ruel Gallery, *Monet*, 1907, no. 6; Pittsburgh, *Pittsburgh International Exhibition*, 1907, no. 332; City Art Museum of Saint Louis, 1914–1915; Boston, Museum of Fine Arts, *Impressionist and Barbizon Schools*, 1919–1920; Boston, Museum of Fine Arts, *Monet*, 1927, no. 74; Boston, Museum of Fine Arts; Art Institute of Chicago; and London, Royal Academy, *Monet in the '90s*, 1990, pl. 12, no. 9.

LITERATURE: Marthe de Fels, *La Vie de Claude Monet* (Paris, 1929), p. 235; Otto Reutersward, *Monet* (Stockholm, 1948), p. 286; Daniel Wildenstein, *Claude Monet: Biographie et catalogue raisonné*, vol. 3 (Lausanne and Paris, 1985), no. 1232, p. 125.

The sun streams across monumental hills to a shimmering river valley, sending ripples of color down the slopes. The large rock formation in the left foreground remains in shadow, and to the right, two brightly lit yellow trees rise above the rushing water. The sky is blue and filled with clouds.

In February 1889 Monet traveled to the Creuse valley for the first time, with his friend Gustave Geffroy. The landscape so captivated him that he returned home to retrieve his materials, and within two weeks had begun to work in the new region. The campaign lasted three months and proved to be his last major excursion from Giverny for the next five years. Monet particularly admired the Creuse valley because of the wildness of its landscape. He wrote to Berthe Morisot while working there that "there is a real savagery here that reminds me of Belle-Isle" (see Wildenstein 1985, vol. 3, p. 244, no. 943), a town on the Brittany coast where in 1886 he had worked on what could be considered his first true series. He soon became attached to the setting in the valley, but spring arrived after a few weeks and overtook events. Never loath to manipulate nature, Monet preserved the winter mood by hiring two men to strip the leaves from the trees as he painted.

Monet began twenty-four canvases during his stay in the small town of Fresselines. Fourteen views of the Creuse valley were displayed at the exhibition *Monet-Rodin* of 1889. This was the first time that such a large group of Monet's canvases had been exhibited at once, a circumstance that might have encouraged him later to show his work in series. Critics responded positively to his documentation of the various effects of weather and seasons on the same motif.

Although a variety of vantage points are employed in the series, rounded hills, ravines, rapids, trees, and a small village appear consistently. More than ten of the paintings depict the same view of hills and rushing water below (see Wildenstein 1985, nos. 1218–1227). For this particular group, Monet chose the most dramatic setting in the area, where the Petite Creuse River meets the Grande Creuse River. These earlier, somber views contrast distinctly with the later, more elemental paintings in the series; the latter have a brighter palette and show less concern with representational topographic detail.

For the final works of the Creuse series, Monet moved his site further down the river, emphasizing the yellow tree on the right of the composition. In a letter to his wife, Alice, in 1889, he revealed a particular fondness for this tree, referring to it as "my poor old oak" (see Wildenstein 1985, vol. 3, p. 247, no. 974). He executed three other canvases of it, including a painting that he devoted to it alone (*Le Vieil Arbe à Fresselines*, since destroyed).

In this version of *The Petite Creuse*, Monet no longer recorded an actual site and situation in nature, but transformed his observations into monumental, even visionary shapes, into mountains that were his idea of mountains rather than their true topographic portraits. He simplified forms and reduced them to their essentials, extinguishing all evidence of man's existence. Whereas somber tones dominate the early works of the series, the remote, secluded site in the present painting is set ablaze with brilliant, vibrant colors.

K.R.

97 PLATE 134

CLAUDE MONET (French, 1840–1926)
Poplars on the Banks of the Epte, Sunset, 1891
Oil on canvas, 39⅜ x 25⅝ in. (100 x 65.1 cm)
Signed and dated at lower right: *Claude Monet 91*
Private collection, New York

PROVENANCE: Sold by Monet to Durand-Ruel in January 1892; sale Paris (Palais Galliera), November 27, 1968, no. 92.

EXHIBITIONS: Paris, Galerie Durand-Ruel, *Monet*, 1882, no. 1; London, Guildhall, *Pictures of the French School*, 1898; Paris, Galerie Durand-Ruel, *Monet, Pissarro, Renoir et Sisley*, 1899, no. 35; Paris, Galerie Durand-Ruel, *Paysages par Claude Monet et Renoir*, 1908, no. 30; Paris, Musée de l'Orangerie, *Centenaire Monet-Rodin*, 1940, no. 46; Boston, Museum of Fine Arts; Art Institute of Chicago; and London, Royal Academy, *Monet in the '90s*, 1990, no. 32.

LITERATURE: Julian Leclercq, "Petites Expositions: Galerie Durand-Ruel," *Chronique des Arts*, April 15, 1899; Camille Mauclair, *L'Impressionnisme* (Paris, 1904), p. 88; Lionello Venturi, *Archives de L'Impressionnisme* (Paris, 1939), pp. 341–42; Daniel Wildenstein, *Claude Monet: Biographie et catalogue raisonné*, vol. 3 (Lausanne and Paris, 1985), no. 1296, p. 146.

Tall poplar trees rise in the vertical canvas, and a second, less distinct row of trees appears behind them. The river in the immediate foreground reflects the elongated forms, reiterating the vertical thrust of the composition. The foliage merges, creating an S-curve, which extends from the upper-right corner of the canvas to the horizon at the left. The pink glow of twilight is mirrored in the water, enhancing the warm tones in the lower half of the composition.

Monet had painted poplar trees at various times throughout his career (see cat. 95), but in the spring of 1891 he began to concentrate exclusively on a particular group of trees located near Giverny. Monet had already begun painting the poplars earlier in the year, and then the village of Limetz decided to sell some trees that had been planted on community property along the banks of the Epte River. Upon hearing this news, he offered to buy the poplars himself in order to save his subject, eventually purchasing them jointly with a local woodmill and finishing his series.

Prior to Paul Tucker's discussions (*Monet in the '90s* [New Haven and London, 1989], pp. 107–41), this series was viewed as primarily decorative, with little or no social or political content. Tucker focused instead on the practical and potentially historic rationales for the series. The trees had not been altered for artistic purposes; rather, their elegant, sculpted forms had been created as a result of traditional pruning practices to encourage maximum growth and profits. Monet's poplars are evenly spaced and located beside a picturesque river not only for beauty's sake but also because this common practice provided an easily accessible source of water for the trees. Thus, on a socioeconomic level, the series can be regarded as both a depiction of an important nineteenth-century French crop and a celebration of aesthetically beautiful forms in nature.

The poplar had been a recurrent motif in eighteenth-century French painting as well; the decorative shape of the tree featured in numerous Rococo paintings. It had been chosen during the French Revolution as the "tree of liberty," and by 1793 more than 60,000 poplars had been planted in support of the new regime. By choosing a subject rich with historical and popular associations that could be understood by the entire French populace, Monet legitimized his series.

In March 1892 the artist exhibited fifteen of his *Poplars* at the Galerie Durand-Ruel in Paris. For the first time, he showed paintings from only one series, a practice he would continue throughout his career. The show was a notable success, with twelve of the canvases being sold prior to the opening. As a sequel to his successful *Grainstack* series, Monet's *Poplars* asserted a new confidence. He worked within rigorous self-imposed constraints upon composition, subject, vantage point, and time. The subtleties of the muted scene in the many versions of the series are difficult to appreciate in the isolation of a single example. Monet conceived of the *Poplar* paintings as a series, and in order to truly comprehend his achievement the sequence should be considered as a whole.

The elongated forms of the trees create a grid on the picture plane that reiterates the geometrics of the canvas itself. Unlike in the earlier *Poplars at Giverny* (1887, cat. 95), the emphasis in the present painting is not on the inherently expressive properties of paint and brushwork but on the compositional tension between the trees as surface pattern and the illusion of deep space beyond them. The muted colors and brush strokes contrast with the strict geometry of the composition within its vertical format.

K.R.

98 PLATE 136

CLAUDE MONET (French, 1840–1926)
Customs House at Varengeville, 1896–1897
Signed and dated at lower left: *Claude Monet 97*
Oil on canvas, 24¼ x 35¾ in. (61.6 x 90.6 cm)
Private collection

PROVENANCE: Sold by Monet to William H. Fuller of New York, 1899; sold by Fuller, New York (American Art Association), March 12, 1903, no. 154.

EXHIBITIONS: Paris, George Petit Gallery, *Monet*, 1898, no. 27 or 28; New York, Lotus Club, *Monet*, 1899, no. 22; Boston, Museum of Fine Arts; Art Institute of Chicago; and London, Royal Academy, *Monet in the '90s* (1990), pl. 74, cat. 70.

LITERATURE: "W. H. Fuller's Monets Sold," *The Sun*, March 14, 1903; Daniel Wildenstein, *Claude Monet: Biographie et catalogue raisonné*, vol. 3 (Lausanne and Paris, 1985), no. 1456.

A cottage sits in solitary isolation upon a cliff overlooking the coast. The land forms a dramatic point on the right side of the canvas, jutting out toward the pastel-colored water and sky. The forceful and energetic brush strokes of the cottage and land contrast markedly with the smooth technique employed in the background.

Monet was fascinated with the landscape of Normandy throughout his career. He was particularly fond of its northern coast, which was depicted by many nineteenth-century artists, who were drawn to its dramatic cliffs and rugged shoreline. In fourteen months during 1896 and 1897, the artist produced more than fifty paintings of the Norman towns of Varengeville, Dieppe, and Pourville. Following the personally exhausting experience of painting his series of the Rouen cathedral in 1895, Monet must have returned with comfort to the familiar and elemental motifs of the sea and the sky. In this series on the Norman cliffs, he was free to explore the landscape without addressing highly specific aspects of the time of day or of seasons, concentrating instead on the elemental mood and atmosphere of the overall setting.

In 1882, Monet had painted the gorge of the Petit Ailly in Varengeville more than twenty times. In these early paintings, he had consistently included a customs house amid other landscape elements. Dating back to the time of Napoleon, such structures had been used by French customs officials to keep watch for goods being smuggled into France. Paul Tucker (*Monet in the '90s* [New Haven and London, 1989], p. 203) suggested that Monet used the house as a surrogate for a human presence, specifically that of the landscapist in the barren and inhospitable terrain.

The artist returned to Varengeville in 1897, and during a three-month campaign painted fourteen canvases that again concentrated on the customs house as a central motif. In a letter to his wife, Alice, in 1897, he mentioned that upon his arrival he had checked immediately on the structure in order to be certain that it was still intact (see Wildenstein 1985, vol. 3, p. 292, no. 1358).

Monet expressed its progressive importance for him in the later works in the series by moving it closer to the viewer and silhouetting it dramatically against the sky. The low vantage point also contributes to this sense of man against the natural elements, as the lilac, pink, and turquoise brushwork of the water and sky dissolves, and the two elements become indistinguishable.

In 1898 Monet exhibited twenty-four paintings from his trip to Pourville, Val Saint-Nicholas at Dieppe, and Varengeville as a series called *Falaises (Cliffs)*. Primarily recog-

nized for the startling use of pastel colors and simplified compositions, this group was the least known of Monet's series of the 1890s until its exhibition in 1990.

K.R.

99 PLATE 135

CLAUDE MONET (French, 1840–1926)
Contarini Palace, 1908
Oil on canvas, 28¾ x 36¼ in. (73 x 92 cm)
Signed and dated at lower left: *Claude Monet 1908*
Private collection

PROVENANCE: Sold by Monet to Bernheim-Jeune and Durand-Ruel galleries, Paris, May 1912; sold by Durand-Ruel to Adolph Lewisohn of New York, January 1917; collection of Mr. and Mrs. Samuel A. Lewisohn of New York; collection of Dr. and Mrs. Ernest Kahn.

EXHIBITIONS: Paris, Bernheim-Jeune, *Monet, Venise*, 1912, no. 27; Paris, Galerie Durand-Ruel, *Monet*, 1914, no. 5; Chicago, Auditorium Hotel, *Tableaux Durand-Ruel*, February 1915; Boston, Brooks Reed Gallery, March and October–November 1915; Saint Louis, Noonan-Kocian Gallery, November 1915; Cleveland Museum of Art, 1916; New York, Metropolitan Museum of Art, *Impressionist and Post-Impressionist Paintings*, 1921, no. 78; New York, Wildenstein Gallery, *Monet*, 1945, no. 77; City Museum of Saint Louis; and Minneapolis Institute of Art, *Claude Monet*, 1957, no. 88; New York, Museum of Modern Art; and Los Angeles County Museum, *Claude Monet, Seasons and Moments*, 1960, no. 94; New York, William Beadleston Gallery, *Claude Monet*, October 26–November, 20, 1982; Boston, Museum of Fine Arts, *Manet to Matisse*, January 29–May 11, 1986.

LITERATURE: Octave Mirbeau, *Claude Monet "Venise"* (Paris, 1912); Arsène Alexandre, "La Vie Artistique. Cl. Monet et Venise," *Le Figaro*, (May 29, 1912), p. 4; Gustave Geoffrey, "La Venise de Claude Monet," *La Dépêche*, May 30, 1912, p. 1; H. Genet, "Beaux Arts et Curiosité: Les 'Venise' de Claude Monet," *L'Opinion* (June 1, 1912), p. 698; André Michel, "Promenade aux Salons, VI," *Journal de Débats* (June 5, 1912), p. 1; "Art et Curiosité: Venise vue par Claude Monet," *Le Temps*, June 11, 1912, p. 4; Henri Ghéon, "A Travers les Expositions: Claude Monet," *Art Decoratif* (June 20, 1912), p. 4; Gustave Geoffrey, "Claude Monet," *L'Art et les Artistes* (November 1920), p. 78; Raymond Koechlin, "Claude Monet," *Art et Décoration* (February 1927), p. 46; Maurice Malingue, *Claude Monet* (Monaco, 1943), pp. 140 and 148; Otto Reuterswärd, *Monet* (Stockholm, 1948), pp. 255–57; Abbé Barbier, "Monet, C'est le Peintre," *Arts* (1952), p. 10; R. Julien, "Les Impressionnistes Français et L'Italie," *Publications de l'Institut Français de Florence* (1968), p. 19; Grace Seiberling, *Monet's Series* (New York and London, 1981), p. 381, no. 19; Daniel Wildenstein, *Claude Monet: Biographie et catalogue raisonné*, vol. 4 (Lausanne and Paris, 1985), no. 1766, p. 244; Philippe Piguet, *Monet et Venise* (Paris, 1986), no. 27, p. 95.

Painted from the steps of the Barbaro Palace, part of the facade of the Contarini Palace on the Grand Canal in Venice fills the canvas. Rapid strokes of purple, green, blue, and red merge, distinguishing the stone of the Renaissance building from the surface of the water in the foreground.

Although traditional *vedute* of Venice's canals stood at a calculated and respectful remove from their subject, Monet's view of the Palace is unconventionally near, awarding equal attention to the architecture and to the water below. Although nineteenth-century artists were interested in investigating new subjects, motifs, and techniques, Venice endured

ANTONIS MOR

as a popular theme among the Impressionist painters. Edouard Manet traveled to the city in 1875, and in 1881 Auguste Renoir made Venice the first stop on his trip to Italy; this sojourn briefly but radically altered his artistic style. Even Monet's teacher, the elderly Eugène Boudin, made the pilgrimage to Venice repeatedly in the early 1890s and returned home with numerous sparkling canvases. Despite these precedents and encouragements, Monet resisted until 1908 the trip that had been recommended to art students for centuries as the ideal experience to sharpen their appreciation of light and color.

On September 29, 1908, Monet left his home in Giverny with his wife, Alice, and traveled to Venice, where he stayed for over two months. This excursion was to be his last trip away from his beloved home. Monet appears to have been intimidated by the setting at first; in a letter to her daughter, his wife reported he repeatedly lamented that the city was too beautiful to render accurately, and found himself unable to paint (Piguet 1986, p. 28), but he eventually was able to create his own, personal view of Venice. By attempting to capture the essence of the city, Monet aligned himself with the august tradition of romantic view painters, but he reinterpreted in an Impressionist idiom the historic motifs once investigated by Carpaccio, Canaletto, Guardi, and Turner.

Monet's Venetian paintings can be divided into two groups: the more traditional *vedutiste* views of architecture, which reveal a dispassionate and reportorial image of the setting; and the more severely cropped works, which are not as concerned with depicting recognizable contexts, but instead concentrate more fully on investigating the play of color and light on architecture and water. Once the artist had become comfortable in his new setting, his compositions and brushwork became increasingly more inventive and daring. The bold and abstracted geometry apparent in this view of the palace is an example of his more experimental style.

In the summer of 1912, Monet exhibited the complete series of twenty-nine paintings, including this version of *Contarini Palace*, at Bernheim-Jeune in Paris. A larger rendition of the palace (Switzerland, Saint-Gall Museum) depicts virtually the same scene, with an added gondola.

K.R.

100 PLATE 20
ANTONIS MOR (Netherlandish, about 1517–about 1577)
Portrait of Philip II, about 1550
Oil on panel, 43 x 33 in. (109.2 x 83.8 cm)
Inscribed in an 18th-century hand at upper left: *Philip 2'd King of Spain / Ant. More Pt*
Private collection

PROVENANCE: The Honorable John Spencer, Althorp, by 1730; to his son the 1st Earl of Spencer (1734–1783), Althorp; by descent to the 8th Earl of Spencer, Althorp; E. V. Thaw & Co. Inc., New York, by 1983.

EXHIBITIONS: Manchester, Museum of Ornamental Art, *Art Treasures of the United Kingdom*, 1857 (1st ed., no. 523; 2nd ed., no. 512); Leeds, *National Exhibition of Works of Art*, 1868, no. 559.

LITERATURE: Gerry Knapton, *Catalogue of Pictures at Althorp Belonging to the Late Honorable Mr. Spencer* (1746), no. 103; T. F. Dibdin, *Aedes Althorpianae* (1822), p. 244; *Catalogue of the Pictures at Althorp House in the County of Northampton* (London, 1831), p. 14, no. 186; G. Waagen, *Treasures of Art in Great Britain* (London, 1854), vol. 3, p. 457; Lionel Cust, *Notes on Pictures in the Royal Collection* (London, 1911), pp. 56–57; Georges Marlier, *Antonis Mor van Dashorstz* (Brussels, 1934), pp. 55–56; Henri Hymans, *Antonio Moro, Son Oeuvre et son temps* (Brussels, 1910), pp. 48 and 174; Max J. Friedländer, *Early Netherlandish Painting, Vol. 13: Antonis Mor and His Contemporaries* (Leiden, 1937; new ed., New York, 1975), pp. 64, 101, no. 346, pl. 172; G. J. Hoogewerff, *De Noord-Nederlandsche Schilderkunst* (The Hague, 1941–1942), p. 247; L. C. J. Frerichs, *Antonio Moro* (Amsterdam, 1947), p. 16, ill. p. 10; K. J. Garlick, "A Catalogue of Pictures at Althorp," *The Walpole Society*, London, vol. 45 (1974–1976), pp. 56–57, no. 462.

Born in Utrecht and trained by Jan van Scorel, Antonis Mor was active in both Antwerp and Brussels as a painter of portraits for such distinguished nobles as Granvella and the duke of Alba. Mor became the favored court portrait painter at the latter city when Emperor Charles v took up residence there in September 1548. By early 1550 the artist had traveled to Portugal, probably via Rome, in order to carry out portrait commissions for the regent Maria of Hungary. He then went on to Madrid. After a quick return to Utrecht, he journeyed to London to paint a portrait of Queen Mary of England, who was to marry Philip II, the emperor's son and heir, in June 1554. Late in 1559 Mor accompanied Philip to Spain and there produced some of his most important court portraits. The artist left Spain in 1560, but his travels to paint powerful men and women continued throughout his life. The court portraits by Titian may be freer and nobler, but those by Mor are distinguished by their keen observation of personality and sharp sense of detail.

Mor was commissioned to paint Philip II. Documents published by Hymans mention a portrait of the prince done by Mor before he went to Portugal (thus, about 1549 or 1550). A number of replicas of this official portrait were undoubtedly required, and today this early likeness is known in at least two versions. Aside from Cust, all writers have agreed that the finer of these is the present one, which was long in the collection of the Lords Spencer at Althorp. The other version is in the English royal collection; formerly housed at Buckingham Palace, it is now at Hampton Court (Friedlander 1975, no. 346a).

A study of the prince's head in Budapest is probably the likeness taken from life by Mor to be used in this portrait. Then, as documents of 1553 recount, the prince sent his rings, jewels, chains, and precious robes to the painter for the careful transcription needed to prepare an official portrait. The resulting work thus combines a most lifelike representation of the intense, youthful bearded face with the formal precision of the garments and the symbols of power, including the chain bearing the insignia of the Golden Fleece. As Friedländer wrote, the success of Mor's portraits was due to

the fact that they "fully live up to the expectations aroused by the historical importance of the sitters." That is certainly the case with this impressive image, which Waagen nevertheless rightly described as "a picture of great delicacy."

E.M.Z.

101 PLATE 145
ANGELO MORBELLI (Italian, 1853–1919)
In Risaia (In the Rice Fields), 1898–1901
Oil on canvas, 71 x 51 in. (180 x 130 cm)
Signed and dated at lower right: *Morbelli 1901*
Private collection

PROVENANCE: Private collection, Milan; sale New York (Sotheby's), January 26, 1979, no. 127; Ira Spanierman, Inc., New York.

EXHIBITIONS: Milan, Regia Accademia di Belle Arti, *IV Esposizione triennale di belle arti*, no. 456; Munich, Glaspalast, *VIII International Kunstausstellung*, no. 1206; Saint Louis, *International Exhibition of Fine Arts*, 1904; Milan, Societa per le Belle Arti, *Esposizione di primavera*, 1905, no. 282; Milan, *Esposizione retrospectiva dell'opera di Angelo Morbelli (?)*, 1949; Milan, Palazzo della Permante, *Arte e socialità in Italia del realismo al simbolismo 1865–1915*, 1979, no. 105; Alessandria, Palazzo Cuttica; and Rome, Galleria Nazionale d'arte moderna, *Morbelli*, 1982, no. 47; Williamstown, Massachusetts, Sterling and Francine Clark Art Institute, *Italian Paintings 1850–1920 from Collections in the Northeast United States*, 1982, no. 48; Trento, Palazzo delle Albere, *Divisionismo Italiano*, 1990, no. 53.

LITERATURE: G. P. Lucini, *Emporium*, (1900), p. 327; W. Ritter, *Emporium* (July 1901), p. 61; "La permanente a Milano," *Bandiera del Popolo*, May 27, 1905; G. Macchi, *Angelo Morbelli* (Milan, 1920), p. 11; U. Nebbia, *Angelo Morbelli* (Milan, 1949); S. Pagani, *La Pittura Lombarda* (Milan, 1955), pp. 504–5, ill. p. 499; E. A. Marescolti, in *Alexandria 3* (1933); Teresa Fiori and Fortunato Bellonzi, *Archivi del Divisionismo*, vol. 2 (Milan, 1968), no. VI 68, p. 111, pl. 1442; Mirella Poggialini Tominetti, *Angelo Morbelli* (Milan, 1971), pp. 69–71; *Post-Impressionism: Cross-Currents in European Painting* (exh. cat., London, Royal Academy of Arts, 1979–1980), p. 242; Annie Paula Quinsac, *"The Rice Gleaners" (In Risaia)* (unpublished paper), 1980.

Morbelli was one of the leading members of the Italian Divisionist school, which flourished from the late nineteenth through the early twentieth century. Although he usually painted landscapes, he did create two quite different representations of women working in the rice fields at Risano Monferrato, near his family's estate. Completed in 1895, the earlier version is a horizontal composition called *For Eighty Cents* (now in the museum at Vercelli), reflecting the difficult economic conditions that forced the women into such hard labor.

This upright version of the subject occupied the artist from 1898 until 1901, owing in part to his painstaking technical process. First, he prepared the canvas in black and white, then he sketched in the composition, and finally he finished it by superimposing thin striations of color in order to achieve the desired luminous quality. Although reminiscent of Millet's paintings of noble farm workers, Morbelli's painting has a more obsessive quality, deriving both from his Divisionist methods and his rhythmical repetition of forms — the rice

plants and the bent bodies of the women — broken only by a single standing figure.

E.M.Z.

102 PLATE 139
BERTHE MORISOT (French, 1841–1895)
Young Woman Holding a Basket, 1891
Pastel on paper (two sheets), 32½ x 16½ in. (60 x 42 cm)
Stamped with signature at bottom right: *Berthe Morisot (Lugt 1826)*
Private collection

PROVENANCE: Sale Paris (J. M. Rouart), n.d.; Galerie Charpentier, Paris; sale London (Sotheby's), March 27, 1985, lot 317.

EXHIBITIONS: Paris, Galerie Durand-Ruel, *Grand exposition des oeuvres de Berthe Morisot*, 1896, no. 180; Paris, Galerie Bernheim-Jeune, November 1919, no. 35; Paris, Galerie Dru, *D'Oeuvres de Berthe Morisot, Portraits et Figures de Femme*, no. 4; London, Leicester Gallery, March–April 1930, no. 51; Paris, Musée de L'Orangerie, *Berthe Morisot*, 1941, no. 95; Paris, Galerie Durand-Ruel, *Exposition de pastels et dessins de Berthe Morisot*, 1941, no. 51.

LITERATURE: Charles Stuckey, *Berthe Morisot Impressionist* (Holyoke, Massachusetts, 1987), p. 152; Kathleen Adler, *Berthe Morisot* (Ithaca, New York, 1987), pp. 76–79; G. Wildenstein and M. W. Bataille, *Berthe Morisot* (Paris, n.d.), fig. 563, cat. 571.

Born in Bourges in 1841, Berthe Morisot was the youngest daughter of an upper-middle-class family. The Morisots moved in 1855 to a suburb of Paris, where along with her sisters Berthe took drawing lessons with the academic painter Geoffrey Alphonse Chocarne, and then with Joseph-Benoit Guichard. Guichard introduced the nineteen-year-old Berthe to Corot, with whom she worked in Ville d'Avray during the summer of 1861. Morisot's parents were supportive of her artistic ambitions, building a studio for her in the garden of their home. In 1864 she exhibited at the Salon in Paris. During the later 1860s Morisot befriended Fantin-Latour, Degas, and Manet. In 1874 she married Eugène Manet, Edouard's brother. Morisot had a significant role in the formation and promotion of Impressionism. She encouraged Manet to paint *en plein air* in the 1870s and 1880s, yet she is generally better known as one of his models (*Repose, Portrait of Berthe Morisot*, 1870; Providence Museum of Art, Rhode Island School of Design). Morisot died of complications from pneumonia at the age of fifty-four in 1895, having participated in all but one of the eight Impressionist exhibitions.

This pastel is a figure study for two large oil paintings titled *The Cherry Tree* (1891, private collection; and 1891–1892, private collection). It was conceived during the summer of 1891 at Mézy, where Morisot and her family had rented a house. Over the course of nearly two years Morisot executed more preparatory studies, in a variety of media, for this project than for any of her other works. Following his visit to Mézy, Renoir wrote to Morisot, offering encouragement on her "painting with the cherry trees." Among the early studies is a sketchy pastel of a ladder against a grouping

of trees (*Study for "The Cherry Tree,"* 1891; Reader's Digest Association, Inc.). A watercolor in which she added figures in a more compact and shallow spatial scheme (1891; New York, private collection) established the composition for the final painted versions, albeit with minor differences. The models for this watercolor were Morisot's daughter Julie, who picks cherries as she stands on a ladder, and her niece Jeannie Gobillard, who holds a basket for the fruit. In the present work Jeannie is more fully resolved than in the earlier watercolor, and Morisot's palette is characterized by bright hues. This pastel study, primarily a linear conception of the motif, appears to have determined not only the color and design of the final paintings, but also the application of pigment. The artist handled the broad linear strokes of brightly colored pigment in a manner analogous to her working of the chalk. Morisot's addition of another sheet to the present study indicates that she already may have begun to block out the figures on her canvas; the figure is approximately the same size as in the oil versions. Unlike the figure of her daughter, that of Jeannie remained posed essentially the same way during later reworkings of the composition.

Figures in garden settings were a popular subject with the Impressionist painters. Throughout her career Morisot frequently depicted stylishly dressed modern women and children in parks and gardens. Although the artist also painted working-class subjects (*Woman Hanging Wash*, 1881; Copenhagen, Ny Carlsberg Glyptoek), the comforts and constraints that structured the life of bourgeois women during the late nineteenth century — and were similar to her own circumstances — are more common in her work. Griselda Pollock has suggested that the garden settings used by both Morisot and Mary Cassatt in their paintings are typified by a shallow spatial scheme, one that can be interpreted as a "homology between the compression of pictorial space and the social confinement of women within the prescribed limits of bourgeois codes of femininity" (*Vision and Difference* [New York, 1988], p. 63).

R.J.B.

103 PLATE 154

OTTO MUELLER (German, 1874–1930)
Bathers in a Landscape, about 1920
Egg / oil(?) on jute, 46⅛ x 34⅞ in. (117.2 x 88.6 cm)
Private collection

PROVENANCE: Acquired from Curt Valentin.

Otto Mueller was born on October 14, 1874, in Liebau, a small city in the Riesengebirge in Silesia. Following an apprenticeship to a lithographer in Gorlitz in the early 1890s, he enrolled at the Dresden Academy in 1894. Mueller befriended Carl and Gerhart Hauptmann and other members of their revolutionary writers' circle. Mueller served as the model for the protagonist of Carl Hauptmann's novel *Einhart der Lacher*.

Disillusioned by the instruction at the Dresden Academy, the artist left in 1897. Between that year and the next, he traveled to Switzerland and Italy with Gerhart Hauptmann. Before moving to Berlin in 1908, Mueller studied briefly at the Munich Academy. In Berlin he exhibited at the Neue Sezession in 1910, attracting the attention of members of Die Brücke. Mueller joined the group later in the year, becoming its eldest member.

Die Brücke was formed in Dresden in 1905 by four students of architecture, Ernst Ludwig Kirchner, Fritz Bleyl, Erich Heckel, and Karl Schmidt-Rottluff. The aim of these young artists, the oldest of whom was then only twenty-five, was to fuse art and life in a sensual harmony. Reacting against what they perceived as the crass materialism and shameless egotism of bourgeois society, they sought new means of expression. In their program of 1906, Kirchner wrote: "We want to gain elbow room and freedom of life against the well-established older forces."

The subject of nudes in natural settings had been one of Mueller's favored motifs even before he joined Die Brücke. The theme complemented the interests of the group, which in part explains their admiration of Mueller's work shown at the Neue Sezession exhibition. Mueller's nudes relate to similar paintings of this subject by the other Brücke artists (for example, Kirchner's *Nudes Playing Under a Tree* [1910, private collection]; Heckel's *Bathers* [1912, Saint Louis, private collection]; and Schmidt-Rottluff's *Three Nudes* [1913, Berlin, Nationalgalerie]. By depicting naked people out-of-doors, Die Brücke hoped to overcome social constraints and moral conventions. Jill Lloyd has speculated that "the bather motif in Brücke art was inspired by the nudist cult which emerged in the 1890s as part of the anti-bourgeois and anti-modern reaction to city life. . . . Nudism or Freikörperkultur was just one of a series of anti-modern reform movements advocating such antidotes to city experience as vegetarianism, homeopathy, land reform, sun and air therapy and dress reform." (*German Expressionism: Primitivism and Modernity* [New Haven, 1991], p. 107). Moreover, the representation of nudes was linked to the goal of evoking an original and pristine state of being, based upon the idea of humankind as an integral part of nature.

In 1919 following his military service in World War I, Mueller accepted a professorship at the Breslau Academy. Die Brücke had disbanded shortly before the beginning of the war. The painter's more delicate colors and bucolic compositions had always distinguished his work from the other members of the group. Although following the war, the other former members evolved individual styles characterized by shrill colors and a broader range of subject matter, Mueller continued to paint his angular, lean figures in pale hues, as exemplified in this painting, until his death in Breslau on September 24, 1930.

R.J.B.

104 PLATE 104
CARL MÜLLER (German, 1818–1893)
The Virgin and Child with Saint Elizabeth and the Infant Saint John the Baptist and Three Music-making Angels, 1859
Oil on paper, mounted on canvas;
total canvas 12½ x 12½ in. (32 x 32 cm)
Signed and dated at lower right: *Carl Muller /
Dusseldorf / 1859*
Private collection

Carl Müller was born in Darmstadt to a family of artists and received his training at the Dusseldorf Academy. He was in Rome from 1840 to 1843. Returning to Germany, he worked from 1844 through 1850 on frescoes in the Apollinariskirch in Remagen. In 1857 he was made a professor at the Düsseldorf Academy, and in 1883 he became its director. Müller was of the second generation of Nazarene painters. His delicate, sweet style owes a clear debt to Italian examples, but he invested his scenes with a remarkable delicacy of touch devoid of sentimentality.

This work is in the tondo format often favored by the Nazarenes and employed by Müller for a probable pendant (location unknown) depicting the Holy Family serenaded by an angel. In the present example, the painter gave the traditional theme a fresh depiction. The Christ Child looks at his adoring mother, completely ignoring the devoted Saint John. These figures are serenaded by an angelic trio, and placed in an idyllic setting of classical ruins replete with white doves and other conspicuously symbolic birds, animals, and plants. The primrose, for example, prefigures the future suffering of Christ, as does the winding purple cloth in the foreground. Müller's remarkable miniaturist technique created a microcosm of delicate details, even extending to individual blades of grass. His use of the smooth paper as a support allowed for exquisite modulations of color and light — especially the glowing effect around the head of Christ — giving the impression that this is a precious work painted on ivory.

E.M.Z.

105 PLATE 47
AERT VAN DER NEER (Dutch, 1603 or 1604–1677)
Moonlit Estuary, 1650s
Oil on panel, 9¼ x 14¾ in. (23.5 x 37.5 cm)
Monogrammed at bottom, left of center
Private collection

PROVENANCE: Collection Daniel Mesman; bequeathed by him to Cambridge University, 1834; Fitzwilliam Museum, Cambridge (inv. 97) until at least 1923; dealer Dick, Vevey; dealer P. de Boer, Amsterdam, 1956; sale Paris (George V) April 12–13, 1989, no. 24; dealer Johnny van Haeften, London, 1989.

LITERATURE: F. R. Earp, *A Descriptive Catalogue of the Pictures in the Fitzwilliam Museum, Cambridge* (Cambridge, 1902), p. 102, no. 97, ill.; C. Hofstede de Groot, *A Catalogue Raisonné of the Works of the Most Emi-*

nent Dutch Painters of the Seventeenth Century, trans. by Edward G. Hawke (London, 1908–1927), vol. 7 (1923), pp. 371–72, no. 181.

A broad marshy plain fills the fore- and middle ground of the composition and is bounded at the left and right by low hills. In the distance, an estuary reflects the opalescent moonlight of the cloud-filled evening sky; on the far side of the water is a small village, with a church nestled amid lower buildings. Walking near a leafless tree at the far right are a man and a woman, and a boy leading a dog who starts eagerly toward some birds perched on a hillock in the left foreground.

Aert van der Neer was famed as a painter of winter landscapes, and particularly of twilight and moonlight landscapes. A skilled colorist, he made atmospheric landscapes that perfectly capture the fiery hues of sunset, the subtle colorations of pale moonlight, or the icy celestial auroras of a northern winter. Van der Neer's earliest dated nocturnal scene is of 1643 (Gotha, Schlossmuseum); after 1646, however, dated works are rare in the artist's oeuvre. An overall monochrome tonality characterizes his mature works of the 1650s, with local colors minimized by the near-darkness of evening. In the *Moonlit Estuary*, however, as in all of the artist's evening landscapes, the brilliant effect of moonlight through clouds and its watery reflection (here rendered in gleaming, luminous tones) creates a compelling focus in this brown and brownish gray land. The monochromatic expanse of the marshy landscape is further enlivened by the colored light reflected in shallow puddles of water, and the thin highlights glinting off the edges of structures in the village, broken fence posts, and the bare branches of the gaunt tree at the far right.

M.E.W.

106 PLATE 48
AERT VAN DER NEER (Dutch, 1603 or 1604–1677)
Estuary Landscape at Evening, 1650s
Oil on panel, 18 x 27½ in. (46 x 69.5 cm)
Monogrammed at lower left: *AVDN* (ligated)
Private collection

PROVENANCE: Collection George Salting (1836–1909), London; by descent in the family; property of the Trustees of the Mellerstain Trust, by whom it was sold in London (Sotheby's), July 8, 1987, no. 13, ill.; dealer Johnny van Haeften, London.

EXHIBITIONS: London, Thomas Agnew & Sons, 1910, no. 200 (as "Canal Scene, with stormy sky: Evening Effect").

LITERATURE: *Catalogue of the Collection of Pictures and Drawings of the Late Mr. George Salting* (London, 1910), p. 10, no. 200.

Manned by two fishermen and laden with large baskets, a small boat drifts close to the marshy bank in the foreground of the composition. Beyond it, the estuary broadens, and various sailing craft ply the waters. On the left bank are a thatched farmhouse surrounded by trees, a small village with a church, and, further in the distance, a windmill. More trees and low structures border the right bank of the estuary, and

two cows, standing motionless on a spit of land, are silhouetted against the pale water.

Rather than depicting the more showy effects of sunset or the pearly gleam of moonlight, van der Neer re-created in *Estuary Landscape* the clear reflected light of nightfall, just before the golden rays of the setting sun shoot through the sky. Local colors, such as the red cap of the man in the fishing boat, have not yet been subsumed by the gathering darkness. Dark clouds and shadowy landforms edge the composition, narrowing the reach of the afternoon's last light. Nearer the horizon, both clouds and water are rendered in subtle shades of blue-gray touched with the palest hints of yellow and pink.

Although van der Neer's paintings are difficult to date precisely, the composition of the present work, with a river receding between two banks and objects (in this case, a large fishing basket) on or near the bank in the immediate foreground, is typical of works associated with the 1650s. The dramatic silhouette of a sailboat, often masking the most brilliant portion of the sky, was a frequent motif in van der Neer's river views (compare, for example, his *Moonlight Landscape with Fishing Boats* [Frankfurt, Städelsche Kunstsammlung] or *Moonrise Landscape* [private collection], both dated to the 1650s; Fredo Bachmann, *Aert van der Neer 1603/4–1677* [Bremen, 1982], pls. 82 and 98, respectively).

M.E.W.

107 PLATE 71

JACOB VAN OOST THE ELDER (Flemish, 1603–1671)
Young Woman, about 1665
Oil on canvas, mounted on panel, 16¼ x 12½ in.
(41.3 x 31.7 cm)
Private collection

PROVENANCE: The Marquess of Landsdowne, Landsdowne House, by 1897, and between the wars in Mansfield Street, London, then by descent; sale London (Sotheby's), February 17, 1988, no. 68 (as Jan de Bray); with Chaucer Fine Art / Johnny van Haeften, Ltd., London; with dealer René Schreuder, B.V., Aerdenhout.

LITERATURE: George E. Ambrose, *Landsdowne House and Bowood* (London, 1897), no. 10 (as Luis de Morales, perhaps confused with Paulus Moreelse).

This bust-length image of a woman was attributed to the Haarlem Classicist Jan de Bray, before Albert Blankert reattributed it to a painter from Bruges, Jacob van Oost the Younger (1637–1713; letter dated April 5, 1988, to M. Violante of Chaucer Fine Arts, London). Blankert compared it to two portraits, of *Leonora Sophie Ulfeldt* and *Ellen Kristine Ulfeldt*, both monogrammed "I.v.O" and dated 1665, which are in the National Historisk Museum, Frederiksborg, Denmark (inv. A 7305). However, Jean Luc Meulemeester (*Jacob van Oost de Oudere en het zeventiende-eeuwse Brugge* [Bruges, 1984], nos. A42 and A43, ills. pp. 290 and 291) tentatively attributed these works to Jacob the Elder (1601–1671),

though leaving open the possibility that they and *Portrait of a Youth* in the National Gallery, London (inv. no. 1137; Meulemeester 1984, no. A29) are by the son.

Van Oost the Elder traveled to Italy in his youth, returning in 1628 to his native city, where he worked as a painter of portraits and historical subjects for the rest of his life. Influenced early in his career by the tenebrous style of Caravaggio, the artist later adopted a softer manner, partly in emulation of the later art of Rubens and van Dyck. In this work, van Oost's atmospheric modeling, limpid touch, and warm palette soften the effects of the subject's very direct gaze and frontal pose. The costume — a gray wrap over a scarlet garment fastened by a gold clasp — and the orange blossoms in her hair suggest that *Young Woman* is an anonymous *tronij*, or head study, for a history painting rather than a portrait. However, the Fredericksborg portraits suggest that van Oost did execute bust-length portraits with comparable directness and candor.

P.C.S.

108 PLATE 54

ANTHONIE PALAMEDESZ (Dutch, 1601–1673)
Merry Company in an Interior Eating and Drinking, 1633
Oil on panel, 21 x 34½ in. (53.5 x 88 cm)
Signed and dated: *A. Palamedes An° 1633*
Private collection

PROVENANCE: Collection Earl of Yarborough, 1887; dealer Leggatt Brothers, London, 1929; sale Mrs. Whitelaw Reid, New York (Anderson Gallery), May 14, 1935, no. 1171, ill.; dealer Johnny van Haeften, Ltd., London, 1987.

EXHIBITION: London, Johnny van Haeften, Ltd., *Dutch and Flemish Old Master Paintings*, 1987, no. 19.

LITERATURE: *International Studio* (December 1929), p. 118, ill.

Within a sparsely furnished interior illuminated by an unseen window at the upper left, a company of elegantly dressed young men and women have gathered to drink, converse, and play or listen to music. At the extreme left a serving boy carefully pours a glass of wine. In the center of the composition a seated dandy raises his glass in a jaunty toast.

Anthonie Palamedesz was a native of Delft who specialized in painting merry companies and scenes of soldiers in barracks rooms; he also painted portraits, landscapes, and still lifes. His genre scenes are similar in style and spirit to those by the Amsterdam painters Pieter Codde and Dirck Hals. From 1632 to about 1634 Palamedesz painted a number of closely related scenes — depicting merry companies singing, gaming, dancing and drinking — that are considered his finest works. Most comparable to the present picture are *Merry Company* of 1632 in the Mauritshuis, The Hague (inv. 615) and the version dated 1633 in the Rijksmuseum, Amsterdam (inv. A 1906), as well as the undated *Elegant Company Gaming and Drinking* (with Richard Green, London, 1984) and *Musical*

Company (Brussels, Musées Royaux des Beaux-Arts, inv. 2837). Similar figures and groupings — most notably the boy pouring wine and the central figure of the seated man extending a shapely leg — recur throughout this series of paintings.

The paintings hanging on the walls in these works remind the viewer that Palamedesz's merry companies are not so far removed from depictions of the Prodigal Son or the more overtly moralizing scenes of merry companies by earlier artists such as David Vinckboons or Willem Buytewech. The stormy seascape (in the manner of Jan Porcellis) on the rear wall was a standard prop in Palamedesz's elegant gatherings, and has been interpreted a reminder of the potential for the abuse of pleasure: that drunkards are as helpless as ships in a storm, and that a (ship)wreck is the only foreseeable end for those leading dissolute lives (see Lawrence O. Goedde, *Tempest and Shipwreck in Dutch and Flemish Art: Convention, Rhetoric, and Interpretation* [University Park, Pennsylvania, 1989], p. 151). The figural painting at the right is more difficult to identify, but may be a representation of Venus and Cupid.

M.E.W.

109 PLATE 3

FOLLOWER OF PARMIGIANINO (Italian, 16th century)
The Concert with Three Goddesses, n.d.
Oil on panel, 59¹/₁₆ x 47¹/₂ in. (150 x 120 cm)
Private collection

PROVENANCE: Sale London (Sotheby's), March 27, 1963.

LITERATURE: A. E. Popham, *Catalogue of the Drawings of Parmigianino* (New Haven and London, 1971), p. 156 (under no. 465); Carlo Ragghianti, "Pertinenze Francesi nel Cinquecento," *Critica d'Arte* 14, new series 122 (March–April 1972), p. 57, note 7, fig. 25; Giovanni Godi, *Nicolò dell'Abate e la presunta attività del Parmigianino a Soragna* (Parma, 1976), p. 66, fig. 54; Diane de Grazia, *Bertoia, Mirola and the Farnese Court* (1991), pp. 158 and 162, no. P2, pl. 2.

This fascinating large panel painting depicts the three rival goddesses of the ancient world — Juno with her peacock, Minerva wearing a helmet, and Venus — listening to and perhaps even singing along with a large bare-chested woman playing the viola da gamba, as Cupid looks on from behind. The attribution of this and a related drawing of a woman playing the viola (Florence, Uffizi, inv. 2022F) have been much debated. In the past both were published as by Bertoia and Nicolo dell'Abate, under the influence of Parmigianino. Most recently, Diane de Grazia has assigned them to Girolamo Mirola (about 1535–1570) on the basis of a painting in Naples, a drawing in Edinburgh, and frescoes in Parma. Even de Grazia, however, has expressed some hesitation, speculating that "perhaps this painting is actually a copy of a Parmigianino composition" (1991, p. 158). In recent correspondence Sydney J. Freedberg has stated that "the attribution to Mirola makes more sense than any other." David Ekserdjian, also in recent correspondence, has proposed that the drawing is "a preparatory study by Parmigianino for a painting of which this one must be a basically reliable early copy." He further suggests that the original painting would date from Parmigianino's Bolognese period (1527–1530). Konrad Oberhuber (in correspondence of December 11, 1991) has written: "I am certain it is a work by Parmigianino from the end of his Roman or early Bolognese period close to the Saint Roch. I think it was painted to be viewed from a distance, like this altarpiece, which explains the rather coarse way of painting and the foreshortening of the figures. I think there must have been a counterpart with a man playing the harpsichord for which there is a drawing by Parmigianino in the Louvre [Popham 1971, no. 465]."

Popham himself (1971, p. 155) noted that the subject of the drawing in the Louvre "is difficult to make out, [but] it seems to be a 'scène galante' with musicians [and] shows some relation" to the present painting. The nude woman in the drawing is distantly related to the figure in the painting, although she holds a different instrument. As Oberhuber has pointed out, a woman with a viola da gamba more like that in the painting appears in a drawing at the Uffizi which was published as being by Bertoia (Augusta Ghidiglia Quintavalle, *Il Bertoja* [Milan, 1963], p. 32, fig. 57) but which Oberhuber believes to be by Parmigianino.

Although it is difficult to see a man playing the harpsichord in the reproduction of the drawing at the Louvre, his presence is evident to Oberhuber, to whom it suggests that there was a second, now-lost painting. In his letter he writes that the three goddesses in the present painting "are all related to marriage, Venus to love, Juno as faithfulness in marriage, Minerva as prudence in marriage," and goes on to say that in the lost painting "the man on the other instrument would have been advised by other allegories. The two make music — love together. So the ensemble must have been created for a marriage decoration."

Certainly, the steep perspective of *The Concert with Three Goddesses*, with the figures squeezed into the space between a balustrade in the foreground and a plant-entwined trellis in the background, suggests a decorative function. The wide-open eyes of the gamba-playing woman, who gazes longingly to the left, seem to further support Oberhuber's hypothesis that there was a male companion piece.

As to the interpretation of the gathering in the present painting, John Herrmann has reasonably suggested that it may be an allegory of harmony, observing (in correspondence): "The three goddesses are, of course, better known for their bitter rivalry over the golden apple of Eris (Strife), which was intended for 'the fairest of them.' But here, through the inspiration of love provided by Cupid, the musician produces exquisite melodies, uniting the often conflicting virtues of Wisdom, War, and Beauty into a harmonious trio."

E.M.Z.

110 PLATE 2

FRANCESCO PESELLINO (Italian, 1422–1457)
Madonna and Child, about 1450–1455
Tempera on panel, 8¾ x 6⅞ in. (22.2 x 17.5 cm)
Private collection

PROVENANCE: Charles Timbal, Paris (purchased in Italy before 1865); acquired by Gustave Dreyfus, Paris, 1872; Duveen, New York, 1930; Mortimer Brandt Gallery, New York, 1964; Norton-Simon Foundation, 1964; Artemis, 1977–1978.

EXHIBITIONS: Waltham, Massachusetts, Rose Art Museum, Brandeis University, *Major Masters of the Renaissance*, 1963, no. 3; Houston, Museum of Fine Arts, 1964; Los Angeles County Museum of Art, 1970.

LITERATURE: Mary Logan Berenson, "Compagno di Pesellino," *Gazette des Beaux-Arts* 26 (1901), p. 28; Salomon Reinach, *Tableaux inedits ou peu connus* (Paris, 1906), pp. 32–33; idem, *Repertoire des Peintures*, vol. 4 (Paris, 1918), p. 421; Lionello Venturi, *Italian Paintings in America* (New York, 1933), p. 11, no. 222; Creighton Gilbert, *Major Masters of the Renaissance* (exh. cat., Meriden, Connecticut, 1963), pp. 11–12; "Berichte," *Pantheon*, July–August 1963, ill. p. 250; Artemis, *A Selection of Italian Paintings, 15th–18th Century* (London, 1977–1978), no. 1.

Probably an apprentice to his grandfather Giuliano d'Arrigo, Pesellino is usually discussed in relation to his better-known contemporary Fra Filippo Lippi, with whom he also probably trained. About 1439 Filippo painted an altarpiece for Santa Croce in Florence for which Pesselino executed a predella. Only one of Pesellino's works, *The Trinity* (London, National Gallery), has been documented. Attributions of works to him have been based upon stylistic similarities to this and to the Santa Croce predella.

The present *Madonna and Child* was published at the turn of the century by Mary Logan Berenson, with a misattribution to the now-discredited "Compagno di Pesellino." However, she rightly noted its similarities to Pesellino's *Madonna and Child with a Bishop Saint, Saint John the Baptist, Saint Anthony Abbott, and Saint Francis* (Paris, Musée du Louvre), noting the masterfully foreshortened limbs of the Child, the rendering of his hair, and the position of the left hand of the Madonna.

At the time of its first publication, the landscape had been overpainted. The overpainting has since been removed, so the viewer can now see the exquisite Tuscan panorama of gently rolling hills, which serves to offset the wistful Madonna.

In an unpublished opinion (quoted in Gilbert 1963) Bernard Berenson rightly identified this painting as "a late work of Pesellino." Both the general pose and the figure types are similar to those in several other representations of the Virgin and Child. These include *Madonna and Child with a Swallow* (Boston, Isabella Stewart Gardner Museum), *Madonna and Child* (Denver Art Museum), and *Virgin and Child with Two Angels and Saint John the Baptist* (The Toledo Museum of Art).

A.N.

111 PLATE 121

CAMILLE PISSARRO (Danish, worked in France; 1830–1903)
Portrait of Père Papeille, Pontoise, about 1879–1882
Pastel on paper, laid down on canvas, 21⅝ x 18⅛ in. (55.5 x 46 cm)
Signed at bottom right: *C. Pissarro*
Scott M. Black Collection

PROVENANCE: H. Cottereau, Paris; Galerie Urban, Paris; sale New York (Christie's), November 5, 1988.

EXHIBITION: Portland (Maine) Museum of Art, *Impressionism and Post-Impressionism: The Collector's Passion*, July–October 1991, no. 28, pp. 57–58.

LITERATURE: Ludovic Rodo Pissarro and Lionello Venturi, *Camille Pissarro, son art — son oeuvre* (Paris, 1939), vol. 1, p. 290, no. 1523.

Camille Pissarro's *Portrait of Père Papeille* is unusual in both its medium and its subject. Although Pissarro is known to have used pastel, he did not favor this medium. Of the portraits Pissarro painted, most were of his family, his friends, or himself. Here, only the sitter's name is known; his relationship to the artist has yet to be discovered. The sitter appears content, even avuncular, suggesting that he may have been a resident of Pontoise befriended by the artist.

Characterized by distinctive effects — soft, subtle tones and delicate gradations of color — pastel was especially popular for French portraiture during the eighteenth century, but following the French Revolution, the medium was used more commonly for preliminary studies than for conventionally "finished" subjects. By the late 1860s, however, Degas had begun to execute finished portraits in pastel (*Mme Edmondo Morbille, née Thérèse De Gas*, 1869; New York, private collection), and Manet and other avant-garde artists soon followed Degas's example.

The date of Pissarro's work is the subject of debate. Lionello Venturi and Ludovic Rodo Pissarro suggest that the artist made it about 1874 (1939, vol. 1, p. 290). A late date of 1890 to 1895 recently ascribed to the pastel is untenable. A comparison of *Père Papeille* with Pissarro's pastel portrait of his own son Lucien (dated 1883; Oxford, Ashmolean Museum), supports an earlier date for this more finished, painterly drawing. Pissarro did not draw contours or exploit the linear potential of the chalk, but rather smudged and modeled it in a manner giving the sitter a corporeal presence. A date of 1874 is less likely than one of 1879 to 1882, the period of Pissarro's more frequent contact with Degas. Degas encouraged Pissarro to draw in gouache and pastel, and to make prints. The extensively worked and relatively finished surface of *Père Papeille* recall Degas's earlier work in this medium.

R.J.B.

112 PLATE 123

CAMILLE PISSARRO (Danish, worked in France;
1830–1903)
View of the New Prison at Pontoise (Spring), 1881
Oil on canvas, 23⅝ x 28 in. (60 x 74 cm)
Signed and dated at bottom right: *C. Pissarro.81*
Private collection

PROVENANCE: Robert Treat Paine, 2nd, Boston.

EXHIBITION: Paris, *Exposition des Artistes Indépendants*, March–April 1882,
no. 125.

LITERATURE: J.-K. Huysmans, "L'Exposition des Indépendants en 1881"
(appendix review of independent artists' show of 1882), *L'Art Moderne*
(1975), p. 235; Ludovic Rodo Pissarro and Lionelli Venturi, *Camille Pis-
sarro, son art — son oeuvre* (Paris, 1939), vol. 1, p. 155, no. 532; J. Bailly-
Herzberg, ed., *Pissarro: Correspondence*, vol. 1 (Paris, 1980), p. 156; *The
New Painting: Impressionism 1874–1886*, (exh. cat., Washington, D.C.,
National Gallery of Art, 1986), p. 395, no. 125.

In 1866 Camille Pissarro and his family moved to Pontoise, a
small town about eighteen miles northeast of Paris. He
worked in and around Pontoise through 1883, with only a
few brief interruptions. According to Richard R. Brettell,
Pissarro's works from Pontoise "form what is probably the
most sustained portrait of a place painted by any French land-
scape painter in the nineteenth century" (*Pissarro and Pontoise*
[New Haven, 1990], p. 1). Pontoise and its environs, particu-
larly the village of L'Hermitage, became the principal source
of the artist's motifs. Located on a series of hills above the
Oise River, Pontoise was reshaped by rural modernization
during the economic development of the Second Empire and
the Third Republic. The town was distant enough from Paris
to retain its own identity during the early nineteenth century,
yet close enough to engage in trade. Three years before Pis-
sarro's arrival there, the French railway network constructed
an iron bridge across the Oise, linking Pontoise with the
French capital. This transformed the town and the area sur-
rounding it. Subsistence farming was replaced by a market
economy. Signs of industrialization, modernization, and the
changing class structure of Pontoise — factory chimneys
(*Usine près de Pontoise*, 1873; Springfield, Massachusetts, Mu-
seum of Fine Arts), new gaslights along rural streets (*Quay at
Pontoise, After Rain*, 1876; Manchester, Whitworth Art Gal-
lery, private collection on loan), and a fashionably dressed
woman and child incongruously walking through a plowed
field (*La Route de Rouen, Les Hauteurs de l'Hautil, Pontoise*,
1872; Dallas, private collection) — make up much of
Pissarro's imagery of the town.

Throughout his years in Pontoise, the artist worked to
subvert the conventions of the picturesque, or classical, land-
scape. The titles of his paintings were even calulated to revise
the expectations of the genre. They are notable for their pre-
cision and inclusion of references to modernity. In a letter of
February 1882 to his dealer, Durand-Ruel, Pissarro titled this
painting *View of the New Prison at Pontoise (Spring)*, identify-

ing it with a specific vantage point and specifying the season
of its execution (Bailly-Herzberg 1980, p. 156).

Originality was a principal interest for the Impression-
ists; thus, the appeal of Pontoise for Pissarro may have re-
lated to its lack of distinct association with any earlier painter
of merit, which allowed him to develop unfettered by tradi-
tion. Despite this highly individual relationship between the
painter and his site, his early work at Pontoise is indebted to
the examples of Corot, Daubigny, and Courbet. By 1879
Pissarro had begun a period of intense stylistic experimenta-
tion, which amounted to a revision of his earlier, Impression-
ist style. This picture masterfully exemplifies Pissarro's re-
working of the transient, or fugitive, qualities so strongly
associated with Impressionism and *plein-air* painting. There is
nothing spontaneous about *View of the New Prison at Pontoise*.
It appears to have been executed *en plein air*, but the surface
of the paint suggests otherwise: Pissarro labored over this
picture, probably reworking it in his studio. Its surface is
painterly but contains nothing like the fluid and calligraphic
brushwork employed by Monet at the same time (see, for
example, *Cliffs of Petites Dalles*, 1880; Boston, Museum of
Fine Arts); rather, Pissarro deployed small, virtually uniform
touches of pigment evenly across the surface of his canvas.

During the 1870s Pissarro often used architecture to
lend order to his landscapes, but in this work buildings ap-
pear only as distant, minor details. Trees and vegetation
structure the composition. A series of rolling hills, articulated
in various states of cultivation, recede toward the horizon.
Despite evidence of careful and sustained deliberation before
executing this motif and its exquisitely crafted surface, the
artist continued to work with some pictorial conventions —
for example, the blue shadow cast by the small foreground
tree — that were fundamental to Impressionism.

During the years following 1880, Pissarro typically re-
placed architecture with figures as the focal elements of his
compositions. Pure landscapes, such as this painting, are far
less common. His participation in the seventh Impressionist
exhibition (1882) attests to his changing interests. Landscape
dominated this exhibition, comprising about three-quarters
of the total of 210 paintings by 9 artists. However, of Pissar-
ro's thirty-six entries, twenty-seven were figure composi-
tions. Critics responded positively to his works. Among
those singled out for special praise was *View of the New Prison
at Pontoise*, which J.-K. Huysmans called "magnificent"
(1975, p. 235). Pissarro himself was happy with his represen-
tation and role in this exhibition, writing to his niece:
"We are very pleased with the results, our reputation is af-
firmed more and more, we are taking our definitive place in
the great movement of modern art" (1980, p. 160).

R.J.B.

113 PLATE 122

CAMILLE PISSARRO (Danish, worked in France; 1830–1903)

Haystacks in a Meadow, Eragny, 1896

Oil on canvas, 28½ x 36 in. (72.4 x 91.4 cm)

Private collection

PROVENANCE: Collection of Mr. and Mrs. Sidney R. Rabb, by 1965.

EXHIBITION: New York, Wildenstein Gallery, *Camille Pissarro* (cat.), 1965, no. 73.

LITERATURE: Ludovic Rodo Pissarro and Lionello Venturi, *Camille Pissarro, son art — son oeuvre* (Paris, 1939), vol. 1, p. 230, no. 1072, ill.; vol. 2, pl. 215.

A woman dressed in a dark, somber colors walks along a country path, carrying water jugs. A lush, green meadow filled with trees, bushes, and two haystacks surrounds her. In the immediate left foreground, a dead branch rests on the ground in front of a large tree. The branches of the tree occupy the top half of the canvas, bisecting the large haystack behind and overshadowing the peasant woman below. In the left background, two women and a child dressed in brighter tones also walk in the meadow. Two horses graze beneath a grove of trees to the right, and a village appears in the distance.

Although Camille Pissarro often painted the more progressive motifs of urban life, the image of the countryside remained a constant presence in his work. Throughout his life, Pissarro preferred to live and work in rural settings, most consistently in Pontoise (1866–1883). During these years, the artist produced hundreds of canvases depicting the town as both an idyllic village and a modernized suburb (see Richard Brettell, *Pissarro and Pontoise* [New Haven and London, 1990]).

In 1884 Pissarro relocated to Eragny, a much smaller village located near the important market town of Gisors, in Normandy. Throughout the 1880s his motifs alternated between images of rural life and concentrated views of the cities of Rouen, Dieppe, Le Havre, London, and Paris. Eragny provided the subject matter for his landscapes, in which he investigated various domestic and agricultural activities. In an interview in 1892 Pissarro said that through his canvases he wanted to express "the true poem of the countryside." His pastoral paintings of this period do not depict the toil of rural life in a literal sense, but rather present an idealized vision of the countryside. Unlike his rural paintings of the 1870s, in which female figures perform lowly tasks, Pissarro's peasants of the 1880s and 1890s form part of a more harmonious and idyllic vision of nature. This rural landscape recalls more traditional French nineteenth-century peasant paintings, particularly those of Jean-François Millet. Both artists addressed the theme of peasants at work, and Pissarro clearly looked to Millet as an inspiration for his subject matter.

The provenance for *Haystacks in a Meadow, Eragny* is unclear, since the painting was misdated in both the catalogue raisonné (1939) and Wildenstein's exhibition catalogue

(1965). Pissarro's inscription in the lower-right corner of the canvas clearly reads 1896, which contradicts the traditionally accepted date of 1899. In the past, the painting was linked with a similar group of works executed during the summer of 1899 (see Pissarro and Venturi 1939, nos. 1071–81), but the date on the canvas proves that this work anticipated those later paintings. Although Pissarro devoted most of the year 1896 to working in the city of Rouen, three compositions depicting a similar meadow in Eragny support the earlier date (see Pissarro and Venturi 1939, nos. 974–76). The most striking example is *Sun Setting in Eragny* (no. 974, location unknown), whose composition — two horses, several trees, and a haystack — clearly resembles the passage at the far right of this painting.

K.R.

114 PLATE 33

JAN PORCELLIS (Dutch, about 1580 to 1584–1632)

Boats on a Choppy Sea, about 1629–1631

Oil on panel, 18½ x 25 in. (47 x 63.5 cm)

Monogrammed on side of rowboat, left of center: IP

Private collection

PROVENANCE: Brod Gallery, London.

Beneath a lowering bank of slate gray clouds, a few boats ply the choppy waters of an inland sea. In the foreground, just to the left of center, is a small fishing boat manned by three men; farther to the right, a *boeier* (or *damlooper*?) plows through the waves. Beyond the two men and two women standing on the bulwark at the right can be seen the masts of two boats docked at the far side of the bulwark. Bordering the horizon are, from left to right, a thin spit of land with the profile of several buildings and a windmill; a large yacht or frigate with furled sails; and, near the center of the composition, the profile of a second, more distant town.

Jan Porcellis played a seminal role in the evolution of Dutch marine painting, from explicitly detailed depictions of historical events to more lyrical evocations of the sea. Porcellis recognized the artistic potential of the ever-changing interplay of sky, wind, and sea, and during the course of the 1620s adopted a monochromatic tonal palette in order to capture such atmospheric effects. He was especially renowned for his depictions of rough and stormy seas, and his light, spirited handling of paint accords perfectly with the quixotic character of this watery world.

The *boeier* was a small inland vessel (primarily used for hauling cargo) with round bow and stern, and broad leeboards. Leeboards were used on most Dutch inland vessels, as shallow waterways precluded the use of deep fixed keels. Though undated, *Boats on a Choppy Sea* was probably painted between 1629 and 1631; in this work, Porcellis shows a fully developed mastery of the atmospheric tonal palette. John Walsh (in correspondence dated July 8, 1991) relates the

painting to Porcellis's *Single-masters and a Rowboat near a Bulwark* of about 1629 to 1631 (Rotterdam, Museum Boymans-van Beuningen, inv. 1657), which features a small rowboat and a bounding *damlooper* in a very similar composition. Comparable dated works include *Single-masters in a Light Breeze* of 1629 (Leiden, Stedelijk Museum "de Lakenhal"). The composition is also quite close to the series of eleven prints engraved after Porcellis's designs by Claes Jansz Visscher for the *Icones variarum navium hollandicarum*, which was published in 1627.

M.E.W.

115 PLATE 143
LÉON POURTAU (French, about 1872–1897)
Beach Scene, about 1890–1893
Oil on canvas, 28¾ x 36¼ in. (73 x 92 cm)
Signed at bottom left: *L. Pourtau*
Josefowitz Collection

PROVENANCE: Artist's family estate; collection of P. Caliure (from his father-in-law, who served as attorney for the artist's estate); sale Paris (Hôtel Maurice), December 2, 1976, no. 23.

EXHIBITION: London, Royal Academy of Arts, *Post-Impressionism: Cross-Currents in European Painting* (exh. cat.), 1979–1980, no. 160.

The painting *Beach Scene* is an accomplished example of Neo-Impressionism, yet its creator, Léon Pourtau, is virtually unknown. Although he was trained and worked as a musician, he knew Georges Seurat and other members of that artist's circle. About 1895 Pourtau left France, traveling to the United States as a member of an orchestra, in the hopes of earning enough money to support a year of uninterrupted painting. With his savings, the artist booked passage to return to France in 1897, but on the voyage home he met his death in the shipwreck of the *Bourgogne*. His death was sadly noted by Victor Barrucand in an obituary in *La Revue Blanche*: "He leaves us some remembrances: a few paintings where his patient hand established harmonies of lines and light" (vol. 16 [May–August 1898]; *Slatkine Reprints* [Geneva, 1968], pp. 549–50). The artist's few remaining works are largely in the possession of his descendants.

During the second half of the nineteenth century, a pleasure-seeking bourgeoisie changed the character of the French coast. Fashionably dressed vacationers transformed simple fishing villages and ports along the Normandy coast into resorts whose landscape was recorded by many painters. Eugène Boudin's *Fashionable Figures on the Beach* (1865; Boston, Museum of Fine Arts), Edouard Manet's *On the Beach at Boulogne* (1869; Richmond Museum of Fine Arts), and Claude Monet's *The Boardwalk at Trouville* (1870; Hartford, Wadsworth Atheneum) depict elegantly dressed strollers, many with parasols, parading on the beach and on recently constructed boardwalks. As new and more efficient trains and railroad routes made the coast more accessible to city-dwellers, its character was profoundly altered. By the late

nineteenth century, vacationers frequently outnumbered native inhabitants during the peak tourist months of summer.

In the tradition of the work of Manet and the early work of Monet, Pourtau's *Beach Scene* presents a crowded beach upon which members of a variety of classes — including a man wearing an elegant dark suit and holding a cane, and a nearby woman dressed as a domestic servant — ostensibly enjoy the sea air and water.

Pourtau's work is related to earlier, generic treatments of the same motif, and John House specifically described it as a "coastal re-creation of Seurat's *Grande Jatte*" (London 1979 [exh. cat.], p. 116). There are, however, important differences between the two pictures. Pourtau applied his Pointillist dots less methodically than did Seurat, and though Pourtau carefully grouped his figures along the beach, they lack the haunting stasis and hieratic quality of the figures in Seurat's *A Bathing Place, Asnières* (1884; London, National Gallery) and *La Grande Jatte*. Had the confident and inventive painter of *Beach Scene* not been lost at sea, he might have distinguished himself as a leading member of the Neo-Impressionist movement.

R.J.B.

116 PLATE 61
PIETER JANSZ QUAST (Dutch, 1605 or 1606–1647)
Peasants in an Interior, n.d.
Oil on beveled panel, 14 x 22⅛ in. (35.6 x 56.2 cm)
Signed on barrel: *PQast*
Private collection

PROVENANCE: Vose Galleries, Boston, 1958.

EXHIBITION: Worcester (Massachusetts) Art Museum, *17th Century Dutch Painting: Raising the Curtain on New England Private Collections* (cat. by James A. Welu), 1979, no. 27.

LITERATURE: Guido Jansen et al., *Meesterlijk Vee: Nederlandse veeschilders 1600–1900* (exh. cat., Dordrechts Museum; and Leeuwarden, Fries Museum, 1988–1989), p. 190.

Two loutish peasant men — one playing a flute, the other peering inside his empty tankard — sit behind a rough wooden table. They are accompanied by two barefoot women; the one on the right offers an apple to the pissing child who squirms on the lap of a straw-hatted woman on the left. An amorous couple grapples in the haystack at right; in the foreground are some cooking vessels and a goat.

A versatile and inventive painter, Quast painted illustrations of proverbs in the manner of Adriaen van de Venne, scenes inspired by contemporary theater, high-life genre scenes, and earthy peasant scenes influenced by Adriaen Brouwer. *Peasants in an Interior* has been interpreted as incorporating references to the five senses — the flute player representing hearing, the lovers touch, and so forth — but it is more plausible that Quast intended these as an evocation of sensuality in its broader sense, particularly its negative connotations, than that he was specifically creating an allegory of

each sense. The gluttonous *kannekijker* (literally, tankard watcher) hopes for still more ale; the flute has phallic and erotic connotations; the unshod women have abandoned decorous behavior; and the young child unabashedly succumbs to his bodily urges. The most graphic examples of sensuality in Quast's painting are, of course, the half-dressed lovers in the hay (their torrid activity is echoed in the smoke that rises from behind the partition at right) and the goat, a symbol of lust and sexuality, situated prominently before them.

There is another dimension to the painting as well. According to the Dutch artist and theoretician Carel van Mander, the unchaste goat "signifies the whore, who destroys the young people even as the goat gnaws off and ruins the young green sprouts" (*Het schilder-boeck* [Amsterdam, 1618], bk. 2, p. 115; quoted in Worcester 1979, p. 92). Without overt moralizing and in a humorous and lighthearted manner, Quast's painting depicts a young child being raised in an environment of licentious behavior and offers little alternative for his future, for, in the words of a traditional Dutch proverb, "As the old ones sing, so pipe the young."

M.E.W.

117 PLATE 55

PIETER JANSZ QUAST (Dutch, 1605 or 1606–1647)
An Elegant Company, 1639
Oil on panel, 18 x 25¼ in. (46 x 64.4 cm)
Signed and dated on fireplace at upper right: *PQ / 1639*
Private collection

PROVENANCE: Collection P. P. Semenov, Leningrad; sale Berlin (Internationales Kunst und Auktions-Haus), October 8, 1932, no. 313; with dealer John Streep, New York, 1963–1964; private collection; with dealer Johnny van Haeften, Ltd., London.

EXHIBITIONS: Worcester (Massachusetts) Art Museum, *17th Century Dutch Painting: Raising the Curtain on New England Private Collections* (cat. by James A. Welu), 1979, no. 28, pp. 94–97; London, Johnny van Haeften, Ltd., *Dutch and Flemish Old Master Paintings*, n.d., no. 17.

LITERATURE: P. P. Semenov, *Studies in the History of Netherlandish Painting Based on Examples That Are Found in Public and Private Collections in St. Petersburg* (in Russian; Saint Petersburg, 1885), p. 306; A. Bredius, "Pieter Jansz. Quast," *Oud-Holland* 20 (1902), p. 76; P. P. Semenov, *Etudes sur les peintres des écoles hollandais, flamande et néerlandais qu'on trouve dans la collection Semenov et les autres collections publiques et privées de St. Petersbourg* (Saint Petersburg, 1906), p. 171; A. Wurzbach, *Niederländisches Künstler-Lexikon* (Vienna and Leipzig, 1906–1911), vol. 2, p. 368.

Clad in a cream-colored doublet and breeches, a dapper young man escorts his elegantly gowned partner to dance in the middle of a sparsely furnished interior. A fire blazes in the fireplace at right; at left, a lutenist and a woman holding a song sheet provide the musical accompaniment. A third couple converses in the background. The figures' richly painted bright costumes contrast markedly with the thin brown monochromatic backdrop.

Although painted while Quast was living in The Hague during the 1630s, *An Elegant Company* belongs to a tradition

of high-life genre interiors developed during the 1620s and early 1630s by artists primarily active in Amsterdam and Haarlem — Dirck Hals, Pieter Codde, and Willem Duyster — and in Delft by Anthonie Palamedesz. Like the latter artist, in his *Merry Company* of 1633 (cat. 111), Quast depicted not only the leisure pastimes of an elegant company, but also included symbolic and lightly moralizing elements that hark back to earlier depictions of the Prodigal Son.

The extreme décolletage displayed by the women may indicate that the scene is set in a brothel and that the women are prostitutes; the open and rather suggestive pose of the songstress at left may be viewed as a further sign of moral laxity. Although dancing was frequently condemned in the seventeenth century by stringent Calvinists as "vain, rash [and] unchaste," in and of itself it cannot be interpreted as an immoral activity, for it remained very much a part of popular culture at all levels of society (see Peter C. Sutton, in Philadelphia Museum of Art; Berlin, Gemäldegalerie der Staatliche Museen Preussischer Kulturbesitz; and London, Royal Academy of Arts, *Masters of Seventeenth-Century Dutch Genre Painting* [exh. cat.], 1984, p. 176).

Gazing at his companion, the man in the center of the composition indicates the fire in the hearth with a sweep of his hat. In contemporary mottos and emblems, love was often compared to a consuming fire; the analogy was used particularly to symbolize fleeting or profane love, as in the following motto from Jacob Cats's *Spiegel van den Ouden ende nieuwen tijdt* (1632): "A harlot's love, like fire of flax, / Shines brightly, but duration lacks."

M.E.W.

118 PLATE 95

SIR HENRY RAEBURN (Scottish, 1756–1823)
Portrait of John Home Home, Esq., about 1810
Oil on canvas, 29 x 24 in. (73.6 x 60.9 cm)
Private collection

PROVENANCE: Montagu Sams (great-grandson of the sitter); sale London (Christie's), November 21, 1952, no. 29; Thomas Agnew & Sons, London; William B. Hitchcock, 1953.

Born in Edinburgh and trained as a jeweler, Raeburn was largely self-taught as a painter. He began by copying other portraits and painting miniatures, but by dint of his natural talent was by 1776 producing the suave, accomplished portraits for which he would become famed over the next twenty years. Raeburn married a wealthy widow in 1780. From 1785 to 1787 he was in Rome, where he was influenced by the fashionable portrait style of Pompeo Batoni. By the end of the eighteenth century, the artist was established as the leading portrait painter of Edinburgh. On his way to Italy, he undoubtedly had passed through London, where he first exhibited in 1793, and he considered settling there in 1810 but then changed his mind. Raeburn became president of the So-

ciety of Edinburgh Artists in 1812. Among his many honors, the greatest was the knighthood bestowed by George IV on a royal visit to Edinburgh in 1822.

Although sometimes called the "Scottish Reynolds," Raeburn was, unlike his London contemporary, not a careful or cerebral artist. If anything, his work, painted directly on the canvas with bold assurance, is more like that of Romney.

Raeburn seldom included any background in his paintings, but rather focused on the heads of his sitters, and often, as in this case, made the collar or neckware framing the face the liveliest part of the composition. The young John Home Home, who is posed as if distracted by a transient thought, gazes to one side. His attractive, poetic features were the perfect subject for Raeburn's fluent touch. The son of Admiral Rodham Home of Longformacus, Berwickshire, John was born on July 6, 1789. He served as an ensign in the First Grenadier Regiment of the Foot Guards, and was gazetted captain twelve days after the Battle of Waterloo. He died as a lieutenant general about 1866. A companion portrait depicting his brother Alexander facing to the left and wearing a midshipman's uniform is in the Brooks Museum of Art, Memphis (see S. P. Thomason, *Painting and Sculpture Collection, Memphis Brooks Museum of Art* [Memphis, 1984], pp. 86–87). Together, they formed a handsome pair epitomizing the ideal of youthful manly elegance.

E.M.Z.

119 PLATE 140
JEAN FRANÇOIS RAFFAËLLI (French, 1850–1924)
Afternoon Tea, n.d.
Oil on canvas, 13¾ x 11⅜ in. (35 x 29 cm)
Signed at lower right: *JFRAFFAËLLI*
Private collection

PROVENANCE: Sale New York (American Art Association), 1887; sale New York (Christie's), February 26, 1986, no. 9 (as the property of the estate of Ray Livingston Murphy); sale London (Christie's), March 19, 1991, no. 34.

Raffaëlli's earliest exhibited works were picturesque genre scenes in the manner of Fortuny or de Nittis. The artist abandoned this type of subject, however, after the Salon of 1877, when his *Famille de Jean le Boiteux*, a stark and unidealized view of a Breton peasant family, was singled out for praise by Naturalist critics, including Edmond Duranty. It probably was Duranty who introduced Raffaëlli into Degas's circle, a group affiliated with the Impressionists but drawn to subjects of modern urban life, rather than *plein-air* nature studies. Through Degas, Raffaëlli was included in the Impressionist exhibitions of 1880 and 1881, although his participation angered some, notably Gauguin, who threatened to withdraw if Raffaëlli's works were shown in 1882.

Raffaëlli's work found support among the Naturalist writers who were less favorably inclined toward Impressionism. Joris Karl Huysmans called the artist "a Parisian Millet . . . the heir of the Le Nains," and Jules Claretie described him as "a sort of Meissonier of misery, the painter of the disinherited." Enlightened sympathy, rather than radical politics, seems to have prompted Raffaëlli's interest in the underclasses. In a letter of 1909 to Arsène Alexandre the artist warned against flattery or pity. Instead, he wrote, one "should paint them in their place, with kindness and sympathy, while keeping one's distance, and with a profound aristocratic sense."

In 1878, Raffaëlli moved to the industrial suburb of Asnières, where he found most of his subjects, from ragpickers to petit-bourgeois genre scenes. *Afternoon Tea* shows an elderly couple, neatly dressed, before an outdoor table set with a tea service. A gray tabby cat sits behind them on a windowsill. As in Degas's *Absinthe Drinker* (Paris, Musée du Louvre), the figures are side by side, not engaged in conversation, but gazing vacantly into the distance. Readily apparent is the artist's focus on physiognomic characterization as a method of analysis and a means of insight. Also typical of Raffaëlli's style, the present canvas is dryly painted, stressing line and texture over color. The somber browns and grays that dominate the palette are relieved only by the gold-edged gleam of the white china tea set in the foreground; the anomaly between the cheerful objects and the dour figures is the real subject of the picture.

P.S.

120 PLATE 115
HENRI ALEXANDRE GEORGES REGNAULT (French, 1843–1871)
Studies of Black Men, about 1870
Oil on canvas, 11¼ x 14¼ in. (28.6 x 36.2 cm)
Private collection

PROVENANCE: Acquired from Peter Tillou, London, in 1991.

The son of the director of the Sèvres porcelain factory, Henri Regnault enrolled at the age of seventeen at the Ecole des Beaux-Arts, where he studied with Louis Lamothe and Alexandre Cabanel. He won the Prix de Rome in 1866, on his third attempt, and left for Italy in the following year. His first *envoi* from Rome, *Automedon with the Horses of Achilles* (Boston, Museum of Fine Arts) is a powerful work in the Romantic tradition. However, the course of Regnault's career was altered by a visit to the Roman studio of the Spaniard Marià Fortuny. The artist was attracted to Fortuny's Orientalist subjects, which are notable for their brilliant palette and glittery, flamboyant technique. Advised to leave Italy for health reasons, Regnault followed the Spanish artist's advice and traveled in 1869 to Spain and then to Tangiers, where he set up a studio with Georges Clairin, his lifelong friend. This situation, which Regnault found exhilarating and inspira-

tional, did not last long. With the outbreak of the Franco-Prussian War in 1870, Clairin and Regnault returned to Paris in order to enlist in the French army. Regnault was killed in the battle of Buzenval in 1871. This early and heroic death was mourned by the French art establishment, which celebrated his achievements with a posthumous exhibit in 1872.

The present canvas contains three spatially unrelated studies of the heads of black men. The largest of the three, at top right, shows in three-quarter view the head and shoulders of a muscular young man with close-cropped hair and pronounced cheekbones; he turns to the right and has his mouth open. The lower two heads are both shown in profile; the face of the one to the right juts forward, and its mustache and small goatee suggest that at least two different models were employed. After painting the heads in dark earth tones, the artist used a cream-colored paint to block in the background, enhancing the contrast and solidity of the informal group of sketches. Painted studies after black models had been widely used by artists since the seventeenth century. Regnault probably knew Rubens's *Four Studies of the Head of a Negro* (Brussels, Musées Royaux des Beaux-Arts), which was sold in Paris in 1867, and he would have seen similar studies in Fortuny's studio.

Throughout his brief career, Regnault made studies from life to ensure that his history paintings had an exotic authenticity. Another *Tête de Negre* by the artist (Rouen, Musée des Beaux-Arts) is signed and dated "69." The present work, however, is difficult to date with certainty. Although in correspondence with his father Regnault often mentioned sketches made after exotic local types during his travels (see *Correspondance de Henri Regnault*, ed. by Arthur Duparc [Paris, 1872], pp. 334, 345–47, and 375), black models also would have been available in Paris during his student years.

Eric Zafran has noted a similarity between the head at lower right in the present sketch and the figure of Holofernes in an oil sketch of 1869 (Cleveland, Butkin Collection) which is thought to have been modeled on Lagraine, the artist's half-Arab servant. A second possibility is that *Studies of Black Men* dates to the spring of 1870, when Regnault was in Tangiers working on his main achievement of the African period, *Summary Execution under the Moorish Kings of Granada* (Paris, Musée d'Orsay). Of his work-in-progress, he wrote to his father: "I have here all the types, all the varieties of heads [necessary]" (Duparc 1872, p. 375). Set against the brilliant architecture of the Alhambra, the scene of a regal Moorish executioner wiping his sword clean over the gruesomely decapitated figure in the foreground rivets the viewer's attention with its sparkling color and handling as much as with its subject matter. The melding of admiration for Moorish culture with a display of senseless violence places Regnault's work in the Romantic tradition of horror and violence in Oriental settings which had been established by such works as Delacroix's *Death of Sardanapalus* (Paris, Musée du Louvre), although Regnault's talents as a colorist suggest that

his career, had it not been cut short, might have taken a different course.

P.S.

121 PLATE 74

REMBRANDT VAN RIJN (Dutch, 1606–1669)
A Pilgrim in Prayer (Saint James), 1661
Oil on canvas, 37 x 31½ in. (94 x 80 cm)
Signed and dated at lower right: *Rembrandt f 1661*
Private collection

PROVENANCE: (Possibly) sale of the Heirs of Caspar Netscher, A. Schouman, and others, The Hague, July 15, 1749, no. 122 (as *A Pilgrim Praying*, without dimensions; see Hofstede de Groot, no. 194c); MacKenzies of Kintore; Sir J. Charles Robinson, C.B., London; Consul Edmund Friedrich Weber, Hamburg, cat. 1872, no. 213; with dealer Charles Sedelmeyer, Paris, cat. 1895, p. 40, no. 29, ill. p. 41; Maurice Kann, Paris, 1901; with Duveen, Paris; with Reinhardt Galleries, New York, 1913; John N. Willys, Toledo, Ohio; sale of the late Isabel van Wie Willys (formerly Mrs. John N. Willys), New York (Parke-Bernet), October 25, 1945, no. 16 (for $75,000, to Billy Rose); Billy Rose, New York, 1950 (see exh.); Oscar B. Cintas (Ambassador to Cuba), New York; Mr. and Mrs. Stephen C. Clark, by 1955 (by whom loaned to the Metropolitan Museum of Art, New York, 1958).

EXHIBITIONS: Detroit Institute of Arts, Rembrandt exhibition, 1930, no. 67, ill.; New York World's Fair, *Masterpieces of Art* (cat. by George Henry MacCall, ed. by W. R. Valentiner) 1939, no. 309, ill.; New York, Wildenstein's Gallery, *A Loan Exhibition of Rembrandt*, January 19–February 2, 1950, no. 24, pl. XXI.

LITERATURE: Carl Woermann, "Meisterwerke Niederländischer Maler in der Galerie Weber zu Hamburg," *Die Graphischen Künste* 14 (1891), p. 32; *Zeitschrift für bildende Kunst* 3 (1892), ill. opp. p. 152 (an etching by Albert Krüger); Emil Michel, *Rembrandt, His Life, His Work and His Time* (London and New York, 1903; first published in French, Paris, 1893), p. 374, ill. opp. p. 374; Wilhelm von Bode, *The Complete Work of Rembrandt*, vol. 6 (Paris, 1901), pp. 30 and 202, and no. 485; W. R. Valentiner, *Rembrandt*, Klassiker der Kunst (Stuttgart and Leipzig, 1921) p. 578, ill. p. 457; C. Hofstede de Groot, *A Catalogue Raisonné*, vol. 6 (1916), p. 121, no. 170 [as *The Apostle James*]; W. R. Valentiner, "Die vier Evangelisten Rembrandts," *Kunstchronik und Kunstmarkt*, new series 32 (December 17, 1920), no. 12; Ralph Flint, "John N. Willys Collection," *International Studio* 80 (February 1925), p. 368, ill. opp. p. 366; W. R. Valentiner, *Rembrandt Paintings in America* (New York, 1931), no. 152, ill.; A. Bredius, *The Paintings of Rembrandt* (London, 1936), p. 37, no. 617; *Die Weltkunst* 28 (September 1, 1958), ill. opp. p. 3; Kurt Bauch, *Rembrandt Gemälde* (Berlin, 1966), no. 236, ill.; Horst Gerson, *Rembrandt Paintings* (Amsterdam, 1968), p. 424, no. 361, ill.; A. Bredius (rev. by H. Gerson), *Rembrandt: The Complete Edition of the Paintings* (London, 1969), p. 521, ill.; Gary Schwartz, *Rembrandt, His Life, His Paintings* (New York, 1985), p. 312, fig. 356; Christian Tümpel, *Rembrandt: Mythos und Methode* (Antwerp, 1986), p. 342, cat. 82, ill.

A pilgrim is depicted half length and turned to the viewer's right. He has long, dark hair and a thin beard, and his hands are clasped in prayer. Over a shirred white shirt he wears a heavy brown cloak with a short cape fastened at the right shoulder with a pilgrim's scallop shell. His staff and his hat, with its broad, upturned brim held by a second scallop shell, lie before him. In the background is a stone wall.

Michel (1893 / 1903) and Bode (1901) regarded the subject as an anonymous pilgrim, but Hofstede de Groot (1916)

identified him as Saint James — an identification followed by, among others, Bredius, Gerson, Bauch, Schwartz, and Tümpel. Saint James (the Great) was one of Christ's apostles, and originally had been a fisherman of Galilee. Legends dating from the Middle Ages mention his mission to Spain and his burial at Compostella, which subsequently became a major center of Christian pilgrimage. James is often depicted wearing a broad hat, a cloak, and a shell, and holding a staff — all of which are his attributes.

By 1656 Rembrandt's finances were so dire that he was forced to claim insolvency. His house was sold and his possessions, including his art collection, were inventoried and sent to auction. In 1660 the artist moved to the Rozengracht, and in December of that year set up a new business arrangement with his son, Titus, and his common-law wife, Hendrickje, to be copartners of an art dealership that would sell his art but in the management of which he would only function as an advisor, ostensibly receiving only room and board. This agreement was probably designed in order to circumvent the guild laws of Amsterdam, which would have otherwise prohibited Rembrandt, following his bankruptcy, from working in the city. The following year, 1661, Rembrandt produced more work than he had in any year since 1634. Among his many paintings from this time is a group of half-length figures of apostles and evangelists. These include *The Apostle Bartholomew* (Malibu, California, Getty Museum, no. 71 PA15), *The Apostle Simon* (Zurich, Ruzicka-Stiftung, Kunsthaus), *The Evangelist Saint Matthew* (Paris, Musée du Louvre, no. 2538), and *Self-portrait as the Apostle Paul* (Amsterdam, Rijksmuseum, no. A4050), all of which are signed and dated 1661 and are among the most brooding and soulful works he ever painted. Several closely related paintings in Rotterdam (*Saint Luke*, Museum Boymans-van Beuningen, no. 2113), Boston (*An Evangelist*, Museum of Fine Arts, no. 39.581), and Cleveland (*Apostle in Prayer*, Cleveland Museum of Art, no. 67.16) now are often considered to have been painted by assistants or followers; it may be recalled that Titus, who is recorded as having been an artist but whose work is not known today, presumably was trained by and worked for his father in this year and until his early death in 1668. Attempts have been made to identify a series of evangelists or apostles in this extensive group; however, the works differ in size and conception, so it is possible, even likely, that they were conceived individually.

In 1893, when the present painting was in the Weber Collection in Hamburg, Emil Michel wrote of its "broad, nervous and superbly expressive" handling, and regarded it as "perhaps the most important of the entire group of half-lengths." Bode (1901, p. 30) also praised the way in which Rembrandt had captured "the pilgrim's personality, his ascetic features and [the] fervid devotion that fascinated the master."

P.C.S.

122 PLATE 82

MICHELE ROCCA (Italian, 1666–after 1751?)
The Temptation of Adam and Eve, n.d.
Oil on canvas, 18¼ x 13⅝ in. (46.4 x 34.6 cm)
Private collection

123 PLATE 83

MICHELE ROCCA (Italian, 1666–after 1751?)
The Expulsion from Paradise, n.d.
Oil on canvas, 18⁷⁄₁₆ x 13½ in. (48.1 x 34.3 cm)
Private collection

PROVENANCE: Purchased in Europe, probably Vienna, between 1925 and 1927; private collection.

Little is known today of the life and art of Michele Rocca. From Nicola Pio's short biography of the artist (published in 1724), it is known that he was born in Parma in 1666 and came to Rome at the age of sixteen to study with Ciro Ferri, an assistant and follower of Pietro do Cortona (*Le vite di pittori, scultori et architetti* [Vatican City, repr. 1977], p. 111). Rocca returned briefly to his native city to study the works of Correggio, but was back in Rome in the 1690s, when he is documented as having executed several large church altarpieces. Recent research has established Rocca's presence in Rome through 1727 (see G. Sestieri, "Michele Rocca," in *Quaderni di Emblema* 2 [1973], pp. 83–96). After that, nothing further is known of Rocca's whereabouts until he is mentioned as having resided in Venice in 1751.

Rather early in his career, Rocca seems to have abandoned large-scale church decoration in favor of small, brilliantly colored cabinet pictures, which he presumably made for private collectors. A sizable group of these unsigned religious and mythological scenes has been attributed to Rocca on the basis of style. However, their stylistic consistency makes the establishment of a chronology difficult.

The present pair of canvases depict *The Temptation of Adam and Eve* and *The Expulsion from Paradise* (Genesis 3:6 and 3:24). Although the subjects of the temptation and the expulsion were not common in eighteenth-century art, they suited the format established by Rocca for his cabinet pictures, which tended to feature a few nude figures in a pastoral setting, typically in a vertical composition. In *The Temptation*, Eve is shown standing, seen from the back, as she hands the forbidden fruit to Adam, who is reclining on the hillside. Responsible for Eve's temptation, Satan is shown in the form of a human-headed serpent coiling around the Tree of Knowledge. In the pendant, a chastened and shamed Adam and Eve are banished from Eden by an angel bearing a sword of fire. In both canvases, the landscapes are freely painted in the light blues and greens typical of the Rococo period.

Successful compositions were occasionally repeated by Rocca. In the present case, he made a close version of *The Expulsion*, with the addition of garlands of leaves to accommodate Adam and Eve's newfound modesty (Hartford,

Wadsworth Atheneum; see Jean K. Cadogan, ed., *Wadsworth Atheneum Paintings II, Italy and Spain, Fourteenth through Nineteenth Centuries* [Hartford, 1991], pp. 210–11).

Rocca's role in the development of the Rococo style has been the subject of art-historical debate. His luminous, clear colors and painterly handling, as well as the small-scale format and pleasant subject matter of his paintings, are consistent with the new style emerging in Rome and elsewhere in the early decades of the eighteenth century, and these qualities initially contributed to the view of Rocca as an early follower of the new manner. However, recent scholarship (see Sestieri 1973) has shown Rocca's "Rococo" style to predate many of the painters previously thought to have influenced him, and instead presents Rocca as a precocious *petit maître* of the Rococo style who was formed by his native Parma as well as by the late Baroque work of Luca Giordano, Francesco Trevisani, and Carlo Maratta, whom he would have encountered in his Roman milieu.

P.S.

124 PLATE 88

ALEXANDRE ROSLIN (Swedish, worked in France; 1718–1793)
Portrait of Abel-François Poisson, Marquis de Marigny, 1762
Oil on canvas, 15⅝ x 11¾ in. (39.7 x 29.8 cm)
Signed and dated on molding at center right: *Roslin Sued. 1762*
Private collection, courtesy of Rosenberg and Stiebel

PROVENANCE: Commissioned by the Marquis de Marigny and delivered to the *Direction des Bâtiments du Roi,* 1762; in the Château de Ménars, 1779; Comte de la Béraudière; sale Paris (Hôtel de la Béraudière), May 20, 1885, no. 70; Comte and Comtesse d'Harcourt; Rosenberg and Stiebel, New York.

EXHIBITION: Memphis, Dixon Gallery and Gardens; and New York, Rosenberg and Stiebel, *Louis XV and Madame de Pompadour: A Love Affair with Style* (exh. cat.), 1990, pp. 79–80, no. 7, ill.

LITERATURE: Fernand Engerand, *Inventaire des tableaux commandés et achetés par la Direction des Bâtiments du Roi (1709–1792)* (Paris, 1901), pp. lvi and 432; A. Marquiset, *Le Marquis de Marigny (1727–1781)* (Paris, 1918), pp. 208, 228–29, no. VI; Gunnar W. Lundberg, *Roslin Liv och Verk* (Mälmo, 1957), vol. 1, p. 65; vol. 2, pp. 29–30, no. 132, ill.; *Les Artistes suédois en France au XVIIIe siècle* (Versailles, 1945), under no. 255; Hôtel de la Monnaie, *Diderot et l'art de Boucher à David* (Paris, 1984–1985), under no. 104.

Although Roslin retained throughout his life a strong identification with his native land, signing his paintings "Roslin le suédois," his work is firmly rooted in the tradition of French portraiture. Born in Malmö, he studied in Stockholm under the court portraitist G. E. Schröder (1684–1750). Roslin spent four years traveling through various Italian cities before settling in Paris in 1752, where he became an academician and exhibited regularly in the Salons from 1753 to 1791. Through friendships with such well-connected artists as Boucher, Vien, and Pierre, Roslin quickly developed a large clientele for his highly finished portraits among artistic, court, and scholarly circles. His detailed likenesses and attentive rendering of fabric convey a debt to Dutch portraiture of the seventeenth century. An occasional detractor notwithstanding, Roslin's reputation was considerable and his output, prodigious.

This portrait depicts Abel-François Poisson (1727–1781), who was the younger brother of Madame de Pompadour and was awarded the title of Marquis de Marigny by the king in 1754. Marigny occupied the post of Directeur Général des Bâtiments du Roi from 1751 to 1773, exerting a powerful influence on official patronage of the arts for over two decades.

The sitter's tastes, projects, and achievements all find expression in Roslin's portrait, which was undoubtably closely supervised by Marigny himself. Seated before a writing table in the newest *gout grêc* (Greek fashion) and wearing on a blue sash the order of Saint Esprit which had been awarded him by the king, Marigny reviews plans for the completion of the Louvre, one of his major projects. Propped on his desk is a watercolor by Pierre-Antoine De Machy showing a view of the east facade of the Louvre obstructed by adjacent, run-down buildings that Marigny had ordered destroyed so as to open up vistas. The sitter's taste for Neoclassicism in public architecture finds a more personal expression here, in his private furnishings: the proto-Louis XVI-style desk, antique-style porphyry vase, fluted pilaster, and rectilinear picture frame. With regard to paintings, Marigny's taste was more catholic. The corner of the canvas visible at the upper right has been identified by Alden Gordon as Greuze's *Village Bride* (Paris, Musée du Louvre), which was exhibited to great acclaim in the Salon of 1761 and was purchased by Marigny.

Roslin's original life-size version of Marigny's portrait, which was destined for the Royal Academy of Architecture, was also exhibited in that Salon. It was praised by all of the critics except Diderot, who liked neither painter nor sitter and described the pose as "affected" (Jean Adhémar and Jean Seznec, *Diderot Salons,* vol. 1 [Paris, 1975], p. 94). The following year two replicas, one full-size and one "en petit," were ordered by the *Bâtiments.* (Interestingly, Roslin was paid the same amount for the reduced version as for the life-size example.) In 1764, a third full-size version was commissioned. Two of the large versions are known today, one at Versailles and one in the museum at Besançon. The present example, the only one that included the Greuze, was intended for Marigny's personal use, and hung in his bedroom at the country seat in Ménars. The reduced dimensions and exquisite handling make this a connoisseur's, rather than a state, portrait. The rich, saturated colors typify this stage of Roslin's career — midway between the clear Boucher-inspired hues of the artist's earlier work and the increasingly austere palette of his later, more Neoclassical style. Marigny's commission of a small repetition for himself suggests that he preferred Roslin's intimate portrait of a connoisseur and ad-

ministrator at work to Louis Tocqué's more Baroque *portrait d'apparat*, a comparable commission of 1755 (now at Versailles) which shows Marigny standing before a heavy swag of fabric, with little elaboration of the individual behind the official persona.

P.S.

125 PLATE 42

JACOB VAN RUISDAEL (Dutch, about 1628 or 1629–1682)
A Pool at the Edge of a Wood, with a Village Church in the Distance, about 1660
Oil on canvas, 20¼ x 27 in. (51.4 x 68.6 cm)
Signed at lower right: *VRuisdael*
Private collection

PROVENANCE: Collection of the Counts Schönborn-Buchheim, Vienna, by 1820; Galerie Sanct Lucas, Vienna; collection Neuman, France, by 1938; by descent in the family to the present owner.

LITERATURE: F. H. Böckh, *Wiens lebende Schriftsteller, Künstler, und Dilletanten im Kunstsache* (Vienna, 1822); G. F. Waagen, *Kunstwerke und Künstler in Deutschland*, 2 vols. (Leipzig, 1843–1845); Theodore von Frimmel, *Die Gräflich Buchheim'sche Gemäldesammlungen in Wien* (*Kleine Galeriestudien*, n.f., vol. 3; Leipzig, 1896), pp. 60–61, no. 73 (as with figures by Adriaen van de Velde; dates to 1659 or soon after); C. Hofstede de Groot, *A Catalogue Raisonné of the Works of the Most Eminent Dutch Painters of the Seventeenth Century*, trans. by Edward G. Hawke (London, 1908–1927), vol. 4 (1912), pp. 163–64, no. 526 (datable to about 1660; figures attributed to Adriaen van de Velde); Jakob Rosenberg, *Jacob van Ruisdael* (Berlin, 1928), p. 96, no. 394; Claus Virch, *Paintings in the Collection of Charles and Edith Neuman de Végvár* (New York, 1970), n.p.

A few gnarled trees stand before a dense thicket of undergrowth on the left; the right half of the composition opens to a vista of fields, a distant village, and far-off hills. The still waters of a marshy pond spread across the foreground; two cows standing placidly by the bank are watched by a herder sitting at the foot of a tree.

The painting can be dated to about 1660. During the early and mid-1650s Ruisdael favored dense and complex woodland views, which by the end of the decade became more open to light and air. Grainfields such as that on the right in this painting were a particularly important theme in his work of the 1660s. Other compositions by Ruisdael which similarly contrast bosky woods and open vistas of grainfields include *Hilly Landscape with Large Oak* (oil on canvas, 41¾ x 54⁵⁄₁₆ in. [106 x 138 cm], about 1652–1655; Braunschweig, Herzog Anton Ulrich-Museum, inv. 376) and *Grainfield at the Edge of a Forest* (oil on canvas, 40⅞ x 57⁹⁄₁₆ in. [103.8 x 146.2 cm]; Oxford, Worcester College). The staffage in *A Pool at the Edge of a Wood* has been attributed to Adriaen van de Velde (1636–1672), who also painted animals and figures in landscapes by Meindert Hobbema, Jan Wynants, Frederick de Moucheron, Jan van der Heyden, and others.

Grainfields had a particular significance in Dutch landscape painting of the seventeenth century (see Alan Chong, in Amsterdam, Rijksmuseum; Boston, Museum of Fine Arts;

and Philadelphia Museum of Art, *Masters of 17th-Century Dutch Landscape Painting* [exh. cat., 1987–1988], pp. 446–47). First included in allegories of the seasons, they emerged as an independent subject in the sixteenth century. Interestingly, though popular in contemporary Flemish landscape painting, grainfields were rare in Dutch painting before Ruisdael; this phenomenon may be tied to national agricultural trends. During the first half of the seventeenth century, the Netherlands imported much of its grain from the Baltic region, but after about midcentury began cultivating grain in areas to the south and east of the Zuider Zee. The grainfields in Ruisdael's work were thus not only a noteworthy topographical feature, but also represented a local industry with great economic and social importance. Moreover, depictions of cows often embodied similar sentiments. The Dutch were renowned for their dairy herds, which contributed to the economic and agricultural prosperity of the country; the cow itself was frequently used as a symbol of Holland.

M.E.W.

126 PLATE 43

JACOB VAN RUISDAEL (Dutch, about 1628 or 1629–1682)
A Rushing Stream in a Mountain Landscape, mid-1650s
Oil on canvas, 31 x 38 in. (78.8 x 96.5 cm)
Signed on rock at right
Private collection

PROVENANCE: Acquired by the First Earl Brownlow, 1809; Rt. Hon. Aelbert Wellington, Third Earl Brownlow; thence by descent in the Brownlow Collection, Belton House, Lincolnshire; sale London (Christie's), May 4, 1923, no. 87 (Gn 700, unsold); sale (the late) Lord Brownlow, London (Christie's), April 6, 1984, no. 83, ill.; with Johnny van Haeften, London, 1984–1985.

EXHIBITIONS: London, British Institution, 1829, no. 128; Maastricht, Pictura, 1985 (exhibited by Johnny van Haeften).

LITERATURE: (Not in Hofstede de Groot or Rosenberg); advertisement for Johnny van Haeften, in *Tableau* 6 (1984), no. 5, p. 88.

A rushing stream runs through the valley of a hilly landscape. On the right the chalky bank rises steeply to a summit tufted with trees that show the first tinge of autumn. On the hillside that rises on the left, fields are interspersed with woods. Shepherds herd the flocks on the lower plateaus; farther up are cottages, and toward the summit, a windmill.

Ruisdael made a specialty of waterfalls. Indeed, so completely was his art associated with the subject that both Arnold Houbraken, the chronicler of artists' lives, and Jan Luyken, the Pietist author of emblematic literature, observed that the artist's name could be a play on the theme: "Ruisdal" means "valley of noise" in Dutch. Despite this interest the artist is not known to have visited Scandinavia or other mountainous regions where he could have seen actual waterfalls, but, as has often been observed, seems to have been partly inspired by the examples of Allart van Everdingen and partly by recollections of his own visit in the early 1650s to

Westphalia. Although it is difficult to date Ruisdael's waterfalls proper, he seems to have begun painting those with a vertical format in the early or mid-1660s, and those on a horizontal format, slightly later.

The present work is scarcely a waterfall, but may more properly speaking, be characterized as a mountain stream with rapids. Its composition, with the torrent running diagonally beneath a rising hill, may be compared to those of paintings in the Czernin Collection (now in the Residenzgalerie; C. Hofstede de Groot, *A Catalogue Raisonné*, vol. 4 [London, 1912], no. 293; Jakob Rosenberg, *Jacob van Ruisdael* [Berlin, 1928], no. 250), formerly in the Heldring Collection, Oosterbeek (Hofstede de Groot 1912, no. 270; Rosenberg 1928, no. 192) and a sale in New York (Sotheby's, June 4, 1987, no. 73; Hofstede de Groot 1912, no. 487; Rosenberg 1928, no. 338). Sequestered in the Brownlow Collection in Lincolnshire for 175 years, the present painting has not entered the Ruisdael literature, but is a superior example of its type. Seymour Slive (in a private communication) has suggested that it is "datable to the mid-1650s." Although Slive allows that it anticipates later developments, he rightly compares its broad prospect with tall, wooded hillside and towering skies to the majestic painting of 1653 formerly in the Beit collection and presented to the National Gallery of Ireland, Dublin (Hofstede de Groot 1912, no. 25; Rosenberg 1928, no. 18), and adds that the relatively thick application of paint also speaks for dating it to the 1650s.

P.C.S.

127 PLATE 44

JACOB VAN RUISDAEL (Dutch, about 1628 or 1629–1682)
Winter Landscape with Two Windmills, early 1670s
Oil on canvas, 14¾ x 16½ in. (37.5 x 42 cm)
Signed at lower right: *vRuisdael* (v and R ligated)
Private collection

PROVENANCE: Sale Sabatier, Paris, March 20, 1809, no. 47 (for Fr 1001); sale John Maitland, London, July 30, 1831, no. 88 (for £47.5, to Seguier); collection Sir Frederick Cook, Bt., Doughty House, Richmond; by descent to Sir Herbert Cook; dealer Thomas Agnew, London, 1959; private collection, Great Britain; dealer Thomas Agnew, London.

EXHIBITION: London, Guildhall Art Gallery, *Dutch Art*, 1895, no. 94.

LITERATURE: John Smith, *A Catalogue Raisonné of the Works of the Most Eminent Dutch, Flemish and French Painters* (London, 1824–1842), vol. 6 (1835), no. 120; C. Hofstede de Groot, *A Catalogue Raisonné of the Works of the Most Eminent Dutch Painters of the Seventeenth Century*, trans. by Edward G. Hawke (London, 1908–1927), vol. 4 (1912), nos. 1006 and 1025; J. O. Kronig, *A Catalogue of the Paintings at Doughty House Richmond and Elsewhere in the Collection of Sir Frederick Cook, Bt., Vol. 2: Dutch and Flemish Schools* (London, 1914), p. 93, no. 348; Jakob Rosenberg, *Jacob van Ruisdael* (Berlin, 1928), p. 111, no. 626; Seymour Slive, *Jacob van Ruisdael* (exh. cat., The Hague, Mauritshuis; and Cambridge, Fogg Art Museum, 1981–1982), pp. 148–49, ill.; Saskia Nihom Nijstad, *Reflets du Siècle d'Or* (exh. cat., Paris, Institut Néerlandais [Collection Frits Lugt], 1983), p. 118.

Beneath an overcast sky, a frozen river landscape is barely illuminated by the pale yellow orb of the setting sun. In the foreground, two *kolf* players wait for their companion to fasten his skates; further to the right a man, accompanied by a dog, makes his way across the ice. In the distance, a second game of *kolf* is under way. The nearer of the two windmills on the right bank of the river is a lumber mill, as identified by the logs scattered along the ice and stacked beneath the shed at the far right. Other structures are tucked behind trees and low hills at the center and on the left of the composition. The scene is rendered almost entirely in shades of gray, with local colors masked beneath a pall of snow and frost.

Only about twenty-five winter scenes by Ruisdael are known; none are dated, but on stylistic grounds they can be ascribed dates ranging from the late 1650s to the 1670s. The present work has been dated by Slive (1981–1982) to the early 1670s. Characteristic of works from this later period of the artist's career is the absence of prominent foreground motifs, as well as a deep spatial recession and expansive skies, which combine to create a calm peaceful mood. Several of Ruisdael's winter landscapes from this period also feature windmills (among them, *Winter Landscape* [Philadelphia Museum of Art, Johnson Collection, inv. 569] and *Winter Landscape with a Windmill* [Paris, Institut Néerlandais, Collection Frits Lugt, inv. 6104]), but the present painting is unusual in that it specifically depicts a lumber mill.

Unlike in the colorful panoramas of frozen waterways executed early in the century by Hendrick Avercamp and others, the emphasis in Ruisdael's landscape is not on an encyclopedic rendering of winter activities, but rather on conveying the somber and elegiac atmosphere of a land muffled in snow and ice. And although his inclusion of a setting sun invokes thoughts of winter landscapes by Aert van der Neer, the latter artist strove for more dramatic virtuoso lighting effects.

M.E.W.

128 PLATE 35

SALOMON VAN RUYSDAEL (Dutch, about 1600 or 1603–1670)
Landscape with Farmhouse, 1629
Oil on panel, 12 x 16¾ in. (30.6 x 42.5 cm)
Signed and dated at lower right: *S.v.RUYESDAEL 1629*
Private collection

PROVENANCE: Acquired from dealer Charles Roelofs, Amsterdam.

LITERATURE: Peter C. Sutton, *Great Dutch Paintings from America* (exh. cat., The Hague, Mauritshuis; and San Francisco, Fine Arts Museums, 1990–1991), pp. 116–17, ill.

A tumbledown farmhouse appears on the side of a dirt road that recedes from left to right. Thatching covers the roof and a wisp of smoke rises from the central chimney. A crude clapboard fence borders the road, and wooden poles and a

low tree rise to the leaden, cloud-filled sky. A low, raking light illuminates the track, and the darkened coulisse on the near side of the road silhouettes the shards of a fence and two resting travelers. Farther down the road, to the right, are another cottage and another figure. Pigs feed out of a trough beneath a sagging enclosure at the side of the central cottage, and the whitened skull of a cow rests on the roof.

This exceptionally well-preserved painting is an important early example of Salomon van Ruysdael's art. Dating works as early as 1626, Ruysdael began his career as a landscapist, depicting the low dunes and country roads around Haarlem. These images have a disarming simplicity, representing the most unpretentious of motifs — often a derelict cottage, a sandy track, and a tufted rise — unified by diagonal designs and a restrained palette of earth colors. However, the artist enlivened his palette in these early works with sudden contrasts of light and shade, such as a break in the clouds near the horizon which sends a low shaft of light over the land. Typical of these early dunescapes is a painting dated 1628 in the Norton Simon Collection, Pasadena (Wolfgang Stechow, *Salomon van Ruysdael* [rev. ed., Berlin, 1975], no. 227). The present work is closest in theme and design to another, less successful painting that is also dated 1629 (sale Paris [Hôtel Drouot], December 10, 1980, no. 16; Stechow 1975, no. 179), and to undated paintings in the National Museum in Prague (inv. no. O-2954; not in Stechow 1975) and the Fitzwilliam Museum in Cambridge (no. 1049; Stechow 1975, no. 251). All three of these works feature a crumbling thatched cottage, a sandy track, and low, raking light (compare also the dunescapes with roadside travelers, one reportedly dated 1626 [formerly with the dealer Katz, Dieren, and later Scheidwimmer, Munich, 1985; Stechow 1975, no. 228B; ill. in *Masters of 17th-Century Dutch Landscape Painting* (exh. cat., Amsterdam, Rijksmuseum; Boston, Museum of Fine Arts; and Philadelphia Museum of Art, 1987–1988), intro. fig. 48]; others dated 162[8?] [sale London (Sotheby's), December 12, 1979, no. 3, ill.] and 1629 [formerly with Brod Gallery, London; *Apollo* 92 (July 1970), p. viii, ill.]). Ruysdael's tawny dunescapes have often been likened to the contemporary works of Jan van Goyen and Pieter Molijn; all three artists apparently had an influence on one another. The trio was instrumental in the formation of the highly naturalistic, tonal manner of landscape painting that emerged in Holland about 1630.

Images of dilapidated farmhouses with resting peasants had appeared earlier in the graphic works of Jacques de Gheyn II and Abraham Bloemaert. At least in the former's art, such imagery probably embodied the sins of Sloth (*acedia*) and Lust (*luxuria*). H. J. Raupp and J. Bruyn, among others, have interpreted the tonal landscapes with cottages of van Goyen and his contemporaries as encoding similar admonitions against idleness, fecklessness, and moral degeneracy, and warnings against straying from the virtuous path on the "pilgrimage of life" (see Amsterdam / Boston / Philadelphia

1987–1988, especially pp. 86–87 and 95). However, the poetic inscriptions by G. Ryckius that attend Boethius à Bolswert's prints after Bloemaert of tumbledown farmhouses with resting peasants suggest that such images could also evoke thoughts of the peace, security, and contentment of country life (see Peter C. Sutton, in Amsterdam / Boston / Philadelphia 1987–1988, p. 36, fig. 50). Simon Schama (Amsterdam / Boston / Philadelphia 1987–1988, p. 69ff.) has written evocatively of the "ambiguity" and revolutionary "realism" of Dutch dunescapes of the late 1620s. Whether such details as the cow skull on the roof function here as *vanitas* is unclear; Ruysdael included whole animal skeletons in other landscapes (see, for example, Dublin, National Gallery of Ireland, no. 507; Stechow 1975, no. 164).

P.C.S.

129 PLATE 41

SALOMON VAN RUYSDAEL (Dutch, about 1600 or 1603–1670)
The Beach at Egmond-aan-Zee, 1652
Oil on panel, 20¼ x 32 in. (51.5 x 81.3 cm)
Monogrammed and dated: *1652*
Private collection

PROVENANCE: Sale Th. de Bock et al., Amsterdam, March 7, 1905, no. 661; collection Maurice Kann; his sale, Paris, June 9, 1911, no. 65 (for Fr 11,500, to Hodgkins); collection E. M. Hodgkins; sale J. R. Holland et al., London (Christie's), April 11, 1913, no. 126 (as "View at Scheveningen"; for Gn 280, to Conrick); dealer Goudstikker, Amsterdam, 1922–1925; dealer P. Bottenwieser, Berlin, 1928–1929; dealer Thomas Agnew & Sons, London, 1946; dealer Johnny van Haeften, London.

EXHIBITIONS: Copenhagen 1922, no. 113; Saint Louis, Goudstikker, 1922, no. 98; New York, Goudstikker, 1923; The Hague, Goudstikker, 1923, no. 108; Rotterdam, Goudstikker, 1924–1925; London, Thomas Agnew & Sons, *35 Masterpieces of European Painting*, 1946, no. 14.

LITERATURE: W. Stechow, *Salomon van Ruysdael* (Berlin, 2nd. ed., 1975), p. 109, no. 269; and p. 110, no. 278a; Seymour Slive, *Jacob van Ruisdael* (exh. cat., The Hague, Mauritshuis; and Cambridge, Fogg Art Museum, 1981–1982), p. 31.

Beneath windswept clouds, fishermen bring in their catch from small boats run aground at low tide. In the center of the composition a crowd of people have gathered, either to purchase fish or simply to watch the daily spectacle; in the distance, beyond a dune to the right, the same scene is reenacted. Just to the left of center, the fishing village of Egmond-aan-Zee nestles amid the rugged coastal dunes. The tall tower at left is from the abbey church of Egmond-aan-Zee, which was already a ruin in the early seventeenth century; the last remains of the structure fell in 1743.

In part because of its picturesque location and its majestic ruins, Egmond-aan-Zee was a favorite destination for Dutch landscapists, among them Jan van Goyen, Jacob van Ruisdael, and, of course, Salomon van Ruysdael. These artists returned to the site again and again: van Goyen depicted the village at least ten times between 1633 and 1653, and

Ruisdael executed eight views from the late 1640s to the 1670s. Salomon van Ruysdael's three other views of Egmond-aan-Zee (1660, Mainz, Mittelrheinisches Landesmuseum; 1660s, Stuttgart, Staatsgalerie; and 1660s, The Hague, Rijksdienst Beeldende Kunst) show the village from the landward side, and include only a limited glimpse of beach in the background of the composition.

In addition to their embodying the constant tension in the Netherlands between carefully protected land and the ever-encroaching sea, beach scenes such as Ruysdael's *Beach at Egmond-aan-Zee* have been described by Simon Schama as an "idealized vision of the perfect Dutch community: sacred, simple and free" (in *Masters of 17th-Century Dutch Landscape Painting* [exh. cat., Amsterdam, Rijksmuseum; Boston, Museum of Fine Arts; and Philadelphia Museum of Art, 1987–1988], p. 77). Schama views the beach as a significant communal frontier encompassing the important economic contribution of the fishing industry, the virtue of piety (represented by the church tower), and the absence of social ranking in the mingling of burghers and fisherfolk.

M.E.W.

130 PLATE 40

SALOMON VAN RUYSDAEL (Dutch, about 1600 or 1603–1670)
Wooded Landscape with Children and a Wagon by a Gate, 1658
Oil on panel, 22 x 27¼ in. (56 x 69 cm)
Signed and dated at lower left
Private collection

PROVENANCE: Major Richard Rawnsley, Will Vale, Lincolnshire; sale Richard Rawnsley, London (Christie's), April 16, 1937, no. 152; sale London (Christie's), June 29, 1951, no. 128; with dealer Eugene Slatter, London, 1952; sale J. de Bousies et al. (as property of "M. X."), Paris (Charpentier), March 24, 1953, no. 56, ill.; sale London (Sotheby's), December 12, 1984, no. 64; with dealer Johnny van Haeften, London, 1985.

EXHIBITION: London, Eugene Slatter Gallery, *Dutch and Flemish Masters*, 1952, no. 7.

LITERATURE: *Illustrated London News*, April 26, 1952; Wolfgang Stechow, *Salomon van Ruysdael, eine Einführung in seine Kunst mit Kritischem Katalog der Gemälde* (rev. ed., Berlin, 1975), p. 106, no. 244A.

In a wooded landscape several children gather around a wooden gate that they have opened to permit a wagon filled with travelers to pass. The heads of the passengers are just visible above the fence on the left. Two children stand on their heads in the hope of earning a handout. The low-angled light streams through the gate, contrasting with the shadows of the tree and a house at the back right.

Some of the essentials of this composition — the passenger-filled cart partially visible on the left and the slanting light streaming down the sandy road — had already been worked out by Salomon van Ruysdael very early in his career (compare, for example, the painting dated 1628 in the Norton Simon Museum, Pasadena; Stechow 1975, no. 233).

However, the present painting, which is one of only three dated 1658 (see also Stechow 1975, nos. 13 and 125), is from the artist's later career and employs the more monumental design and darker palette of that period.

When the painting sold at auction in Paris in 1953, it was entitled *Le Droit de Passage*, and in London in 1984 it was called *A Wooded Landscape with a Toll-gate*. It is unclear whether the children are exacting a toll, but their antics are surely intended to beg a few stivers from the travelers. The charming detail of children standing on their heads for passing coaches had appeared in earlier landscapes by Esaias van de Velde (compare the painting now in the Minneapolis Art Institute).

P.C.S.

131 PLATE 142

THÉODORE VAN RYSSELBERGHE (Belgian, 1862–1926)
La Régate, 1892
Oil on canvas with painted wooden liner, 34 x 42 in. (64.5 x 83.8 cm)
Initialed and dated at bottom right: *18VR92*
Scott M. Black Collection

PROVENANCE: Saenger-Sethe; Mr. and Mrs. Hugo Peris, New York; sale New York, (Christie's), November 10, 1987, lot 25.

EXHIBITION: Ghent, Musée des Beaux-Arts, *Rétrospective Théo van Rysselberghe* (exh. cat.), July–September, 1962, p. 38, no. 58; Portland (Maine) Museum of Art, *Impressionism and Post-Impressionism: The Collector's Passion* (exh. cat.), July–October 1991, no. 50, pp. 87–88.

The Belgian painter Théo van Rysselberghe's landscapes from 1892 through 1894 are considered the best of his work in this genre, and *La Régate* is among the most accomplished paintings from this period.

Born in 1862, van Rysselberghe received a conservative education at the Académie des Beaux-Arts in Ghent and at the Académie des Beaux-Arts in Brussels. He exhibited for the first time at the Salon in Brussels in 1881. Along with Emile Verhaern and Octave Maus, the artist founded Les XX (The Twenty), an avant-garde exhibition society, in Brussels in 1883. Les XX was succeeded by La Libre Esthétique, an organization in which van Rysselberghe was also active. In 1886 he saw Georges Seurat's *Sunday Afternoon on the Island of the Grande Jatte* (1884–1886; Art Institute of Chicago) at the last Impressionist exhibition in Paris. On subsequent visits to Paris the artist befriended the writer and critic Félix Fénéon, a champion of Neo-Impressionism, and became an important link between the literary and artistic circles of Paris and Brussels.

By 1889 van Rysselberghe had adopted a Divisionist technique, and in 1890 he began exhibiting with Paul Signac, Maximilian Luce, and the other French Neo-Impressionists at the Salon des Indépendants. Fundamental to Seurat and the Neo-Impressionists' aesthetics was the belief that the tradi-

tional practice of mixing pigments on the palette resulted in duller colors. Applying unblended pigments directly to the canvas in the form of small dots, the Neo-Impressionists sought to achieve the effects of colored light. The contrast of complementary colors, or opposites on the color wheel, guided the Neo-Impressionists in their deployment of hues, as the juxtaposition of these opposites heightened their vibrancies. The most orthodox application of this principle, however, rarely involved juxtaposing complementary colors dot by dot; rather, the artist generally applied complementary colors in adjacent passages of the canvas. For example, van Rysselberghe used dots of varying hues — from orange-yellow to green — for the coastal rock formation, and the complements of those colors — blue, violet, and purple — for the adjacent sea. Although Neo-Impressionism was derived from the late-nineteenth-century optics and color theory principally formulated by Michel Chevreul, Charles Blanc, and Ogden Rood, the application of this aesthetic was often subjective. Proof of the artists' personal touch lies in the viewer's ready ability to differentiate the styles of various practitioners.

Although clearly reflecting van Rysselberghe's own touch and sensibility, *La Régate* also relates to a series of five paintings entitled *La Mer, les Barques* (*The Sea, the Boats*), which Signac exhibited at the Exposition des XX in Brussels in 1892. In particular, Signac's *Brise, Concarneau* (originally called *Presto*; formerly, collection of Sir Charles Clore; sale London [Sotheby's], December 3, 1985, no. 17) informs van Rysselberghe's variation of this subject. Signac's *Presto* (the artist changed the title to the name of the actual location of the picture a few months later, when it was exhibited in Paris) represents a regatta, a large grouping of boats with their sails diagonally aligned, gliding upon the open sea. Signac joined van Rysselberghe on the Mediterranean coast about mid-March 1892. Although the site of van Rysselberghe's picture is unidentified, he probably executed it about the time of Signac's visit.

La Régate is not a copy of *Presto*, but rather it displays compositional principles found in the early work of Signac, such as a group of sailboats depicted at a repeated diagonal on the open sea. The two paintings differ in several ways. Van Rysselberghe raised the horizon line and included the coastal rock formation as repoussoir. He also painted a Pointillist border around the painting, executing this in dense clusters of dark blue and purple dots. Seurat had pioneered the device of the border as a means of accentuating the luminous vibrancy of the surface of the painting.

R.J.B.

132 PLATE 46

CORNELIS SAFTLEVEN (Dutch, about 1607–1681) and
HERMAN SAFTLEVEN (Dutch, 1609–1685)
Sleeping Hunter in a Landscape, 164(2)
Signed and dated at lower right: *Saft Levens 164[?]*
Oil on panel, 14½ x 20½ in. (36.8 x 52 cm)
Private collection

PROVENANCE: Sale Brussels, December 13, 1774, no. 37; sale The Hague, September 27, 1791, no. 30 (to Coclers); sale London (Christie's), April 25, 1952, no. 83 (as by A. Lievens); collection Walter Chrysler, Provincetown, Massachusetts.

EXHIBITIONS: Saint Petersburg, Museum of Fine Arts; and Atlanta, High Museum of Art, *Dutch Life in the Golden Age* (cat. by Franklin W. Robinson), 1975, no. 10, ill.; Cambridge, Fogg Art Museum, *The Draughtsman at Work: Drawing in the Golden Century of Dutch Art*, 1980–1981; Philadelphia Museum of Art; Berlin, Gemäldegalerie, Staatliche Museen Preussischer Kulturbesitz; and London, Royal Academy of Arts, *Masters of Seventeenth-Century Dutch Genre Painting* (cat. by Peter C. Sutton et al.), 1984, no. 97; Amsterdam, Rijksmuseum; Boston, Museum of Fine Arts; and Philadelphia Museum of Art, *Masters of 17th-Century Dutch Landscape Painting* (cat. by Peter C. Sutton et al.), 1987–1988, no. 96.

LITERATURE: Wolfgang Schulz, *Cornelis Saftleven* (Berlin, 1978), p. 28, no. 646, pl. 29; idem., *Herman Saftleven* (Berlin, 1982), p. 132, no. 28, fig. 10; William W. Robinson, *Seventeenth-Century Dutch Drawings: A Selection from the Maida and George Abrams Collection* (exh. cat., Amsterdam, Rijksmuseum, Rijksprentenkabinet; Vienna, Graphische Sammlung Albertina; New York, Pierpont Morgan Library; and Cambridge, Fogg Art Museum), 1990–1992, p. 158.

Nestled in the shadowed hollow of a hillside beneath the spreading branches of an oak tree, a hunter sleeps, flanked by the trophies of his hunt: a gutted hare and a dead mallard. A greyhound is poised alertly at the hunter's side, and another dog is visible at the crest of the hill. A broad panorama stretches to the right; the minute figures of a mounted hunt can be seen in the bottom corner.

The plural form of the signature, "Saft Levens," confirms that this work is a product of the particularly seamless collaboration between the brothers Cornelis and Herman Saftleven. Herman, primarily a landscape painter and printmaker, executed the landscape; Cornelis, a versatile painter of still lifes, barn interiors, animals, peasant genre scenes, and history paintings, added the foreground figures and still-life elements. The Saftlevens collaborated on at least three other paintings, including a portrait of the Godart van Reede family (1634–1635; Maarsen, Stichting Slot Zuilen) and a *Landscape with Animals* (signed and dated "Saft Levens 1660"; The Netherlands, private collection). Though the last digit of the date in the present painting is not completely legible, Cornelis Saftleven's signed and dated study for the figure of the sleeping hunter (1642; Boston, collection of Maida and George Abrams) provides a secure date for the composition.

Herman Saftleven carefully orchestrated the dramatic silhouette of the dark foreground hillock against the lighter forms of the distant panorama; pentimenti reveal the artist's meticulous adjustments. The composition recalls landscapes by Saftleven's Utrecht colleague Cornelis Poelenburch, who

employed similar coulisses in his works. The strong contrast of light and dark is paralleled by the juxtaposition of the slumped figure of the slumbering hunter and his watchful hound, whose ears prick up at the sound of the distant chase.

M.E.W.

133 PLATE 67

CORNELIS SCHAECK (Dutch, active 1660s)
Peasants in an Interior, n.d.
Oil on panel, 12¾ x 11½ in. (32.5 x 29.2 cm)
Indistinctly signed at upper left: *C Shaak f.*
Private collection

PROVENANCE: Collection Francis Gibson (d. 1859); by descent in the family and exhibited at the Gibson Picture Gallery, Saffron Walden, Essex; sale London (Sotheby's) December 8, 1976, no. 1, ill. (as by Cornelis Bega, signed and dated 1662); Robert Noortman Gallery, London, about 1978–80 (as by Schaeck, signed); collection Ambassador J. William Middendorf II, Washington, D.C.; private collection, New York.

EXHIBITION: Norwich Castle Museum, *Dutch Paintings in East Anglia*, 1966, no. 3 (as fully signed by "C. Schaack," upper left).

Five figures are gathered around a table in a humble interior; a stairway at the right leads to an upper level, where a table and a basket hanging on the wall may be glimpsed through an open door. In the foreground, a man pours liquid into an earthenware cup; two of his companions smoke clay pipes, while a third slumps over the tabletop, fast asleep. At the left, a white-kerchiefed crone possessively cradles her own earthenware jug. Two other figures stand before a fireplace in the left background.

Cornelis Schaeck was one of a family of artists active in Rotterdam and Amsterdam; although there is little specific information about him, the activities of other members of the family are slightly better documented. Andries Jacobsz Schaeck (active 1608–1631) was a painter in Rotterdam; his sons Andries and Jacob were also painters. Andries Andriesz Schaeck (active 1651, died 1689), a painter in Rotterdam and Amsterdam, was termed a *grofschilder* ("rough painter") in a document of 1653. Jacob Andriesz Schaeck was buried in Rotterdam in 1657. Cornelis Schaeck is mentioned in the 1663 estate inventory of the Rotterdam painter Isaac de Colonia as being indebted to the estate for paintings that had been delivered (A. Bredius, *Künstler-Inventare* [The Hague, 1915–1922], vol. 1, p. 165). Finally, there is in the Rijksmuseum, Amsterdam, a *Vanitas Still Life* signed "B Schaak f"; the relationship of this artist (if any) to the abovementioned painters is not known.

The present painting is by the same hand as are three paintings signed "CJ [in ligature] Schaeck": two versions of *Cobbler's Workshop* (Lyon, Musée des Beaux-Arts, inv. H663; and Marseille, collection Rau) and *Kitchen Interior* (sale Frankfurt, June 28, 1938, no. 117). Three other paintings are attributable to the same artist: *Tavern Scene*, which is currently attributed to Andries Andriesz Schaeck (New Orleans, Mu-

seum of Art); *Peasant Interior*, which is signed "Schaeck" (sale Vienna, June 21, 1960, no. 92 [as by Andries Andriesz Schaeck]); and an unsigned *Peasant Interior* (Marseille, private collection). As Schaeck signed at least three of his paintings with the initials "CJ," it is possible that his full name was Cornelis Jacobsz Schaeck, and thus that he was the son of Jacob Andriesz Schaeck.

In style and subject matter, Schaeck's *Peasants in an Interior* is closely related to peasant genre scenes by Dutch followers of Adriaen Brouwer and David Teniers, especially Pieter Duyfhuysen and Hendrick Martensz Sorgh in Rotterdam and Cornelis Bega in Haarlem (1631 or 1632–1664); it is possible that additional works by Schaeck are hidden in the oeuvres of the latter two artists. His work also bears some similarities to workshop interiors by the Leiden painter Quirijn van Brekelenkam.

M.E.W.

134 PLATE 16

FRANCESCO SOLIMENA (Italian, 1657–1747)
The Immaculate Conception, n.d.
Oil on canvas, 39¾ x 30½ in. (101 x 77.5 cm)
Mr. Randolph J. Fuller

PROVENANCE: Heim Gallery, London.

First trained by his father, Angelo Solimena, Francesco in 1674 went to Naples, where he was exposed to the painterly manner of Luca Giordano. In the 1680s Solimena carried out large fresco cycles and altarpieces for churches in Naples and the surrounding region; these works show his early mastery of the effects of golden light and of visionary compositions. This style culminates in the frescoes of San Paolo Maggiore of 1689 and 1690. After Giordano left for Spain in 1692, Solimena's work became darker and heavier, perhaps in response to an interest in the work of Matia Preti. In the early 1700s the artist went for the first time to Rome, and there was able to learn much from the classical manner of painters such as Domenichino, Reni, and Maratta. This Roman influence was evident not only in the artist's style, but also in his subject matter of Arcadian scenes drawn from Greek and Roman mythology. In 1709, in the sacristy of the church of San Domenico Maggiore, Naples, Solimena painted his most important frescoes, *The Triumph of the Domenican Order*, which revealed many of his most influential qualities, especially the spiraling masses of energetic figures with emphatic gestures. Solimena continued to paint well into his eighties despite failing eyesight. He often reverted in later works to his darker, Pretiesque manner, adding some Venetian richness. Solimena's fame and his impact on younger artists were enormous. He maintained a large workshop, where many artists, from Conca to de Mura and Bonito, were trained. There, they produced numerous replicas in the manner of the mas-

ter, who, although he was based in Naples, achieved a truly international reputation.

During the Counter-Reformation, the Immaculate Conception became a frequent theme and was presented as a heavenly vision, with the Virgin of the Apocalypse standing on the crescent moon and crushing underfoot a serpent, the symbol of sin, as she is observed by the Trinity and angels. In this example, which has some of the delicacy associated with de Mura, the subject is presented with celestial radiance. Solimena presented it in a different format in a large *bozzetto* for an unknown cupola (sold London [Sotheby's], December 12, 1990, no. 50).

A smaller version of this same composition, by one of the artist's many followers, has appeared in sales (New York [Parke-Bernet], March 11, 1978, no. 22; and New York [Sotheby's], October 10, 1991, no. 132). That work lacks both the subtlety of modeling and the refined color of the present one, which ranges from deep blue and red around the Virgin to the glowing golden aura of the heavenly figures. Despite its larger size, the Fuller version has a freedom of handling that suggests it was actually a *modello* for a larger painting.

E.M.Z.

135–137 PLATES 13–15

FRANCESCO SOLIMENA (Italian, 1657–1747)
Allegories of Three Continents: Europe, America, and Asia, n.d.
Oil on canvas, each 36 x 28⅜ in. (92 x 72 cm)
Mr. Randolph J. Fuller

PROVENANCE: Private collection, Naples; Heim Gallery, London, by 1973.

EXHIBITION: London, Heim Gallery, *Paintings & Sculpture of the Italian Baroque*, May–September, 1973, nos. 11–13; Cleveland Museum of Art; Washington, D.C., National Gallery of Art; and Paris, Grand Palais, *The European Vision of America*, 1975–1977, no. 128 (*America* only).

According to Bernardo de Dominici (*Vite de Pittori* [Naples, 1742–1744; 1840–1846 ed.], vol. 4, p. 449), in 1738 Solimena received a commission to decorate the *gabinetto* in the Palazzo Reale of Naples with frescoes depicting the four (then known) parts of the world, in celebration of the wedding of Charles III and Maria Amelia of Saxony and Poland. These originals are now lost, but they were copied in engravings by P. J. Gaultier, and Solimena and his workshop seem to have executed a great many replicas of these popular compositions.

A set of all four continents is in the Galleria Doria-Pamphili in Rome, but Ferdinando Bologna (*Francesco Solimena* [Naples, 1958], p. 273) accepted only *Europe* and *Asia* as having been painted by the master, and thought the other two to be by the workshop. Another complete set is in the National Gallery, Warsaw, and a partial set, of *Europe* and *Africa*, from the Earl of Halifax's collection are now in the

City Art Gallery of Leeds. Another complete set was sold in Berlin (Lepke, November 4–5, 1937, nos. 11–14); a partial set, of *Europe* and *America*, from the collection of Edwin Bechstein was exhibited in the Akademie der Kunst, Berlin (July–August, 1925, nos. 360–61), and a complete set in rectangular format which had belonged to Hazlitt Gallery, London, was sold at Christie's (London, April 21, 1989, no. 80).

A number of compositional variations exist among the many versions; most notably, *Europe* in the present set does not have a dove in the center of the sky, and both *America* and *Africa* in the Doria-Pamphili and former Hazlitt series are robed, whereas in all other versions they appear nearly nude.

These three paintings do not have the looseness of preliminary sketches, but rather possess the smooth finish of completed compositions. The rich chiaroscuro effects characterize Solimena's Preti-influenced works of the 1730s. One may admire particular details such as the deep folds of the garments in *Europe* and the voluptuous treatment of the birds in *America*.

The personification of the two older continents as female figures follows fairly closely the traditional arrangement as described in Ripa's *Iconologia* of the early seventeenth century. The crowned figure of *Europe* is seated and points to both a papal tiara and an imperial crown. At her feet are both the spoils of war and objects symbolizing patronage of the arts and sciences. Behind her a classical temple represents the true faith.

Asia, also seated, is crowned with flowers and accompanied by a camel that has born the spices and fragrances she holds aloft in her censer. A nude warrior maiden with feather headdress, *America*, the youngest of the continents, holds arrows with which to slay her foes. Brilliantly colored macaws and a caimen, an alligator-like creature from central America, represent the animal life of this continent.

E.M.Z.

138 PLATE 69

HENDRICK MARTENSZ SORGH (Dutch, 1609 or 1611–1670)
Cardplayers in a Tavern, 1669
Oil on panel, 19¾ x 15¾ in. (50 x 40 cm)
Signed and dated at lower left: *H. M. Sorgh 1669*
Private collection

PROVENANCE: Sale Marquis de Salamanca, Paris, June 3, 1867, no. 104; sale Wasserman, Paris (Gallièra), November 26, 1967, no. 40; sale New York (Sotheby's), January 17, 1985, no. 11.

LITERATURE: Liane Schneeman, "Hendrich Martensz Sorgh, a Painter of Rotterdam, with Catalogue Raisonné" (Ph.D. diss., Pennsylvania State University, 1982), p. 158, no. 33, note 7.

The Rotterdam painter Hendrick Martensz Sorgh was a specialist in peasant interiors and market scenes, the latter in part reflecting his experience as the skipper of a marketing barge.

Arnold Houbraken, the chronicler of artist's lives, reported in 1718 that Sorgh had been a student of the Rotterdam artist Willem Buytewech (1591 or 1592–1624) and also of David Teniers the Younger in Antwerp. The influence of the latter artist, as well as that of Teniers's own mentor, Adriaen Brouwer, is evident in Sorgh's earliest low-life tavern scenes (see, for example, the painting dated 1642, sale London [Robinson and Fischer], April 20, 1939, no. 105). However, in the company of fellow artists Cornelis and Herman Saftleven and Pieter de Bloot, all of Rotterdam, Sorgh developed his own style of low-life art. By the mid 1640s he had developed a more decorous approach to peasant painting; though he retained the vitality of older representations of slap-and-tickle-the-tavern-hostess, he eschewed the coarsest aspects of that tradition (see, for example, the paintings of 1646, Paris, Musée du Louvre, no. M.I.1014; and of 1647, Stockholm, Nationalmuseum, no. NM4320).

Sorgh's earliest dated example of the time-honored theme of card playing is dated 1644 (formerly Hannover, Niedersächsisches Landesmuseum, no. FCG AM398). The subject also appears in a work dated 1657 from the Sackville Collection, Knole Park, Sevenoaks (sale Onians, London, December 5, 1967, no. 92); one signed but undated example is in the Gemäldegalerie, Dresden (no. 1808), and another was formerly with Newhouse Gallery, New York. Several of the figures and their gestures occur both in these works and in the painting under consideration. However, all of Sorgh's other card scenes and, in fact, the majority of his peasant interiors, employ horizontal rather than vertical designs. Earlier, both Brouwer and Teniers had employed the vertical format, though sparingly, in genre scenes, but these usually depicted fewer figures. This format came back into fashion in the Netherlands just before 1660, in part through the efforts of artists such as Gerbrand van den Eeckhout and Jacob van Loo, but usually in guardroom and high-life scenes.

Although the cardplayers in this painting exchange smiling glances and poker faces, they are exceptionally well behaved, even domesticated, by the standards of their brawling ancestors. The knife fights that broke out among card-playing peasants had been the traditional emblem of Wrath (*Ira*) in personifications of the Seven Deadly Sins. As Liane Schneeman (1982, p. 158) observed, Sorgh took up the theme of brawling card players in a painting in Berlin-Dahlem (Gemäldegalerie, cat. 1986, no. 967A, fig. 852), which contrasts thematically with the present work.

P.C.S.

139 PLATE 146

JOAQUÍN SOROLLA Y BASTIDA (Spanish, 1863–1923)
Elena on the Beach of Biarritz (Low Tide), 1906
Oil on canvas, 69 x 56 in. (175.2 x 142.2 cm)
Signed and dated at lower left: *J. Sorolla y Bastida / Bia[rritz] 1906*
Private collection

PROVENANCE: Peter Chardon Brooks, by 1909; Mrs. Richard M. Saltonstall.

EXHIBITIONS: Berlin, Schulte Galleries, *Sorolla*, 1907; London, Grafton Galleries, *Sorolla*, 1908; New York, Hispanic Society of America; Buffalo Fine Arts Academy; and Copley Society of Boston, *Paintings by Joaquín Sorolla y Bastida*, 1909, no. 65.

LITERATURE: Hispanic Society of America, *Eight Essays on Sorolla* (New York, 1909), vol. 1, p. 313, pl. 95; vol. 2, p. 402, no. 95; Bernardino de Pantorba, *La vida y la obra de Joaquín Sorolla* (Madrid, 1953), p. 184, no. 1597.

Born and trained in Valencia, Sorolla had his first success in 1884, when *May 2*, which he painted in the open at a bullring, won the second prize at the Spanish National Exhibition. This allowed him to travel to Rome and Paris, thus expanding his artistic horizons. Settling in Madrid, he first achieved fame as a painter of society portraits and realistic social themes. With his reputation thus established, Sorolla was able to develop a more personal style, especially in his many beach scenes of children and boats.

The broad Impressionistic manner of these works found a receptive international audience, beginning with a large one-man exhibition in Paris in 1906. At a showing of his work in London in 1908, Sorolla met Archer M. Huntington, the founder of the Hispanic Society of America, who commissioned him to paint for its library in New York an enormous decorative cycle, *The Vision of Spain*, showing the diverse regional peoples of Spain and Portugal. Sorolla finished this in 1919, and it was installed in 1925. In the interim he had visited America twice, first in 1909, for his highly successful exhibition in New York, Buffalo, and Boston (during this trip he painted a portrait of President Taft), and again in 1910, for an exhibition in Chicago and Saint Louis.

The sea, which Sorolla had known since childhood, was his favorite theme, and he delighted in employing his fluid manner to capture its vitality and the brilliant contrasts of light and shadow along the shore. Against this backdrop the artist often set members of his family, especially his three children, María, Joaquín, and Elena. The family spent time at the beaches of Biarritz and Valencia in the early 1900s, and many paintings of these outings were included in Sorolla's American exhibition of 1909. This large painting is one of four, including the lovely *Lighthouse Walk at Biarritz* (also 1906; Boston, Museum of Fine Arts), that were bought at that time by the perceptive Bostonian collector Peter Chardon Brooks.

The success in America of Sorolla's beach scenes may have had something to do with the warmth they conveyed, for as the artist wrote to a Spanish friend about the show of 1909: "New York had had a terrible winter, snowy and weeks without any sun; its people were anxious for the sun; I brought it and they sought it" (quoted in Priscilla Muller, "Sorolla and America," in Edmund Peel, *The Painter Joaquín Sorolla y Bastida* [San Diego, 1989], p. 61). In this example he brilliantly captured not only the slickness of the sparkling beach, but also the innocent pleasures of childhood.

E.M.Z.

140 PLATE 58

JAN STEEN (Dutch, 1625 or 1626–1679)
Cardplayers, about 1667–1671
Oil on canvas, 16⅛ x 14⅛ in. (41 x 36 cm)
Signed at lower left
Private collection

PROVENANCE: Sale Donaldson et al., London, July 6, 1901, no. 90; Duke of Shrewsbury; Botfield Collection, which in the 1950s was inherited by Lord Bath; Marquis of Bath, Longleat House, Warminster; Galerie Sanct Lucas, Vienna (which illustrated the painting in an undated flyer for the art fair in Maastricht); acquired from dealer Robert Noortman, London.

LITERATURE: C. Hofstede de Groot, *A Catalogue Raisonné of the Works of the Most Eminent Dutch Painters of the Seventeenth Century*, trans. by Edward G. Hawke (London, 1908–1927), vol. 1, no. 734a; Karel Braun, *Alle tot nu toe bekende schilderijen van Jan Steen* (Rotterdam, 1980), p. 118, no. 228, ill. p. 119.

An elegantly dressed man and a woman seated at a round table play cards. Between them a man smoking a long pipe observes the game, and at the right a second woman, standing over the female cardplayer, seems to advise her on her hand. A serving man brings a platter of food through the open door at the back left. On the table are a white ceramic wine jug, a brazier of coals, and a tobacco tin, as well as playing cards. At the back right is a covered bed, and a lute and a painting hang on the wall. On the floor are the shards of a broken pipe, a footwarmer, and discarded oyster shells, one of which attracts a spaniel. A slate with chalk marks and a piece of chalk on the chair in the right foreground suggest that the scene probably takes place in an upper-class tavern or bordello.

Steen repeatedly represented taverns with figures playing cards, tric-trac, or other games. Card playing was exceptionally popular in the Netherlands in that period. Bredero's farces and other theatrical performances refer to all sorts of card games. When Steen depicted peasants or other low-life comical types playing cards, the game as often as not ended in a brawl (see Berlin-Dahlem, Gemäldegalerie, Staatliche Museen Preussischer Kulturbesitz, no. 795B) — a theme ultimately descended from moralizing sixteenth-century depictions of *Ira* (Anger) in representations of the Seven Deadly Sins. However, when men and women were shown playing

cards together, the subject could also prompt moralizing on gaming as an idle or seductive pursuit. Calvinist predicants, such as Henricus de Frein of Middleburg, fulminated about "young girls, gotten up like worldly dolls" who were seduced by young men using the game as an opportunity "to wander in the paths of their hearts and [to catch] the glance of their eyes, to kindle foul lusts, never thinking . . . that they will come before the Last Judgment." Card playing between the sexes had been depicted in some of the earliest genre paintings by Lucas van Leyden, and naturally was associated with the game of love. Here, despite the oyster shells in the foreground and the bed behind, there is little in the two players' relationship to suggest an amorous resolution. However, Steen did depict gaming between the sexes in other, similar scenes suggestive of high-class brothels (compare, for example, *Tric-Trac Players*, dated 1667; Saint Petersburg, Hermitage).

In the only published attempt to date the present work, Karel Braun (1980, p. 118) suggested sometime between 1664 and 1668. The breadth of Steen's application of paint (compare the broadly painted *Brawling Cardplayers* dated 1671; Arnhem, Gemeentemuseum) and the resemblance in design to the painting of 1667 in the Hermitage suggest a somewhat later date of about 1667 to 1671.

P.C.S.

141 PLATE 39

JAN STEEN (Dutch, 1625 or 1626–1679)
Village Fair with a Pamphleteer, n.d.
Oil on oval panel, 23¼ x 29¼ in. (59 x 74.5 cm)
Signed at lower center: *JSteen* (J and S ligated)
Private collection

PROVENANCE: Sir Thomas Beauchamp-Proctor, Bt. (1756–1827; who formed his collection with the advice of the artist Henry Walton), Langley Hall, by 1815; by descent to Sir Ivor Beauchamp, Bt.; dealer Harari and Johns, London, 1985; sale New York (Sotheby's), January 14, 1988, no. 120, ill. (bought in); with Otto Naumann, Ltd., New York.

EXHIBITIONS: Norwich Castle Museum, *Dutch Paintings from East Anglia*, 1966, no. 43, ill. pl. 1 (lent by Sir Ivor Beauchamp); Maastricht, Pictura, March 1985.

LITERATURE: "Pictures and Sculptures at Langley Hall" (ms. cat., Norfolk, 1815; as by Adriaen van Ostade); J. P. Neale, *Views of the Seats of Noblemen and Gentlemen in England, Wales, Scotland and Ireland* (London, 1820), vol. 3 (as by Ostade); John Chambers, *A General History of the County of Norfolk* (Norwich, 1829), vol. 2, p. 846.

A colorful crowd gathers in a village to listen to the cries and blandishments of peddlers selling what may be pamphlets, broadsheets, or *corantos* — the predecessors of newspapers. News, as well as scandalous political criticism, was often circulated by these criers, who sometimes also peddled song sheets. Jan Both (working from a painting by his brother Andries), Jan van Vliet (see Alfred von Wurzbach, *Niederländisches Kunstler-lexikon*, vol. 2 [Vienna and Leipzig, 1910], no.

15), and Leonaert Bramer had executed earlier depictions of broadsheet peddlers in prints and drawings. Like the pancake baker at the lower left, peddlers were part of the common stock of characters in low-life genre paintings. The crowd includes an elegant couple — a dandy and his lady friend (the commonest and most credulous victims of hustlers and cutpurses in such scenes) — as well as brawling urchins. In the distance, beyond a stream where revelers arrive by boat for the fair, are other tents and booths as well as an old country villa (*hofstede*) with round stone tower and pennant.

When at Langley Hall in the nineteenth century, the painting was mistakenly attributed to Adriaen van Ostade. Early in his career, Steen, who had been a pupil of Jan van Goyen as well as of van Ostade, often depicted landscapes with country fairs, livestock markets, rural inns, and roadside taverns, subjects that also occur in van Ostade's works. As often as not, Steen populated these landscapes with his favorite comic characters: mountebanks, gypsies, street swindlers, theatrical figures, and roving bands of *rederijkers* (rhetoricians) on grossly drunken outings (compare, for example, Karel Braun, *Alle tot nu toe bekende schilderijen van Jan Steen* [Rotterdam, 1980], nos. 75–76).

P.C.S.

142 PLATE 60
FOLLOWER OF JAN STEEN (Dutch, late 17th century)
Market Scene with an Old Woman Selling Vegetables, n.d.
Oil on panel, 29 x 23½ in. (71.6 x 59.6 cm)
Initialed at lower left: *I.S.*
Private collection

PROVENANCE: Jacob van Reygersberg, Heer van Cauwerven (or Couwerwen), Middelburg, by 1752 (see Hoet 1752, in lit.); sale Leiden, July 31, 1765, no. 50 (for Fl 115); sale M. de Montribloud, Paris, February 9–12, 1784, no. 41 (wrongly as on canvas; for Fr 570, to Herrier); sale Jan Gildemeester Jansz of Amsterdam (Agent and Consul General of Portugal; d. 1799), Amsterdam, June 11–13, 1800, no. 202 (for Fr 575, to Wijnands); dealer Henri de Ruiter, Vienna, about 1934; Galerie Sanct Lucas, Vienna, 1936; acquired by the family of the present owners in 1936.

EXHIBITION: Hempstead, New York, Hofstra University Museum, *People at Work: Seventeenth-century Dutch Art*, April 17–June 15, 1988, no. 17.

LITERATURE: G. Hoet, *Catalogue of naamlyst van schilderijen*, vol. 2 (The Hague, 1752), p. 538; P. Terwesten (supplement to Hoet 1752; The Hague, 1770) vol. 3, p. 483; J. B. Descamps, *La vie des peintres flamands, allemands et hollandais*, 4 vols. (Paris, 1753–1764), vol. 3 (1760), p. 31; John Smith, *A Catalogue Raisonné*, vol. 4 (London, 1833), nos. 42 and 61; Tobias van Westrheene, *Jan Steen* (The Hague, 1856), p. 158, nos. 349 and 350; C. Hofstede de Groot, *A Catalogue Raisonné of the Works of the Most Eminent Dutch Painters of the Seventeenth Century*, trans. by Edward G. Hawke (London, 1908–1927), vol. 1 (1908), no. 261; E. Trautscholdt, in U. Thieme & E. Becker, *Allegemeines Lexikon der Bildenden Künstler*, vol. 31 (Leipzig, 1937), p. 511; Claus Virch, *Catalogue of the Collection of Charles and Edith Neumann de Végvar* (unpublished), n.p.; Karel Braun, *Alle tot nu toe bekende schilderijen van Jan Steen* (Rotterdam, 1980), p. 166, no. B-63; Linda Stone-Ferrier, "Gabriel Metsu's *Vegetable Market at Amsterdam*: Seventeenth-century Dutch Market Paintings and Horticulture," *Art Bulletin* 71 (September 1989), p. 430, fig. 3.

With reason, this painting has been repeatedly praised for its quality by, among others, G. Hoet in 1752 ("a capital work"), the author of the catalogue for the de Montribloud sale in 1784 ("peut aller avec les meilleurs choses de cette école"), and Hofstede de Groot in 1907 ("a masterpiece, both in composition and execution, and . . . equal to a G. Metsu"). However, at the Rijksbureau voor Kunsthistorische Documentatie in The Hague, Horst Gerson qualified the attribution on the photo mount as "trant [manner of] Jan Steen," which led Karel Braun to reject the painting in his catalogue raisonné (1980, no. B-63). Lyckle de Vries, the authority on Jan Steen at Groningen University, initially was inclined to accept this painting as a masterpiece from Steen's Warmond period (late 1650s), but upon reflection also came to doubt the picture, suggesting that it might even be "a work from the early 18th century" (letter, December 16, 1985).

Clearly, the painting is by a strong admirer of Steen (compare, for example, the paintings of poultry vendors: one known as *Cock Fight*, Hofstede de Groot 1908, no. 746; Braun 1980, no. 105; Hofstede de Groot 1908, no. 256; Braun 1980, no. A-146; and the painting that was with Lord Mottistone, Mottistone Manor, 1938). Another Leiden painter, Quirijn van Brekelenkam, painted similar depictions of fruit- and greengrocers, including examples in the Gemäldegalerie, Staatliche Museen Preussischer Kulturbesitz, Berlin-Dahlem (no. 796A, dated 1661); in the Detroit Institute of Arts (no. 89.32, dated 1665); and in the Suermondt Museum, Aachen. This author believes that a seventeenth-century artist, which is to say a virtual contemporary of Steen, painted the present picture. Other marketing scenes with vegetable stands have also been wrongly attributed to Steen (see sale New York [Sotheby's], January 15, 1987, no. 42; Hofstede de Groot 1908, nos. 862 and 264; Braun 1980, no. B-64), but are probably by a different hand than that of the present work. Steen's follower Richard Brackenburgh also addressed this subject but did not paint this particular picture. A copy of the present painting is in Wiszowitz Castle, Czechoslovakia (dimensions unknown; as "H. Govaerts").

The subject of marketing and greengrocer scenes descended from sixteenth-century Flemish genre and still-life paintings by Pieter Aertsen and Joachim Beuckelaer, and was popularized in the Netherlands by Sybrant van Beest and Hendrick Sorgh. Metsu's lovely *Vegetable Market in Amsterdam* (Paris, Musée du Louvre, inv. 1460) is a high point in this tradition and probably was the inspiration for Hofstede de Groot's comment quoted above. Linda Stone-Ferrier (1989) has discussed the relationship of this theme to the history of Dutch horticulture and literature.

P.C.S.

143 PLATE 90

GIOVANNI DOMENICO TIEPOLO (Italian, 1727–1804)
Old Man with a Gilt Buckle, n.d.
Oil on canvas, 24½ x 20½ in. (62.2 x 52.1 cm)
Private collection

PROVENANCE: Giancarlo Baroni, Florence, until 1983.

The eldest surviving son of Giovanni Battista (Giambattista) Tiepolo (1696–1770), Domenico proved both a valued assistant and a talented artist in his own right. Precocious like his father, he was patronized at the age of sixteen by Francesco Algarotti, and by the age of twenty had been commissioned to paint *The Stations of the Cross* for the Oratory of the Crucifixion at San Polo in Venice. In addition to accepting independent commissions when time allowed, Domenico continued until his father's death to assist in Giambattista's renowned decorative and religious cycles in Venice, Würzburg, and Madrid.

Although Domenico was fully competent in the grand idiom of his father, the younger artist's gifts emerged most fully in the treatment of less-elevated subjects. His sharp sense of observation captured all that was ironic and bizarre in the mundane world around him. Domenico excelled in genre scenes — his *Punchinello* drawings combine a nervous, expressive handling with a wit rarely glimpsed in the more rarefied realms depicted by Giambattista. In oil paintings, Domenico's style stressed surface over volume; his paint surfaces are distinguished by their energetic handling and luscious, painterly effect.

The present canvas belongs to a large and complex group generally known as the "Philosopher Portraits," whose creation involved all three of the Tiepolos — Giambattista and his sons Domenico and Lorenzo. The project must have had its genesis in an undocumented commission to the elder Tiepolo for twenty or more idealized heads of old men. These were probably intended as philosopher portraits in the established seventeenth-century tradition, a well-known example being Jusepe de Ribera's series of wise men for the Duke of Alcala. Giambattista's series was etched by Domenico between 1757 and 1758, and was collected in book form as the *Raccolta di Teste*. Four subsequent painted versions of the series exist, one by Domenico and three by Lorenzo, all after either the etchings or Giambattista's originals. Although the theme of philosophers had never previously been popular in Venice, the Tiepolos apparently found a strong market for these images in Italy and also perhaps in Spain, where the Tiepolos traveled in 1762 and where several of these portraits have come to light.

Old Man with a Gilt Buckle was not known to George Knox when he catalogued the Tiepolos' "Philosopher Portraits" in 1975 (*Burlington Magazine* [March 1975], pp. 147–55). Nevertheless, the fresh, impressionistic handling clearly identifies this as a work by Domenico. The works in his painted series follow his etchings, and thus are reversed from the corresponding originals by Giambattista. Furthermore, they tend to enlarge the scale of the face and to omit certain details and attributes. In the present example, which follows number 19 in the *Raccolta di Teste*, the old man's sleeve and hand have been omitted from the lower part of the canvas. The handling is characteristically loose and sparkling, especially in the hair, beard, and buckle. This liveliness of execution is echoed in the glint of the old man's eyes, and shows to advantage Domenico's talent for portraiture.

P.S.

144 PLATE 120

HENRI RAYMOND DE TOULOUSE-LAUTREC-MONFA (French, 1864–1901)
Old Man with a Beard, 1882
Oil on canvas, 21⅝ x 18⅛ in. (54.9 x 46 cm)
Stamped with monogram at lower left: *HTL*
Private collection

PROVENANCE: M. M. d'Anselme; Sam Salz, New York; Mr. and Mrs. Nate B. Spingold, New York; given to the Rose Art Museum, Brandeis University, Waltham, Massachusetts, 1979; deaccessioned in 1991; sale New York (Christie's), November 5, 1991, no. 37.

EXHIBITIONS: Paris, Galerie Durand-Ruel, *Toulouse-Lautrec*, 1902; Paris, Galerie Manzi-Joyant, *Toulouse-Lautrec, Rétrospective*, June–July 1914, no. 165; New York, Museum of Modern Art, *Toulouse-Lautrec*, 1956, no. 1, ill.; Los Angeles, Municipal Art Gallery, *Henri Toulouse-Lautrec*, May–June 1959, no. 2, ill.; New York, Wildenstein and Co., *Toulouse-Lautrec*, February–March 1964, no. 5, ill.; New York, Metropolitan Museum of Art, Summer Loan Exhibitions, 1960, 1963, 1965, 1966, 1967, and 1968; Clinton, New York, Emerson Art Gallery, Hamilton College, *Art from the Ivory Tower: Selections from College and University Collections*, April–May 1983.

LITERATURE: Maurice Joyant, *Henri de Toulouse-Lautrec (1864–1901)* (Paris, 1926), p. 256; A. Astre, *Henri de Toulouse-Lautrec* (Paris, 1938), p. 68; M. G. Dortu, *Toulouse-Lautrec et son oeuvre* (New York, 1971), vol. 2, p. 68, no. 151, ill.; M. G. Dortu and J. A. Méric, *Die grossen Meister der Malerei; Toulouse-Lautrec*, vol. 1 (Berlin, 1979), p. 42, no. 125, ill.; G. M. Sugana, *Tout l'oeuvre peint de Toulouse-Lautrec* (Paris, 1986), p. 105, no. 207, ill.

Born into a wealthy family that was descended from an ancient line of French nobility, Henri de Toulouse-Lautrec was spared the financial struggles common to many artists of his generation. He spent a pleasant childhood at Albi and at the family's various country estates, including the châteaus at Céleyran and Malromé, and made frequent visits to Paris and Nice. Two childhood broken legs left Toulouse-Lautrec a dwarf, and his family raised no objection to his decision to pursue art as a vocation, a choice consistent with his earliest inclinations.

He was apprenticed at the age of fourteen to René Princeteau, a well-known painter and family friend who specialized in pictures of horses and dogs. The majority of Toulouse-Lautrec's subjects of this early period was in the same vein: horses and carriages, men on horses, and dogs. A more self-initiated interest, and one that would ultimately

prove more enduring, was portrait painting. Among family members, servants, and estate workers, the artist found no shortage of models. Evident in these early studies are the penetrating characterizations that were his forte and that in his later work would border on caricature.

The present canvas was painted in 1882, when the Toulouse-Lautrec was seventeen years old. Later that year, he entered the studio of Léon Bonnat, the esteemed portraitist of the Third Republic; in this studio the artist would receive his first disciplined training. *Old Man with a Beard* most likely represents one of the vineyard workers at the family estate in Céleyran. Dating from 1882, a related group of portraits of estate workers is in the Musée Toulouse-Lautrec, Albi.

For *Old Man with a Beard*, he chose a shallow, frontal, half-length composition, as he had for the portrait of his mother (1881; Albi, Musée Toulouse-Lautrec). In the present case, however, the coloring is more somber. The artist also broke with his usual practice of placing sitters in a garden setting. This haggard-looking old man is dressed in a drab brown coat and set against an interior wall that is loosely brushed in earth tones; all attention has instead been focused on the sitter's face. Sharply observed and carefully rendered in thinly applied paint, the man's physiognomy epitomizes the weariness of his position. The skin on the right side of his face stretches as he rests his head against his left hand. In its truthfulness and absence of idealization, the present portrait presages Toulouse-Lautrec's later achievements as the insightful and exuberant recorder of Parisian nightlife in all its aspects.

P.S.

145 PLATE 85

GASPARE TRAVERSI (Italian, about 1722–1769)
Old Woman and Children (An Allegory of the Sense of Smell), n.d.
Oil on canvas, 38⅞ x 28⅞ in. (98.8 x 73.5 cm)
Private collection

PROVENANCE: De Castro, Rome.

Traversi began his career as a religious painter in Naples. His earliest dated works (1748–1749) reveal the influence of both de Mura and Solimena. By the early 1750s the artist was in Rome, where he seems to have remained until his death. Although continuing to paint religious subjects and some portraits, Traversi gained his distinction primarily as a genre painter. His many depictions of elegant musical parties and rough peasant scenes display a crude humor and a vigorous rendering verging on caricature. Although Traversi's works often provided examples of moral virtue and impropriety, their rowdy Neapolitan character may have had its roots in the theater.

None of Traversi's genre paintings are dated, but Ro-berto Longhi placed them around the mid-eighteenth century, based on comparison with his dated religious works. First (orally) attributed to Traversi by Briganti, this example has elements found in a number of other works. The old woman with the wrinkled face was one of the artist's stock types and also appears, for example, as a fortune-teller in a work in the San Francisco Art Museums (F. Bologna, *Gaspare Traversi nell'illuminismo europeo* [Naples, 1980], fig. 33).

This most unusual and earthy of Traversi's compositions accords well with what had in northern European art become an established depiction of one of the five senses. As Peter Sutton has pointed out in conversation, the motif of an old woman wiping a baby's bottom appears as a representation of the sense of smell in a set of paintings of the senses by Jan Miense Molenaer (1637; The Hague, Mauritshuis; see Seymour Slive, *Frans Hals* [London, 1970–1974], vol. 1, fig. 56). The same meaning may be attached to a work by the Spanish painter Murillo (Fort Worth, Kimbell Art Museum) in which a young child, resting on the lap of an old woman, wears ripped pants that expose his behind. Other elements in this work, such as the eyeglasses of the old woman, would also then logically relate to the other senses.

Attempting to reconstruct a series of the senses from among Traversi's works is problematic, although many of his works do lend themselves to such interpretation. The only one of similar proportions that immediately presents itself is *The Music Lesson* (London, private collection; Bologna 1980, fig. 14), in which an old woman plays the spinet and looks out at the viewer, thus conceivably offering an allegory of the sense of hearing. Portraying a similar old woman holding a tambourine and a child holding a bell is a horizontal picture that may also represent the sense of hearing (Milan, Brera; Bologna 1980, fig. 57a). Even *The Fortune-teller* in San Francisco and its mate, *A Merry Company* (Bologna 1980, fig. 12), have many of the elements of the senses. In the former the sense of touch is evident not only in the palm reading but also in the removal of the purse, and in the latter a raised wine glass may represent the sense of taste, and a pipe, smell. Both works also have leering figures that may indicate the sense of sight. Another pair of Traversi's works — *Youth Playing a Lute* and *Youth Holding a Glass of Wine* (Pinacoteca Matera; Bologna 1980, figs. 10 and 11) — could be interpreted equally well as the senses of hearing and taste. Although it is not possible to reconstruct from among Traversi's surviving works a coherent group of paintings depicting the five senses, it is evident that he was absorbed by the motifs. He may well have known prints after works such as those by Molenaer, in which the excessive buffoonery and vulgar actions of peasants, originally rendered as moralizing images, had become purely comic scenes to be adapted as the artist desired.

E.M.Z.

146 PLATE 51

ADRIAEN VAN DE VELDE (Dutch, 1636–1672)

Pastoral Landscape with Herdsmen, 1663

Signed and dated at lower right: *1663*

Oil on canvas, 14½ x 16½ in. (36 x 42 cm)

Private collection

PROVENANCE: Koucheleff-Besborodko Collection, cat. 1886, no. 12; Pushkin Museum, Moscow, inv. no. 589, until at least 1957; sale Marquis R. de Larrain et al., March 22, 1984, no. 49, ill.; with Johnny van Haeften, London, 1985; sale Patino et al., New York (Sotheby's), January 15, 1987, no. 41 (as signed and dated 1661[?]).

EXHIBITION: Maastricht, Pictura, 1985 (exhibited by J. van Haeften).

LITERATURE: Koucheleff-Besborodko Collection, cat. 1886, no. 12; C. Hofstede de Groot, *A Catalogue Raisonné of the Works of the Most Eminent Dutch Painters of the Seventeenth Century*, trans. by Edward G. Hawke (London, 1908–1927), vol. 4 (1912), no. 229; Pushkin Museum (Moscow, cat. 1957), p. 25, no. 589; Johnny van Haeften, *Dutch and Flemish Old Master Paintings* (London, n.d. [1984?]), no. 33, ill.

Adriaen van de Velde came from a distinguished family of painters in Amsterdam; his father (1611–1693) and his brother (1633–1707), both called Willem van de Velde, were accomplished marine painters. According to Arnold Houbraken (*De Groote Schouburgh*, vol. 3 [Amsterdam, 1721], p. 90), Adriaen was taught first by his father, then by Jan Wijnants (1631 or 1632–1684), who specialized in dunescapes. Adriaen began dating paintings in 1653. Although he is often assumed to have traveled to Italy, there is no proof of such a journey, and he may have become familiar with the Italianate landscape motifs that he favored through the works of other northern artists.

This hilly bucolic scene of a herdsman with livestock well illustrates van de Velde's mature Italianate manner. Although the last digit of the date is obscure, it was read as 1663 when the painting was in the Pushkin Museum in Moscow, and that reading has been supported by comparisons with other works dated in this year (compare, for example, the similarly conceived pictures in the Museum of Fine Arts, Boston [acc. no. 50.864; probably Hofstede de Groot 1912, no. 12], and in the Mauritshuis, The Hague [Hofstede de Groot 1912, no. 140], as well as the more grandly conceived painting in the Thyssen-Bornemisza Collection, Lugano [no. 1978.56; cat. 1989, no. 106], all of 1663).

Among the landscape artists who most influenced van de Velde were Nicolaes Berchem, Karel du Jardin, and, above all, Paulus Potter; the last's *Hilly Landscape with Herdsmen* (dated 1651; Amsterdam, Rijksmuseum, inv. A318) offers many points of comparison with the present work and attests to the ultimate origins of these bucolic themes in the prints of Pieter van Laer. As William Robinson showed (see "Preparatory Drawings by Adriaen van de Velde," *Master Drawings* 17 [1979], pp. 3–23), Adriaen van de Velde's working method involved an extensive use of preparatory drawings, some of which the artist reused; this undoubtedly explains the appearance, in virtually the same poses, of several

of the animals in this scene and in others. Just when the painting was deaccessioned by the Pushkin Museum has not been pinpointed, but it appeared in the catalogues of the museum as late as 1957.

P.C.S.

147 PLATE 28

ESAIAS VAN DE VELDE (Dutch, 1587–1630)

Winter Landscape, about 1614–1615

Oil on panel, 10⅜ x 18⅛ in. (26.5 x 46 cm)

Signed at bottom right: *E. VEL DE*

Private collection

PROVENANCE: Collection Van Es, Wassenaer; dealer P. de Boer, Amsterdam, 1954; collection J. G. Schlingemann, The Hague; private collection, United States; Galerie Hoogsteder, The Hague; private collection, England; Galerie Hoogsteder, The Hague.

EXHIBITIONS: Rotterdamsche Kunstkring, *Collectie C. V. Kunsthandel P. de Boer, Amsterdam*, 1954; Breda, Cultureel Centrum "de Bayerd"; and Ghent, Musée des Beaux-Arts, *Het Landschap in de Nederlanden 1550–1630. Van Pieter Breugel tot Rubens en Hercules Seghers* (cat. by Horst Gerson), 1960–1961, no. 70; Amsterdam, Douwes Fine Art, *Esaias van de Velde, schilder: 1590/91–1630; Jan van Goyen, tekenaar: 1596–1656*, 1981, p. 5, ill.; Zouz (Graubünden), *"Holland im Engadin." Sechzig niederländische Gemälde des 17. Jahrhunderts*, 1986, no. 52, ill.; The Hague, Galerie Hoogsteder, *The Hoogsteder Exhibition of Dutch Landscapes* (cat. by Paul Huys Jansen), 1991, p. 124, no. 39.

LITERATURE: George S. Keyes, *Esaias van den Velde 1587–1630* (Doornspijk, 1984), p. 140, cat. 78, pl. 10 and color pl. iv.

A frozen country road curves gently through the center of the composition. A series of windmills and other wooden structures stand to the right of the road; to the left is a level expanse of ice dotted with skaters. Before the frozen *slot* (ditch) in the left foreground is a wooden outhouse. A warmly dressed couple walk along the road at center, and just to the right is a horse hitched to an empty sledge. In the distance are a horse-drawn cart and several other travelers. The wispy overcast sky suggests the changeable weather patterns of this coastal region. The three windmills were undoubtedly erected to pump water from reclaimed polder; with the onset of frigid weather their activity ceased, and the flooded fields became a frozen playground.

The present painting is one of Esaias van de Velde's earliest winter scenes, and indeed, is among the earliest landscapes executed during his years in Haarlem (1609–1618). It is analogous in composition and execution to winter scenes dated 1614 in Cambridge (Fitzwilliam Museum, inv. M 79; Keyes 1984, no. 71) and Raleigh (North Carolina Museum of Art, inv. 52.9.91; Keyes 1984, no. 89). Despite superficial similarities of this work with contemporary winter scenes by Hendrick Avercamp and others (which employ the traditional Flemish-styled, all-inclusive "bird's-eye" view), van de Velde here employed a lower, more naturalistic, vantage point. His palette tended toward steely gray and delicate amber, rather than the pastel hues favored by Avercamp. Fi-

nally, van de Velde generally restricted the number of figures in his compositions, and, as Keyes noted (1984, p. 49), they remain oblivious to and therefore distanced from the viewer, thus eschewing the anecdotal quality of Avercamp's busy tableaux of *ijsvermaak* (recreation on the ice). Van de Velde's simple, intimate, and realistic approach led to the development of a more naturalistic conception of Dutch landscape, which culminated in the "tonalist" landscapes of the late 1620s and 1630s by artists such as van de Velde's Haarlem colleagues Pieter Molijn, Jan van Goyen, and Salomon van Ruysdael (see cats. 90, 64, and 128).

M.E.W.

148 PLATE 29
ESAIAS VAN DE VELDE (Dutch, 1587–1630)
Winter Landscape, about 1617–1618
Oil on panel, 9 x 13 in. (22.9 x 33 cm)
Private collection

A frozen waterway occupies the center of the scene, its flow interrupted by two earthen barriers with sluice gates. In the foreground are several skaters; just left of center a man sits on the bank so he can adjust his skate. Several boats, from small dinghies to larger masted fishing vessels, are immobilized in the ice. A plume of smoke emanates from the chimney of the half-timbered building on the left bank; several other structures, including a windmill, also line the bank. At the far left, a couple hurries past a large, bare tree, their hands buried in their clothing for warmth. On the horizon are more farm buildings and a covered haystack. The two sluice gates, in conjunction with the windmill at left, probably functioned as a system of locks leading to the broader expanse of water in the distance.

The costumes of the figures and the style of this previously unpublished painting indicate a date of 1617 or 1618, just prior to van de Velde's move from Haarlem to The Hague (according to verbal communication with George S. Keyes). Within the artist's painted oeuvre, the present work relates most closely to the circular *Tower by a Frozen River* (Leiden, Stedelijk Museum "de Lakenhal"), which Keyes dates to about 1618 or 1619 (*Esaias van den Velde 1587–1630* [Doornspijk, 1984], cat. 81). Both were executed with a painterly touch accented with a smattering of thickly painted white highlights, and include a high cloud bank below a horizontal expanse of sky, a pictorial device encountered frequently in van de Velde's works from the years 1618 through 1624. Even closer parallels exist between *Winter Landscape* and the artist's drawing *Farms and a Dovecote by a Frozen Stream* (Berlin-Dahlem, Staatliche Museen Preussischer Kulturbesitz, Kupferstichkabinett, no. 3846; Keyes 1984, no. D 69), which Keyes also dates to about 1617 or 1618. Motifs such as the group of three figures in the foreground, as well as the pole-carrying skater to the right of the painting, are

also recognizable in the drawing. Moreover, individual components of the present painting, such as the bare trees and the masts and rigging of the boats, reinforce its strong linear and graphic qualities. During his Haarlem period (particularly after 1615), van de Velde devoted much of his energy to the production of landscape drawings and etchings distinguished by sharp observation and varied character of line; his facility in these less formal media contributes to the charming realism of *Winter Landscape*.

M.E.W.

149 PLATE 30
ESAIAS VAN DE VELDE (Dutch, 1587–1630)
Riders Resting on a Wooded Road, 1619
Oil on panel, 15 x 19⅝ in. (38 x 50 cm)
Signed and dated on a branch at lower left: *E V VELDE 1619*
Private collection

PROVENANCE: Sale A. Grossmann, Munich (Helbing), October 30, 1902, no. 150, ill.; collection Albrecht Grossmann, Brambach; sale A. Grossmann, Munich (Helbing), May 12, 1910, no. 72, ill.; collection Duschnitz, Vienna; dealer Colnaghi, London; dealer Heide Hübner, Würzburg (about 1986).

EXHIBITION: Amsterdam, Rijksmuseum; Boston, Museum of Fine Arts; and Philadelphia Museum of Art, *Masters of 17th-Century Dutch Landscape Painting* (cat. by Peter C. Sutton et al.), 1987–1988, no. 105.

LITERATURE: George S. Keyes, *Esaias van den Velde 1587–1630* (Doornspijk, 1984), pp. 161 and 266, no. 156, pl. 84; Jan Briels, *Vlaamse Schilders in de Noordelijke Nederlanden in het begin van de Gouden Eeuw 1585–1630* (Haarlem, 1987), pp. 321 and 324, ill. (with dealer Heide Hübner).

A group of mounted soldiers have paused to rest by a bend in a road. In the foreground, two foot soldiers relax by the roadside, while nearby two riders have drawn up to converse, and a third rider's horse relieves himself. Continuing around the bend in the road, which skirts a marshy pond and two gnarled trees, three other riders wait for their companions.

Esaias van de Velde was a pupil of Gillis van Coninxloo (1544–1607) and subsequently of David Vinckboons (1576–about 1632), both Flemish emigré painters of densely forested landscapes. In the early 1610s, together with Willem Buytewech and Hercules Seghers, van de Velde was a leader in developing a new naturalism in landscape painting in Haarlem predicated on the convincing representation of familiar — though not necessarily identifiable — Dutch landscapes. By 1618, when van de Velde moved to The Hague, these principles were well established in his art.

Riders Resting on a Wooded Road incorporates many of the successful innovations of the artist's Haarlem period, and presents a charming, unembellished vignette of the Dutch countryside. A smooth spatial recession is accomplished by a zigzag organization from left foreground to right middle ground to left background, as facilitated by the sharply curving road. The abstract arabesque of the spare tree at left is a

motif frequently encountered in van de Velde's art (compare, for example, a similar coulisse in his etching *Square Landscape*, about 1618–1619). In the painting, however, the tree has a more naturalistic, less starkly decorative character. Among the works specifically related to the present painting are van de Velde's drawing *Riders in a Forest*, dated 1616 (Kassel, Graphische Sammlung), which depicts a similar composition in reverse; and a painted *Landscape with Riders*, dated 1619 (Besançon, Musée des Beaux-Arts). The present work, however, is a more intimate view, with the human element assuming a more prominent role in the composition.

M.E.W.

150 PLATE 45
WILLEM VAN DE VELDE THE YOUNGER (Dutch, 1633–1707)
Fishing Boats by the Shore in a Calm, about 1665
Oil on canvas, 12¼ x 15 in. (31 x 38 cm)
Private collection

PROVENANCE: Collection Lensgreve Holstein, Holsteinborg, Denmark, by 1891; sale Amsterdam, July 20, 1928, no. 31; collection P. Smidt van Gelder, 1929; sale Amsterdam (F. Muller), November 20–23, 1951, no. 1925; coll. S. J. van den Bergh, Wassenaer; dealer J. R. Bier, Haarlem, 1960; collection Mevr. B. Gispen-van Eijnsberg, Nijmegen, by 1963; Newhouse Galleries, New York.

EXHIBITIONS: Copenhagen, 1891, no. 220; London, Royal Academy of Arts, *Exhibition of Dutch Art*, 1929, no. 291; Laren, Singer Museum, *Kunstschatten, twee Nederlandse collecties schilderijen*, June–August 1959, no. 84 (collection Van den Bergh); Haarlem, J. R. Bier, 1960), no. 26; Nijmegen, De Waag, *Kunst uit Nijmeegs particulier bezit*, 1963, no. 34; Dordrechts Museum, *Zee-, Rivier- en Oevergezichten*, 1964, no. 34.

LITERATURE: C. Hofstede de Groot, *A Catalogue Raisonné of the Works of the Most Eminent Dutch Painters of the Seventeenth Century*, trans. by Edward G. Hawke (London, 1908–1927), vol. 7 (1923), no. 323; M. S. Robinson, *The Paintings of the Willem van de Veldes* (London, 1990), vol. 2, p. 713, no. 440 (as "An English fishing smack aground on a spit of sand").

Willem van de Velde the Younger was perhaps the greatest Dutch marine painter of the seventeenth century. His father, Willem van de Velde the Elder (1611–1693), was also a marine painter; his younger brother Adriaen (1636–1672) was a talented landscapist. The younger Willem van de Velde studied first with his father and subsequently (about 1649–1651) with Simon de Vlieger. Willem's mature paintings combine the almost clinical precision of his father's "ship portraits" with the more atmospheric tonalism of de Vlieger's seascapes.

During the first phase of his career (from about 1653 through the mid-1660s), van de Velde focused on painting calms, depicting ships lying in still waters and bathed in subtle atmospheric effects. Many of these scenes are set close to shore, with ships at anchor or, as here, run aground. In the present picture, an English fishing boat (its country of origin indicated by a banner with the cross of Saint George atop its mast) is aground on a spit of sand. The boat itself is probably a fishing smack, a single-masted coastal vessel with a stand-

ing gaff extending diagonally from the main mast. On the sand to the right of the smack is a small bivouac tent, with three figures grouped around a cook fire. On the distant horizon is the profile of an unidentified city. A variety of fishing boats and small rowboats are scattered across the left half of the composition, punctuating the smooth and luminous expanse of water. Golden sunlight accents the masts and sails silhouetted against the dramatic cloud-filled sky.

Fishing Boats by the Shore has been dated by M. S. Robinson (1990, vol. 2, p. 713) to about 1665; he notes similarities with dated works of this period which also situate the principle vessel well in the foreground (compare, for example, *Calm*, signed and dated 1663; London, Dulwich Picture Gallery, inv. 197). The inclusion of an English fishing smack is unusual for works from van de Velde's Dutch period, however, and may indicate a later date for the work, after the artist's move to England in 1672.

M.E.W.

151 PLATE 27
ADRIAEN VAN DE VENNE (Dutch, 1589–1662)
"Fray en Leelijck" (*"Beautiful and Ugly"*), n.d.
Oil on panel, 14⅝ x 11⅝ in. (37.2 x 29.5 cm)
Signed at upper right: *A V Venne*
Inscribed in banderole at upper right: *Fray en Leelijck*
Collection of Noah Mathews

PROVENANCE: Collection Alfred Kaveusth (?); sale London, October 13, 1913, no. 5; sale London (Christie's), July 4, 1986, no. 20, ill.; dealer Otto Naumann, Ltd., New York.

EXHIBITION: New York, National Academy of Design, *Dutch and Flemish Paintings from New York Private Collections* (cat. by Ann Jensen Adams), 1988, p. 133, no. 51.

Clad in tattered rags, a heavily bearded blind beggar plays a wooden pipe while a wrinkled crone accompanies him on a hurdy-gurdy. The painting is executed primarily in *brunaille*, but with subtle gradations of green and other deep tones in the figures' garments set off against the soft blue of the background sky. In the upper-right corner of the composition, a banderole inscribed "Fray en Leelijck" ("Beautiful and Ugly") expresses the theme of the work: the musicians themselves may be unsightly (not to mention unsighted), but their harmonies are beautiful. The beggar is, moreover, blind to his companion's cosmetic defects, and recognizes only her musical abilities.

The idea that no misfortune is without its positive aspects was a recurring theme in van de Venne's *grisaille* and *brunaille* paintings, many of which are inscribed with humorous or satirical proverbs or phrases highlighting the ironies of life. The majority of them are about poverty, about wealth and the lack of it. The present painting is the artist's only known work illustrating the phrase "Fray en Leelijck," and is also unusual in that it depicts figures at half length. Both the

subject and the figures themselves, however, are quite similar to those of van de Venne's *"Arme Weelde"* (*"Poor Man's Luxury"* (signed and dated 1631, location unknown; Annelies Plokker, *Adriaen Pietersz. van de Venne: de Grisaille met spreukbanden* [Amersfoort, 1984], p. 58, ill.), in which two tattered beggars dance arm in arm (in the original Dutch, a pun on the word *arme*), glad of each other and of the bowl of food one of them holds. In *"Armoe' soeckt List"* (*"Poverty Leads to Ingenuity"*), van de Venne depicted two aged, blind itinerant musicians — one with a hurdy-gurdy, the other with a *rommelpot* — being guided in their journeys by a small dog tethered to their waists (private collection; Laurens J. Bol, *Adriaen van de Venne: Painter and Draughtsman* [Doornspijk, 1989], p. 86, ill.; for other versions, see Plokker 1984, pp. 66–69).

M.E.W.

152 PLATE 62
ADRIAEN VAN DE VENNE (Dutch, 1589–1662)
"Alle Baeten Helpen" (*"Every Profit Helps"*), 1655
Oil on panel, 23½ x 29½ in (59.5 x 45 cm)
Signed and dated at lower right: *1655*
Inscribed at lower left: *Alle Baeten Helpen*
Private collection

PROVENANCE: Sale Enschedé, Haarlem, April 16, 1776, no. 50; Holland Collection, Braunschweig, cat. 1843, no. 28; Dr. Martin Schubart Collection, Munich, cat. 1894, p. 17; sale Schubart, Munich, October 23, 1899, no. 78, ill.; private collection, New York; sale New York (Sotheby's), January 17, 1985, no. 56.

EXHIBITIONS: Munich, Königlich Kunstausstellungs-Gebaude, *Sammlung hervorragender alter Meisterwerke*, 1895, no. 72.

LITERATURE: C. Hofstede de Groot, *Sammlung Schubart. Eine Auswahl von Werken alter Meister* (Munich, 1894), p. 17; Annelies Plokker, *Adriaen Pietersz. van de Venne (1589–1662): de Grisaille met spreukbanden* (Amersfoort, 1984), pp. 26–27, no. 2, ill.; Laurens J. Bol, *Adriaen van de Venne: Painter and Draughtsman* (Doornspijk, 1989), p. 100.

The multifaceted artist Adriaen van de Venne was not only a painter in color as well as *grisaille* and *brunaille* (paintings, respectively, in tones of gray and brown, as in the present work), but also a draftsman, a printmaker, an illustrator, and a poet. Here, he depicted the crowded and clamorous annual fair held in the Buitenhof in The Hague. In the center two blind men are tethered together and led by a dog. On the left is a pickpocket, and on the right, a mounted quacksalver, who offers medicines to a ring of eager women beneath him. In the distance the tents of other marketing stands rise above the crowd.

Although many Dutch genre painters encoded concepts or morals into their outwardly naturalistic scenes, van de Venne literally inscribed messages into his paintings, especially those he painted in monochrome rather than color. In the lower left of this work is the expression "Alle baeten helpen" ("Every gift [or profit] helps"). The seventeenth-

century Dutch word *baet*, comparable to the modern word *beetje*, means profit or benefit, but also monetary gain. The expression "Alle beetjes helpen" suggests that every gain, no matter how small, is always welcome. Thus van de Venne's inclusion of the proverb seems to comment ironically on the ways in which his several standard low-life characters earn their living: the blind mendicants playing a flute to beg a few stivers, and the more illicit activities of the quack and cutpurse. As Annelies Plokker observed (1984, cat. no. 21), in van de Venne's book *Tafereel van de belacchende werelt* (*Picture of the Ridiculous World* [The Hague, 1635]), a variation on the title of this painting appears in an inscription in the margin: "Alle baten helpen veel menschen / veel baten helpen alle menschen" ("All profits help people / much profit helps all people"). Another large *brunaille* depicting the crowds at the annual fair in The Hague (dated 1652; private collection; Bol 1989, fig. 83), features the inscription "Bij het volck is de neering" ("Where there are people, money may be made").

P.C.S.

153 PLATE 79
FRANÇOIS VERDIER (French, 1652–1730)
Christ Carrying the Cross, about 1700
Oil on canvas, 36 x 58½ in. (91.5 x 148.5 cm)
Mr. and Mrs. William Julien

PROVENANCE: Bernard Coyne, Salem, Massachusetts, to 1970.

EXHIBITION: Paris, Grand Palais; New York, Metropolitan Museum of Art; and Art Institute of Chicago, *France in the Golden Age: Seventeenth-Century French Paintings in American Collections*, 1982, no. 111.

LITERATURE: Pierre Rosenberg, "France in the Golden Age: A Postscript," *Metropolitan Museum Journal* 17 (1982), p. 37.

In 1676, after studying at the Académie Royale in Paris, Verdier was admitted there, and two years later he was granted full membership. With the backing of Charles Le Brun the artist then pursued his studies in Rome. In 1684 Verdier became a professor at the Académie Royale. He painted primarily religious subjects, and, as Pierre Rosenberg observed, "although Verdier's style is closely related to that of Le Brun, the simplified gestures and staid facial expressions of his figures and the unusual discordant colors give his work a strange and arresting character" (1982, p. 130).

It was also Rosenberg who first identified this work as Verdier's, correctly pointing out its dependence on a depiction of the same subject which Le Brun had painted for Louis XIV in 1688, and which possibly was the one shown in 1979 at the Heim Gallery, London. Verdier's work may date from not too much later and may be identical with one he exhibited at the Salon of 1704, even though the latter was described as *Christ Carrying His Cross to the Gate of Jerusalem*, which is actually a somewhat earlier incident in the Passion. Shown here is the moment when Christ, bearing the cross and beaten by his tormentors, stumbles to the ground. He is

comforted by Saint Veronica, who appears seated at the right. The figures are arranged as in a frieze before the architecture, and their clear, theatrical gestures are typical of Verdier's distinctive style, of which other examples are in the museums of Tours and Budapest; another was sold at Sotheby's, London (April 11, 1990, no. 203).

E.M.Z.

154 PLATE 91

JEAN LOUIS VOILLE (French, worked in Russia; 1744–after 1802)
Portrait of John Cayley, 1788
Oil on canvas, 25½ x 20 in. (64.6 x 52 cm)
Signed and dated at right, just below center: *Voille / 1788*
Private collection

PROVENANCE: Sarah Moberly, daughter of the sitter; by family descent to Rev. Edgar Moberly, 1931; P. G. Bennett, Flokestone, Kent; Alex Wengraf Ltd., London; acquired from Colnaghi, New York.

LITERATURE: Brinsley Ford, "Portraits of the English Abroad in Countries Other than Italy," in *The Fashioning and Functioning of the British Country House* (*Studies in the History of Art*, vol. 25), (Washington, D.C.: Center for Advanced Study in the Visual Arts, National Gallery of Art, 1989), p. 99.

Born in Paris in 1744, Jean Louis Voille studied with the fashionable portrait painter François-Hubert Drouais (1727–1775) at the Académie Royale, where the youth was first listed in 1758 as being among the students. Almost all of Voille's known works were produced in Saint Petersburg, where he set up shop in 1770 or 1771. Proficient in the current French manner, Voille gained considerable success among members of the Russian court and visiting European notables with his sensitive and stylish portraits. He was befriended and patronized by Grand Duke Pavel Petrovitch (later Czar Paul I), who in 1780 named Voille court painter and granted him a stipend. The artist seems to have returned to France only once, in 1793, when relations between France and Russia soured. Several of his works were exhibited in the Salon of 1795. By 1802 he was back in Russia, where he presumably died not long afterward.

The present portrait is of John Cayley, the English consul-general in Saint Petersburg. Born in 1730 to an old Yorkshire family, Cayley joined the Russia Company as a freeman in 1754 and traveled to Saint Petersburg as a junior partner in Thornton & Cayley, an import-export firm. Two years later, he married Sarah Cozens, the daughter of the master shipbuilder to Czar Peter the Great, and the sister of the painter Alexander Cozens. The couple had eight children. In 1787 Cayley was appointed consul-general and agent for the Russia Company. Later in the same year he was presented at the court of Empress Catherine the Great. Brinsley Ford suggests that Cayley may have commissioned his portrait from Voille to commemorate his appointment. Ill, Cayley returned to England in 1794; he died in Richmond, Surrey, the following year.

Voille's typical portrait, of which many examples remain today in the collection of the Hermitage in Saint Petersburg, featured a bust-length view of the sitter, usually full face, in fashionable but not excessively ornamented attire. For the present canvas, Cayley's face was closely observed and delicately rendered. The naturalistic glow of the subject's skin emerges from the warm olive and brown earth tones that predominate the canvas, and is punctuated by the sharpness of the orange and black striped collar that peeks out from under his coat. The exotic quality that Russia had for western European visitors is summoned up by the heavy coat, with its toggle clasps and dense fur collar, which is evocative of swirling snow and Tartars on horseback.

P.S.

155 PLATE 19

MARTEN DE VOS (Flemish, 1532–1603)
The Virgin and Christ Child Welcoming the Cross, about 1600
Oil on panel, 44⅛ x 34⅞ in. (112 x 88.5 cm)
Signed on prie-dieu at lower right: F. *MERTINO D. VOS*
Private collection

PROVENANCE: Collection of a European noble family, by whom it was sold in London (Christie's), July 4, 1986, no. 13, ill.; P. & D. Colnaghi & Co., Ltd., London.

EXHIBITIONS: London, P. & D. Colnaghi & Co., Ltd., *Gothic to Renaissance: European Painting 1300–1600*, 1988, no. 31; Worcester (Massachusetts) Art Museum (on loan).

LITERATURE: Ivan Gaskell, in *Gothic to Renaissance: European Painting 1300–1600* (exh. cat., London, 1988), p. 136.

Marten de Vos was the most important Antwerp painter during the generation immediately preceding Rubens. Following the Iconoclastic riots and the official restoration of Catholicism to the Southern Netherlands in 1585, there was a great demand for altarpieces to replace destroyed works, and for new images to express the more powerful religious iconography of post-Tridentine Catholicism. De Vos responded with dynamic compositions that revitalized pictorial traditions and effectively conveyed the new doctrinal messages.

The artist was a pupil in Antwerp of Frans Floris (1516–1570), but equally important in the formation of his art was his Italian sojourn of 1552 to 1558. De Vos visited Rome and Florence, and worked briefly with Jacopo Tintoretto in Venice. The rich colors and figural elegance characteristic of sixteenth-century Venetian art continued to dominate de Vos's work even after his return to Antwerp.

In the present painting, the Virgin is seated by her prie-dieu, with her sewing basket by her side, as she offers her breast to the Christ Child. He, however, reaches up toward the wooden cross supported by a glory of angels at upper left. The brilliant *changeant-couleur* of the angels' garments, as

well as the rather agitated movement of the draperies themselves, reveals the late Mannerist tendencies of de Vos's art. The Italianate architecture of the interior also appears in many of de Vos's late works (compare his *Saint Luke Painting the Virgin* of 1602 [Antwerp, Koninklijk Museum voor Schone Kunsten, inv. 88]). Both the forms of the architecture and the complex spatial organization, with views to another room at the right and a balcony overlooking a courtyard at left, recall the influential perspective and architectural studies of de Vos's Antwerp colleague Hans Vredeman de Vries (1527–1604 or 1624).

There is a long pictorial tradition of allusions to the Passion in scenes of Christ's infancy which focus either on the anticipated suffering and resurrection of Christ himself or on the Virgin as Mother of Sorrows; in the latter, Christ holding the Cross signified one of the Seven Sorrows of the Virgin. In the Southern Netherlands, Counter-Reformatory doctrine (promulgated particularly vigorously by the Jesuits) espoused new forms of meditational devotion which focused on personal knowledge and experience of Christ's sufferings. These teachings emphasized Christ's willing acceptance of his sacrifice, which de Vos represented in the present painting by having the infant Christ turn away from his mother's breast to welcome the celestially-borne cross.

There is a drawing by de Vos of the same subject in Dresden (dated 1595; Kupferstichkabinett, Staatliche Kunstsammlungen, inv. C 874); an engraving after the painting (in the same direction, with minor variations) by Raphael Sadeler I (dated 1614); and an anonymous early-seventeenth-century copy of the composition, probably done after the engraving, in Innsbruck (Tiroler Landesmuseum Ferdinandeum, inv. 124).

M.E.W.

156 PLATE 149

EDOUARD VUILLARD (French, 1868–1940)
Portrait of Ambroise Vollard, about 1897–1900
Oil on paper mounted on board, 15¼ x 21¼ in.
(38.7 x 54 cm)
Signed with stamp at bottom right: *E. Vuillard*
Private collection

PROVENANCE: Galerie Durand-Ruel, Paris; Mrs. Steinberg, from whom it was a gift.

EXHIBITIONS: Shown in conjunction with New York, Museum of Modern Art, *Ambroise Vollard Editeur, Prints, Books, Bronzes*, 1977 (not in catalogue).

Edouard Vuillard was born on November 11, 1868, in Cuiseaux, a small town on the edge of the Jura. In 1877 his family moved to Paris. Vuillard's mother joined a firm of corset makers shortly after the family's arrival in the capital, taking over the business in 1879. Following the death of his father, a retired marine infantry captain who had won the Lé-

gion d'honneur in 1883, the painter's mother moved her business into their home (the seamstress's workshop was to become a favored motif of the artist in the 1890s). Vuillard was preparing to enter a military college when his close friend Ker-Xavier Roussel persuaded him to attend Diogène Maillart's free evening classes at the Gobelins school. In 1886 Vuillard failed the entrance exam for the Ecole des Beaux-Arts. While preparing to retake the exam, he enrolled at the Académie Julian. In 1888 the artist was finally admitted to the Ecole, but studied there very briefly, perhaps only six weeks. Belinda Thomson has suggested that Vuillard's formative artistic training was independent of conventional study. According to Thomson, his visits to the Louvre and his sketches of Parisian street scenes were as influential to him as the lessons of the Académie Julian or the Ecole. Vuillard exhibited at the Salon for the first time in 1889.

During 1888 and 1889 a group of students who were dissatisfied with the conventional instruction and conception of art at the Académie Julian banded together and formed a secret society under the leadership of Paul Sérusier. A student monitor at the Academie, Sérusier had gone on a summer holiday in Brittany, where Gauguin had encouraged the youth to experiment with exaggerated colors and simplified forms. The first members of the society included Maurice Denis, Pierre Bonnard, and Paul Ranson, among others. They called themselves "Nabis" (the Hebrew word for prophet), a name that related to their goal of abandoning naturalism in favor of an art derived from Gauguin's Synthetism. The Nabis sought to pursue a higher, more ideal conception of art. Vuillard probably joined the group in 1890, and they began exhibiting together at Le Barc de Boutteville's gallery in 1891. The range of the Nabis' artistic activities — including easel painting, mural decorations, prints, designs for the theater, and decorative arts — as well as their theorizing about art, established them as the most progressive representatives of the avant-garde in Paris during the 1890s. Following the death of Le Barc in 1896, the group became associated with the dealer Ambroise Vollard, who exhibited the work of Vuillard and other members for the first time in 1897, at his gallery at 6 rue Laffitte. During the same year, Vollard commissioned Vuillard to produce a lithographic series, *Landscape and Interiors*.

Vuillard probably painted this unfinished portrait of Vollard about 1897 or 1898. Its small size is typical of the artist's work during the 1890s. By the time of Vuillard's association with Vollard, he was known for his Intimist interiors. Insofar as it is possible to observe of an unfinished work, Vuillard's portrait is characterized by his personal variation of the Nabis' style: the elimination of deep space, the use of a passage of white underpainting to suggest a broad, flat area of color in the background, and the tendency to suggest rather than describe forms, including the features of the sitter.

The style of the present painting is less significant than its subject. Following the breakdown of the Salon as the prin-

cipal institution for the exhibition and purchase of works of art, small-scale commercial dealers opened galleries that provided artists with an alternative means of displaying and selling their work. Nicholas Green has begun to chart the importance of the "strategic alliances between speculative collectors, critics and dealers" which emerged during this period. Green stresses the significance of "the network of publicity and sales campaigns" that in part structured artistic production ("Dealings in Temperaments: Economic Transformation of the Artistic Field in France during the Second Half of the Nineteenth Century," *Art History* 10, no. 1 [March 1987], p. 60).

Members of the Nabis, including Vuillard, participated in a group exhibition called "Impressionist and Symbolist Painters" at Le Barc's gallery in 1893. In the preface to the catalogue of this exhibition Camille Mauclair wrote: "They have no relations with society, except insignificant ones: they are a society unto themselves." Mauclair's statement, however, is not entirely borne out by the circumstances of the lives of Vuillard and the Nabis. Actively involved with galleries, periodicals, and commissions, they were constantly in contact with society. On the other hand, Mauclair is accurate in describing the Nabis and the other participants in this exhibition as "a society unto themselves." By the 1890s a circumscribed community of collectors, dealers, and critics had created an alternative system of support for the arts. Vuillard executed portraits of many of these supporters. It was in keeping with Vuillard's practice to paint his new dealer following the death of Le Barc. It is surprising, however, that this portrait remained unfinished. Other portraits of Vollard by artists he represented include Cézanne's (1899; Paris, Musée du Petit Palais), Vallotton's (1902; Rotterdam, Museum Boymans-van Beuningen), and Bonnard's (1904–1905; Zurich, Kunsthaus). Maurice Denis's *Homage à Cézanne* (1900; Paris, Musée d'Orsay) documents the close ties that existed among the various constituencies of the avant-garde in Paris about the turn of the century. Denis's painting is as much an homage to Vollard as to Cézanne, as it is clearly set in the dealer's gallery and includes his image. Among the Nabis depicted, Vuillard is also present, demonstrating not only his admiration for Cézanne but his affiliation with the dealer.

R.J.B.

157 PLATE 148
EDOUARD VUILLARD (French, 1868–1940)
The Hessel Salon, rue de Rivoli, about 1901–1904
Oil on panel, 29 x 25 in. (74 x 63.5 cm)
Signed at lower right: *E Vuillard*
Private collection

PROVENANCE: Purchased from the artist in 1904 by Bernheim-Jeune, Paris; Albert Bernier, Paris; sale Paris, November 1910, no. 55; Bernheim-Jeine, Paris; Henri Canonne, Paris; Edouard Jonas, Paris; Josef Stransky, New York; Wildenstein and Co., New York; Herman Schulman, New York; D. L. Podell, United States; private collection, United States; Lefevre Gallery, London; acquired in 1985.

EXHIBITIONS: Washington, D.C., Phillips Memorial Gallery, *Vuillard*, 1939, no. 13; New York, Museum of Modern Art, 1940; New York, Museum of Modern Art, *Art in Progress*, 1944, p. 224, ill.; London, Lefevre Gallery, *Important XIX- and XX-Century Works of Art*, 1983, p. 48, no. 19, ill.

LITERATURE: Arsène Alexandre, *La Collection Canonne, Une Histoire en action de l'Impressionnisme et de ses suites* (Paris, 1930), p. 91, ill.; Ralph Flint, "The Private Collection of Josef Stransky," *Art News*, May 16, 1931, p. 88; Denys Sutton, "Round the Galleries, Visual Delights," *Apollo* (December 1983), p. 520, ill.; Belinda Thomson, *Vuillard* (New York, 1988), p. 69, ill.

Vuillard's artistic formation was a complex one. His beginnings are best described as "realist," though he shared with his Impressionist contemporaries a dedication to subjects that were familiar and modern. An aesthetic reformulation took place around 1890, when Vuillard became associated with the recently formed Nabis group. Imposing a simplification of form and an arbitrariness of color onto his still-realist subjects, Vuillard created small, highly charged Intimist scenes, which were widely admired for their magical color harmonies and rhythmic silhouettes. Toward the turn of the century, the Nabis went their separate ways. About this time, Vuillard's interiors began to lose their flattened, decorative quality. His rooms gained a newfound depth and airiness, and his colors were closer to nature without foregoing their subtle harmonies.

The Hessel Salon, rue de Rivoli is an accomplished work of this period and is among Vuillard's finest achievements. Confident, open brushwork conveys the glittering opulence of this warmly lit haute-bourgeois salon in the home of Lucy and Jos Hessel. Lucy Hessel, in a fashionable black dress trimmed in white, stands to the left, adjusting her hat. Her husband, Jos, and his brother, Gaston, were the proprietors of Bernheim-Jeune, a very successful gallery dealing in modern art. Vuillard first showed work in this gallery in a group exhibition in 1900, and after 1906 had regular one-man shows there. In the present painting, works of contemporary artists represented by the gallery adorn the Hessels' salon: *Bathers* by Cézanne (Paris, Pollerin collection) hangs above the window, *Profile of a Prostitute* by Toulouse-Lautrec (1893; Pasadena, Norton Simon Museum) hangs to the left, and a second Cézanne, a portrait of Mme Cézanne of 1885 (formerly in the collection of Henri Matisse), is partially visible at the right.

Vuillard spent considerable time with the Hessels and formed an intimate friendship with Lucy, who played a prominent role in his life for the next forty years. Vuillard, a bachelor living with his mother, and Hessel, who was often neglected by her husband, saw each other almost daily. In spite of their close emotional bond, their relationship apparently remained platonic. Lucy Hessel was by Vuillard's side when he died in 1940.

In *The Hessel Salon*, the luscious effect of Vuillard's characteristic brushwork unifies the composition. The patterns of various planes float forward to form an overall pattern across the surface of the picture, an effect often likened by Vuillard's contemporaries to an Oriental carpet or tapestry. The painting has traditionally been dated to 1901, although Belinda Thomson (1988, p. 69) has assigned it a date of 1903 or 1904.

P.S.

158 PLATE 150
EDOUARD VUILLARD (French 1868–1940)
Nude in an Interior, 1923
Oil on board, laid down on panel, 29⅜ x 20½ in.
(74.4 x 52 cm)
Stamped with signature at bottom right: *E. Vuillard*
(Lugt 2497a)
Scott M. Black Collection

PROVENANCE: The artist's estate; Yves Doornic, Paris; anonymous sale Paris, (Hôtel Drouot), July 4, 1949, lot 17; Dalzell Hatfield Galleries, Los Angeles; sale New York (Christie's), November 14, 1989, lot 28.

EXHIBITION: Portland (Maine) Museum of Art, *Impressionism and Post-Impressionism: The Collector's Passion*, July–October 1991, no. 53, pp. 91–92.

Vuillard is perhaps best known for his Intimist interiors of the 1890s. Small in scale, the painter's interior views are characterized by nuanced colors arranged in delicately balanced patterns. Although Vuillard's Intimist paintings contain recognizable imagery, the artist's concern with formal issues seems to overshadow his subjects, which verge on abstraction. After 1900 the Nabis began to work more independently of each other, and Vuillard's interests shifted away from the radical style of his Intimist interiors to a new emphasis on the material particulars of bourgeois interiors.

As the artist's work received greater critical acclaim, he was much sought after by dealers and collectors. Following 1912, he received many commissions for portraits. In keeping with his habit of portraying his subjects in their domestic environments, Vuillard frequently depicted the sitters in his commissioned portraits in their haute-bourgeois homes or apartments. The setting for the present painting, however, is Vuillard's own apartment on the rue de Calais. The identities of the two women are unknown. The central nude has her back turned to the viewer as she arranges her hair in a mirror. Seated at her side, the second woman turns her face away from the viewer. Such placement of the figures both draws the viewer into the picture and imbues the scene with an enigmatic quality.

The theme of women observing themselves in mirrors is traditional in western painting and had been associated at least since the Middle Ages with *Superbia*, and with the sins of Pride and Vanity. Vuillard probably knew famous later ex-

amples, such as Velazquez's *The Toilet of Venus* (about 1648; London, National Gallery) and Rubens's *Venus Looking in a Mirror* (about 1615–1616, Prince of Liechtenstein Collection, Vaduz Castle), as well as much more recent works, such as Cézanne's *The Toilet* (about 1878; Merion, Pennsylvania, Barnes Foundation). The subject became particularly popular during the early twentieth century. Bram Dijkstra has noted: "By the end of the first decade of the twentieth century, as a matter of course, the theme of a woman before her mirror had become perhaps the single most prominent excuse for figure paintings at the Parisian 'salons de peintur'" (*Idols of Perversity* [New York, 1986], p. 140).

The present picture makes both direct and indirect references to precedents. Upon the mantelpiece below the mirror is a plaster cast of the Venus de Milo (photographs of Vuillard's apartment facilitate this identification). In several of the examples cited above, the theme of women examining themselves in mirrors is specifically identified with Venus. The presence of the cast in the present painting is merely suggested by cursory strokes of white pigment, yet it occupies the center of the composition. Standing slightly to the left of the sculpture, the nude model is rendered as a dense plastic form. The sculptural conception of the live model is contrasted with the flat notation of the sculpture, which had such a central position in western culture. Of course, this juxtaposition would have been known only to the painter and those privileged to have visited his apartment; thus it remains a very private symbol.

It is possible, however, to suggest an interpretation of the picture which transcends the depiction of a mere interior. A variety of references and conflicting interests are included in this painting: figure / ground, painting / sculpture, identification / anonymity, and tradition / innovation. The infinitely subtle and sophisticated Vuillard presented an inventory of the conflicting issues that informed both his oeuvre and the nature of representation itself during the first quarter of the twentieth century. This private meditation upon the art of painting remained in the artist's possession until his death in 1940.

R.J.B.

159 PLATE 102
GEORGE FREDERICK WATTS (English, 1817–1904)
Orpheus and Eurydice, n.d.
Oil on canvas, 29½ x 18½ in. (74.9 x 46.9 cm)
Private collection

PROVENANCE: William Connal, Jr.; John Reid, Glasgow; sale London (Christie's) October 24, 1975, no. 112 (as "the property of a gentleman"); private collection.

EXHIBITIONS: Glasgow, Royal Institute, 1890, no. 631; Rome, *International Fine Art Exhibition*, 1911, no. 107; Paisley, Scotland, 1913.

LITERATURE: *Catalogue of the Collection of Pictures of the British, French and Dutch Schools Belonging to John Reid* (Glasgow, 1913), p. 41.

George Frederick Watts was born in London in 1817 to humble origins and lifelong poor health. Steadfast in his determination to follow his artistic calling, Watts was largely self-taught. He began to exhibit portraits at the Royal Academy in 1837 and, at the age of twenty-six, won a prize in a government-sponsored competition for mural painters, which allowed him to travel to Italy. Watts spent the following three years in Florence, where his exposure to works of the Italian Renaissance had a lasting effect on his work.

Returning to England in 1847, Watts spent several unhappy years painting Social Realist themes before settling as the thirty-year houseguest of Mr. and Mrs. Thoby Prinsep, at whose weekly salons of English literary and artistic figures he was the centerpiece. Earning money mainly through portrait painting, Watts had grander ambitions of large-scale public work, which eventually were realized during his long and prodigious career. His oeuvre includes allegorical and biblical subjects, public murals and frescoes, and even several cast-bronze sculptures. Watts assumed a hero's mantle in his later years, when he was described by Ruskin (1850) as "the only real painter of history or thought we have here in England" (quoted by Allen Staley in *Victorian High Renaissance* [Manchester, Minneapolis, and Brooklyn, New York, 1978–1979], p. 56). In 1884 Watts was one of the first two British artists (Millais being the other) to be offered a hereditary title, but he refused it. Watts worked until his death in 1904, at the age of eighty-seven.

The myth of Orpheus and Eurydice was a subject often treated by Watts. His first completed version of the theme was exhibited at the Royal Academy in 1869 (New York, Forbes Magazine Collection); Watts continued to produce repetitions of it until 1903. There are five known full-length versions, including the present canvas, and three half-length examples. Orpheus, the supreme musician of Greek mythology who sought to reclaim his wife from the underworld through the charm of his lyre, was granted his desire on the condition that he not turn to look at her until they reached the surface again. However, unable to resist the temptation, Orpheus turned to gaze at his wife's face, only to have her vanish back to Hades. His resulting gloom and self-exile brought about the wrath of the Thracian women, who tore him to pieces, leaving only his severed head, which continued to sing after his death.

Watts focused on the moment when Orpheus mournfully realizes his loss; he bends backward, trying to hold onto Eurydice, who already is falling away from him. Staley suggests that the subject, which was popular among painters of the later nineteenth century, may have had special meaning for Watts, who was briefly married in 1864, at the age of forty-seven, to the sixteen-year-old actress Ellen Terry; to Watts's disappointment, the marriage dissolved in less than a year, with Terry leaving him to pursue her career on the stage (Staley 1978–1979, p. 76).

As in many of Watts's works, the layers of heavy brushwork and scumbled paint in the present canvas seem to indicate extensive reworking. The dark strokes that outline Eurydice's left leg have an unfinished quality that perhaps indicates a stage of reworking.

P.S.

160 PLATE 92
JEAN BAPTISTE WICAR (French, 1762–1834)
Portrait of an Officer, n.d.
Oil on canvas, 29¾ x 24½ in. (75.6 x 62.2 cm)
Graham Prescott Teller

Wicar received his first training in his native Lille. In 1780 he went to Paris, where he studied painting under David, accompanying the master to Rome in 1784; Wicar produced a number of historical and biblical works during the following years. Having also learned the skill of engraving, he went to Florence, where he made more than 400 drawings of works in the Pitti Collection, which were published in engraved form between 1789 and 1807. During the era of the French Revolution, Wicar returned to Paris in order to assist David in reordering the official art world. The artist gained his greatest notoriety for launching, in the midst of the Reign of Terror in 1794, a charge of licentiousness against the works of genre painters, especially his more renowned compatriot of Lille, Boilly. The latter, however, was able to clear himself, and Wicar, who was discredited along with David, was imprisoned for a time. He was freed in June 1795, and departed soon thereafter for Italy. During Napoleon's reign Wicar, who was on good terms with Lucien and Joseph Bonaparte, was given employment in Naples and Spain, and also helped choose works of art for shipment back to Paris. The artist then settled permanently in Rome, where he worked primarily as a portrait painter and became well known as a collector. At his death his collection was bequeathed to the Musée des Beaux-Arts of Lille.

This oval portrait of an officer was first tentatively attributed to Wicar by Pierre Rosenberg (in a letter of November 8, 1984). This attribution was recently confirmed by Annie Scottez-De Wambrechies (in a letter of July 25, 1991), who pointed out that the modeling and the treatment of the hair are characteristic of Wicar. Comparison can be made in this regard with the portraits of both Joseph and Lucien Bonaparte (now in Versailles; see *Le Chevalier Wicar* [exh. cat., Lille, Musée des Beaux-Arts, 1984], figs. 5, 6, and 10). The uniform in the present work has been identified by A. Demasles of the Musée de l'Armée in Paris as of the "Régiment de la Reine, division de la Romana (Espagne)." Many of Wicar's Roman portraits depict such Scarpiaesque officials, whom he faithfully recorded in their period fashions, according great attention to the details of their medals and ribbons.

E.M.Z.

161 PLATE 52

PHILIPS WOUWERMAN (Dutch, 1619–1668)
Cavalry Watering Their Horses, 1660s(?)
Oil on panel, 14 x 16¼ in. (35.5 x 41.2 cm)
Signed with a monogram
Private collection

PROVENANCE: Purported to have come from the Escorial Palace; Prince Louis Napoleon Bonaparte, who sold it to Pennell, 1840 (for £350); with dealer Gritten, London, 1842; sale T. Patureau, Paris, April 20, 1857, no. 45; Empress Eugenie, Tuileries, Paris, who bequeathed it to Dr. Hugenschmidt, May 20, 1921; private collection, Paris; acquired from dealer Johnny van Haeften, London.

LITERATURE: John Smith, *A Catalogue Raisonné of the Works of the Most Eminent Dutch, Flemish, and French Painters*, vol. 9 (suppl.; London, 1842), no. 82; C. Hofstede de Groot, *A Catalogue Raisonné of the Works of the Most Eminent Dutch Painters of the Seventeenth Century*, trans. by Edward G. Hawke (London, 1908–1927), vol. 2 (1909), no. 832.

In an open landscape, with a river on the left and mountains in the distance, an extensive company of soldiers weaves back from left to right and again to the left across a bridge into a misty distance, where the whitened clouds of explosions suggest ongoing hostilities. In the foreground, mounted soldiers and sutlers water their horses, and foot soldiers kneel to drink. A mounted soldier blows a bugle, and another holds his instrument at the ready, perhaps preparing to signal for the procession to halt. On the right an old peasant couple approaches deferentially, the man with his hat in hand.

Wouwerman was the most accomplished Dutch painter of horses and other equestrian subjects in Italianate landscapes. He often painted hunting equestrians, horse fairs, riding schools, and cavalry scenes. He repeatedly treated the subject of a long troop of mounted soldiers stopping to water their horses (see, for example, Amsterdam, Rijksmuseum, no. C271; and sale Carnavon [Lord Ashburton], London, May 22, 1925, no. 104 [Hofstede de Groot 1909, no. 20]). Wouverman often had the caravan stretch back into an extensive landscape (compare, particularly, the designs of his paintings in sale Monaco [Christie's], December 7, 1987, no. 15, ill. [Hofstede de Groot 1909, no. 834] and sale London [Christie's], July 11, 1980, no. 11, ill. [Hofstede de Groot 1909, no. 830]). Although it is quite difficult to date the present painting, its darker tone and broader execution suggest that it is a later work, from the 1660s. The famous connoisseur John Smith (1842, no. 82), who published the painting when it was with the London dealer Gritten in 1842, praised it as "a beautiful little picture."

In the seventeenth century there was no formal system for provisioning troops in the field. Soldiers were billeted with civilians, the peasantry becoming involuntary hosts of the military. Camp followers, sutlers, and the families of soldiers formed the straggling entourage of all military campaigns. Plunder and booty were regarded as legitimate supplements to the mercenary soldier's meager pay. Thus, artists often depicted soldiers and peasants as natural adversaries (see, especially, David Vinckboons's early-seventeenth-century series of prints called *Peasant Sorrow*). Wouwerman followed this tradition when he depicted peasants cowering before or being mistreated by cavalry officers (see, for example, Paris, Musée de Louvre, inv. 1963). As in Vinckboons's prints, however, the peasant could have his revenge (see Wouwerman's *Victory of the Peasants*, Amsterdam, Rijksmuseum, no. A476).

P.C.S.